Interpreting Art

Interpreting Art

Reflecting, Wondering, and Responding

Terry Barrett

The Ohio State University

Boston Burr Ridge, IL Dubuque, IA Madison, WI New York
San Francisco St. Louis Bangkok Bogotá Caracas Kuala Lumpur
Lisbon London Madrid Mexico City Milan Montreal New Delhi
Santiago Seoul Singapore Sydney Taipei Toronto

McGraw-Hill Higher Education

A Division of The **McGraw-Hill** *Companies*

Interpreting Art: Reflecting, Wondering, and Responding

Published by McGraw-Hill, an imprint of The McGraw-Hill Companies, Inc., 1221 Avenue of the Americas, New York, NY 10020. Copyright © 2003 by The McGraw-Hill Companies, Inc. All rights reserved. No part of this publication may be reproduced or distributed in any form or by any means, or stored in a database or retrieval system, without the prior written consent of The McGraw-Hill Companies, Inc., including, but not limited to, in any network or other electronic storage or transmission, or broadcast for distance learning.

This book is printed on acid-free paper.

8 9 0 DOC / DOC 0 9

ISBN: 978-0-7674-1648-1
MHID: 0-7674-1648-1

Publisher: *Chris Freitag*
Sponsoring editor: *Joe Hanson*
Marketing manager: *Lisa Berry*
Production editor: *David Sutton*
Senior production supervisor: *Richard DeVitto*
Designer: *Sharon Spurlock*
Photo researcher: *Brian Pecko*
Art editor: *Emma Ghiselli*
Compositor: *ProGraphics*
Typeface: *10/13 Berkeley Old Style Medium*
Paper: *45# New Era Matte*
Printer and binder: *RR Donnelley & Sons*

Because this page cannot legibly accommodate all the copyright notices, page 249 constitutes an extension of the copyright page.

LIBRARY OF CONGRESS CATALOGING-IN-PUBLICATION DATA

Barrett, Terry Michael, 1945-
 Interpreting Art: reflecting, wondering, and responding / Terry Barrett.
 p. cm.
 Includes bibliographical references and index.
 ISBN 0-7674-1648-1 (alk. paper)
 1. Art Criticism. I. Title.

N7475.B275 2002

2002029910

http://mhhe.com

For Susan

Contents

Black-and-White Illustrations

Acknowledgments

M Y DREAM OF writing a book about interpreting art started to become a reality over dinner in a restaurant in Columbus with Jan Beatty, who was at that time my editor with Mayfield Publishing Company, which was subsequently bought by McGraw-Hill. Upon Jan's departure to another position, Joe Hanson, art editor for McGraw-Hill, graciously took on the project as one of his own and saw it to completion in a very pleasant fashion.

Thanks to the production staff at McGraw-Hill: Jeanne Schreiber, Robin Mouat, Sharon Spurlock, Emma Ghiselli, Brian Pecko, and David Sutton.

Thanks to the following reviewers; Carole Henry, University of Georgia; Thomas Larson, Santa Barbara City College; Sally McRorie, Florida State University; Keith Dills, California Polytechnic State University; Mary F. Francey, University of Utah; Marcia Eaton, University of Minnesota; Rita Irwin, University of British Columbia; and Kathryn Coe, University of Missouri.

Jim Hutchens, chairperson of art education at Ohio State University, supported this book by providing an environment conducive to writing. Barrie Jean Barrett, my oldest sister, brought insights to the manuscript from outside of the academic art community. I especially want to acknowledge all the work that Susan Michael Barrett, my wife, generously gave to this book: it is deeply nourished by her loving partnership.

Thanks to Janice Glowski of the Huntington Archives of The Ohio State University for help with portions of the text and selecting images, and to Ann Bremner and William Horrigan of the Wexner Center for the Arts for help with obtaining reproductions.

Introduction

INTERPRETATION IS articulated response based on wonder and reflection. Works of art are mere things until we begin to carefully perceive and interpret them—then they become alive and enliven us as we reflect on, wonder about, and respond to them.

This book is written for anyone interested in actively engaging in interpretive thought about art of all kinds. The ultimate purpose of the book is to help you look at art and other phenomena with a sense of wonder and curiosity and then to satisfy your curiosity with informed interpretive thinking about what you perceive.

The book is about you actively looking and interpreting, actively listening to others' interpretations rather than passively receiving such interpretations. This book will be successful if, after reading it, you want to interpret art, you want to hear and read others' interpretations of art, and you believe that you have things of value to say about works of art and about others' responses to those same works of art.

When reading this book, students of art may be surprised by how many meanings any work of art can generate and to find that artworks may not generate the meanings intended by the artists who made the works being interpreted. When artists make marks, they make meaning; or, more precisely, after artists make marks, viewers make meaning of those marks. Interpretive viewers take artists' marks seriously. I hope that artists will be excited about making more art when they read the insights and revelations that artworks inspire: art can and does change lives.

Students of art history will find multiple references to art-historical scholarship about art from the near and distant past, as well as to new art and visual objects not routinely included in art history courses. I hope that students of art history will become more engaged in their studies after reading this book, particularly in their reading of other historians' intellectual interests and specific and differing interpretations of some works of art.

I hope that students of aesthetics will be engaged with aestheticians' positions and counter-positions on philosophical topics about art and meaning, including absolute and relative meaning, artistic intent and meaning, truth and interpretation, multiple and competing interpretations, and criteria for interpretations. Student aestheticians will also likely be impressed with what aestheticians can and do offer to insightful engagements with works of art.

Students of art education will see artworks from the different and complementary perspectives of art historians, critics, artists, and aestheticians. Each of these vantages on artworks is different because each is motivated by different concerns. Each of these vantages also overlaps the others, especially when they are focused on the same work of art. I hope that, from reading this book, art educators will learn how different vantages can be brought to bear on works of art and debates about those artworks and the issues that they raise. If the book is successful, it will also motivate readers to pursue, on their own, new views raised by historians, critics, artists, and aestheticians.

Students of museum education will find in this book strategies that they can use to engage art museum visitors in interactive interpretive discussions about artworks on display in the museum. The book might also inspire the invention of new strategies for engaging viewers with works. Museum educators, daily, have exciting opportunities to hear new interpretations of works of art that are already familiar to them, by inviting and hearing varied interpretive responses from their visitors, many of whom arrive from different cities and countries and all of whom come to works of art with unique life experiences that affect how and what they see.

Students of humanities will read in this book responses to works of art by writers of fiction as well as philosophy, by poets as well as historians. Students of communication will be intrigued by individuals' processes of understanding as well as the meanings they derive from works of art.

If this book is successful, all readers, no matter the discipline from which they approach works of art, will find themselves encouraged and motivated to join ongoing and fascinating discussions about works of art and what they reveal about the world and people's experiences of it. Each reader will quickly come to believe that he or she has unique and valuable insights to offer about works of art and the experiences they engender.

VALUING ART

This book presupposes the positive value of art. A major supposition of this book is that, through art, people can express ideas and feelings that they cannot express otherwise. Works of art provide knowledge and experiences that we would not otherwise have. A painting expresses ideas and emotions in ways that arguments, graphs, charts, poems, and stories cannot. To miss paintings, sculptures, and photographs is to miss a lot. Works of art, however, provide knowledge and experiences only if the works of art are *interpreted;* not to interpret them is to miss them.

VALUING INTERPRETATIONS OF ART

There are many benefits to interpreting art. When we interpret a work of art, we engage meaningfully with the work of art, intellectually and emotionally. We *perceive* the work and very likely *receive* the work—our version of it—and make a response to it, privately or publicly. When we interpret a work of art, we construct a version of that work in our minds, for ourselves. When we build a version of that work, we learn about the work itself; we experience its insight, its particular view of the world and of human experience. We get a glimpse of the world through the artist. This is often satisfaction enough.

If we interpret with some self-reflection, we may also get a glimpse into ourselves: what we value, what we prefer, what we resist, what we accept. Self-knowledge can come through interpreting works of art, those that we are drawn to and those that may repel us.

When we choose to interpret out loud to others who want to hear us, we become active participants in public life rather than passive observers, moving toward community and away from isolation. We share our views and perhaps engage the views of another who has heard ours. When a group of people interprets a work of art out loud, for viewers who want to hear, we have opportunities to learn about the object being interpreted, but we also have an opportunity to learn about the people who are giving their interpretations. We can learn about art, about the particular world that the artist shows, and about one another in the community of interpreters.

CONSEQUENCES OF INTERPRETATION

The consequences of art interpretation can be serious and severe. On February 26, 2001, Mullah Mohammed Omar, supreme leader of the Taliban, the fundamentalist religious group then controlling Afghanistan, issued an edict declaring all statues to be insulting to Islam. He ordered his Minister of Vice and Virtue to send men to destroy all statues, including giant statues of Buddha made in the fifth century. One was the tallest of its kind in the world, measuring 175 feet high. Taliban soldiers used explosives and fired rocket-propelled grenades and cannons at the statues of Buddha[1] while many people of the world, including people of Islamic belief,[2] watched in horror, unable to persuade the Mullah to stop the destruction.

The Mullah's judgment that the statues were an insult to God was based on his *interpretation* of the words in the Qur'an, the sacred scripture of Islam, revealed by God to Muhammad in the early seventh century. Many Muslims and scholars of the Qur'an disagreed with the Mullah's interpretation.

THE CENTRALITY OF INTERPRETATION

Central issues of our day revolve around interpretation. In an op-ed piece in the *New York Times Sunday Magazine* later that year, Abraham Verghese, a professor of medicine at Texas Tech University, discussed stem-cell research and the legislation of it by the United States government. In his analysis, he cited the Taliban's destruction of the statues of Buddha: "The House vote against all human cloning, in its abruptness and its finality and in the magnitude of its penalties for those who dare oppose it, made me think of the Taliban and their draconian edicts: very little sorting out of details, few distinctions, meaningful debate drowned out by fundamentalist rhetoric and then an a priori proclamation of what society needs, followed by the order—destroy the Buddhas."[3]

This book will not be addressing interpretive questions, along with their ethical implications, that arise from the realms of science and technology. It will, however, address interpretive and ethical questions about art. I will employ and analyze the interpretive and evaluative argumentation that is used to determine answers to difficult questions in the world of art. Thinking about art may beneficially transfer to thinking about the world in which we live.

MULTIPLE INTERPRETATIONS, VOICES, AND REFERENCES

Art generates responses. A major supposition of this book is that any work of art or artifact will attract different interpretations from different viewers. A further supposition is that multiple interpretations are better for the world than single interpretations. Arguments supporting these suppositions are offered throughout the book.

A corollary supposition is that it is better for the world to hear multiple voices rather than one voice. It is not just the interpretation that we are interested in, when we read about art; we are also interested in the way the interpretation is built and how it is nuanced through interpreters' choices of words, figures of speech, and tone of voice. In other words, it is not just the conclusion of the argument that is important to the discourse about art, but also the argumentation itself. This book purposely minimizes dubious distinctions between form and content in art and in interpretations of artworks. How we say something is often more important than what we say.

Articles, books, catalogues, and works of art are carefully cited in this book. The references given here are meant to encourage you to pursue, on your own, the topics that most interest you: more works by an individual artist, more commentary about any artist or work or period, or more literature by a particular historian or critic with whose ideas you especially engage.

VISUAL CULTURE

Conceptions of visual culture subsume all artifacts, "high," "low," and in between: "art" and "craft"; "fine art" and "commercial art"; artifacts preserved in art museums and historical museums; visual items sold in galleries, stores, and from newsstands; posters, paintings, and press photographs. Within that vast range, this book, in its selection of artifacts discussed, is weighted toward the art found in art museums, contemporary art galleries, and performance venues. In that context, many kinds of works are considered: various genres of painting from different continents and centuries, photography, dance, architecture, and some controversial contemporary art. This book also embraces popular art and encourages its interpretation, discussing artifacts including commercials, and magazine covers.

Some assumptions made in this book are that hierarchical labels are not particularly useful, that different artifacts emerge from different social contexts and serve multiple uses, and that all artifacts can be and usually ought to be interpreted. Learning to interpret one kind of artifact is informative in interpreting other kinds of artifacts. Also, people working in different cultural contexts inform one another and influence what, how, and why people make things to be seen.

A WESTERN EMPHASIS

This book has a Western emphasis. I assume that most readers of the book will be American, with all the diversity that implies, and that the culture one was born in or has inherited is a natural place to begin interpretive endeavors. The artworks chosen are predominantly from the West, and intentionally include a wide range of Western makers and interpreters. Chapter five, Interpreting Old and Foreign Art, contains reflections on a temple in India built by the Jains in the fifteenth century and presents the point of view of an Eastern scholar as well as the point of view of people living in the West who have studied the East. The Indian temple and the interpretive challenges it presents motivate a discussion of problems and solutions to understanding any art that is not of one's own time or culture.

LOGIC OF THE CHAPTERS

The book opens with multiple interpretations of the work of one artist, René Magritte, an artist of the twentieth century whose paintings continue to fascinate. This chapter contains many voices expressing different points of view about one artist's life work: the voices of the author Michel Foucault, Suzi Gablik, art historians, children, teachers, and museum guides. The purpose of the chapter is to introduce processes of interpretation and to show that anyone can contribute meaningful thoughts to meaningful works.

The second chapter is an exploration of a single famous painting, *A Bar at the Folies-Bergère*, by Édouard Manet. This particular painting is important in the history of art, especially because it has generated so many differing interpretations by historians of art. The purpose of the chapter is to examine one painting in depth and to show how scholars of the same discipline, art history, can and do arrive at different and competing interpretations of the same work of art. It is also meant to show the advantages of multiple interpretations over single interpretations.

Controversial art is the topic of chapter three. It focuses on controversies art has given rise to, because of religion, sex, politics, and race, in recent America. The chapter carefully illustrates the interdependence of interpretation and judgment—namely, how judgment (decisions about the worth of a work) influences interpretation (decisions about the meaning of the work) and, conversely, how different interpretations of a work lead to different judgments of it.

Abstract painting continues to challenge many viewers of art. Chapter four is about contemporary abstraction and how to appreciate abstraction. The chapter addresses the interaction of interpretation and appreciation.

In chapter five, I concentrate on the challenges of interpreting works of art (and architecture) that were made long ago or in faraway places. It shows how scholars determine what a work of art meant to the people who made it and the first people who saw it. The chapter also demonstrates how contemporary viewers can make art of the past relevant to their lives in the present.

In chapter six, I look at the influence of media on meaning: what a work is made of, and how it is made, strongly influence how and what it means. Photography is the medium used to exemplify relationships of matter and ideas.

Chapter seven provides a potpourri or sampler of interpreters and of objects that can be interpreted. Its purpose is threefold: first, to show that reading interpretations can be entertaining as well as enlightening; second, to include a variety of interpretive voices that are not usually included in courses on art; and, third, to broaden the interpretive scope to include meaningful and influential artifacts from daily life.

The book ends with a set of tentative and nondogmatic principles to guide interpreters in making meaning of artworks and all artifacts. The principles are also helpful for anyone who wants to adjudicate among competing interpretations. These principles emerge gradually in chapters one through seven and are featured in display quotes throughout the book: for example, "Feelings are guides to interpretation."

Although the book was put together with the logic just described, you could start anywhere. Chapter seven is full of examples of enjoyable interpretations in action, and any one of them can of course be read separately. Chapter eight provides a principled overview of the whole interpretive process and could perhaps be the first chapter, rather than the last. If you get bogged down in a particular chapter, move on to another. If a particular interpreter or artist intrigues you, stop and seek more information about that person, and then return more enlightened. The purpose of the book is

to set you on your way to interpreting art in ways that are enjoyable and meaningful to you and to those with whom you share your interpretive insights.

ABOUT THE AUTHOR

Terry Barrett is Professor of Art Education at The Ohio State University, where he is the recipient of a distinguished teaching award for courses in criticism and aesthetics within education. He has authored four books: *Interpreting Art: Reflecting, Wondering and Responding; Criticizing Art: Understanding the Contemporary* (2nd ed.); *Criticizing Photographs: An Introduction to Understanding Images* (3rd ed.); and *Talking about Student Art*. He edited the anthology *Lessons for Teaching Art Criticism*, published articles in *Aesthetic Education, Afterimage, Art Education, Exposure, Camera-Lucida, Dialogue, Cultural Research in Art Education, New Advocate, New Art Examiner, Studies, Theory into Practice, Visual Arts Research*, and chapters in edited books. He is an art critic in education for the Ohio Arts Council, and consults with museum educators.

About Interpretation: René Magritte

This first chapter explores concepts of interpretation by examining the paintings of René Magritte, a popular and influential Surrealist painter of the twentieth century. The premise of this chapter, and of the whole book, is that anyone can engage in meaningful interpretive thought and in meaningful interpretive talk about works of art and that multiple interpretations are better than single interpretations. I begin with my investigation of one of Magritte's paintings, in a kind of thinking-out-loud process, as I engage you in the process of constructing an interpretation of a painting. The chapter then introduces other voices into the discussion of Magritte's work, including a short essay by Michel Foucault, the famous French scholar who reconstructed histories of ideas; an analysis of a ten-year personal examination of the artist and his work by Suzi Gablik, a contemporary American art critic; other recent scholarly views of Magritte that contrast with Gablik's; and, finally, some everyday interpretive voices, including those of fourth graders, high school and college students, teachers, and an art museum guide.

- *To interpret a work of art is to make it meaningful.*

This chapter provides preliminary answers to some essential questions. What does it mean to interpret a work of art? Who interprets art? Are interpretations necessary? What is a good interpretation? Is there a right interpretation for a work of art? Is there more than one acceptable interpretation for an artwork? If more than one interpretation is accepted, are all interpretations equal? What is the artist's role in interpretation? Is not the artist's interpretation of the artist's own work of art the best interpre-

tation? Who decides about the acceptability of an interpretation? Are correct interpretations universal and eternal? Questions such as these propel the whole book.

RENÉ MAGRITTE: *THE POSTCARD*

The Postcard (**Color Plate 1**), painted by René Magritte in 1960, can serve as a work of art with which to explore questions about interpretation, especially questions that can be answered on the basis of direct observation. The choice of *The Postcard* is arbitrary but not random: any one of Magritte's more than thirteen hundred paintings could serve as a prompt for interpretive thinking. The choice is partially based on personal preference. We get to choose what we want to interpret, what we want to spend time on. Moreover, this particular painting is often reproduced, so we can be reassured that others who have looked at Magritte's work consider *The Postcard* worthy of reflection. The choice of Magritte, rather than any one of thousands of other artists, is based partially on preference but, more important, on educational reasons. Magritte offers a representational realism that is easy to decipher, along with a conceptual ambiguity that is challenging to interpret. Magritte is an artist who is generally appealing to readers, whose work particularly and obviously invites interpretation, and who is of our times and rooted in Western culture and, thus, intellectually accessible to most people who will read this book.

By looking directly at *The Postcard*, and by thinking about it, anyone can answer many interpretive questions. (What do I see? What do I feel when I look at it? Does it have personal significance for me?) Some questions that come up can be answered by looking at other paintings of Magritte's. (How does it fit with other works by the artist?) Some questions will require answers from others. (Is it an admired or an abhorred work of art, and for what reasons?) Historical research would help in answering other questions. (What is it about for the artist? From what cultural traditions does it emerge? Has it influenced art made after it?)

Take time to look at *The Postcard* (see Color Plate 1) and answer for yourself the questions that intrigue you about it and what it might mean to you. Would you choose to interpret this painting? Would you rather interpret some other painting by Magritte? (If so, which one, and why?) If you were to interpret this painting, how might you go about it? Where would you begin? How would you proceed? When would you stop? Would you want to tell someone your thoughts about the painting?

Some facts about the painter are generally known or easily found. Magritte is considered an important Surrealist. Surrealism is a twentieth-century movement in art and literature, centered in Europe, that was most robust between the first and second world wars. There are many Surrealist artists; some of the better-known ones are Salvador Dalí, Joan Miró, Max Ernst, Jean Arp, Yves Tanguy, and Paul Delvaux. Some Surrealist artists, such as Miró and Arp, worked abstractly, while others, such as Dalí and Ernst, used representational imagery (Dalí's *Last Supper* and his melting watches are frequently reproduced and widely circulated[1]).

André Breton, a French poet, founded the movement and wrote Surrealist mani-

festos. Surrealists believe that the European pursuit of rationalism in culture and politics and the European belief in the idea of progress through science and technology resulted in the horrors of World War I. Surrealists chose to be anticonventional and antirational and to celebrate unconscious modes, especially the modes of dream and fantasy; they seek to express the subconscious mind through a variety of literary and artistic techniques and are heavily influenced by the theories of the subconscious, particularly those of Sigmund Freud. The surrealists tend to admire the work of Edgar Allan Poe; Magritte titled paintings after Poe's short stories.

Surrealist authors sometimes use the technique of automatic writing, in which they write freely and spontaneously, without self-censoring or editing, anything that comes to mind. Surrealist films include, most unforgettably, the 1928 *Un Chien Andalou* (*An Andalusian Dog*) by Salvador Dalí and Luis Buñuel with its horrific close-up of a man slicing the eyeball of a woman with a straight-edge razor. (Buñuel later directed *Belle de Jour, Tristana,* and *The Discreet Charm of the Bourgeoisie.*)

René-François-Ghislain Magritte was Belgian and lived from 1898 to 1967. The eldest of three brothers, each of whom wrote Surrealist prose and poems, he began making art as a child, attended art school as a young adult, earned wages as a designer in a wallpaper factory, and made posters and advertisements before becoming a full-time painter in 1926.

At age fourteen, Magritte found his mother in the river one night with her face covered by her nightgown, drowned by suicide. Many of Magritte's paintings include people with covered faces. Some show women with faces covered with fabric.

Magritte's art is well represented in museum collections around the world and in large, one-person, traveling retrospective exhibitions. His paintings, sculptures, sketches, and murals can easily be found reproduced in books, magazines, and on the Internet. Derivations of Magritte's paintings and of the art of other Surrealists are very present in popular culture, especially in the startling selections and juxtapositions of objects that appear in advertisements on billboards, in magazines, and in television commercials.

This cursory information about Surrealism and about Magritte provides a starting point for thinking about Surrealist work in context, but it does not answer all questions about a particular work such as Magritte's *Postcard.* The pages immediately following are my own interpretive thoughts about *The Postcard,* intended to reveal thought processes, to explicitly model interpretive thinking, and to invite you into interpretive thinking about this and any work of art. One can passively receive interpretations, or one can actively pursue them: this book encourages the latter while simultaneously acknowledging the value of prior research by scholars.

Interpreting Out Loud

Having some contextual knowledge of Magritte and of Surrealism offers me sufficient confidence with which to start; I also have experiential knowledge of the time and

place in which the image emerged. Suited men, apples, and mountains in the West in the twentieth century are familiar to me. The image is of my time and place in the world. Were the image from a culture and time very different from mine, I would be more reluctant to interpret it on my own, without the orienting contextual clues that others' knowledge can provide about the origin of the image. (Interpreting objects from cultures that are not one's own is the subject of a later chapter in this book.)

When interpretively engaging with a work of art, anyone can first seek to identify the literal aspects of a work: what it shows; what people, places, or events it depicts; and how one thinks they fit together in the artwork. In *The Postcard,* I see a large green apple in the sky above the head of a man wearing a black coat and standing before a stone wall that is between him and a mountain range. I am careful not to say "we see," because we do not all see the same things, even when they appear to be obvious. What is obvious to one person might be invisible to another.

In my literal reading of the painting, I do not know whether the man (I assume, because of the haircut, that he is a man) is aware of the apple. The apple's placement is ambiguous and I am not certain whether it is behind him, above his head, or in front of him. Perhaps I see the apple but he does not. Maybe the apple is in his imagination, and that is what I am seeing. Perhaps the apple imagines him!

I do not know in what kind of place the man is standing. Magritte gives no clues for the man's placement. He could be on the overlook of a mountain highway; he could have stepped from the stone room of a castle onto a balcony. The gray wall, though, is apparent. It is meticulously crafted of stone blocks and well kept. It separates him from the beyond, but it also protects him from the edge.

From the label, I can tell that the painting was made in 1960, but this does not tell me what year the painting depicts, though it does not seem to be set very long ago. The painting does not reveal the season of the year: the mountains are light gray and could be snow-covered; the air is clear. The scene looks chilly and the man wears a coat, but it is the kind of coat that could be worn in summer or winter. The sun provides light, but I do not feel its warmth.

The man in the picture is curiously unmoved. He seems neither startled, nor scared, nor awed in the presence of such a mysterious phenomenon. He is stiff, his head straightforward. His face is not visible but because his posture is so void of expression, I imagine that his face, too, is frozen in a vacant stare. Such cool aloofness, such dissociation and detachment do not fit the eerie circumstance.

Magritte's handling of the paint is merely adequate for representing the scene in a realistic manner: He is not attempting *trompe l'oeil* effects, effects that would fool the eye into believing that it is looking at an actual apple; nor is he trying to dazzle with his draftsmanship and painterly abilities. The compositional devices are straightforward: the apple and the human figure are centrally located along a vertical axis, while the apple dominates the upper area of the picture along the horizontal axis. The picture has an erect stability. It also has directness about it. This painting does not seem to be at all about an artist's virtuoso display of technique in rendering the three-

dimensional world in paint on a flat canvas. This is not a painting that is meant to trick the eye, but one meant to perplex the mind.

On the surface of the picture, the paint of the apple almost touches the paint of the man's hair. The man's coat collar aligns exactly with the top of the distant mountains, as if that horizon line could sever the man's head. There is ambiguity about foreground, middle ground, and background relationships. Which is closer to us, the top of the apple or the back of the man? The painting tests our tolerance of ambiguity. I think the apple takes the middle ground, the mountains the background, and the man the foreground, but I can't be sure.

Magritte's color palette is muted, the colors are cool, and the light green of the apple is the brightest hue. There is an indication of a light source coming from above and to the right of the figure and the apple. The light is likely from the sun, although it could be the moon. Yeats wrote of "the silver apples of the moon, the golden apples of the sun." This painting feels more silver and moonlike than golden and sunlike.

Even though the spatial relationships in the picture are unclear, Magritte has rendered all of the individual items in the picture clearly and simply, leaving few doubts about the literal aspects of the objects he shows. A man facing (or maybe standing under?) a huge apple in the sky as it is depicted here does not make logical sense of the material world: the apple is too big; it seems not to fall, but to float. If this large orb in the sky were a full moon, rather than an apple, my literal search of the painting would be over; but it is an apple, not the moon or the sun. These literal, *denotational* observations state the obvious, but do not provide sufficiently satisfying answers to questions of what the image might be about. Especially because the literal meaning of the painting is so easily deciphered but makes so little sense in the empirical world, I feel compelled to seek a metaphoric interpretation, to investigate the painting's allusions, to wonder about its symbolic content. I seek the *connotations* of the literal, denotational choices Magritte has made and switch back and forth between the literal and the symbolic, the denotational and the connotational.

An apple fills the sky, not a pear, nor a plum, nor a pomegranate. An apple is common and readily available; a pomegranate would have been more exotic. Why did he choose the more common fruit? And why not some common vegetable? I suppose broccoli or cauliflower would look ludicrous because of their shapes. The apple is an orb like the sun, opaque like the moon, and it almost feels comfortable in the sky.

The apple carries with it many associations. There is the forbidden apple of wisdom in the Garden of Eden, and the golden apple of discord that Paris awarded to Aphrodite, who in turn helped him kidnap Helen of Troy, starting the Trojan War. There is the apple William Tell placed on his son's head, the apple that fell on Isaac Newton's head, the apple of my eye, the applecart I mustn't upset, the French *pomme de terre*—apple of the earth—for *potato,* and apple pie and motherhood.

That the apple is green holds my attention. Magritte has made the apple green, and a green apple has connotations different from those of a red apple. When I hear *apple,* I first think of a red apple. I imagine Eve's apple to have been red, not green. The ap-

5

ple of desire is depicted as a red apple. I can't recall ever having seen a picture of Eve offering a green apple to Adam. The snake is green, but not the apple in its mouth. Even in Greek mythology, it was a golden apple, not a green one, that honored the most beautiful woman.

Although there are green apples sufficiently sweet to be eaten raw, the green of an apple connotes to me an apple not yet ripe, an apple that can cause a stomachache, or an apple so tart that it needs sugar to be edible, an apple for baking. Because the apples above my head in my childhood backyard were green, I imagine the apple that fell from a tree onto Newton's head to be green. Newton's apple defined gravity; Magritte's defies it. My associations with apples are American and Magritte is Belgian. Perhaps the green of an apple has different connotations in Belgium than it would in North America; perhaps in Belgium green apples are more common than red apples.

New York City is called the Big Apple and we use the phrase "as American as apple pie," but these associations seem too particularly, explicitly American to apply to the painting. Magritte's apple could allude to the forbidden apple from the tree of knowledge told about in the book of *Genesis*. The apple in the Garden of Eden is said to be the cause of the fall of man, and there could be visual punning with Magritte's apple if it were seen to be falling, and falling on the head of the man, but other evidence in the painting does not bring the biblical story to mind, and I do not feel confident about a biblical interpretation. Nor is there enough in the painting to really suggest the apple of discord from Greek mythology. Magritte's apple in this painting is a source of intellectual discord because it confounds the common experience of how the world is, but the discord in the Greek legend has to do with feminine physical beauty, seduction, and ultimately war. Surrealists and Magritte were concerned with war, particularly the world wars, and *The Postcard* was painted after both wars occurred, but such links to discord in Greek mythology seem to be too stretched here to be convincing.

The phrase "the apple of my eye" fits the painting if "my" refers to the man. The man does seem to see the apple; he could be the only one seeing it. Perhaps it exists only in the eye of his imagination. This would account for the strangeness of the scene: we can all imagine strange things, and we have all at one time or another believed one thing to be true, only to discover later that we had misperceived something.

Of all these associations with apples and *The Postcard,* the connection with Newton seems the most plausible. The most notable properties of this apple are its incongruously huge size, its placement in the sky, and especially its seeming ability to be airborne, suspended in denial of gravity. Therefore, the connection to Newton is strongest for me. Above all, the painting provides a test of anyone's tolerance for, or joy in, ambiguity.

How Does *The Postcard* Fit with Other Works by Magritte?

Has Magritte used apples in his other works, and would they be informative in interpreting this work? An online browse yields 331 other paintings by Magritte,[2] 11 of

them containing apples. (He made more than thirteen hundred paintings and some sculptures, prints, and murals.) One early apple painting is *The Listening Room*, 1953 (**Color Plate 2**), in which a huge green apple fills an otherwise empty room, floor to ceiling, touching three walls. The room has a hardwood floor, red walls, white ceiling molding, and a window on the left through which we see what seems to be a city. Warm sunlight from the window bathes the apple. In a second painting with the same title, *The Listening Room*, made in 1958, a green apple is in a room made of stone blocks reminiscent of the blocks of the stone wall in *The Postcard*. The left wall of the room of stone blocks has a rounded opening that looks out to the sea and a blue sky with white clouds.

There are three paintings with not only green apples but also men wearing suits. In *The Idea*, 1966, it is as if the man in *The Postcard* has turned to face us. The painting is a close-up of the man, showing him from the shoulders up, wearing a dark gray suit and a white shirt and red tie; but in place of his head and face, there is a green apple. The apple-head is disconnected from the suit and there is space where there would be a neck, recalling *The Postcard* and the horizon line formed by the mountaintops that visually separate the man's head from his shoulders. The background is a gray-brown color and otherwise blank. *The Son of Man*, 1964, shows the suited male figure from the knees up, with a green apple floating in front of his face, covering any distinguishing facial features. He is wearing a bowler hat and he stands in front of the now familiar stone block wall, but this time it has the sea and sky behind it. In *The Great War*, 1964, a green apple with stem and leaves covers the suited man's mouth, nose, and eyes. He again wears a bowler hat. There are dark gray clouds behind him. The suited men in all of these pictures are stiff in posture, just as is the man in *The Postcard*. They could all be the same man. Each one is anonymous. Each one could be any middle- or upper-class Belgian man. The men in the pictures do not reveal emotion, but the feelings that they invoke in me are isolation, alienation, and loneliness.

Guessing Game, 1966, features a painting with an apple in a neutral, unidentifiable space. On the front of the apple, in script, are the words *Au revoir*. I can associate the phrase *au revoir*, meaning good-bye, with the title *The Postcard* because the phrase might well appear on a postcard, but neither the words *Au revoir* nor the title *The Postcard* leads me further in deciphering the metaphoric meaning of either painting. These words and titles give me more information to interpret, rather than help in interpreting the information I have. They make no literal sense when matched with the pictures, nor do the pictures make literal sense when matched with the words.

This Is Not an Apple, 1964, is the most straightforward of the apple pictures I have seen by Magritte, and it also has a title that directly relates to what is pictured. Like an illustration one might see in a botanical encyclopedia, it shows a green apple that is beginning to redden at the top. It is rendered very realistically, with much detail. It has leaves and a stem. Above the apple, Magritte has written, in script, the phrase *Ceci n'est pas une pomme* (This is not an apple). It is a variation of a well-known image by Magritte, *The Treachery of Images*, 1929, that shows a pipe for smoking tobacco and

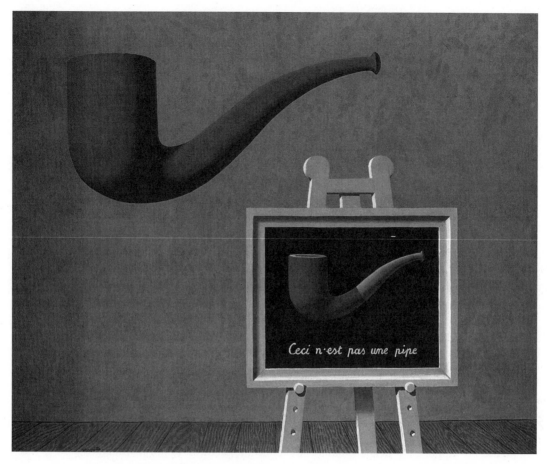

1-1 *The Two Mysteries,* René Magritte, oil, 65 x 80 cm, 1966. Oil on canvas, 25½ x 31½ inches. Photo © Phototèque R. Magritte-ADAGP/Art Resource, N.Y. © C. Herscovici, Brussels/Artist Rights Society (ARS), New York.

the words *Ceci n'est pas une pipe* (This is not a pipe) written below the pipe. The image is well known because it is frequently referred to as an early and pivotal work of conceptual art, a later art movement that featured art about the nature of art. *This Is Not an Apple* serves as a reminder that these are, in fact, not apples we are looking at and thinking about, but pictures of apples, paintings, representations and that, despite their realism, they are closer to thoughts than to things.

Michel Foucault, the French philosopher and psychologist whose writings continue to influence contemporary thought about the concepts by which societies operate, wrote a book on Magritte's work titled *This Is Not a Pipe.*[3] Magritte had written a letter and sent reproductions of some of his paintings to Foucault in June of 1966, after reading Foucault's *Les mots et les choses*[4] (words and things). In his letter, Magritte

offered Foucault some thoughts on the concepts of resemblance and similitude. Magritte died in September of 1967, before he could meet Foucault, but their correspondence led Foucault to write an essay, "Ceci n'est pas une pipe," which he later slightly revised and expanded into the little illustrated book in 1973.[5] Foucault's book, only about fifty pages long, is a short and meditative homage to Magritte's work and the thoughts they provoke in Foucault. The first chapter is a lovely essay celebrating the ambiguity of Magritte's paintings, particularly this one.

Two Pipes by *Michel Foucault*

The first version, that of 1926 I believe: a carefully drawn pipe, and underneath it (handwritten in a steady, painstaking, artificial script, a script from the convent, like that found heading the notebooks of schoolboys, or on a blackboard after an object lesson), this note: "This is not a pipe."

The other version—the last, I assume—can be found in Aube à l'Antipode. The same pipe, same statement, same handwriting. But instead of being juxtaposed in a neutral, limitless, unspecified space, the text and the figure are set within a frame. The frame itself is placed upon an easel, and the latter in turn upon the clearly visible slats of the floor. Above everything, a pipe exactly like the one in the picture, but much larger.

The first version disconcerts us by its very simplicity. The second multiplies intentional ambiguities before our eyes. Standing upright against the easel and resting on wooden pegs, the frame indicates that this is an artist's painting: a finished work exhibited and bearing for an eventual viewer the statement that comments upon or explains it. And yet this naïve handwriting, neither precisely the work's title nor one of its pictorial elements; the absence of any other trace of the artist's presence; the roughness of the ensemble; the wide slats of the floor—everything suggests a blackboard in a classroom. Perhaps a swipe of the rag will soon erase the drawing and the text. Perhaps it will erase only one or the other, in order to correct the "error" (drawing something that will truly not be a pipe, or else writing a sentence affirming that this indeed is a pipe). A temporary slip (a "mis-writing" suggesting a misunderstanding) that one gesture will dissipate in white dust?

But this is only the least of the ambiguities: here are some others. There are two pipes. Or rather must we not say, two drawings of the same pipe? Or yet a pipe and the drawing of that pipe, or yet again two drawings each representing a different pipe? Or two drawings, one representing a pipe and the other not, or two more drawings yet, of which neither the one nor the other are or represent pipes? Or yet again, a drawing representing not a pipe at all but another drawing; itself repre-

9

senting a pipe so well that I must ask myself: To what does the sentence written in the painting relate? "See these lines assembled on the blackboard—vainly do they resemble, without the least digression or infidelity, what is displayed above them. Make no mistake; the pipe is overhead, not in this childish scrawl."

Yet perhaps the sentence refers precisely to the disproportionate, floating, ideal pipe—simple notion or fantasy of a pipe. Then we should have to read, "Do not look overhead for a true pipe. That is a pipe dream. It is the drawing within the painting, firmly and rigorously outlined, that must be accepted as a manifest truth."

But it still strikes me that the pipe represented in the drawing—blackboard or canvas, little matter—this "lower" pipe is wedged solidly in a space of visible reference points: width (the written text, the upper and lower borders of the frame); height (the sides of the frame, the easel's mounts); and depth (the grooves of the floor). A stable prison. On the other hand, the higher pipe lacks coordinates. Its enormous proportions render uncertain its location (an opposite effect to that found in Tombeau des lutteurs, where the gigantic is caught inside the most precise space). Is the disproportionate pipe drawn in front of the painting, which itself rests far in back? Or indeed is it suspended just above the easel like an emanation, a mist just detaching itself from the painting—pipe smoke taking the form and roundness of a pipe, thus opposing and resembling the pipe (according to the same play of analogy and contrast found between the vaporous and the solid in the series La Bataille de L'Argonne)? Or might we not suppose, in the end, that the pipe floats behind the painting and the easel, more gigantic than it appears? In that case it would be its uprooted depth, the inner dimension rupturing the canvas (or panel) and slowly, in a space henceforth without reference point, expanding to infinity?

About even this ambiguity, however, I am ambiguous. Or rather what appears to me very dubious is the simple opposition between the higher pipe's dislocated buoyancy and the stability of the lower one. Looking a bit more closely, we easily discern that the feet of the easel, supporting the frame where the canvas is held and where the drawing is lodged—these feet, resting upon a floor made safe and visible by its own coarseness, are in fact beveled. They touch only by three points, robbing the ensemble, itself somewhat ponderous, of all stability. An impending fall? The collapse of easel, frame, canvas or panel, drawing, text? Splintered wood, fragmented shapes, letters scattered one from another until words can perhaps no longer be reconstituted? All this litter on the ground, while above, the large pipe without measure or reference point will linger in its inaccessible, balloon-like immobility?

Foucault's essay can stand alone here as a model of carefully descriptive and interpretive writing about a seemingly simple painting. The painting motivates Foucault to explore it in great detail and to reveal its conceptual complexity. The essay also demonstrates that Magritte's paintings can sustain and reward careful scrutiny.

Returning then to our consideration of *The Postcard:* at least twelve of Magritte's paintings have green apples in common, but Magritte uses the apples differently in each painting. Sometimes he gives apples anthropomorphic characteristics, such as when he puts masks on them. Sometimes the apple competes with the humanity of the figure, in that it takes the place of the head and face, as in those paintings with an apple and a man with a suit and bowler hat. In other paintings, the apple is shown as a natural apple but with unnatural properties, such as gigantic size and the ability to defy gravity. He places some natural-looking apples in unconventional settings: on beaches, in skies, and in living rooms. One of his apples is made of stone. Two others are accompanied by phrases that confound what we see.

These twelve paintings have commonalities beyond the mere presence of apples. They are all rendered in a similarly simple, realistic style that remains constant. Subject matter recurs: stone walls, clouds, the ocean, interiors of rooms, objects that float unnaturally, men with suits and bowler hats, and words superimposed on pictures. While researching Magritte paintings with apples, I notice that the apples he floats in the sky share resemblances to other paintings with floating castles and large rocks. The apples with masks are similar to paintings in which horses have blond hair and the throats of women. The two paintings with apples that fill rooms are similar to a painting of a room filled with a red rose and another room that is filled with a rock similar to the rocks that float in the sky. The paintings of apples with words on or above them are a conceptual match with the paintings of pipes with words that deny the pipes, and there are many of these.

It is clear that Magritte chose apples for many paintings, but he frequently used other inanimate objects more than once as well, including oranges, peaches, rocks, castles, tables, tubas, bouquets, keys, mountains, the moon, sleigh bells, glasses of water, cigars, umbrellas, clouds, candles, pillars of stone, locomotives, curtains, half-walls of stone, doors, and windows. Animate things that he uses more than once, some of them frequently, include trees, leaves, birds and especially doves, bird nests, bird cages, eggs, women clothed and nude, men in suits and bowler hats, lions, fish, horses, and horses with riders. Although his range of chosen things is wide, it is not infinite. The items he uses are common, not exotic: sleigh bells and castles are not common to an American living in Ohio, but they would be to a Belgian living in Europe.

I looked for Magritte paintings that contained apples to see if they would further my understanding of *The Postcard,* the painting with which I began. They do and they don't. They do give insight into *The Postcard* because apples turn out to be significant to Magritte: he uses them often and in some ways similarly to the way he uses the apple in *The Postcard.* The painting of the large green apple filling the traditional living

11

room and the painting of the large green apple filling the room made of stone feel similar to *The Postcard*. The apples in these three paintings have properties that they do not have in real life: one has mass but is weightless, all three have an absurdly large size, and all are abnormally situated. Each one of these paintings has an attracting rather than repelling mysteriousness about it. They remain in my memory and intrigue my imagination.

- *Interpreters are attentive to unity and diversity in multiple works by the same artist.*

Searching for paintings with apples led me to browse through hundreds of Magritte paintings, and the hundreds provided a much broader interpretive context for the one, so it was a useful search. However, now that the twelve apple paintings are grouped together simply because they have apples in them, there is further confusion, because there is no apparent idea that unifies all the apple paintings. Magritte uses apples in many different ways. The apple is the subject matter common to these paintings, but there does not seem to be a single, coherent idea that unifies the paintings.

However, a re-sorting of these twelve paintings with apples into different groupings begins to help me make sense of them. The stone apple in *Memory of a Journey* fits within a category of Magritte paintings that feature objects, rooms, and people made of stone. The painting with the floating apple, *The Postcard,* can be placed with paintings of rocks and castles that float in skies, and now I have a new category, the category of paintings-of-things-with-weight-that-defy-gravity. Because *The Postcard* features a man wearing a suit, it can also be classified with the many other paintings Magritte has made of men wearing suits and bowler hats. The men in the paintings seem lonely, alienated, and isolated. *This Is Not an Apple* fits with the pipe pictures and within a larger category of paintings that combine words and pictures. They especially remind me to be careful with language and to write out the words *paintings of apples,* rather than merely writing the word *apples,* when referring to the apples depicted in the paintings. Very importantly, Magritte has made me more aware of the differences between words and pictures and things.

When the twelve apple paintings are placed in new categories, each painting becomes more intelligible. It is not the apple or any other particular thing that is the unifying subject matter that constitutes a theme; it is, rather, that Magritte uses apples and other recurring objects differently in paintings that have different themes. He returns to these themes again and again, at different points in his career, and in articulating each theme, he uses a wide but limited repertoire of objects in different ways. The illustration *fifteen drawings* is visual evidence of this in Magritte's own hand: late in his life he was still playing with different combinations of objects. I now want to learn more about the themes, the big ideas, that unify such a diverse body of works by one artist. Because I have invested time and thought in looking at Magritte's work and still remain intrigued by it, I want to find what others have said about it. I am motivated to read.

1-2 René Magritte, *Fifteen drawings,* 1967. René Magritte (1898-1967). Ink, 10½ x 7⅞ inches. Collection Harry Tovczyner. © C. Herscovici, Brussels/Artist Rights Society (ARS), New York. Photo © Malcolm Varon.

13

SUZI GABLIK'S *MAGRITTE*

Suzi Gablik, a critic of contemporary art,[6] wrote one of the earliest books on Magritte, first published in 1970, three years after his death.[7] Her book provides 228 reproductions, 19 in color. Gablik wrote it after visiting Magritte and spending eight months living with him and his wife in their house. Because she has firsthand knowledge of Magritte and his work, her book provides a consideration of Magritte's work from the perspectives of both the artist and the critic.

Gablik expresses gratitude for the trust that the artist and his wife put in her over the years while she wrote her book (she first met the couple in 1959, and the book was published eleven years later). She thanks Louis Scutenaire, a poet who wrote about Magritte and an important friend to Magritte throughout the artist's adult life. Scutenaire gave Gablik access to his personal dossier of documents on Magritte and allowed her to draw from them freely. Gablik relates some anecdotes about Magritte told her by Scutenaire, and she quotes some of Scutenaire's writing about Magritte. She quotes Magritte's writings but not her conversations with him or with his wife. Gablik also expresses indebtedness to twenty-one other people who provided her unspecified support over the years in writing her book. From these acknowledgments,

we can conclude that as an interpreter, Gablik had direct access to the artist and his cooperation in the project. She also had help from his friends and others who knew him and his work. She does not tell us how others helped her, but we can conclude that, for Gablik, interpretation of Magritte's art was not an isolated endeavor—she considered the artist and others who knew him and his work, and she sometimes uses their ideas as evidentiary support for her interpretations.

Early in her book, Gablik identifies what could be an insurmountable problem for her and for us: Magritte does not want his work to be interpreted! She writes that Magritte "considered his work successful when no explanation of causality or meaning can satisfy our curiosity." Gablik writes that when people would tell Magritte that they had found the meaning of one of his paintings, he would reply, "You are more fortunate than I am."[8] Magritte was especially displeased with efforts to find symbols in his work, and he wrote, "People who look for symbolic meanings fail to grasp the inherent poetry and mystery of the image. . . . The images must be seen *such as they are*."[9]

Magritte's explicit distrust of interpretations of his art must have put Gablik in an awkward position as an interpreter. Nevertheless, she did not pack up her suitcase and return home but continued her quest for interpretation and eventually wrote a book about Magritte's work, not allowing the artist to deter her from interpreting his work. One wonders if she purposely put off finishing and publishing the book until after the artist's death. She seems to have accepted parameters to her interpretations. She writes about groups of work, and Magritte's overall life project as an artist, but she does not interpret individual paintings. She also seems to respect Magritte's request not to look for symbols in his work.

Perhaps as justification for continuing her interpretive endeavor, Gablik recounts a story that Scutenaire told about Magritte. If some knowledgeable person were to talk to Magritte about his painting, he would complain, "He had me cornered for an hour telling me sublime and incomprehensible things about my painting. What a pain in the neck!" If the same person had not talked about his work, Magritte would remark, "What a pain in the neck! He cornered me for an hour and didn't breathe a word about my painting."[10]

- *Interpretations of artworks need not be limited to what the artist intended in making those artworks.*

Early in the book, Gablik provides an interpretive overview of Magritte's work. In the first paragraph of chapter one, she states her understanding of Magritte's purpose as an artist in life: "to overthrow our sense of the familiar, to sabotage our habits, to put the real world on trial." She writes that he "always tried to live in the subjunctive mood, treating what *might* happen." Painting represented for Magritte "a permanent revolt against the commonplace of existence." She writes that Magritte, in his paintings, is trying to effect moments of panic in his viewers, moments of panic that might happen when one has been "trapped by the mystery of an image which refuses all explanation," and that these are "privileged moments" for Magritte, "because they tran-

scend mediocrity." Painting for Magritte, according to Gablik, "is a way of questioning the stereotyped habits of the mind, since only a willful disruption of the usual certainties will liberate thought and open a way to authentic revelation."[11]

Gablik likens Magritte to a philosopher who uses paint to express ideas, rather than a painter interested in the aesthetic effects of a painting. She characterizes Magritte's style of painting as a "matter-of-fact literalness" that allows him "the most effective means of achieving clarity of thought." This idea is foundational for the book and liberates her from stylistic analyses of Magritte's compositions and techniques of painting, allowing her to concentrate on the ideas behind the paintings. She thinks that his paintings are more about ideas than aesthetic effects with paint, and she interprets them that way.

Gablik provides brief biographical information about Magritte, including a paragraph about the influence of Magritte's astrological sign, Scorpio. She tells anecdotes from Magritte's childhood that have likely connections to paintings that he made, although she is careful not to suggest direct correspondence between this event and that painting. He remembered a large wooden chest that stood by his cradle. He remembered two balloonists who accidentally landed on the roof of his house when he was a year old and unexpectedly descended the stairs of the house with their deflated balloon. He played in a cemetery with a little girl, and remembers one day seeing, among the broken columns of the cemetery, an artist painting. Painting had a magical quality to him from that time on. He dressed up and pretended to be a priest in front of an altar he made. When he was fourteen, he found his drowned mother. At age fifteen, on a carousel at the annual town fair, he met his future wife, Georgette Berger, whom he married in 1922. Cubism and Futurism, artistic styles and movements that preceded his work, heavily influenced Magritte's first paintings. Magritte, with three others, produced a monthly publication called *Correspondance* in 1925, the date Gablik cites as the beginning of Belgian Surrealism.

When interpreting Magritte's work, Gablik does not rely on chronology, proceeding from earliest work to latest, as would be typical in an account of an artist's life work. Rather, she classifies images into groups according to themes and ideas. She chose this strategy because Magritte worked and reworked certain ideas in many variations throughout his career. She says that he had formulated most of his key ideas by the year 1926, when he was twenty-eight. In support of her decision to look at his paintings in thematic groupings rather than by historical occurrence, Gablik writes, "In this way each separate work has a positional value in relation to a sequence, in addition to the value that it has on its own. The range of discourse for a given picture is thus enlarged when it is seen as part of a connected effort toward the solution of a particular problem, rather than as an isolated entity."[12] In other words, she recommends that one not look at any one painting as an isolated painting, but as one in a sequence, and that the place in the sequence, in turn, is not to be determined by the year the painting was made, but by what imagery it contains and how it addresses a problem or idea. This interpretive strategy of Gablik's to find the central problems that Magritte

15

grapples with in his work provides her with a means both to privately consider interpretations of his work and then to publicly present them in an orderly and coherent fashion in her book.

- *Artists often provide interpretive insights
 into their own work.*

Gablik provides us with Magritte's own interpretive notions of what he was doing with his art. She quotes a lecture about his art that Magritte gave in Antwerp in 1938, in which he says that he wants to establish "a contact between consciousness and the external world." He also provides a list of the means that he uses in his art to do this: "the creation of new objects, the transformation of known objects, the change of material for certain objects, the use of words combined with images, the putting to work of ideas offered by friends, the utilization of certain visions from half-sleep or dreams."[13]

Gablik also retells a story Magritte has told about himself and a "magnificent error" that occurred when he awoke in a guest room and noticed a bird in a cage in the room that revealed to him an "astonishing poetic secret" that furthered his artmaking. He thought he had seen an egg in that cage rather than a bird: "the shock I experienced had been provoked precisely by the affinity of two objects, the cage and the egg, whereas previously I used to provoke this shock by bringing together objects that were unrelated."[14] Here Magritte himself provides us with two major ways of looking at his paintings. We can look for the shock caused by his bringing disparate objects together in single paintings (for example, an apple and a man's face), and we can look as well for the shock of Magritte putting together like things whose affinities may have otherwise gone unnoticed (a bird cage and a bird's egg).

Searching for paintings in which Magritte brought disparate objects together revealed paintings of tubas that appear to be burning, a cigar that is also a fish, a lighted candlestick in a bird's nest of eggs, a table on top of an apple, and a champagne glass overflowing with a white cloud. When looking for paintings in which Magritte put together like things whose affinities may otherwise have gone unnoticed, paintings can be found of a violin in a white tie and starched collar, boots that have human toes and human feet that have the ankles of boots, leaves that look like trees and trees that look like leaves, birds made of sky, a glass of water on top of an umbrella, and a jockey on a racehorse on top of an automobile. Both of these means of juxtaposition support Magritte's larger idea of shaking up complacent thought. Magritte has provided an interpretive strategy for looking anew at his paintings.

The artist himself thus provides us with interpretive insights into his own work, but we would not know of them if Gablik, the interpreter, had not selected those insights from the artist's writings and re-presented them in the new context of her book. As an interpreter, Gablik does not stop with the artist's insights, but goes beyond what Magritte has articulated about his work and his working method, when she very use-

fully identifies eight visual strategies that Magritte uses in constructing meaning in his paintings. She identifies these as isolation, modification, hybridization, change in scale, accidental encounters, double image, paradox, and conceptual bipolarity.[15]

Gablik explains that *isolation* is the means by which Magritte removes an object from its ordinary field to one that is paradoxical and newly energetic, freeing the object of its expected role: think of an apple in the sky. She explains that *modification* is the means by which Magritte alters an aspect of an object by introducing a new association or by withdrawing a familiar property: I think of Magritte's apple of stone and apples that he has freed from gravity. He employs *hybridization* by combining two familiar objects to produce a bewildering third object: an apple wearing a mask. *Change in scale* is a means that creates incongruity: a table atop an apple. Gablik's example of Magritte's use of an *accidental encounter* is when he paints a rock and a cloud meeting in the sky. The *double image* is a type of visual pun, such as Magritte's painting *The Seducer*, 1950, which shows a sailing ship to be made of the blue water on which it sails. Gablik identifies *paradox* as the use of delicately balanced contradictions and she cites *Hegel's Holiday*, 1958, in which Magritte shows a glass of water standing on top of an open umbrella. She defines *conceptual bipolarity*, finally, as showing two situations from the same vantage point modifying spatial and temporal expectations, as in *Euclidian Walks*, 1955, a painting within a painting in which Magritte simultaneously shows a plausible interior and an implausible exterior in which the receding street in the exterior confusingly resembles the conical tower with which he juxtaposes it.

17

By providing this list of intellectual maneuvers and visual techniques that Magritte uses, Gablik offers us a powerful interpretive tool by which we can examine all of Magritte's work. We could use her list and apply it to works by other Surrealists and see if it applies, and if it does, then use it to see how Magritte's work is similar and dissimilar to that of other Surrealists. We could also look at any body of work, by one artist or by many artists grouped together in a gallery or a museum, and attempt to identify the visual strategies used by those artists in making their art. Gablik interprets Magritte's work, and, more than that, she provides us a means by which we can construct our own interpretations, by seeing the work in terms of those strategies of Magritte's that she has identified and provided.

Throughout her book on Magritte, Gablik offers her further interpretations and elaborations on Magritte's paintings by discovering and identifying themes to which Magritte returned again and again throughout his life. These themes include Magritte's use of words and pictures in many paintings and the disjunctions between objects and their symbols, most famously in his painting *This Is Not a Pipe*. In her writing about Magritte's use of words in paintings, she likens his thinking to that of Wittgenstein, the influential analytic philosopher of language and logic. Gablik says that although Magritte read philosophy, particularly Hegel, she has no evidence that he knew or read Wittgenstein, but she identifies parallel ideas the two men hold, apparently independently.

1-3 *Les promenades d'Euclide (Euclidian Walks)*, 1955. René Magritte (1898-1967). Oil on canvas, 162 x 130 cm. The William Hood Dunwoody Fund. Photo © Photothèque R. Magritte-ADAGP/Art Resource, NY. Minneapolis Institute of Arts, Minneapolis, Minnesota, USA.

Gablik explores Magritte's simultaneous explorations of insides and outsides in single paintings; paintings within paintings, such as *Euclidian Walks*; and his repetitive use of doors that are firmly shut yet allow passage. Two more major themes involve heavy objects that float and the bowler-hatted man. Both of these themes are represented in *The Postcard*. About the man in Magritte's paintings, Gablik writes, "a metaphysical loneliness, bordering on the spiritual and the stoical, surrounds the bowler-hatted man." She sees the man as detached from experience with "a certain haughty exclusiveness that is provocative in its very coldness." She sees him as representing all men. In paintings in which the man and the floating objects both appear, such as *The Postcard*, Gablik interprets the man to be the observer of phenomena, and a figure who is "a perfect vehicle for our projections."[16]

Gablik's reading of the apples and rocks and castles that Magritte floats in his paintings are consistent with my association of the floating apple with Isaac Newton and a denial of gravity, but she puts denial of gravity into a larger and more meaningful concept, contrasting classical Newtonian physics with modern physics. Gablik writes, "Relativity has radically altered the philosophical ideas of space and time and their relation to matter; where previously events could be ordered in time independent of

their location in space, we now know that there is no such thing as absolute rest or absolute motion. Magritte's images show an extraordinary sensitivity to the changes which have occurred in our conception of reality as a result of the shift from Newtonian mechanics to formulations of relativity and quantum theory."[17]

- *Interpreters interpret the lifelong work of artists as well as their individual pieces.*

Gablik saves her observations about Magritte's use of relativity and his presentation of metaphysical loneliness for the concluding chapter of her book-length study of the artist. Her summative interpretive idea is that Magritte, through his art, explores mysteries of existence. She interprets his work as a rejection of any diametric opposition, any black-and-white answers to the question of the meaning of life, and as an embrace of the ambiguous position on this and all questions. Classical Newtonian physics would have us believe that there is a permanent and fixed external world that can be described objectively and independently of the human observer. Through his artworks, Magritte casts doubts on absolutes and confirms principles of relativity. Yet he does not accept that everything happens by chance, nor does he accept a separation of the world from the self. Instead, he embraces the mystery. Gablik quotes him saying, "I am not a determinist, but I don't believe in chance either. . . . It is rather pointless to put one's hopes in a dogmatic point of view, since it is the power of enchantment which matters."[18]

OTHER SCHOLARLY INTERPRETATIONS OF MAGRITTE'S WORK

- *No single interpretation of an artist's work exhausts the meaning of that work.*

Gablik's book provides a comprehensive interpretive treatment of Magritte's life work. Nevertheless, after Gablik's book, others follow, and before hers, books and exhibition catalogues (publications, often of book length, that accompany an exhibition and include essays and reproductions) on Magritte were in print. Gablik lists twenty-two books and catalogues in her bibliography, including three by Scutenaire. One of the newer books on Magritte is a short introductory handbook written for a mass audience, *The Essential René Magritte* by Todd Alden;[19] two others are more scholarly treatments, one by Jacques Meuris,[20] and one by A. M. Hammacher.[21]

Alden, Meuris, and Hammacher each refer to Gablik's book and from this we can conclude that her interpretation of Magritte's work is foundational—as is Scutenaire's, upon which Gablik draws. The books more recent than Gablik's do not contradict Gablik's reading of Magritte: on the contrary, they usually reinforce it. These more recent authors add to Gablik's interpretations and to our understanding of Magritte based on Gablik's book, adding details, providing nuances, offering elaborations, em-

1-4 *Le domaine d'Arnheim (The Domain of Arnheim),* 1962. René Magritte (1898-1967). Oil on canvas, 57½ x 44⅞ inches. Photo © Photothèque R. Magritte-ADAGP/Art Resource, NY. Musees Royaux des Beaux-Arts, Brussels, Belgium. © C. Herscovici, Brussels/Artist Rights Society (ARS), New York.

phasizing different aspects of Magritte's life, providing new insights, and drawing connections of their own.

By reading the additional sources, we learn, for example, more about Magritte's practices of titling his works. Gablik makes it clear that Magritte's titles do not function as descriptions of what we see or as interpretations of what the pictures might mean. On this point, Meuris quotes Magritte: "The titles are not descriptions of the pictures and the pictures are not illustrations of the titles."[22] The titles work independently, in parallel to the paintings. They are important to Magritte and he considered them carefully, often having his circle of intellectual friends, most of whom engaged in Surrealist writing, gather round a finished painting and suggest titles from which Magritte would select one. We learn that he even corresponded in letters about his title choices. The authors make clear some connections between Magritte's titles and literary works. *The Domain of Arnheim,* for example, is the title of a short story by Edgar Allan Poe. Hammacher points out that, although Magritte's painting and Poe's story both contain moonlit mountain landscapes, Magritte is *not* illustrating Poe's

story with his painting. There is no nest of eggs or mountain eagle in Poe's story as there is in Magritte's painting.[23] Hammacher reinforces Gablik's point that Magritte sought what he called "poetic" connections between titles and paintings, not logically explanatory connections.

Gablik indicates that Freudian theory was important to most Surrealists, but that Magritte did not accept Freudian psychoanalysis. Meuris and Hammacher both add that Magritte, at the prompting and arrangement of a Surrealist associate, allowed a pair of psychoanalysts in London to analyze his paintings, including *The Red Model*, 1937, a painting that depicts two bare feet in the shape of ladies' boots. Magritte derided their findings about it: "They see in my picture a case of castration. You see how simple that makes things."[24] Hammacher writes that Magritte believed the mystery of the world was beyond the grasp of psychoanalysts.

Even though Alden states his awareness of Magritte's expressed distrust of Freudian psychoanalysis, Alden employs it anyway, noting that Freud was also impatient with Surrealists. Alden draws a parallel to Freud's idea of the "uncanny" and Magritte's "mysterious poetic effect" and writes that "Freud's examples of uncanny things read like a laundry list of Magritte's disturbing pictorial imagery: doubles, automatons, the return of the dead, dismembered limbs, a severed head, and a hand cut off at the wrist."[25] Thus, as an interpreter, and despite what Magritte says, Alden recognizes resonance between the two men's work and sees important Freudian influences on Magritte's work. The interpreter in this case does not permit the artist to dictate and limit the terms of interpretation.

Although Magritte expressed interest in dreams and in different states of sleeping and waking, he did not paint dreams. According to Hammacher, through his paintings, Magritte did not want to lead viewers back to himself, or to his unconscious, but he wanted, rather, to lead them "forward to that strange and mysterious world which every day, on waking up, reveals itself to the eye of consciousness."[26] Magritte sought to elucidate consciousness, including and especially consciousness of the irrational and the unknown. The authors also reinforce Gablik's assertion that Magritte said that he did not use symbols in his paintings. Meuris further explains that for Magritte, in his paintings, a jockey is a jockey, a curtain is a curtain, and the trees are trees. They are not intended to be symbols of anything; they are, however, intended to evoke mystery by their juxtapositions.[27]

Gablik's analysis of Magritte's style is that it is direct and adequate to his purpose. Meuris reinforces this analysis by writing that, although Magritte had a certain skill in painting, he broke with the habits of prior artists, who were prisoners of their own talent and virtuosity and aesthetic specialties. Magritte did not want his viewers distracted by technique. Meuris asserts that Magritte meant to surpass painterly talent and virtuosity so that his paintings would be subversively poetic.[28]

Gablik states that although most Surrealists were politically involved, Magritte avoided political affiliations (except for a brief and short-lived membership in the Belgian Communist Party, in 1945). The other authors give more emphasis to Magritte's political involvement. Meuris writes that Magritte was a sporadic member

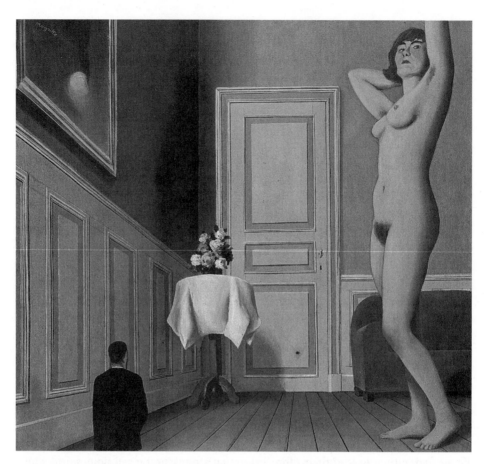

1-5 *La Geante (the Giantess),* 1931. René Magritte (1898-1967). Gouache and India ink on hardboard, 53 x 73 cm. Photo © Photothèque R. Magritte-ADAGP/Art Resource, NY. Museum Ludwig, Cologne, Germany. © C. Herscovici, Brussels/Artist Rights Society (ARS), New York.

of the Communist party, but that he leaned more toward anarchism, desired utopia, and was generally a "scandalous malcontent" who sought to undermine common sense and all convictions in which we place our trust. Hammacher also asserts Magritte's dissatisfaction with society and desire for a better future. Alden writes that Magritte sympathized with leftist struggles all his life, that he was particularly resistant to Hitler's Fascism and designed anti-Fascist posters in the 1930s, and that, although he was sympathetic to Communism, he was too much of an individualist to remain a member of the party.[29]

Gablik explains that when Hitler's Nazi army invaded Belgium, Magritte radically changed his style, for what turned out to be a short time, painting in an Impressionist manner. His stated intent, in Gablik's words, was to "celebrate sun, joy and plenitude

in opposition to the psychological oppression of the occupation."[30] In Magritte's words, quoted by Gablik, "Before the war, my paintings expressed anxiety, but the experiences of war have taught me that what matters in art is to express charm. I live in a very disagreeable world, and my work is meant as a counter-offensive."[31] The other authors also acknowledge this departure by Magritte from his usual style.

Gablik acknowledges the Surrealists' and Magritte's penchant for eroticism, mentioning, for example, his painting of a reclining nude man whose erect penis is a figure of a woman, and she reproduces Magritte paintings that have erotic content, but she does not pay attention to the paintings as erotic, per se, but as erotic in the service of larger themes. Meuris, however, directly addresses Magritte and eroticism, identifying it as a central theme in Magritte's work. Whereas Gablik distributes Magritte's erotic pictures throughout her categories, Meuris thinks they warrant a category of their own. Meuris states that in Magritte's life, as in his pictures, eroticism "leads a concealed existence" and that for Magritte the female body is an object of desire and "a secret actively pursued." He quotes Magritte referring to eroticism as "the pure and powerful sensation." Alden seems to concur with Meuris and succinctly asserts that the Surrealists saw women as the embodiment of mystery and that the "mystery plumbed by Magritte and the Surrealists is definitely male heterosexual desire."[32]

Meuris makes an interpretive connection between Magritte seeing his dead mother nude, but with her face covered with a nightgown, and Magritte's paintings of nude women with their faces covered by cloths. He specifically cites a painting of a nightgown on a clothes hanger with nude breasts very apparent beneath the fabric (*Homage to Mack Sennet,* 1937) and another painting similar to it that reveals breasts and pubic hair (*Philosophy of the Boudoir,* 1966). Gablik presents biographical information about Magritte and his mother's suicide but she is careful not to suggest cause and effect relationships between biographical facts of the artist's life and paintings the artist made. The other authors are freer in their conjectures. Meuris tells us that Magritte's father kept a tailor shop and that the artist's mother was a milliner, and that suits and hats are prevalent in Magritte's paintings. While Alden suggests affinities between Magritte and the man in the bowler hat that Magritte frequently painted, Alden explicitly asserts that Magritte *is* the man in the bowler hat. Alden writes that Magritte is also a "painter, writer, thinker, chess player, graphic designer, ad-man, magazine editor, Charlie Chaplin-lover, occasional Communist, anti-Fascist, infrequent traveler, classical music buff, and avid pulp mystery reader."[33]

The different authors make different connections between Magritte, philosophers, and other scholars. Gablik draws parallels between Hegel and Magritte, and Hammacher reinforces them. They write specifically of Magritte's use of Hegel's idea of the "unity of opposites" and they refer to Magritte's painting that he titled *Hegel's Holiday.* It shows a glass of water on top of an open umbrella. The painting unites in a whimsical way an object that contains water and another that repels it.[34] Gablik also associates Magritte's ideas with those of Wittgenstein, whom Magritte had not read. Hammacher concurs with Gablik's pairing of the ideas of Wittgenstein and Magritte. Hammacher lists the philosophers whose books were part of Magritte's library:

Feuerbach, Fichte, Heidegger, Plato, Sartre, and Spinoza. Hammacher also writes of the importance of Foucault's ideas to Magritte. (It seems that Gablik was unaware, at the time of her writing, of this relationship between Magritte and Foucault, or perhaps she was just not fully aware of Foucault's stature among intellectuals.) Hammacher also pairs Magritte's ideas about language with those of Ferdinand de Saussure, a pioneer of linguistics and an earlier writer than Wittgenstein. Alden credits Magritte with echoing the ideas of Saussure, whose ideas on language were foundational to Structuralism in the 1970s, and identifies two key ideas of Magritte's that are compatible with linguistic theory: "There is little connection between an object and what represents it," and "An object never fulfills the same function as its name or image."[35]

Hammacher introduces Samuel Coleridge into the discussion of Magritte's ideas, showing an affinity of thought between the two, even though Hammacher acknowledges that Magritte had not read anything by this poet and philosopher of the Romantic era. Hammacher thinks that Magritte learned principles of Coleridge's thought by reading Poe, who had read Coleridge. Hammacher tells us that Magritte read Poe's theoretical writings as well as his fiction. According to Hammacher, Magritte's contribution to thought, through his paintings, was to synthesize and add to prior ideas of other thinkers: "The essence of Magritte's activity as a painter is the liberation of things from their confining, misleading names and from their social, moral, and linguistic history, in order to present them mysteriously, as new, original, and restored to their earliest state."[36]

Magritte himself indicates some of the connections that the authors draw between Magritte and philosophical thinkers, and then the authors further the relationships of Magritte's ideas and those of the philosophers he mentions. Other connections that the authors draw are original and unknown to the artist: The interpreters see significant relationships and parallel thinking between Magritte and others, and they make these relationships evident, even though they may not have been evident to Magritte. In both cases, the authors' interpretive claims are larger than claims that the painter was influenced by philosophical thinkers: these authors claim that Magritte as a painter furthered philosophical thought in the twentieth century. Such comparisons of Magritte to modern philosophical thinkers of such renown, by all four of these interpreters of Magritte's work, are high compliments to the painter. The connections the authors draw are interpretive, but they are also implied positive value judgments of the importance of Magritte's work and its significant influence. Gablik, for example, writes that Magritte has provided "astonishing philosophical insights" into the problems of the relationships between a painting and that which it represents.

- *The evaluation of a work of art is dependent on how it is interpreted.*

In addition to placing Magritte in an intellectual context, each of the authors places him in an artistic context, explaining, from their individual interpretive points of view, who in the world of art influenced Magritte and who in turn was influenced by

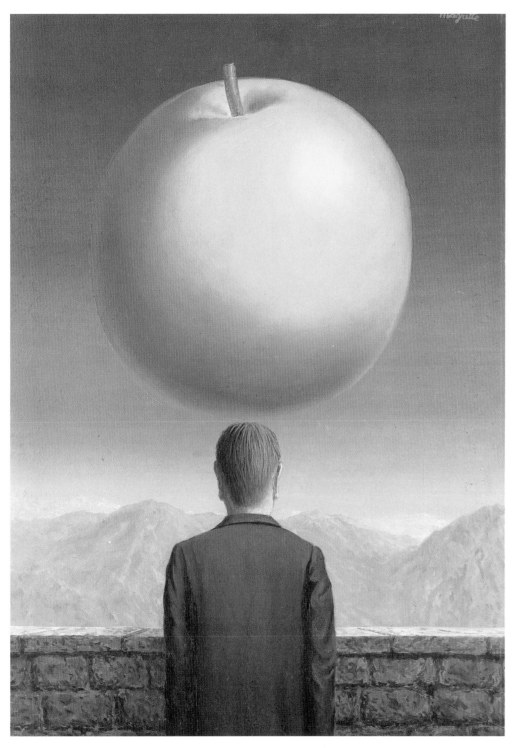

1 *La Carte postale (The Postcard)*, 1960, **René Magritte** (1898-1967), Oil on canvas, 27 1/2 x 19 1/2 inches. © C. Herscovici, Brussels /Artist Rights Society (ARS), New York.

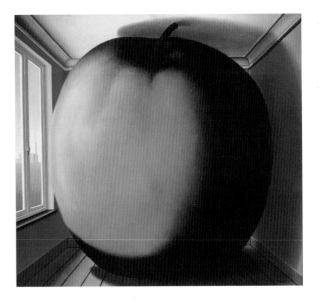

2 *La chambre d'ecoute (The Listening Room),1953,* **René Magritte** (1898-1967). Oil on canvas, 80 x 100 cm. Photo © Photothèque R. Magritte-ADAGP / Art Resource, NY. Private Collection © C. Herscovici, Brussels / Artist Rights Society (ARS), New York.

4 *Dejeuner sur l'herbe (Luncheon on the Grass),* 1863, **Édouard Manet** (1832-1883). Oil on canvas, 7' x 8'10". © Erich Lessing / Art Resource, NY. Musee d'Orsay, Paris, France

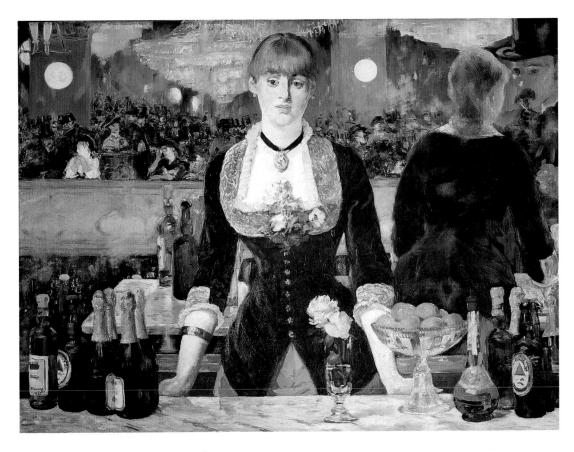

3 *A Bar at the Folies-Bergère,* 1882. **Édouard Manet** (1832-1883). Oil on canvas, 96 x 130 cm inches. © The Courtauld Institute Gallery, Somerset House, London.

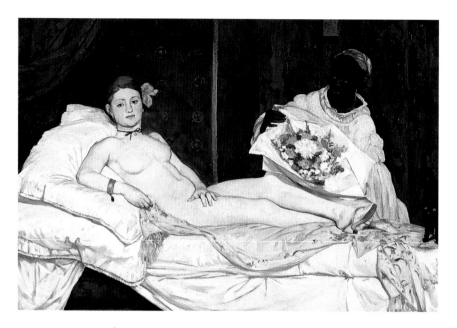

5 *Olympia,* 1863, **Édouard Manet** (1832-1883) . Oil on canvas, 150 x 190 cm.
Photo © Hervé Lewandowski. © Réunion des Musées Nationaux / Art Resource,
NY Musee d'Orsay, Paris, France

7 *Birthday Boy,* 1983, **Eric Fischl** (1948-). Oil on canvas, 84 x 108 inches.
Courtesy of the artist and Mary Boone Gallery, NY.

6 *The Holy Virgin Mary,* 1996, **Chris Ofili** (1968-). Paper collage, oil paint, glitter, polyester resin, map pins, elephant dung on linen, 243.8 x 182.9 cm. Victoria-Miro Gallery, London The Saatchi Collection

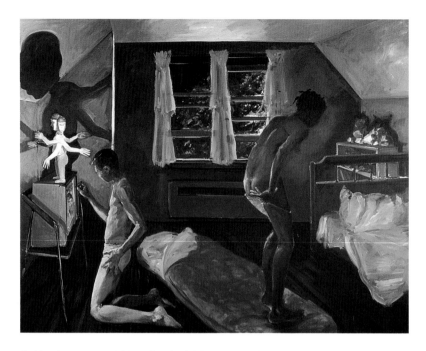

8 *Slumber Party,* 1983, **Eric Fischl** (1948-). Oil on canvas, 84 x 108 inches. Courtesy of the artist and Mary Boone Gallery, NY.

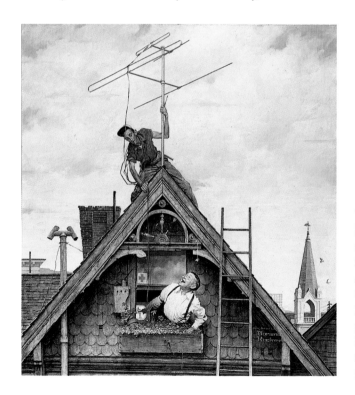

10 *New Television Set* **Norman Rockwell** (1894-1978). Oil on canvas, 46 1/16 x 43 3/8 inches. Photo © 2002 Museum Associates/LACMA Los Angeles County Museum of Art, Gift of Mrs. Ned Crowell. Printed by permission of the Norman Rockwell Family Agency. ©2002 the Norman Rockwell Family Entities

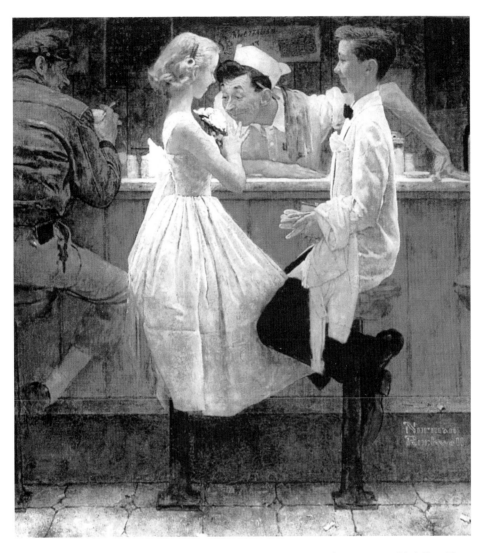

9 *After the Prom,* 1957, **Norman Rockwell** (1894-1978). Oil on canvas, 31 1/8 x 29 1/8 inches. Photo © The Curtis Publishing Company. Printed by permission of the Norman Rockwell Family Agency. ©2002 the Norman Rockwell Family Entities

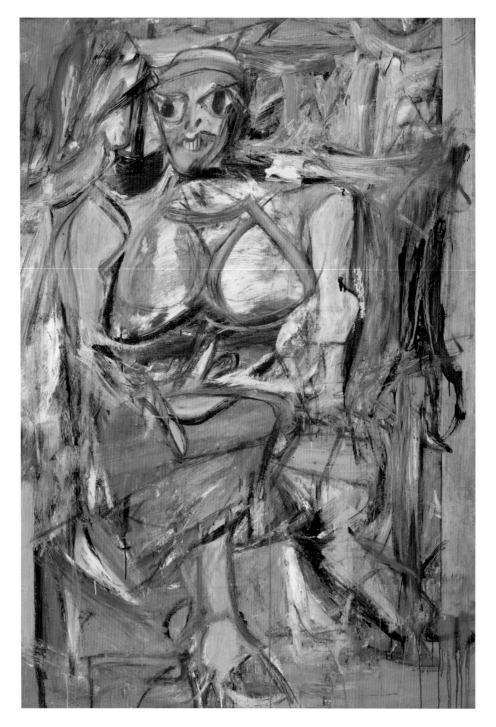

11 *Woman I,* 1950 - 52, **Willem de Kooning** (1904-1997). Oil on canvas, 6' 3-7/8" x 4' 10". Purchase. (238.1948). Photo © The Museum of Modern Art / Licensed by SCALA / Art Resource, NY. Museum of Modern Art, New York, NY, USA © The Willem de Kooning Foundation / Artist Rights Society (ARS), New York.

Magritte. Gablik argues that Magritte's paintings are major contributions to the "central fact of twentieth-century art: the collapse of the conventional devices of illusionistic representation." Since the Renaissance, the imitation of nature had been the basis of painting. Magritte and other artists of the twentieth century, however, discarded this notion. The authors argue that Magritte, in particular, contradicted rather than imitated nature and showed that signs and what they referred to were based on invention and convention rather than on nature: signs are cultural rather than natural. Thus the authors place him at the center of modern developments in art: such placement is both interpretive and positively judgmental.

Gablik acknowledges Giorgio De Chirico's realistic paintings of irrational events as a major influence on the young Magritte. The other authors also acknowledge this influence; they also draw stronger connections between Magritte and Dada than does Gablik. Gablik credits Picasso and Cubism as being the first to overthrow the concept of "fooling the eye'" when Picasso blurred the distinction between real-world objects and depictions of them, pasting real objects, such as pieces of newspapers, into his paintings. Throughout her book she also acknowledges the singular importance of Marcel Duchamp on Magritte and all of twentieth-century art, in his placement of real things into art exhibitions as "readymades."

Pop artists further eroded distinctions between mere things and works of art. Robert Rauschenberg, for example, in *The Bed*, 1955, painted an actual bed and hung it on the wall instead of painting a picture of a bed on a canvas. Andy Warhol made, and displayed in museums, Brillo boxes and Campbell's soup cans that closely resembled those one would see in grocery stores. Magritte did not take Pop art seriously, but Gablik does and points out similarities in the artistic thinking of Magritte and influential Pop artists who came after Magritte. Gablik is aware of the importance of Pop art in the history of twentieth-century art and she does not want Magritte's negative judgment of it to minimize the credit bestowed upon Magritte for his influence on Pop. Meuris claims that New York Pop artists Rauschenberg, Warhol, Roy Lichtenstein, Tom Wesselmann, James Rosenquist, and George Segal have all credited Magritte with influencing their work.[37] Meuris also favorably compares Magritte's general objectives with those of conceptual art, as developed in the 1960s and iterated by Joseph Kosuth in his 1969 publication, *Art after Philosophy*.[38]

25

- *Interpreters place artworks into philosophical and artistic contexts.*

To show what and how Magritte contributed to the history of the art of the twentieth century requires interpretative argument by Gablik and the other authors. Attributing such influence to Magritte is also an act of judgment: Gablik and the others not only tell how they think Magritte fits within the twentieth century, they also make positive evaluative claims about his importance in the history of art and intellectual thought.

The authors also breathe more than the rarefied air of art and art history; they see and discuss how Magritte's works of art influence daily living and popular culture. Alden, whose book on Magritte is the most recent of the four, credits Magritte with still influencing images we see today in ads selling everything from compact discs to credit cards. He credits Magritte's painting *False Mirror,* 1928, a close-up of an eye and a black iris with clouds reflected in the iris, as the source for the CBS television network logo of an eye in a circle. Meuris devotes much of the last two chapters of his book to Magritte's continuing influence on popular culture.

Each of the authors selects certain works by Magritte to write about, and, then, from that selection, chooses certain works to reproduce in their books. Choices about reproductions in art books require decisions by authors and their editors, and these decisions significantly influence readers' understandings of the artists being discussed. Magritte made over thirteen hundred works of art. Because authors writing about Magritte will generally not be able to reproduce all thirteen hundred, they need to make choices about which to reproduce and how. Their choices significantly influence our understanding of Magritte, even if we do not read their books but just browse through them in a bookstore or library. Authors' choices of which images to reproduce influence all readers, scholars as well as casual readers, because as a result of the authors' choices some images circulate and others do not. Images that are not in reproduction can only be seen by visitors on foot in museums, spread around the world, and some not even there: many artists' works are in private collections and are not accessible for public viewing.

The number and type of reproductions allowed in a book are usually a matter of economics and determined by the publisher on the basis of marketing considerations. Reproduction rights must be obtained before images can be reproduced, and there are fees to be paid for these rights. In addition, reproductions are costly to print, especially when they are in color. A book needs to be both affordable and profitable. (For this book, for example, I am able to select up to 75 images; of those, I must of course decide how many to devote to Magritte, how many to Sean Scully, and so on.) Gablik's book provides 228 reproductions of Magritte's work, Meuris's has 207, Hammacher's 138, and Allen's 66. Which 228, 207, 138, or 66 of Magritte's artworks should the authors include, how, and on what basis?

Most of the reproductions in these books are in color, but some are in black and white, and the authors and their editors needed to decide which to reproduce in color. In a book that has both color and black-and-white reproductions, color usually signifies to readers that the author considered those artworks more important than those reproduced in black and white, though this may not have been the case at all. It may just have been that some artworks were reasonably satisfactory in black and white, while for other works, color was essential.

The four books I talk about here include some reproductions of drawings, sculptures, and murals Magritte made, but, although Magritte also made films and photographs, the authors do not include any reproductions of Magritte's photographs nor

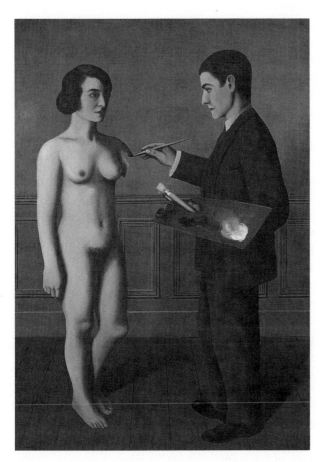

1-6 *La Tentative de l'impossible (Attempting the Impossible),* 1928. René Magritte (1898-1967). Oil on canvas, 116 x 81 cm. Photo © Photothèque R. Magritte-ADAGP/Art Resource, NY. Galerie Isy Brachot, Brussels, Belgium. © C. Herscovici, Brussels/Artist Rights Society (ARS), New York.

stills from his films. Not to include them implies that the authors consider them less important than Magritte's paintings, although none of the authors state this.

Thus, the choice and presentation of images reproduced in books constitute a form of implied interpretation. By implication, the author suggests that those works reproduced in the book are the significant images, the important works to consider, and that an understanding of the artist will not be imperiled if the reader is not shown other works. Curators in art museums face similar choices and challenges when they put together art exhibitions. Readers of comprehensive interpretations and viewers of retrospective exhibitions can wonder whether authors' or curators' selections adequately represent the artist's whole body of work or whether their selections unfairly skew the visual evidence toward particular and overly idiosyncratic interpretations.

What reproductions do Gablik, Alden, Meuris, and Hammacher use? All four authors provide black-and-white photographs of Magritte and his wife, Georgette. They

show the couple at different stages of their lives (embracing as newlyweds, socializing with members of Surrealist groups). The authors tell us that Georgette modeled for Magritte, and the photographs of her make the likeness in the paintings evident. Magritte's painting *Attempting the Impossible,* 1928, shows a man in the act of painting a nude as she stands before him: the man looks like Magritte and the woman like Georgette. The painting seems to be modeled on a photograph made in the same year, for the painting, showing the two in a similar composition. Although all four of the authors reproduce photographs of Georgette, and ones that would lead us to believe that the two had a loving and close relationship, not one of the authors attributes any influences on Magritte's life or work to Georgette. The authors render her physically visible but intellectually invisible.

Meuris tells us that some of Magritte's paintings (for example, *Clairvoyance,* 1936, and *The Magician,* 1952) are self-portraits, although the artist does not title them as such. In the photographs of the artist, Magritte is usually dressed in a suit and sometimes is wearing a bowler hat, like many of the men in his paintings. Pictures of Magritte at work show him in shirt and tie, and sometimes in a suit coat, painting at a small easel set up in a seemingly tight and tidy living space. The photographs of the artist and his wife provide visual information on what the man and his wife looked like, and they look like figures in Magritte's paintings. The photographs function as partial and visual answers to the interpretive question that some interpreters try to answer about a work of art: "Who made it?"

(An aside about pictures and interpretations: The books reproduce photographs of Magritte made by Duane Michals, a well-known and respected art photographer with many monographs and catalogues and exhibitions of his own art. In the Magritte books, however, Michals is not identified as the maker of his photographs of Magritte, except in credits in the very back of the book. Whereas Magritte's paintings are signaled in the books as art—because they are reproduced on the page along with titles, size, date, and medium—Michals's photographs of Magritte in these same books are signaled only as pictures, by a picture maker who does not need to be identified. They are not given the status of art. In books of Michals's works, these same photographs have the status of art and are the objects of interpretation. In the Magritte books, they are *mere illustrations,* in Michals's books they are *art,* and because of these significations they will be received by viewers differently in each presentation.)

Hammacher's and Meuris's books, published nine years apart, both use Magritte's painting *The Castle in the Pyrenees,* from the Israel Museum, as cover images, and Alden reproduces the image within his text. Gablik does not reproduce this painting in her book but does reproduce three other paintings of Magritte's that utilize rocks similar to the one he painted in *The Castle in the Pyrenees.* (Strangely, Hammacher and Meuris attribute different dates to the painting: Hammacher gives 1959 and Meuris gives 1961.) The Meuris cover has a cropped reproduction of the painting, one that eliminates the sea. To crop the sea from the bottom of the painting changes the painting significantly and necessarily alters its meaning. No explanation for the choice is

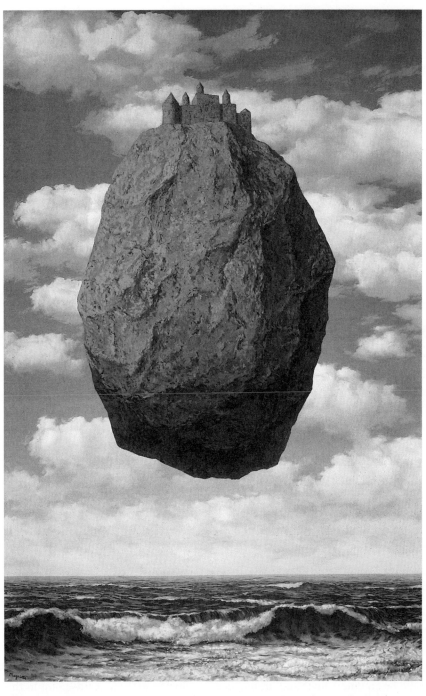

1-7 *Le Chateau des Pyrenees (Castle in the Pyrenees),* 1959 (disputed). René Magritte (1898-1967). Oil on canvas, 79 x 55 inches. Photo © Herscovici/Art Resource, NY. © C. Herscovici, Brussels/Artist Rights Society (ARS), New York. Israel Museum, Jerusalem, Israel.

provided: the identification of the cover image merely calls it a *detail*. Perhaps the cover designer or the marketing director thought the altered image more appealing than the one Magritte painted. The authors think *The Castle in the Pyrenees* is a significant, signature image of Magritte's, and perhaps the editors who put it on the covers think the public will best recognize this image by Magritte and be attracted to it and buy the book.

- *Interpreters' selections of which images by an artist we see greatly determine our understandings of that artist's work.*

All four books particularly attend to *Treason of Images* (This Is Not a Pipe), 1929, and variations of it, and Alden uses it as the cover image for his book. Gablik uses *Black Magic* for her cover and Hammacher reproduces it. All four authors reproduce *The Blank Signature*. Others that are often reproduced are *Personal Values*, *Euclidian Walks*, *Homage to Mack Sennett*, *Hegel's Holiday*, *Elective Affinities*, and *The Balcony* (a painting by Édouard Manet on which Magritte based a painting). Even a casual survey of the images that are selected for reproduction by interpreters provides much to think about. It is these images, rather than others from Magritte's larger body of work containing over thirteen hundred images, that we are given to contemplate. Unless the authors state otherwise, we as readers are justified in thinking that the interpreters who selected these images for publication think that they are the most significant images of Magritte's to reproduce and consider. We are right to assume, unless the authors state otherwise, that these are typical rather than atypical, and foundational rather than marginal, works by Magritte. We assume, and hope, that the selections are made on the basis of suitability and not merely on the basis of availability. The authors' selections, especially when they are common among several authors, provide a condensed body of work that we are implicitly asked to accept as a conceptually accurate representation of the artist's life work. When the authors place the reproductions within chapters of their books, the authors form a kind of scaffolding for understanding by which we can apprehend Magritte's work. When we encounter an image of Magritte's that is new to us, their scaffolds provide us a place to mentally hang the unfamiliar image.

MAGRITTE AND EVERYDAY INTERPRETERS

Reading interpretations by professional art critics, art historians, philosophers, and published authors such as Scutenaire, Gablik, Foucault, and Hammacher might have the undesirable effect of discouraging our own attempts at building independent interpretations of Magritte's work and encouraging us to leave the enterprise to scholars. This would be an unfortunate and unintended conclusion to draw at this point in this book. One does not need knowledge of modern art history, of Surrealism, or of recent developments in philosophy to make sense of Magritte's paintings. To demonstrate this, interpretations of Magritte's work by everyday interpreters, including children, follow.

A class of fourth graders in an urban public school examined twenty-four color re-productions of Magritte's paintings, from two large wall calendars, during a fifty-minute session.[39] The children looked at about ten of the paintings one at a time and said out loud what they saw. They identified subject matter such as mountains and ap-ples and trees. They made observations about how Magritte put the pictures together, noting that they were realistic but "weird," that some of the things that he showed could not happen in reality, that most were balanced down the middle, and that he changed the sizes of things. They quietly viewed the remaining fourteen paintings but didn't talk about them. Then they identified things that recurred in more than one of the paintings, naming such things as walls and skies with clouds and moons. They then each wrote one paragraph about "the world of Magritte." From their individual paragraphs, it became evident that they could articulate some comprehensive under-standings of what Magritte's work might be about. Their understandings were com-patible with those of scholars who had written about Magritte's work.

Charkeeta wrote this paragraph:

> I can see that when he makes his painting it's like a puzzle. It's like a mystery you have
> to try and find what he put in. I think that his pictures are real pure and like pure wa-
> ter. I think that he sees two halves, the first is bright and colorful the second is dreary
> but OK.

Molly wrote,

> René Magritte sees the world in a different way than you and I. He has more than just
> an ordinary eye. A mountainside to you and I looks like an eagle spreading his wings
> to him. Only René Magritte would draw a painting of a painting of a scene. What other
> artist would draw a woman in a peach or a man thinking of an apple. René Magritte
> sees the world with a different eye.

The students' teacher, who was not an art teacher, voluntarily joined in the writing activity and wrote a paragraph of his own:

> René Magritte has a curious twentieth-century view of the world. He is not painting to
> describe his world but rather to help the viewer feel his world. While his paintings are
> fairly bold and simplistic, they also are clearly surrealistic. They have a symmetry that
> is easy to see, but his subject matter haunts the viewer. Why does the key burn? Why
> does a large green apple float over a man's head? Magritte's paintings clearly stretch our
> imagination to try to capture the unreality of our reality. Is our world real or is it illu-
> sion? Magritte's rather sober paintings point to the latter.

The paragraphs by Charkeeta and Molly are representative of what each of the chil-dren wrote. After a first look at some of Magritte's paintings, for less than an hour, and after hearing one another's observations, these fourth graders and their teacher, in

31

quick and spontaneous writing, were able to approximate thoughts on Magritte carefully fashioned by scholars after years of study. Charkeeta, like Gablik and the others, identified the mystery of Magritte's paintings. She knows that Magritte presents her with the challenge of figuring out the puzzles that he makes, and she accepts the challenge. She does not burden herself with finding the "right answers" to the questions the paintings raise. Magritte would likely be pleased with Charkeeta's comment that "his pictures are real pure." She seems to grasp the nonsymbolic content of the paintings, in Magritte's sense of his painting simple things rather than symbols. Nor is she distracted by the relative simplicity of his style. She seems to see what he shows and to see it in the spirit of his intentions. She also perceptively identifies sets of paintings having very different emotional content—"bright and colorful" and "dreary"—and this observation corresponds with observations made by the critics about Magritte's existential ennui about the world, as well as the period during which he made happy paintings to offset the horror of the Nazis.

Molly, like the scholars, attributes extraordinariness to Magritte's view of the world. His is not "just an ordinary eye." Molly identifies paintings of Magritte's that fit within Gablik's categories: pictures within pictures, like *Euclidian Walk,* which Gablik calls use of *conceptual bipolarity;* the mountain that is an eagle that Gablik would identify as a *double image;* and a painting that includes a woman in a peach that Gablik might identify as a strategy of *modification.* Molly interprets *The Postcard* as the man thinking of the apple, one of the plausible possibilities mentioned earlier in the chapter. Their teacher identifies key themes of the work that match the themes identified by Gablik: Magritte's view of the world is distinctly twentieth century; Magritte is not interested in replicating the real world; his paintings are stylistically simple and direct; and, most important, the purpose of the paintings is to stretch our imaginations and have us revel in the unknown. Molly and Charkeeta and their teacher each seem to readily accept Magritte's own premise for his work: "People who look for symbolic meanings fail to grasp the inherent poetry and mystery of the image . . . The images must be seen *such as they are.*"[40]

High school students have been asked to engage in a similar activity. Their observations are based on what they saw in the paintings themselves and on their own life experiences, not on prior knowledge of Magritte or of Surrealism. Rachel observed that Magritte's paintings were "filled with metaphors," that he used "much irony" and that he created "a dramatic point out of a subtle style." Jennifer, a freshman in an English class, wrote, "The world of Magritte is one of mystery and wonder that boggles the mind and puzzles human understanding. His peculiar art draws your attention and curiosity to find out what it means."[41] A senior in an English class wrote,

> I think Magritte was a sort of in-drawn man who had a lot of fears about the world. In each of his pieces there is a lot of symbolism. Similarities between paintings include a glazed over sort of texture, some sort of wall or barrier, and unexpected subject matter. He was probably a very interesting man who was scared of how people would regard

his work. The paintings aren't shocking or electric but subtly show bizarre compositions of things which usually don't fit together. It's very interesting and soothing and relaxed in a way.[42]

In an introductory college class on writing about art, John, a history major, wrote,

René Magritte's paintings all seem to be somewhat sad. Most of the paintings I saw dealt with a sense of longing for something. Longing for nature, truth, adventure. Magritte's reoccurring images include windows, walls, birds, skies, shades of blue, water, and people looking out at something. All of these paintings are settings on the edge of something, like water, or the crest of a mountain, I think this ties in with the sense of longing that I feel in each painting—longing to cross over into a new world.[43]

These three high school students and the college student make observations that are consistent with those of the scholars. Rachel notices Magritte's subtle style but dramatic impact; Jennifer clearly recognizes the mystery and is engaged by it; and the senior accurately infers Magritte's personality. John, the college student, writes that the paintings seem to place Magritte on the edge of things, a similar thought to Gablik's about Magritte's "dislocated" bowler-hatted man. None of the conjectures by these students are out of line with those of the scholars.

Teachers in an arts-centered school, grades six through twelve, examined art interpretation as it might apply to literary interpretation.[44] Small groups of teachers each examined a reproduction of a Magritte painting and then told what they saw and thought about the painting they had examined: thus the group heard in some detail about ten paintings, and then they cursorily looked at another ten that are representative of Magritte's major work. The teachers wrote about any one of the images, or all of them, but made personal connections to the paintings, seeing what personal significance Magritte's images might have for them as individuals and for their own lives.

In her written reflections, Ms. White referenced Magritte paintings with close-ups of the eyes and clouds and recalled her dear artist friend who feared loosing her sight through required surgeries: "I never said it to her, but I knew that seeing everything around her and remembering how it looked was so important. We'd talk about how some day she might be blind and she wanted to remember how things looked. Wendy didn't live long enough to be blind. I would have gladly been her eyes."

Ms. Swatosh's reflections are about her loss of her mother and were prompted by knowledge of the suicide of Magritte's mother and his paintings of women with covered faces and his use of birds and nests and eggs.

René Magritte's maternal and protective images speak to me regarding the loss of my mother. Her death was not obviously self-imposed—so it was not suicide—but her choice to smoke for forty-five out of fifty-nine years of life was destructive to her health. In the prints we viewed, Magritte creates a bird figure that looms, hovers, and

appears to want to protect vulnerable new life. That mother-like bird figure can't protect, however, and is forced to witness the young in precarious situations without being able to control, nurture or comfort them. The mother bird figure is watching the young, but they are unaware of her presence. This is tragic in and of itself, but to me, the most tragedy lies in the mother's choice to leave a life that could interact, touch, and embrace her children.

Ms. Thompson was inspired to write a spontaneous poem that refers to at least two of Magritte's paintings, *The Postcard* and *The Seducer* (the painting that shows a sailing ship that is made of the same water on which it sails). Her line "bathed in early loss" refers to Magritte's loss of his mother:

Hey, Mister indrawn man
What is that apple in your eye
Golden delicious horizon
Pie in the sky?

Bathed in early loss
Mirage in sea blue green
Along with siren songs
The seducer is not what she seems.

In another situation, a group of tour guides in an art museum explored personal interpretations of Magritte's paintings.[45] After the guides, mostly of retirement age, had examined Magritte's works objectively, they explored personal connections with the work. One woman identified with Magritte's faceless women and wrote, "Sometimes I have felt like a faceless female—the wife of, the mother of, the daughter of, the volunteer of." Another found personal motivation and challenge in the paintings: "Magritte's works often seem to be of someone looking on life from the outside not a participant. As a widow, I often feel that way. It's sometimes hard to make myself participate. It's often simpler to stay inside, behind walls, behind a curtain—isolated. Life should not be a picture you view. You must put yourself into the picture."

These interpretations of Magritte paintings that have personal meaning are both objective and subjective. They are objective in the sense that they pertain to the objects, the paintings, in ways that we can understand and see. They are subjective in the sense that they also pertain to individual lives seen through unique personal experiences. Were these personal interpretations so subjective that we could not tell that they were directly related to the paintings by Magritte, they would be too subjective to be informative about Magritte. As they are, they both inform us about ways to understand Magritte and provide a means of understanding individual viewers and the richness that is life.

• *Meaningful interpretations are both personal and communal.*

Interpretations and reference to Magritte are common in popular culture to this day. Paul Simon, the musician, on his album "Hearts and Bones," 1983, wrote and sang a song he titled "René and Georgette Magritte with Their Dog after the War." He named the song after a photograph of the artist and his wife with their dog. He calls it one of his best songs, although he realizes that many in his audience may not know of Magritte or catch the references to Penguins, Moonglows, Orioles, and Five Satins. Simon knows that he is writing about a Surrealist painter, that he is forming new associations, and considers his song Surrealist. Simon's lyrics seem to refer to Magritte's use of doors and moons and gently embrace the eroticism of Magritte's paintings.

> René and Georgette Magritte with their dog after the war
> Returned to their hotel suite and they unlocked the door
> Easily losing their evening clothes they dance by the light of the moon
> To the Penguins, the Moonglows, the Orioles, the Five Satins
> The deep forbidden music they've been longing for.
> When they wake up they will find
> All their personal belongings have intertwined.[46]

Many bowler-hatted men appeared in the 1999 version of the movie *The Thomas Crown Affair*. When Crown, the protagonist played by Pierce Brosnan, returns a very valuable Monet painting to the museum from which he stole it, he befuddles the waiting New York police by dressing as a Magritte figure and then intermingling and losing himself among many other identically dressed men, all going rapidly in different directions.

SUMMARY AND CONCLUSIONS

This chapter can now address the large questions about interpretation with which it began, and to which the book will frequently return: What does it mean to interpret a work of art? Who interprets art? Are interpretations necessary? What is a good interpretation? Is there a right interpretation for a work of art? Is there more than one acceptable interpretation for an artwork? If more than one interpretation is accepted, are all interpretations equal? What is the artist's role in interpretation? Is not the artist's interpretation of the artist's own work of art the best interpretation? Who decides about the acceptability of an interpretation? Are correct interpretations universal and eternal?

What does it mean to interpret a work of art? From this study of interpretations of Magritte's life work, to interpret a work of art is to make some sense of it. The schoolchildren readily engaged in Magritte's mysterious views of the world. After experiencing Magritte's paintings of women with hidden faces, and parent birds that were

powerless to protect their young, a high school teacher grieved the loss of her own mother. The widow at the art museum made personal sense of Magritte's work by applying it to her own life as a motivation to live more fully. Gablik made sense of the many Magritte paintings by grouping them into sets according to themes identified by the artist and invented by her. She then could place any single painting into a group of like works and make sense of its relation to the themes and other paintings in the group. Hammacher made sense of Magritte's paintings more conventionally, by putting them into historical order, from earliest to latest, and ruminating on how Magritte's ideas changed and developed over time. Gablik, Meuris, Alden, and Hammacher all brought other thinkers and artists to bear on Magritte's work. They saw how Magritte differed from and was similar to those artists who came before him and to other painters of his time, especially Surrealists, and how he influenced artists who have come after him. They also identified some of his influences on popular culture. Because they saw philosophical ideas in his paintings, they considered how his paintings reverberate with the ideas of philosophers who also ponder problems of signs and what and how they signify.

Who interprets art? It should now be apparent that most anyone can interpret art, if they want to. Interpreting art seems to require, first, a disposition to interpret, a positive willingness to engage in thought about a work of art. Magritte's paintings can engage fourth graders and senior citizens, philosophers and art critics, poets and musicians, and all of these interpreters can enlarge our experience of Magritte's work. The views of scholars and fourth graders can expand our own experiences and understandings of Magritte's paintings and his views of the world.

Are interpretations necessary? Certainly the world would go on without interpretations of Magritte's paintings, and without the paintings themselves, but those who interpret them seem rewarded in their efforts with intrinsic enjoyment of the pursuit, gain new insights into the world and their experiences of it, and are even inspired to change how they live.

What is a good interpretation? This question in particular is explored throughout the book. In general, good interpretations are those that satisfactorily provide answers to questions of meaning posed by viewers in response to works. A good interpretation is one that satisfies your curiosity about the artwork that is of interest to you. It is one that clearly relates to what you can see in the work, one that expands your experience of the work, one that leads you to think further about artworks and ideas, and one that motivates you to explore more artworks and ideas on your own. A good interpretation is one that gives you knowledge about the work and about the world and about yourself as an explorer of works and worlds, one that is satisfying to others who are interested in the work, and one that allows you to make meaningful connections between Magritte's work, for example, and the thinking of others as expressed in visual art (De Chirico and Warhol), short stories, poems, literary theory (Poe and Coleridge), linguists (Saussure), philosophy (Wittgenstein and Hegel), and physics (Newton and Einstein).

Is there a right interpretation for a work of art? The position of this book is that there is no single right interpretation for *The Postcard,* for example, nor will there be one forthcoming, but that some interpretations of *The Postcard* are nevertheless better than others: that is, more insightful, better conceived, more responsive to what is in the painting and in harmony with the social and intellectual milieu in which the painting was produced.

Is there more than one acceptable interpretation for an artwork, and if more than one interpretation is accepted, are all interpretations equal? The next chapter is about multiple and competing interpretations of a single work of art, so these questions are on hold until then. The next chapter will also deal with the question of whether correct interpretations are universal and eternal.

What is the artist's role in interpretation? Magritte presents an interesting case for this question. Had his interpreters listened to him, there might not be any interpretations of his work. Yet, from comments of his quoted by Gablik, we know that Magritte wanted people to think and talk about his work. Regardless of Magritte's desires, people do interpret his work, and, when they do so, they sometimes consider what he has said about it. They use his thoughts about his work to inform their own, but they do not let the artist's thoughts limit their own thoughts or the connections they can make between Magritte's work and other knowledge and experience they possess.

Is not the artist's interpretation of the artist's own work of art the best interpretation? Although Magritte says that he does not understand his own work, he occasionally wrote articulately about it, as when he iterated the themes of his upon which Gablik built and when he related the story of his awakening to imagine seeing an egg in a bird cage and how this influenced him to bring things together with poetic affinity in new paintings. If Scutenaire and Gablik and the others had been beholden to Magritte's admonishments not to interpret his work, we would not have their considerable insights into it. The view upheld and further explored later in this book is that the artist's interpretation, when it is available, is one among many and may or may not be the best interpretation at any given time. This view, however, is controversial, as we shall see. Magritte's resistance to interpretations of his work and others' intuitive distrust of interpretation may turn out to be fear of overinterpretation. The topic of overinterpreting a work of art will also be dealt with later in this book.

Who decides about the acceptability of an interpretation? You do, on the basis of an interpretation making sense to you, compelling you to accept it, satisfactorily answering some of your curiosities about it. You would also likely want the interpretation to be acceptable to others who have viewed the work in question and thought about it. If you were the only one in a group of knowledgeable interpreters who found an interpretation acceptable, it would be wise of you to listen to others' interpretations and, then, either decide to modify your own or continue to hold it while being aware that yours is different and of how it differs. The position that this book takes is that interpretation is and should be both an individual and a communal endeavor.

37

2

Multiple Interpretations of One Work of Art: Édouard Manet's *A Bar at the Folies-Bergère*

SINCE IT WAS FIRST shown in 1882, Manet's painting, *A Bar at the Folies-Bergère* (**Color Plate 3**), has been the subject of many different interpretations. This chapter examines some of the interpretations of the painting given by art historians to show the variety of interpretations one work of art has yielded and, by implication, the variety of interpretations that any single work of art can yield. Because there are so many careful but different and competing interpretations of this one painting by professional scholars, it provides us the opportunity to continue to examine central issues about interpretation. The varied interpretations that Manet's *Bar* have received especially raise the issue of whether there are "right" interpretations. They also raise the question of what we should do when faced with competing interpretations, especially when they are all informed and sensible.

In the last chapter, different interpretations of Magritte's body of work were examined; here we will look at interpretations of a single work by another artist, Édouard Manet. It should be clear now that any work of art can and often does receive many and varied interpretations. Magritte's works provided us with interpretations from children, teenagers, and adults, by both everyday interpreters and published scholars. It was relatively easy to see that Magritte's paintings meant different things to a wide range of interpreters. Looking at interpretations of Manet's painting, we will concentrate only on interpretations by scholars, particularly art historians. The range of interpretations here is narrower, but, as we shall see, still broad. The different interpretations by art historians of the painting are interesting in themselves, and they enlighten us with multiple points of view about a significant painting by a historically important artist of the Impressionist period. Most pertinent to our purpose of exam-

ining art interpretation, they provide us provocative examples of different and competing interpretations, all of them well argued by professionals on the basis of historical evidence and clear reasoning. This diversity of interpretations will allow us to see that one work of art can elicit many different interpretations, some different approaches toward interpretation, and the opportunity to examine choices when we are faced with multiple interpretations.

One immediately apparent difference between interpretations of Magritte's paintings and of Manet's is that most, but not all, who write about Manet consider the general as well as the historical context in which the paintings were made. In writing about Manet's work, historians are more compelled to articulate the social context of the work than are writers about Magritte's work. This is probably because Magritte's work was made more recently than Manet's, during the life span of the scholars who have written about it: in other words, Magritte and the scholars who wrote about his work shared the same time frame. Manet's paintings, however, were made over a hundred years ago. Thus the historians writing in our own day about the work of Manet for the most part take on two tasks: one, of explaining how viewers alive at the time the paintings were made saw and understood them, and, two, how we see and understand the paintings now.

39

ÉDOUARD MANET

Art historians tell us that Édouard Manet was born in Paris in 1832 and died there in 1883. He is known as a painter and printmaker whose work bridges the realism of Gustave Courbet (1819–1877) and Impressionism (from about the mid-1860s through the mid-1880s). Manet's work is honored in art history for two reasons. First, Manet depicted everyday subjects and events and appearances of his own day, continuing Courbet's turn away from classical idealism toward everyday realism. Whereas traditional artists contemporary to Manet were idealizing their subjects, striving to depict generic beauty and represent timeless values, Manet was depicting the particularity of individuals rather than idealized types and the temporary rather than the eternal. Second, he also began to think of and make paintings as arrangements of paint on canvas and not just as a means of representing things. Thus he is considered influential in moving art from representation toward abstraction. In the words of Peter Schjeldahl, an art critic who writes for the *New Yorker*, "Manet's style is a revolving door between a classical past and an audacious future that is still with us."[1] Manet's three most famous paintings are *Luncheon on the Grass*, 1863 (**Color Plate 4**), a nude woman with clothed men; *Olympia*, 1863, a reclining nude; and *A Bar at the Folies-Bergère*, 1881–1882 (see Color Plate 3), the last major painting before his death in 1883.

Manet was born into a well-to-do and elegant Parisian family and traveled widely throughout Europe to view and carefully copy the old master painters. He was particularly impressed by the work of Frans Hals, Diego Velásquez, and Francisco José de

Goya and admired the work of Courbet and Honoré Daumier, artists of his own day. Some recent historians identify Manet as a *flaneur* as well as an artist. A flaneur was "a perpetual idler, browser, or window-shopper who saw the city of Paris as a spectacle created for his entertainment, and judged commodities to be icons made for his veneration." The flaneur strolled the city streets scrutinizing everything: "the cut of a sleeve or trouser, the sheen on a piece of satin, the trim of whiskers, and the depth of a plunging neckline are all prerequisite for the discovery of identity in a city of strangers."[2]

MANET'S *LUNCHEON ON THE GRASS*

After the Paris Academy Salon of 1863 rejected *Luncheon on the Grass (Le Déjeuner sur l'herbe)* (see Color Plate 4), Manet displayed it with other rejected paintings in the *Salon des refusés,* but it was controversial there too. The Academy Salons were government-sponsored events that displayed thousands of paintings every year. The Salons were juried, prizes were given, and recognition followed. Reactions to paintings shown in the Salons could ensure professional success or lead to neglect and failure. During the years that Manet submitted work to the Academy Salons, they were scenes of intense competition among artists and formed the battleground between modern and traditional art. Yet even those viewers who went to the Salon des Refusés expressly seeking avant-garde art were shocked by Manet's *Luncheon.*[3]

Manet based *Luncheon on the Grass* on earlier works of Renaissance art depicting pastoral paradises but updated the theme by painting real and identifiable people of his day. He portrayed the two men in Parisian clothes of the time, but he painted the woman who sat with them nude. His juxtaposition of the nude and the clothed men out of doors offended contemporary morality, especially since Manet did not elevate the subject with an allegorical title. A historian of today, H. W. Janson, sees the *Luncheon* as a visual manifesto of artistic freedom in that "it asserts the painter's privilege to combine whatever elements he pleases for aesthetic effect alone. The nudity of the model is 'explained' by the contrast between her warm, creamy flesh tones and the cool black and gray of the men's attire . . . the painter's first loyalty is to his canvas, not the outside world."[4]

Nevertheless, Manet's first viewers objected to the unidealized people and the nudity of the woman in the midst of the clothed men, especially to the fact that she seems unperturbed and at ease and looks directly at the viewer. A critic contemporary to Manet wrote, "A commonplace woman of the demimonde, as naked as can be, shamelessly lolls between two dandies dressed to the teeth" and concluded that the painting is a "shameful, open sore."[5] Art historians of today explain that Manet's work would have been acceptable to the viewers of his day if he had shown the men and women, dressed or undressed, as classical nymphs and satyrs. Manet's contemporaries also objected to his manner of painting, intensely disliking the combination and juxtaposition of soft-focus landscape with the sharply defined and harshly lit figures. It

is this very juxtaposition that is now said to flatten the form and give it a "hard snapping presence" (like that of the photographs made during Manet's time), an effect caused not by line but by paint and light. The Parisian public and early critics, however, saw only "a crude sketch without the customary finish."[6]

MANET'S *OLYMPIA*

Manet's exhibition of his painting *Olympia,* 1863 (**Color Plate 5**), caused more furor than *Luncheon on the Grass* and, according to Stephen Eisenman, a recent historian, eclipsed it as "the most notorious painting in the history of art."[7] Manet based *Olympia* on an esteemed painting by a master of the Venetian Renaissance, the *Venus of Urbino* by Titian, 1538. Titian's Venus was one of many idealized versions of the love goddess painted and sculpted throughout history, but Manet's version was ridiculed as vile by those who saw it when it was first exhibited. One of Manet's contemporary critics wrote of his painting as a "vulgar" rendition of "a base model picked up from I don't know where." Manet's critics saw his Olympia as indecently naked and lacking the supposedly elevating qualities of the traditional love goddess. According to Robert Bersson, a historian writing today, Manet's public would likely have accepted his painting had he made Olympia "coyly charming" and "sensuously alluring" like Titian's Venus, or if he had presented her as an "exotic bather" in the "refined style" of Jean-Auguste-Dominique Ingres, or if he had painted her as a "stylishly formed, softly pornographic nude" like Alexandre Cabanel's *Birth of Venus,* 1863.[8] The Parisians objected to the ordinariness of the model and Manet's decision not to idealize her appearance. Émile Zola, the novelist, playwright, and journalist who was a friend of Manet's, attempted to defend the artist and his painting with this argument: "When other artists correct nature by painting Venus, they lie. Manet asked himself why he should lie. Why not tell us the truth? He has introduced us to Olympia, a girl of our own times, whom we have met in the streets pulling a thin shawl of faded wool over her narrow shoulders."[9]

Zola also argued that the objecting Parisian viewers missed the main point of the painting, that what was most important about it was not the characteristics of its subjects but its visual qualities, notably its colors, and the white tones of Olympia on white sheets in contrast to the black cat on the bed, the dark-skinned woman, and the black background. Along the line of reasoning offered by Zola, Edmund Feldman, a recent historian, speculates that "it may have been this merciless flat light as much as his subject matter which aroused the indignation of the French public. That is, they may have believed they were objecting to his candid and highly individualized treatment of nakedness, but perhaps they were aesthetically offended by his realistic and unsentimental application of paint, his glaring treatment of light."[10] Bersson summarizes that for Manet the human figure ceased to be more important than its surroundings and that, by giving import to abstract elements and treating all parts of a painting equally, Manet inspired future generations of artists toward abstraction.[11]

41

Nevertheless, Manet provoked critics and the public alike by challenging their notions of sex and race. As the historian Eisenman explains, although images of women, painted and sculpted, traditional and modern, dominated the visual culture of Paris at the time, none of them were as controversial as Manet's. Manet's Olympia suggested an independent sexuality: "She was not a grand courtesan paid to confirm myths of masculine desire, but a proletarian who owned only her labor power and her sex."[12] Critics at the time argued that Manet's Olympia was subhuman. Racist views of blacks were prevalent then and Parisian viewers supposedly linked together the body of the lower-class prostitute and the body of the Afro-Caribbean woman who served her as intellectually, physically, and morally depraved and inferior. At that time prostitutes were believed to be congenitally deformed and preconditioned to hypersexuality. Manet's choice of depicting lower-class women, and in a flattened anti-Classical style, "incited a frenzy of shrill critical antagonism."[13]

- *Interpretations and judgments are intermeshed and mutually affect one another.*

42

Before moving on to consider *The Bar at the Folies-Bergère,* there is already an important conclusion to be drawn here about interpretation based on the controversies over *Luncheon on the Grass* and *Olympia.* The conclusion involves interpretation and judgment, with *interpretation* building meaning about a work and *judgment* appraising how good a work is. Among the writings on Magritte examined in the last chapter, all the writers quoted were positively disposed to Magritte's work. They implicitly judged it to be good art and went about interpreting it accordingly. Here, however, in some writings about Manet's work, we have clear and explicit negative judgments, as well as interpretations. The writers' judgmental conclusions about the worth of Manet's art and their decisions about the meaning of the paintings are very interdependent. If one does not interpret *Luncheon on the Grass* as a play on a traditional theme and an occasion to paint both flesh tones and fabrics in new compositional ways, then one might interpret it as a picture of promiscuity and judge it negatively. Or if one does not interpret *Olympia* as having to do with lights and darks and innovations of composition, then, on realist grounds, one might judge it negatively, as an inept treatment of figures in a landscape. Even if one recognizes Manet's artistic innovations, one can still disapprove of his use of a woman as an object of sexual display and of the racist connotations that may be implied by his use of a woman of African descent as the servant of Olympia. One may judge the painting favorably on aesthetic grounds and judge it negatively by social criteria. How one understands a work of art, that is, how one interprets the work of art, strongly affects how one will judge its value. The interrelationship of interpretation and judgment will be explored more fully in the next chapter.

MANET'S *A BAR AT THE FOLIES-BERGÈRE*

Although *A Bar at the Folies-Bergère* was a much less controversial painting in its day than *Luncheon on the Grass* or *Olympia*, it raised many interpretive questions when it was first shown in the Paris Salon of 1882. It continues to raise questions today. Twelve newly written essays on the painting are included in one recent book,[14] and many other articles are available in other sources. The painting is referred to in every comprehensive overview of art history. *A Bar at the Folies-Bergère* is a *canonical* work of art history; that is, it is considered to be a masterpiece by traditional art historians and an essential work of art for understanding the history of art.

When it was shown, there were immediately many disagreements among French viewers about what they saw in the painting, especially regarding the woman and the mirror. The woman and the mirror continue to preoccupy scholars today, who have added many more questions about the painting and continue to provide different answers. Their questions and answers revolve around then and now and involve distinctions between the painting and the world. Historians seek to know what the original viewers saw and experienced in Paris and in the folies in 1882, as well as what they saw in Manet's painting of the folies and what it might have meant to them. Scholars also seek to know what current viewers see in the old painting and what it might tell us about the painting, art, Paris, the folies, the Folies-Bergère, men, and women.

Paris in the Second Half of the Nineteenth Century

Historians tell us that Manet's lifetime largely coincided with the modernization of Paris. Prior to 1852, Paris was in many respects a medieval city, with narrow twisting streets, wooden houses, and inadequate water and sewage facilities. The population grew from one million in 1836 to a million and a half by 1856. To accommodate this growth, open city squares, parks, and cemeteries were built over; this in turn restricted access to light and air and the movement of people and goods, and tuberculosis and cholera became an increasing threat. Upon seizing control in a coup d'état in 1852, Napoléon III initiated a massive public works project to rebuild Paris. New water and sewer systems were constructed, streets were widened and straightened, street lighting was added, and new residential and commercial structures were built. During a time of high unemployment, thousands were provided jobs and health improved. Within a generation, Paris became a modern city, fashionable and elegant. The physical changes brought significant social and cultural changes. Rich and poor became increasingly separated, with the rich moving to new apartments along the boulevards and the poor moving to tenements outside the city. A lower-middle class emerged between bourgeois and proletarian classes, but mass-produced clothing sold in the new department stores confused previously clear signs of social class, occupation, and sexual availability, and thus who was available to whom socially and sexually.[15]

43

The Folies-Bergère, Paris

When historian T. J. Clark examines Manet's *A Bar at the Folies-Bergère,* he writes thirty-two pages about the culture of the folies in Paris, and how they functioned for those who frequented them, before he investigates the painting in seventeen pages.[16] With less detail, John House, another historian, informs us that the Folies-Bergère was one among many places of entertainment in Paris called *cafés-concerts.*[17] The Folies-Bergère charged for admission as well as for drinks, and it had fancier decor and a more lavish ambience than other *cafés-concerts.* All *cafés-concerts* provided entertainment, including song and dance, but the Folies-Bergère distinguished itself by the grandness of its stage shows, and it was particularly known for its mimes, gymnasts, and acrobats. Note the acrobat's legs in the upper left corner of *A Bar at the Folies-Bergère.*

People of "high culture" viewed all cafés, including the Folies-Bergère, as "popular" and appealing to the working class, although frequented by members of the bourgeois and petit-bourgeois classes as well. One of the attractions of the folies was the mixing of classes. Above all, folies were considered places of spectacle. Tag Gronberg, a recent historian, writes that the Folies-Bergère offered a complex double spectacle: one taking place in the promenades and another on the stage in the auditorium. He notes drawn pictures of the Folies-Bergère in a popular journal of the time showing "frock coated boulevardiers flirting with barmaids or surveying the passing parade of women on the promenoirs and a profusion of acrobats, clowns, and gymnasts."[18] Jack Flam, another recent art historian, identifies the Folies-Bergère as "a world of frivolity, gaiety, high spirits, and erotic encounters, a world dedicated to surfaces and to the stirring of appetites and desires."[19]

Historians also tell us that *cafés-concerts* raised the concerns of government officials who regarded them as forums for political opposition and potential hotbeds of social radicalism. The cafés were also suspected of contributing to the decline of moral order, especially through the public sale of alcohol. Alcoholism, sexual promiscuity, and the mixing of classes all threatened the established social order. Sexual promiscuity, and prostitution in particular, were very much a concern during Manet's times, and some French people at the time even attributed the collapse of Napoléon III's empire in part to prostitution: "Who can say how much energy was destroyed, strength enervated and spirit debilitated by that laxity of morals?"[20]

In 1880, two years before Manet painted *A Bar at the Folies-Bergère,* Zola published *Nana,* a novel about prostitution. It is one of twenty novels that Zola wrote to observe and record the times, examining in fiction the effects of heredity and environment on one family. Manet encouraged Zola to write *Nana,* and in 1877 Manet painted a picture of Henriette Hauser, a courtesan, and titled it *Nana.* Zola's preparatory notes for the writing of the book are very revealing of then current French attitudes toward prostitution. Zola described the men who provided the high-class prostitutes, *grandes cocottes,* with their wealth and power as "a whole society clinging to the skirts of those

women. The pressure of the males. Old men debauching themselves and breathing their last away from home. Bestiality, an old man sniffing in slippers. Young idiots ruining themselves, some to keep in fashion, some out of infatuation. Middle-aged men with high positions falling in love."[21] Zola stated the theme of the book that he was to write as this: "A whole society hurling itself at the cunt. A pack of hounds after a bitch, who is not even on heat and makes fun of the hounds following her. *The poem of male desires,* the great lever which moves the world."[22]

Zola wrote this characterization of the main character he was to portray in his novel: "Nana eats up gold, swallows up every sort of wealth; the most extravagant tastes, the most frightful waste. She instinctively makes a rush for pleasures and possessions. Everything she devours; she eats up what people are earning around her in industry, on the stock exchange, in high positions, in everything that pays. And she leaves nothing but ashes. In short a real whore. Don't make her witty, which would be a mistake; she is nothing but flesh in all its beauty. And, I repeat, a good-natured girl."[23]

The novel *Nana* was widely publicized before its release and appeared in chapters in the popular press before it was published as a book. Flaubert and a few other friends of Zola praised the novel but polite society was shocked by what it called the novel's crudity. Moneyed people did not like references to workers slaving in the mills to provide the wealth to satisfy Nana's caprices. Literary critics thought the book obscene. Manet's painting *Nana* was rejected by the Salon of 1877.

Historians acknowledge that prostitution was available at the Folies-Bergère and one identifies a complex sexual geography for the place: there were orchestra stalls where ordinary bourgeois families sat to see the show, and there were boxes in a winter garden where prostitutes could be procured. Barmaids might also offer sexual favors, but after hours, and therefore they had more choice in their sexual partners than those operating in the stalls and winter garden.[24]

The Barmaid in *A Bar*

Different viewers read the barmaid's expression differently. When the painting was first shown in 1882, Paul Alexis wrote of the woman as "a beautiful girl, truly alive, truly modern" and Le Senne referred to "the brightness of her gaze." Maurice Du Seigneur, however, saw her as having a "bored look."[25] Raymond Mortimer writes that she looks "sulky" and "tired and glum."[26] Recent writers also read her expression differently from one another. Griselda Pollock refers to her "disturbing impassivity,"[27] Flam writes that she seems "distant, melancholy, absent" and "detached" from her surroundings,[28] and Albert Boime sees her as bored, aloof, fatigued, and lonely,[29] but Clark writes of her as "impassive, not bored, not tired, not disdainful, not quite focused on anything."[30] Pollock comments that "She appears but does not see. The dropped eyelids prevent her from looking at us in a way that would be brazen, like the stare of Olympia."[31]

There are also comments on the dress that the woman wears, with an early critic noting that it is tight-fitting, another that it is a "gaudy blue" color, and another referring to her "vulgar bodice."[32] Many recent authors also note its tight fit, with Pollock observing "the fetishism of her tightly corseted waist."[33] Flam and Jeremy Gilbert-Rolfe claim that Manet has drawn attention to the barmaid's sex. Flam notes that the buttons of her jacket lead our eyes down to a gray triangle, bisected by a seam, "and there a most unsettling thing happens. We realize that this triangular area very much resembles a pudendum."[34] Gilbert-Rolfe writes, "Manet has emphasized the barmaid's vagina through the arrow-like cut of her vest."[35]

Pollock attends to the barmaid's hands, believing that Manet's depiction of her hands reveals attitudes about class, gender, and sexuality. She notes "the stark nakedness of the barmaid's hands plonked forcefully and gracelessly on the counter so that only the bulging mounds of Venus, as the fleshy parts below the thumbs are named, ridge up against the counter's edge." The "bulging mounds of Venus" is another allusion to the pudendum. Pollock goes on to explain that in bourgeois society, women could bare their chests and upper arms in ball gowns, but that a woman's hands had to be gloved, thus they "acquired a symbolic significance of sexual topography of the female body unfamiliar to us today. To go about ungloved was akin to leaving your body physically naked."[36]

The facial makeup that the barmaid wears was an issue for many who saw the painting in 1882. Some during that time celebrated makeup as a positive and unproblematic sign of the new urban modernity of Paris, but others resisted it as a sign of moral decay.[37] Henri Houssaye, writing at the time, disparagingly referred to Manet's painted barmaid as having a "flat plastered face."[38] Clark sees her as, above all else, fashionable and that she wears her fashion to disguise her class, which is likely not the bourgeoisie. Hers is "the face of fashion, first of all, made up to agree with others quite like it, the hair just hiding the eyebrows and leaving the ears free, the cheeks pale with powder, the lips not overdone this season, the pearls the right size."[39]

The Mirror

Parisian critics were quick to point out the inaccuracy of Manet's painting of the mirror behind the barmaid and what it reflects.[40] The barmaid's back reflected in the mirror is not where it should be by optical standards. One nineteenth-century writer did not even see it as a mirror and thought the barmaid's reflection to be the barmaid's twin sister. A cartoonist of the time "repaired" the painting by publishing in a magazine a drawing of how Manet should have rendered the mirror.[41] Historians continue to point out the lack of realistic fidelity in Manet's painting of the mirror, noting the things in the painting for which the mirror does not account. James Herbert, for example, writes, "the problematic displacement of the barmaid's reflection to the right, the subtle mismatch between the arrangement of bottles in the left foreground and that of the corresponding group in the mirror, and so forth."[42] Flam notes that the mir-

ror does not reflect anything exactly, pointing out, for example, that all the bottles on the left side of the bar are depicted as reflected on the wrong edge of the bar—on the bar they are at the edge closest to the barmaid, but in the mirror they are on the farthest edge.

To explain the discrepancies in Manet's painting of the mirror, some recent historians employ a psychoanalytic view. Richard Schiff and Bradford Collins, for example, argue that the mirror not only reflects but also splits the painting into alternative zones, one of reality and the other of illusion. In their readings Manet may be simultaneously revealing his conscious and unconscious worlds, both his reality and his dream.[43] While contemporary authors know that Manet chose to manipulate the reality of the mirror, many of the painting's original viewers attributed discrepancies to the presumed ineptitude of the artist. Houssaye wrote, "Is this picture true? No. Is it beautiful? No. Is it attractive? No. But what is it, then?"[44]

Collins asserts the function of the mirror in this painting as well as in other nineteenth-century paintings, namely: "to provide the male spectator a more complete inventory of a female subject's physical charms." He points out that the woman's reflected back receives more space and thus more attention than the woman herself, and he concludes that "Manet's emphasis suggests that the barmaid exists less as a tangible person than as a spectacle for our masculine gaze."[45]

47

The Bar

Manet's depiction of the bar itself also elicited comments and objections from those who first saw it, and recent historians continue to pose questions and offer their answers for those questions. The early critics who saw the painting and who also knew the Folies-Bergère from having been there were perplexed by aspects of Manet's depiction of the scene. They expected an accurate correspondence between the painting and what they knew of the real bars within the Folies-Bergère.

Flam and House also note the bottles on the bar. One identifies them as bottles of ale, cognac, and champagne, while the other names them champagne, vin rosé, crème de menthe, and Bass ale and notes that these are fashionable and comparatively expensive in their time. They ask why they are unopened, why so many of the champagne bottles are unchilled, and why there are no glasses with which to serve the drinks. The roses to some seem too personal a touch and out of place. The mandarin oranges also seem out of place but some historians think they signify the Folies-Bergère's higher-class clientele (because the oranges would not have been normal bar fare). One commentator notes that fruits used with images of women have traditionally symbolized fertility, and feminist historians have pointed out that fruits and flowers have also been used to suggest an essential male conception of women, namely to provide sensual pleasure for men.[46]

The Man in the Top Hat

The man in the top hat at the right of the canvas who appears to be talking to the barmaid is variously described as a boulevardier, a dandy, and a flaneur. Several historians agree about how the painted figure functions in the painting. In the words of Gronberg, the top-hatted man "makes his blurred appearance in order to act out the part of the flaneur; chatting up the barmaid, his presence signals (indeed emphasizes) woman as spectacle—as object of the gaze."[47] Collins sees the man and "his phallic walking stick" differently. He does not think he is chatting with the woman, but looking at her, and, more important, looking up at her. For this historian, the mirror functions to reveal the spectator, and the woman towers over the smaller male figure whom she appears to ignore. "What had been a fairly conventional rendition of the male fantasy of erotic mastery has been transformed into a very unusual statement of male inferiority and female inaccessibility."[48]

The Form of the Painting

Recent historians[49] inform us that Manet made a mock-up of the bar in his studio and placed a model in it. The model's name is Suzon, and she was actually a barmaid at night and Manet's hired model during the day. Manet painted the picture from memory of the Folies-Bergère and with the aid of preliminary sketches. A contemporary of Manet, Georges Jeanniot, visited his studio while Manet painted *A Bar* and observed that Manet "did not copy nature at all closely; I noted his masterly simplifications. . . . Everything was abbreviated; the tones were made lighter, the colors brighter, the values were more closely related to each other, the tones more contrasting." Throughout the artist's career, however, other critics complained of Manet's supposed pantheism, and Theophile Thoré objected that Manet painted everything uniformly whereby he supposedly placed "no higher value on a head than a slipper," and "sometimes gives more importance to a bunch of flowers than a woman's face."[50]

Recently, House observes that, as we would expect, the principal woman is more sharply focused than the reflection: "The figure of the barmaid stands out boldly from the flurry of seemingly improvised marks that evoke the audience on the opposite balcony. Yet this principal figure is not the most sharply focused element in the picture: the bottle and fruit bowl are treated with great richness and finesse, while the barmaid is more broadly and simply treated."[51] This shift of focus is an anomaly in conventional painting of that period and it may also be an anomaly in Manet's paintings.

Early commentators were generally appalled by the lack of fidelity to realism in Manet's handling of the mirror and generally attributed this to his ineptness as a draftsman. As we have seen, recent historians assume that Manet intentionally made the mirror the way it is, but then speculate at length about the choices Manet made in not representing the mirror and its reflections with realistic accuracy.

Recent historians are in general agreement that Manet's application of paint constructs a look of abruptness and spontaneity, a quality of the here and now. Schiff notes that Manet's very application of paint draws viewers' attention to it and that Manet's style suggests a directness of vision, and hence a sense that he is being true to appearances and has a sincerity of emotional response. His paintings have "idiosyncratic immediacy—bold, summary brushwork, the spread of blond tonalities, the radical simplification of perspective effects."[52] Armstrong points out Manet's scumbling of white paint on the parts of the canvas that are meant to depict the mirror, his loose manner of painting the mirror, as well as his light-handed rendering of the lace edging of the barmaid's décolletage, and the "brushily rendered blossoms" tucked into the barmaid's bodice that link her to the flowers that are in front of her on the bar.[53]

When the painting was first shown there was disagreement about how well or poorly the barmaid was painted. One early critic, Jules Comte, observed the "incorrectness of the drawing" and the "absolute inadequacy" of her painted form; Charles Flor wrote that she looks "paralyzed," Houssaye that she has "a cardboard head," and Le Senne commented on her "mediocre" anatomy in her "tight-fitting dress." Emile Bergerat, however, saw her as "beautiful" and painted with "remarkable sureness," and as being "natural in pose and altogether full of character," "happily rendered," and "firmly established with a natural movement."[54] Today most writers refer to the barmaid as an attractive woman attractively painted.

Readings of Narratives in the Painting

While looking at the *subject matter* of the painting—the mirror, the bar, the barmaid, and so forth—and the *form* of the painting—how it is composed and painted—most viewers seek to make sense of the painting by looking for a narrative or story that explains how everything works together in the painting. Most commentators, upon inspecting the painting closely, find it curiously complicated.

One standard and widely used art-historical textbook, *Gardner's Art through the Ages,* however, recognizes no need for interpretive confusions about *A Bar at the Folies-Bergère.* The book says that "The painting tells no story, and has no moral, no plot, no stage direction; it is simply an optical event, an arrested moment, in which lighted shapes of one kind or another participate."[55] Kermit Champa, a contemporary historian, in the course of a more involved interpretation, supports the textbook's view with his observation that the bottles are unopened and there are no glasses in which to serve anything. He asks what else is there to do but gaze? "When mirrors lie and bars can't serve, what kind of spectacle is being offered? The answer is ultimately a simple one, the spectacle of painting as painting."[56]

These two views would be considered *formalist* views; that is, they adhere to a formalist theory that holds that all concerns for narratives and messages in art are misplaced—the only thing important in a painting is with what aesthetic effect the paint is arranged on the canvas. Most critics and historians, however, favor a *contextualist*

approach, that is, that a work of art can only be fully understood and appreciated if it is seen within social and cultural history, as well as aesthetically.

Most of those who write about *A Bar at the Folies-Bergère* do see narrative content in the painting. When Parisian critics first saw the painting, they raised the question of what the woman is selling, and some indicated that she is a prostitute selling herself as well as the refreshments of drinks and oranges; many recent historians uphold this belief. According to this view she is painted in such a way as to seem emotionally detached and this is to allow the customer to think that "she is one more object which money can buy, and in a sense it is part of her duties to maintain that illusion. Doing so is a full time job."[57] Carol Armstrong, a historian sympathetic to this view, writes that "in the world that Manet paints, seeing and buying are twinned like Siamese twins."[58]

Robert Herbert, a recent historian, sees two impressions of the barmaid, one that Manet painted to face the viewer and the other to be reflected in the mirror. Facing the viewer, she seems to be a professional barmaid, but in the mirror she seems to take on a role envisioned by the man with the top hat and cane in the right of the canvas who appears to be looking at her. "In the mirror, her more yielding nature is revealed, detached as it were from her body by the man's power of wish-fulfillment . . . we can't really be that man, yet because we are in the position he would occupy in front of the bar, he becomes our second self." "His disembodied image seems to stand for a male client's hidden thought when facing such an attractive woman."[59] Flam agrees that the barmaid is an object of desire among other objects of desire on the bar, a commodity among other commodities. He points out the "rhymes and echoes" of her body and the painting, "the audacious way that her torso in its tight-fitting jacket rhymes with the champagne bottles."[60] But Flam does not conclude that she is a prostitute.

Writing from a feminist point of view, Pollock points out that these and other accounts are written by male historians, and that the "we'" they use is the collectivity of men who can in fantasy and in scholarship identify with Manet, "the dandy who painted it, and whose surrogate stands in the right hand side, offering his implied place for the viewer to occupy." As a female viewer, she sees that Manet's is "a social space catering to masculine desire" and that the barmaid is "the embodiment of bourgeois men's fantasies about female availability in which woman is like a blank page upon which is inscribed a masculine script." In her essay on the painting, Pollock wishfully wonders, "instead of addressing her customer and asking what he wanted, maybe she dreamed of his asking what she needed; what she as a working class woman actually desired: what her fantasies of pleasure, ease, and gratification might be."[61]

Two historians see a narrative of death in the painting. Georges Bataille sees it as Manet's last gasp. He sees the main topic of the painting to be light: "an explosive festival of light, obscuring and absorbing the girl's motionless beauty." The painting is a large composition with all its spaces filled, "a bewitching interplay of lights gleaming in a vast mirror." It is a painting that sublimates the horror of death in a play of light.[62] In Flam's interpretation it is the man in the top hat with the cane who is symbolic of

death, more specifically, Manet's death. In this view, the man might be Manet himself. Fram points out that Manet painted the picture when he was terminally ill and aware of his death. He painted a world of frivolity and high spirits and erotic encounters, but when Manet painted it, "it was also a world that he could no longer move in, and that he quite literally has to summon by an act of the imagination aided by memory." Further, in this account, the barmaid "is also a surrogate of the artist, both detached and engaged, absent but always present. Like the artist, she stands at the edge of an abyss, contemplating the transience of all pleasures and all things."[63]

Historians also direct our view to minor characters in the painting and work them into narratives. Flam notes the two women in the far balcony who seem to be watching a stage show that includes a trapeze artist, whose legs are visible in the upper left corner of the painting. He notices two other women, one who looks out across the space, sitting next to a woman who seems to be fanning herself. He is unsettled by the man with the mustache and the top hat because he looks to the historian remarkably like the top-hatted man standing next to the barmaid and seems to be looking at the barmaid: "What we see is this man's view of the woman. It is he who stares at her from the distant balcony, unseen by her, imagining himself to be the object of her attention."[64]

Pollock, the feminist art historian cited earlier, also turns our attention to minor characters in the painting, and builds a narrative that identifies the ways in which gender is enacted in the masculine canon. Most historians ponder the barmaid, but Pollock wryly comments that "only certain bodies, it seems, achieve art historical acknowledgment and arrest the desiring masculine gaze, while others fall below the threshold of masculine interest and become invisible." She then turns our attention to the woman with lemon-colored gloves whom she identifies as Méry Laurent, a woman known to perform on stage in the varieties, scantily clad, and who became a mistress at age seventeen. She identifies the woman in the black dress, holding binoculars in gray gloves, as the metaphorical female spectator who is not interested in the transaction between the dandy and the barmaid. "This feminine figure looking elsewhere installs in the painting an active and independent woman spectator who is, however, ultimately distanced and diminished by the compositional balance Manet has chosen." She looks off into space, signifying desire for "the more" for which feminism stands.[65]

Collins equates the minor figure of the trapeze artist with the major figure of the barmaid, asserting that they both are performers, but that the trapeze artist relies on honest craft while the barmaid relies on craftiness. The trapeze artist acknowledges her performance but the barmaid must not.[66]

Champa, finally, finds an entirely different narrative in the painting, seeing it as a very soothing picture and feeling religious vibrations when he looks at it. He sees a young, attractive, and fashionable woman positioned in a priestly manner in front of a bar that Manet has arranged to be much more like an altar. She stands with her potions or ointments. "Perhaps she is there to heal us, the socially and spiritually disoriented urban bourgeois spectators, and Manet, the physically ailing artist."[67]

CONCLUSION

We left our consideration of interpretations of Magritte's paintings in chapter one with some conclusions and some unanswered questions. One conclusion was that to interpret a work of art was to make sense of it, and we saw a variety of different interpretations from different viewers, including children and professional scholars, each of whom made some sense of Magritte's work. They made sense of the work both for themselves and for anyone who looked at the paintings and read the interpretations that they wrote. This chapter on Manet contains interpretations formulated for the most part by scholars. Whereas levels of intellectual and emotional sophistication differed among the children and adults whose interpretations of Magritte's paintings were quoted in chapter one, all the scholarly interpretations of Manet's *A Bar at the Folies-Bergère* retold in this chapter share a high level of sophistication. Nevertheless, all the interpreters are still trying to make sense of the painting, for themselves and for their readers.

The interpretations of *A Bar at the Folies-Bergère* offered here have much in common, yet they sometimes differ greatly. Sometimes the interpretations differ because the interpreters are asking different questions about the painting. For example, some interpreters are seeking answers to questions about how original Parisians saw it, while others are concerned with what it might mean to viewers who see it now. Some interpreters seek to answer questions of how this painting is foundational for modernist paintings of the early twentieth century. Some wonder if Manet had unusual insights into the social conditions of his day or if we are now endowing Manet with current insights to which he did not have access when he painted.

The interpreters commonly identify the *subject matter* that can be seen and recognized in the painting—the barmaid, the top-hatted man, the items on the bar, the people in the balconies, and so forth. The interpreters also commonly identify aspects of the painting's *form*—the distortions in the mirror, Manet's disregard for realistic representation, the way he applied the paint to the canvas. What may be surprising is that even though the interpreters, for the most part, agree on the descriptive facts about the painting, they disagree as to how these facts should be put together to form an interpretation of what the facts might mean. Accurate and careful description does not constitute interpretation. Although careful and accurate description is necessary for interpretation, description is not sufficient for an interpretation. A listing of the facts about the painting and how and when it was made does not answer the essential interpretive question: What is the painting about?

• *Description does not constitute interpretation.*

The interpreters generally agree on the facts of the painting, and there are no evident factual disputes about it regarding who made it, when, what kind of thing it is, how it was originally perceived and received by the public, and so forth. The interpreters of the painting do, however, notice different aspects of the painting and give

import to different descriptive facts about the painting. One interpreter pays special attention to the top-hatted man next to the barmaid while another interpreter notices a similar top-hatted man in the balcony and draws inferences about the two men. Another interpreter pays particular attention to the barmaid and her dress and posture and expression and above all her sexuality, while another critic looks beyond the barmaid and brings our attention to a woman in the balcony who is not even looking at the central scene that concerns most of the interpreters. How one meaningfully selects and combines facts to answer questions of meaning constitutes interpretation.

• *Description and interpretation are interdependent.*

More generally, there are no descriptive facts without interpretive theory. What we describe as relevant in the painting is dependent on our interpretation of the painting. Foremost, we interpret the object *A Bar at the Folies-Bergère* to be a painting rather than something to cover a drafty hole in a wall or a decorative item to complete a room. Medieval wall tapestries served such functions. Because we interpret it to be a painting rather than a thick colored cloth to reduce drafts, we can notice certain aspects of it and ignore others. We don't seek to know its insulation value in the Parisian climate. We want to know why the marks on its surface look the way they do and what they might mean to us and to those seeing them in Paris in the 1880s. More to the point, if we think the painting will tell us something about how men think of and represent women, we may pay particular attention to how the women are portrayed and pay less attention to the ambiguity of space in the painted mirror. If we are careful interpreters, however, we must not overlook descriptive facts that are relevant to understanding the painting that Manet made.

If we only attend to the women in the painting and ignore the objects on the bar, the man beside the barmaid, the acrobat, the reflection in the mirror and how it distorts, then we may be missing important aspects of Manet's painting. Interpreters switch back and forth from describing a particular object and interpreting the whole of the painting, much as when reading a sentence we must know the meaning of the words in the sentence, but we also need the context of the whole sentence to understand the meaning of the words. The word affects the meaning of the sentence and the sentence affects the meaning of the word. This part-to-whole relationship is known as the "hermeneutic circle" of interpretation, and the circle is in play in the interpretations of *A Bar at the Folies-Bergère* and all works of art. The hermeneutic circle is a reminder of the interdependency of interpretation and description.

Some interpreters of *A Bar at the Folies-Bergère* pay much more attention to the social circumstances of the painting than do others. For some interpreters, what is important is that the painting was made by Manet, who lived at a certain time, and who made certain "advances" in the history of painting, namely, moving painterly representation away from the realistic and toward the abstract. For other interpreters, such stylistic considerations are not sufficient for an understanding of the painting: they

53

seek to understand the man who made the painting, the times in which he worked, and especially the special forces at play in Paris when he painted. Still other interpreters seek to understand the psychology of those who viewed the painting in the past and now, as well as the psychology of the artist who made it. Interpreters also write about how male viewers responded to the painting then, and how men respond to it now, and how female viewers might respond to it differently than men. Gender differences were not made an important or explicit part of the chapter on Magritte's paintings. Nor were distinctions made between viewers then and now, because Magritte worked during a time closer to our own than did Manet.

The interpretive understandings of *A Bar at the Folies-Bergère* differ significantly when the interpreters choose to tell the stories that they read when they see the people, places, and things in the painting, and relate them to the social circumstances of the making of the painting. Some recent scholars see no need to look for any story in the painting at all: the painting is simply and sufficiently a dazzling display of pigment on canvas by an artist who furthers the history of art expressly by concentrating on the paint and how it is arranged on a surface. There is no need for more of a story, and reading stories in the painting is misguided. This view of art is referred to as *formalism*: what is important about art is its aesthetic form, no more, no less. Subject matter, for formalists, is merely something that holds form. Social context, for formalists, is the business of biographers and social scientists, and distracts from the essence of art. Opposing the theory of formalism is *contextualism*. Contextualists do not limit themselves to the form of a work of art. They certainly consider and enjoy aesthetic form in art, but they pursue many more aspects of how art is made, perceived, understood, and valued.

Most of the scholars past and present and cited in the chapter do see a narrative within the painting, but the narratives that they see differ, and sometimes greatly. The barmaid, for example, is variously seen as a priestess or a whore; the top-hatted man is seen as Manet himself, or as us, the viewers, who are presumed to be male and heterosexual. Based on their understandings of the subject matter, the form, the social context, and the narrative (or lack of one), the interpreters then variously interpret the painting to be about the commodities offered by capitalism, or about the intricacies and oddities of male desire, or about the impending death of the artist who made the painting, or simply about the joy of seeing paint on canvas.

In this case of Manet's *A Bar at the Folies-Bergère,* we have many different and competing interpretations. They are all written by informed scholars. Each is backed by factual evidence and reasons. We are left with some questions: How are we to decide among these competing interpretations? Is there a right one now, or is there a right one that will come along in the future? If we combine all the interpretations already written about *A Bar at the Folies-Bergère,* or that might yet be written, will we then have the right interpretation? Hopefully, reading the summaries of the competing interpretations of *A Bar at the Folies-Bergère* included in this chapter will provide and reinforce answers to these questions and render some of them irrelevant.

The variety of insights into the painting that the multiple and competing interpretations offer are justification enough that multiple interpretations are more desirable than single interpretations. Each interpretation shows us different aspects of the painting, aspects that we would not have noticed without reading the interpretations. What once seemed simple is now much more interestingly complex. We do not have to choose among the interpretations; we can enjoy each for what it contributes to our understanding, experience, and appreciation of the painting and of the interpretive human mind. Nor is it likely that combining these many different and competing interpretations would yield one acceptable, non-contradictory, and sensible interpretation. Part of the reason for this is that interpreters ask different kinds of questions about a painting because they have different interests in the painting and in what thoughts their investigations of the painting might yield.

Interpretation and Judgment: Controversial Art

A LL THE RESPONSES TO the work of René Magritte cited in chapter one were favorable. Those quoted respondents implied that they valued Magritte's work. They admired it, although they were never quoted saying so directly; their judgments were implicit and positive. In the case of paintings by Édouard Manet, however, viewers and commentators made judgments that were explicit and sometimes very negative. Some Parisians who first saw Manet's paintings stated that they were ineptly painted, vulgar, and even immoral. Indeed, the jurors of the Paris Salons, the official arbiters of artistic taste at the time, refused to hang them. Some of Manet's contemporaries, and most later historians, implicitly praised the work by devoting much thought and writing to it and then by including Manet's paintings in the canon of art history. Commentators and historians also made explicit positive judgments of Manet's work when they praised it for its contributions to stylistic changes and attitudes in art, most noticeably in its depiction of daily subject matter and the ordinary in life and in its push toward abstraction.

As mentioned previously, the activities of *describing, interpreting,* and *judging* are interdependent. These activities are intermingled and form a circle of meaning. How and what we describe is highly influenced by how we interpret and judge it. For example, I could say that the culture in which I live informs me that Manet's *A Bar at the Folies-Bergère* is important (judgment), and when I look at it I see a woman and a bar in front of a mirror (description), but the woman's reflection in the mirror does not make optical sense (interpretation), and therefore I think that Manet's is not a very good painting because it does not accurately portray what I know to be real and, at the minimum, paintings ought to be optically true (judgment). Or I could say, for

example, that I see colors on a surface (description) that delight me (judgment) and I wonder how this array of colors and splotches that form a place and people and things might inform me about what I am attracted to (an impulse to interpret). Or, as the jurors of the Salons may have thought, this painting is inaccurately (description) and ineptly (judgment) painted and does not deserve to be hung in the Salon or to be interpreted at all. This chapter examines further the interdependence of interpretation and judgment by looking at works of art that are controversial in the present day.

RELIGIOUSLY CONTROVERSIAL ART: *THE HOLY VIRGIN MARY* BY CHRIS OFILI

On Saturday, October 2, 1999, at the opening of an art exhibition at the Brooklyn Museum of Art in New York, protestors outside the Museum handed out "vomit bags" embossed with the sword and shield of the Catholic League, suggesting to visitors that the exhibition they were lined up to see was sickening. The afternoon before, supporters of the Museum and the exhibition staged a rally featuring celebrities and politicians who passionately defended the exhibition. The brouhaha quickly spread nationally and internationally through TV news and the press. The exhibition was called "Sensation: Young British Artists from the Saatchi Collection." It included the work of forty artists with around ninety paintings, sculptures, and installations, many of them large, displayed in two grand galleries in the Museum. These were recent works by avant-garde British artists, the best-known of whom was Damien Hirst. The works were selected from the personal collection of Charles Saatchi, an advertising executive in England and collector of contemporary art. The controversy centered on one picture in the exhibition, a painting made by Chris Ofili, called *The Holy Virgin Mary* (**Color Plate 6**). Central to the controversy was how the painting was interpreted.

• *Interpretation is central to controversy.*

The picture and the artist achieved instant notoriety when the mayor of New York, Rudolph Giuliani, condemned it, calling it "sick stuff." The Museum is partially funded by city tax dollars, and the mayor demanded that the Museum remove the painting from the exhibition. If the Museum did not take the painting down, or move the whole exhibition to a private exhibition space, he threatened to withhold the city's annual contribution to the Museum of $7.2 million (about a third of the Museum's operating budget), withhold a promised $20 million for building improvements, dismiss the Museum's board of directors, and reclaim the city-owned building.

When the Museum refused to capitulate to the mayor's demands, the city withheld the half-million-dollar October payment and sued to evict the Museum from its city-owned site. The Museum filed a lawsuit of its own, claiming its First Amendment rights had been violated by the freeze on its subsidy from the city. Eventually, a federal judge restored city funding to the Museum, ruling that Mayor Giuliani had vio-

57

lated the First Amendment. She wrote, "There is no federal constitutional issue more grave than the effort by government officials to censor works of expression and to threaten the vitality of a major cultural institution. . . ." The mayor reacted by saying the "judge is totally out of control"[1] and vowed to counter her decision with new legal moves, but both sides dropped their respective lawsuits in March. The show ran for three months, closing in January 2000 after more than 180,000 visitors had seen the exhibition.[2]

Although the mayor had not seen the painting, he said it represented "Catholic bashing" and "hate speech." What was so offensive to the mayor was that the painting included elephant dung, and he apparently believed, based on whatever he had been told, that people were "throwing elephant dung at a picture of the Virgin Mary." Cardinal John O'Connor, then head of the archdiocese of New York, joined the fray and in his weekly sermon from St. Patrick's Cathedral, asked Catholics to condemn the painting, saying, "I'm saddened by what appears to be an attack not only on our Blessed Mother . . . but on religion itself."[3]

The wall text accompanying the painting at the Museum listed the media of the painting as "paper collage, oil paint, glitter, polyester resin, map pins, elephant dung on linen." The collage elements in the painting include magazine pictures of women's bare buttocks, cut in shapes reminiscent of butterflies. They are small and float about the Virgin. The painting does not hang on the wall but leans against it. Two clumps of elephant dung beneath the painting on the floor function like two pedestals for the painting. One has the word *Virgin* and the other *Mary* spelled out with map pins that look like African beadwork. The painting is large, eight feet high by six feet wide. The overall surface of the painting is bright and glittery. (Because of the painting's shiny surface, it is difficult to obtain a good photographic reproduction of it.)

The artist's use of elephant dung was the element that the media latched onto in its reporting about the painting. The painting was referred to as "splattered with dung" (*Wall Street Journal*), "dung smeared" (*New York Post*), "dung encrusted" (Associated Press), "elephant-dung-ornamented" (*New York Times*) and was said to have used "a mixture of paint and elephant dung" (*Business Week*), "elephant doo-doo" (*Sarasota Herald*), and "imported pachyderm parcels" (*People*). The controversy gave rise to puns such as the front-page headline of "No Dung Deal" in the *New York Post,* September 29, 1999.

The artist was interviewed in England by a newspaper reporter and observed, "I think there's some bigger agenda here." Ofili seems astute in his observation, made from across the ocean, about politics in New York. Elizabeth Kolbert of the *New Yorker* referred to the mayor's outrage as "a piece of political theatre."[4] Cathleen McGuigan of *Newsweek* magazine identified some of the agenda at work: "The Mayor was looking to appeal to upstate voters in his New York Senate race, the Museum needed a hit show to put itself on the map and the city's other cultural institutions were looking for a way to show solidarity without giving Giuliani an excuse to cut off their city subsidies. And of course, there was Charles Saatchi . . . the Mayor's office charged that he

only stood to gain from the scandal, which will inevitably increase the value of his collection."[5]

Ofili also quickly and importantly noted that "the people who are attacking this painting are attacking their own interpretation, not mine." The artist did not provide an interpretation of the work, but he distanced himself from those who thought the work obscene and hateful toward religion. He revealed that he has a Roman Catholic upbringing and that he is a church-going Catholic. He is British-born with African ancestry. Both his parents were born in Lagos, Nigeria, and their first language is Yoruba. Ofili says he was very moved by the beauty of the African land when he studied and painted for eight weeks in Zimbabwe when he was twenty-four. Most of his works are vibrantly colored, employing multiple layers of dots, inspired by images in ancient caves in Zimbabwe. He rests his paintings on clumps of dung, saying, "It's a way of raising the paintings from the ground and giving them a feeling that they've come from the earth rather than simply being hung on a wall." About his use of dung as an element of his artistic media, he says, "There's something incredibly simple but incredibly basic about it. It attracts multiple meanings and interpretations."[6]

New York City's best-known black newspaper, the *Amsterdam News,* offered a counter-interpretation to the mayor's: "Ofili portrays Mary as a rather exciting Black with impressive eyes, a hint of breast upon which a piece of dung has been placed, signifying nourishment, the color of darkness, a broad nose and a sensuousness not generally assumed when one sees the Eurocentric version of Mother Mary. . . . We believe that his [Giuliani's] sensibilities were shocked by the belief that Mother Mary happened to be some color other than the color that he has accepted for everything that is good and pure and right and white."[7]

Although most commentators attended to the elephant dung, some also addressed the artist's use of magazine cutouts of female buttocks and genitalia. His oil paintings often include pictures cut from magazines as well as comic-book-like characters. Michael Kimmelman, art critic for the *New York Times,* sees the cutouts in *The Holy Virgin Mary* as allusions to naked putti—winged, chubby, cute, naked, angelic children with round bottoms and rosy faces—in Old Master paintings. Kimmelman reports Ofili recounting that, in his own childhood, he was struck by all the paintings of the Virgin Mary with an exposed breast that were sexually charged. Kimmelman finds this observation by Ofili to be "perfectly fair," and recalls paintings of religious themes that have offended throughout history. Michelangelo offended the church with his *Last Judgment.* Paolo Veronese's *The Last Supper* includes black pages, turbaned Muslims, a dwarf, and two soldiers in German dress, all of whom offended church powers at the time. Veronese was called before the Inquisition in 1573 and subsequently changed the name of the painting to *Feast in the House of Levi.*[8]

Lynn MacRitchie, a London-based art critic writing for an American art journal, thinks Ofili consciously brings Christian iconography into proximity with contemporary profanity in everyday culture. MacRitchie wrote, "As a painter and as a Roman Catholic, Ofili has long been familiar with the image of the Virgin as both an artistic

and a religious icon. As a young black male steeped in contemporary culture, he found it perfectly sensible to rework Mary as a black woman and to place her in juxtaposition with the contemporary discourse of pornography. In doing so, the artist chose to make explicit the sexual undertones which cannot be separated from any image of a beautiful young woman suckling her child."[9]

Based on the controversy over *The Holy Virgin Mary,* Stephen Dubin, an art historian, wrote an account of the events and took occasion to generalize about cases of artistic censorship, inventing a character he calls *Homo censorious* to stand in for all humans who would censor what other human beings might otherwise see. A basic assumption, according to Dubin, is that "*Homo censorious* insists on a single interpretation of a work of art." To provide an example, Dubin quotes a letter writer to the New York *Daily News* about *The Holy Virgin Mary:* "I know what the Virgin Mary looks like, and that is nowhere near a resemblance." Dubin explains that such people are certain that they know what some works of art mean and refuse to consider any alternative interpretations of them. They fail to recognize the principle that "the most compelling art typically generates multiple interpretations."

Dubin asserts that "*Homo censorious* takes a few elements out of context—specific words, titles, part of a design—and treats them as if they embody the entire work of art." He argues that "condemning works of art on the basis of isolated components is misleading and unfair. Art cannot be judged by focusing only on a fragment: the full meaning of a disputed piece can only be gleaned by considering the work in its entirety, relating it to the rest of the artist's output and considering the context provided by the work of his or her contemporaries." The dung in Ofili's work is only a part of the painting, and those who fault the painting for its use of dung only see one interpretation for the dung, that is, that the artist is committing the sin of sacrilege. Ofili, however, uses elephant dung in many of his paintings, including paintings he makes about secular culture. He is not singling out religious subjects with the medium. One of Ofili's other paintings in the "Sensation" show, for example, is *Afrodizzia,* a work that pays tribute to Cassius Clay, Miles Davis, Diana Ross, and other black icons, and it too utilizes elephant dung in a manner very similar to its use in *The Holy Virgin Mary.*[10]

Dubin offers another characteristic: "*Homo censorious* assumes a paternalistic attitude toward the public," and explains that *Homo censorious* "is both self-righteous and adamant about what he believes, and assumes that others are incapable of deciding for themselves what is good and bad, right and wrong." The paternalistic attitude is based on beliefs that there is a natural as well as cultural hierarchy among living things and that the male of the human species is on top and ought to exert control, because he knows best what is good for the rest. Sometimes *Homo censorious* claims to be trying to protect children, but he usually extends his surveillance to adults.

A final characteristic of Dubin's *Homo censorious* is that he or she "overestimates the power of exposure to different forms of cultural expression and assumes the effects to be immediate and irreversible." *Homo censorious* fears that many aspects of contemporary culture can only contaminate minds and believes that if you "eliminate

what you perceive to be pernicious, you've performed a momentous deed."[11] In other words, censors have rescuer mentalities, believing they need to jump in and save people from what will harm them if they see it. Neither the mayor nor the cardinal who would have had Ofili's painting removed from the exhibition gave extended reasons for their decisions, only revealing that they thought the work to be sacrilegious, anti-religious, or offensive. The cardinal and the mayor did not explain what dire things they thought would happen to people who looked at the painting. Apparently they assumed, as Dubin says, that something pernicious, immediate, and irreversible would occur to anyone who saw *The Holy Virgin Mary*. The mayor and the cardinal failed to explain, however, what those horrible consequences would be, and they did not provide any empirical evidence or rational arguments to support that what they feared would actually come about.

> • *How one judges a work will likely affect how one describes it.*

Verbal descriptions figure very prominently in the critical discourse surrounding *The Holy Virgin Mary*. Those who are opposed to the work do not describe it, but typify it with derogatory terms. For example, Roger Kimball, art critic for the *Wall Street Journal* and managing editor of the *New Criterion,* a scholarly journal of art criticism, refers to the painting as "splattered with elephant dung."[12] For a professional art critic to refer to Ofili's use of dung in *The Holy Virgin Mary* as "splattered" is either an irresponsible lack of research—that is, he did not observe the painting he described—or an act of intentionally cynical and misinformative writing to inflame his readers, most of whom will never see the actual painting nor even a good reproduction of it. The *Wall Street Journal* published no reproduction to accompany Kimball's article.

Michael Kimmelman, the art critic for the *New York Times,* was ambivalent about the painting and the controversy, pointing out both positive and negative effects, and offered this introductory description of Ofili's works for his readers: "He has several large pictures in the show, all of them incorporating elephant dung, one way or another. They're basically abstract, brightly colored, meticulously made works of swirling shapes and beautifully stippled surfaces, throwbacks to the 60's psychedelic art, with occasional bits of text woven into them, conveying a lightness of spirit."[13] MacRitchie, a critic who is positive about the artist's work, wrote this introductory description: "Chris Ofili's paintings are joyous things to behold. Dotted with bright pastel colors, layered with shiny varnish, sprinkled with glitter, their surfaces seem to dance and dazzle and shimmer and shine. Some even glow in the dark. Complex, decorative and mostly figurative, they are populated with an ever-increasing cast of characters, both real and imaginary. And, oh yes, they are often presented leaning against rather than hanging on a wall, supported on balls of varnished elephant dung, the way that overstuffed armchairs used to rest on carved wood spheres."[14]

Thus, Kimball, Kimmelman, and MacRitchie have different judgments of the painting, and their descriptions of it are influenced by their judgments. They also use lan-

61

guage persuasively to sway their readers' judgments of the painting. Readers can check the accuracy of critical descriptions by comparing critics' words to artists' pictures.

> • *Descriptions are accurate or inaccurate: readers can check the accuracy of critical descriptions by comparing critics' words to artists' works.*

A letter writer to *Newsweek* underscores the importance of seeing works that are the objects of judgments when she thanked the magazine for printing a reproduction of the painting, saying, "It's too easy to condemn something that you've never seen. I was prepared to be offended and outraged after hearing about his dung-decorated rendering of Mary. To my surprise, I think it's a terrific work." Seeing a reproduction of the work allowed her to form her own interpretation of it: "Yes, it's different. But this very contemporary rendering tells me that if Mary were a young woman today, she would be bombarded and surrounded by sexual images at every turn: television programs and commercials, movies, pop-music lyrics and magazine ads, to name a few. The title of the work, *The Holy Virgin Mary*, says it all, that a contemporary Mary would reject the barrage of temptations, remain a virgin and do God's will."[15]

> • *Politics affect interpretations.*

The mayor's position on the painting and on the Museum's exhibition of it had severe economic, as well as political, sanctions attached to it, and other museum directors were likely cautious in their defense of freedom of expression and exhibition, so as not to incur sanctions from the mayor on their own institutions. It is likely that politics affected both interpretations and judgments of *The Holy Virgin Mary* and the right of a public museum to display it.

Philippe de Montebello, director of the New York Metropolitan Museum of Art, wrote an op-ed piece in the *New York Times* that praised Giuliani for his "astute critical acumen" and his "aesthetic sensibilities," while expressing regret for the mayor's effort at censorship. De Montebello's criticism of Ofili's and the other artists' work in the exhibition was harsh: "artists who deserve to remain obscure or be forgotten."[16] Lee Rosenbaum, a critic writing for *Art in America,* noted de Montebello's judgment while pointing out that the director's own museum had just purchased for its permanent collection a set of Ofili etchings.[17]

More than a week after the worst of the storm had passed, the director of the Museum of Modern Art came to the defense of the Brooklyn Museum with a short and mild op-ed piece in the *New York Times*. He argued that "to work with contemporary art is to understand that new ideas require a great deal of patience and openness. Art is a language, a means of communicating deeply held ideas and beliefs, and to dismiss that which we do not like because we do not understand it makes no more sense than ignoring German or Chinese literature because we cannot read German or Chinese."[18]

What is particularly notable about this case of Ofili's painting in the "Sensation" exhibition is how many commented on the painting, very passionately, without having seen it, including the mayor. People, for the most part, were commenting on the verbal observations of reporters and commentators and others who also had not seen the painting. People were either accepting the descriptions and interpretations of others or forming their own based on others' words, and then, in turn, they were making very forceful judgments about the painting. Had the contributors to the furor over the painting first gone to see the painting in the Museum, there may have been no furor at all. No one who saw the painting in person could accurately or honestly state that it was smeared, splattered, or splashed with dung. The dung that the artist used was dried, heavily shellacked, and, in a small clump, attached to the painting and, in two larger clumps with beadwork, used as short pedestals. Seeing the actual painting without being told what the material was, one would have been hard pressed to figure out that the material was dung.

Once one knew the material to be dung, one's interpretation of its meaning became paramount. Many of those who heard "dung" took immediate offense, forming an interpretation that imputed to the artist sacrilegious disrespect of the Virgin Mary. The wall text, however, prominently displayed right next to the painting, gave a reasonable account of the painting and a different interpretation of its use of dung as a respectful symbol of nourishment in an African context:

63

> From a distance, this painting looks as glittering and stylized as a traditional religious icon. But up close, we see some unexpected attributes. The Virgin is not surrounded by putti or angels, but by photos of buttocks, oddly cut out so as to resemble angel wings. This Virgin is black, not white, with African, not European, features. And her exposed breast, traditional symbol of divine generosity, is made of the manure that nourishes African soil.

Most of the commentators in the media did not read this text or chose to ignore it in their reporting on the painting and the events surrounding it. Dung that was falsely said to be "splattered" was more newsworthy than "manure that nourishes."

The Brooklyn Museum of Art unwittingly set up its audience with misinterpretive expectations by its own marketing of the exhibition, with a tongue-in-cheek "health warning" that was meant to be playful advertising:

> HEALTH WARNING
> The contents of this exhibition may cause shock, vomiting, confusion, panic, euphoria, and anxiety. If you suffer from high blood pressure, a nervous disorder, or palpitations, you should consult your doctor before viewing the exhibition.

This attention-getting publicity device of the Museum's, however, provided a general interpretive mindset for all the works in the exhibition, including Ofili's. In effect, the Museum prompted visitors before they even entered the exhibition to interpret *The*

Holy Virgin Mary as sensational, shocking, and sickening. When visitors stood next to Ofili's painting of the Virgin, however, the Museum, with its wall signage, was sending the opposite message, telling the visitors to calm down, that the painting merely had "some unexpected attributes."

• *All works of art are candidates for controversy.*

Works of art, in themselves, are not controversial. Works of art might be difficult, challenging, or unconventional, or possess unexpected attributes, but people make them controversial. To make an artwork controversial, someone interprets the work to mean a certain thing, then asserts that the artwork will be harmful to those who see it, and gets public support for their position. Without public support and publicity, there may be disagreement, but there is no public controversy. When talking and writing about the artwork, those who believe the work to be harmful use language to alarm others. For example, they seem to be describing the work, but they are actually choosing words that encourage outrage against the artwork and anger toward the artist who made it and toward those who would show it. Any work of art can be made controversial. There are works of art in "Sensation" and in New York City that might be even better candidates for controversy than Chris Ofili's painting, but Mayor Giuliani chose *The Holy Virgin Mary*.

SEXUALLY CONTROVERSIAL ART: PAINTINGS BY ERIC FISCHL

In 1997, Robert Hughes, the art critic for *Time* magazine, made a television series on American art called "American Visions: The Epic History of Art in America, 1997," which was shown by the British Broadcasting Corporation in Great Britain and by the Public Broadcasting System (PBS) in the United States. Eric Fischl is one of the contemporary American painters whom Hughes features in the series. When PBS broadcast the series, however, they removed two of Fischl's paintings from it. The producer of the American version of the series explained that he omitted the two paintings "in light of American taste and notions of decency."[19] The two paintings are *Sleep Walker,* 1979, and *Birthday Boy,* 1983 (**Color Plate 7**). *Sleepwalker* features an adolescent boy masturbating in a wading pool, and *Birthday Boy* shows an open-crotched woman with a young boy on a bed.

Jack Flam provides an overview of Fischl's work that he wrote for readers of the *Wall Street Journal,* an audience who might be interested in art but that is for the most part not professionally engaged in the art world. Flam writes, "Mr. Fischl remains a very controversial painter. Critical opinions about his work run from enthusiastic praise to outright disdain. To some, he is a ruthlessly honest realist; to others, he is a cheap sensationalist." Flam goes on to explain that "the controversy centers almost exclusively on the content of Mr. Fischl's work rather than its form. Much of his straightforwardly realistic, sometimes flat-footed imagery is overtly sexual. And it is

3-1 *Sleep Walker,* 1979. Eric Fischl (1948-). Oil on canvas, 69 x 105 inches. Courtesy of the artist and Mary Boone Gallery, NY.

also fraught with suggestions of alcoholism, voyeurism, onanism, homosexuality, bestiality and incest—all set smack in the middle of suburban middle-class America." Flam thinks that Fischl's work has "a distinctly unpleasant edge" and that "if you have not seen Mr. Fischl's paintings, all of this may sound perfectly awful: vulgar, obvious, tawdry. But in fact, although Mr. Fischl's paintings are sometimes tawdry, they are not particularly vulgar and not at all obvious." He thinks that the paintings' complexity lies in their moral and narrative ambiguity.

They are narratively ambiguous because their stories are not clear. According to Flam, the paintings are like stills from films: "like movie stills, they present fragments of suspended narrative that pique our curiosity about what may have gone on before or what will happen later. But while a movie still is part of an actual narrative, which can be known by going to see the film, Mr. Fischl's narratives are permanently unknowable and exist only by implication. The mysteries are evoked but not resolved; it is the viewer who must fill in the missing elements." Flam finds the paintings to be morally ambiguous because "despite topical and often sensational subject matter, Mr. Fischl's paintings are not mere acts of obvious social criticism. At their best, they give us glimpses into parts of ourselves where we might prefer not to look. They are not pleasant, but their images stick in your mind long after you have walked away from them."[20]

The moral ambiguity surrounding Fischl's paintings can be stated clearly in the question, Does Fischl promote what he depicts? For some viewers, the paintings promote the acts that they show: that is, some viewers think that the paintings encourage incest and other acts that the viewers believe to be reprehensible. For other viewers, however, Fischl's paintings do not promote these acts, but they do "give us glimpses into parts of ourselves where we might prefer not to look."

When invited to write about *any* work of contemporary art of his choosing, Stephen Wright, a contemporary American novelist, chose a Fischl painting. He wrote that when he first saw Fischl's work, his response was "immediate and visceral. Here was an artist tunneling through the complexities of a genuine, urgent vision, operating as much from his gut as his head, and actually saying something, it seemed to me, that needed to be said."[21]

What Fischl's paintings might be saying is a matter of interpretation. Whether it should be said is a matter of judgment. Critics generally agree on what Fischl's paintings "say." Here is a representative sampling of some critics' descriptions and interpretations of Fischl's paintings.

Art critic Robert Hughes sees the paintings as "pure Hollywood: an art of hand-painted, keyed-up film stills, fragments of psychic plots tell of the pangs of parental estrangement, adolescent rebellion, and emptiness in the suburbs. . . . With rueful scorn, his narratives fix on the white middle-class world from which he came. They are relentlessly adult-hating: a sour discontinuous serial, packed with tension, farce, and erotic misery. Fischl country is suburban Long Island. It smells of unwashed dog, barbecue lighter fluid, and sperm. It is permeated with voyeurism and resentful tumescence."[22]

Erika Billeter, a Scandinavian art critic, thinks that Fischl "paints situations in life which society has declared taboo, which it does not talk about, even suppresses the thought of. He brings archetypal material to the light of day, which is always there but is pushed aside by society because it does not admit its existence" (as in *Slumber Party,* **Color Plate 8**). Billeter identifies Fischl's major theme as "the soft decline of an unloved human society." She admits to "an erotic and psychic tension which electrifies the person looking at the pictures" and writes that the paintings "unveil the thoughts which produce a sort of guilty feeling in the observer."[23] A fellow Scandinavian critic, Oystein Hjort, says this about *Sleep Walker,* one of the paintings omitted from the American version of Hughes's television series: "Two empty garden chairs stand as silent witnesses. They must represent parental authority; the pubescent discovery of sexuality becomes possible in their absence, and perhaps is also a necessity; self-satisfaction substitutes an unfulfilled need for tenderness and the lack of contact with those parents who are truly conspicuous in their absence in more than one sense."[24]

Art critic Richard Field writes that Fischl's paintings show "the failure of American culture to deal seriously with sexuality, desire, parenting, hostility and death—that we are a citizenry that acquires, plays, distracts and makes material demands upon life but can not pause to contemplate the tragedies of the human condition itself."[25] Critic Elizabeth Armstrong acknowledges that Fischl's work shocks "with pictures that fo-

cus on alcoholism, sexual desire, incest, and the dysfunction of the American family." She goes on to write, "few visual artists living today have explored such disturbing subjects in their work, and fewer still have done so without resorting to caricature or satire." She writes that the paintings dig beneath the conventional veneer of the American middle and upper-middle classes. She concludes, "Rarely have artists been willing to represent their own milieu with such insight and honesty."[26]

In an introduction to an interview of the artist, A. M. Holmes acknowledges "the emotional side where you go in and explore feelings and relationships and memories. Often times you find things you're not ready for and you can't bear that this is in front of you." She explains that "it was the timing, the deft nearly comic timing that first drew me to the work of Eric Fischl. It was the thing about to happen, the act implied but not illustrated, the menacing relations between family members that made Eric Fischl's paintings disturbing. It was the way in which he forced the viewer to fill in the blanks, to answer the question: What is exactly going on here? In his early work invariably the answer was sex; first sex, illicit sex, weird sex, seeing or touching something you shouldn't, rubbing up against the taboos of familial flesh, interracial relations, etc.; the kind of thing you've considered, but aren't necessarily willing to admit. Yet, in order to read the paintings, one had to participate, to admit at least to oneself that yes, we have noticed. It was that, exactly that, the way Fischl subtly and subversively required the viewers to call upon their own experiences, fantasies, nightmares, that impressed me most." She thinks that Fischl is "a compulsively honest painter, depicting the very parts of ourselves we work so hard to keep hidden."[27]

Fischl agrees with the critic's appraisal of his honesty. In her interview with him, Holmes says, "There seems to be a determination to be completely honest. I don't want to see this, but if I don't show it to you I'll be lying." Fischl responds, "My imagination is not about flights of fantasy. It's really a process of discovering who I am, so it's about peeling away and peeling away. It's about meeting something essential. The body poses the biggest question for me. It's a question itself. It's all about needs and desires and union and oneness and aloneness. It is about the edges and boundaries of the flesh, the needs of the flesh. I'm trying to find out what my relationship to the body is, the comfort, the discomfort, the appropriate and the inappropriate." The interviewer comments that Fischl's paintings "show you what you don't really want to see" and Fischl reveals motivations from his childhood and his alcoholic mother. "Reality became a passion of mine. I willfully chose to be painfully honest." He explains that denial is built into alcoholic families and that as a child and adolescent he could not acknowledge that alcoholism was present in his family. He provides us insights into how the form of his paintings adds to their meaning when he explains that his early paintings, in expressing the emotional discomfort of a child, looked up at the adult world, literally, from the point of view of a child—with tilted planes and with a scale larger than life.[28]

Some critics judge the work of Fischl very positively. Sidney Tillim, an art critic, went to see a 1990s show of Fischl's work three times and then wrote in *Art in America* that it is "the first great exhibition of postmodern figurative art."[29] Others do not

want to see the work at all. Although his paintings were shown on television in Great Britain, an American television producer deemed two of them unfit for public broadcast in the United States. Why is it that some do not want to see what Fischl shows?

The comments by art critics quoted in this chapter clearly interpret the paintings to be critical of what they show. Some viewers, however, fear that the paintings will encourage the behavior shown in the paintings. They seem to fear that the paintings will actually promote alcoholism and the dysfunction to life that it causes. Objecting viewers seem unable or unwilling to interpret the paintings to be about anything but promotion of promiscuity and familial dysfunction. Perhaps objecting viewers do not know of the life situations which Fischl portrays; more likely they do know of them, firsthand or through the hearing of tales, but do not want to admit such knowledge into their consciousness. They judge the content of Fischl's paintings to be inappropriate for art and, thus, inappropriate for inclusion in a television series about art. They want neither to see Fischl's paintings nor to talk about them. Their judgments, if acted upon, would disallow certain pictures from entering social discourse and prevent subsequent interpretations of the meanings of those pictures and considerations of their possible social ramifications.

68

IDEOLOGICALLY CONTROVERSIAL ART: ILLUSTRATIONS BY NORMAN ROCKWELL

While Eric Fischl is sometimes judged negatively for exploring the dark side of social reality, an earlier American painter, Norman Rockwell, is sometimes judged negatively for ignoring it. In prior decades Rockwell's work was hardly interpreted at all, because it was judged to be so obvious and transparent that it needed no interpretation; now, however, it is being judged positively and interpreted with seriousness. Because Rockwell's work was for so long denied interpretive thought, because it was judged to have too little to offer when it was interpreted, it provides a striking example of how interpretation and judgment are interdependent.

Commentators have observed that no other American artist, with the exception of Walt Disney, has been so revered by the majority of the American people and so ignored by art critics and historians as Norman Rockwell. Rockwell (1894–1978) took his first job as an illustrator at eighteen, published his first *Saturday Evening Post* cover at twenty-two, and was a nationally known figure by the age of thirty. During his career, he made more than four thousand images, including 800 magazine covers, 322 of which were for the *Post,* and ad campaigns for more than a hundred and fifty companies. During World War II, his "Four Freedoms," 1943 (*Freedom to Worship, Freedom from Want, Freedom from War, Freedom of Speech*), were seen by over twenty-five million people. He illustrated Boy Scout calendars for fifty years and statisticians estimate that his calendars received 1 billion, 600 million viewings on any given day.[30]

Nonetheless, for several generations in the last half of the twentieth century, Norman Rockwell was the butt of art world jokes. Arthur Danto, aesthetician and critic,

in 1986 acknowledged "the silent consensus that Norman Rockwell is no great shakes as an artist."[31] As the twenty-first century began, however, Rockwell was the center of art world attention, with a large retrospective exhibition of his work traveling around the country, with a final stop in 2002 at the Solomon R. Guggenheim Museum in New York, a prestigious venue for recent art.

Ned Rifkin, the curator of the Rockwell traveling exhibition, concedes negative criticism of Rockwell's work, explaining that "much of the disdain for Rockwell's art springs from his consistent sentimentality about American values and the belief of his critics in the modernist canon of refinement and advancement of abstraction, the progressive invention of style, and the idea that concept should supersede subject matter and even content."[32]

Neil Harris, a contributor to the Rockwell exhibition catalogue, complains that Rockwell rarely acknowledged urban America, that he captured "only one of many Americas" and the one he captured lacked complication, provided sugar coating, "simplified unmercifully," "reassured inappropriately," and is so idealized that it is "patently false."[33]

Theodore Wolff, former critic for the *Christian Science Monitor,* wrote in 1980, "There can be no doubt that Rockwell's production was uneven, that most of it was trivial, even, at times, embarrassingly hackneyed. He had a difficult time avoiding the obvious and overly sentimental: little boys were invariably freckled and gawky, had big ears, and loved baseball; little old ladies were kindly and loved nothing so much as to give cookies to children and to beam at evidence of young love. And everyone was God-fearing, patriotic, hardworking, and respectful of motherhood, apple pie, and the sanctity of marriage."[34]

In reflecting on the artist's oeuvre, Danto wrote that Rockwell's "scenes, for all their attention to detail, look staged and artificial, and what they display is perhaps what his fans hoped was the life of America but knew, as he did, was too benign, too happy and finally too cute to be true . . . a landscape of amiable codgers, nurturing moms, adorable dogs, callow soldiers with hearts of gold." Danto concludes that Rockwell "could not resist the extra effort to amuse, to get the extra laugh—the freckle, the missing tooth, the outdoor toilet, the torn pants seat, the spanked bottom, the hobo, the fat boy, the foxy grandpa, the mugging workman, the spilled milk, anything to flatter his viewers into a state of indulgent superiority."[35]

Daniel Belgrad, writing in *Art in America* in 2000, summarizes the negative criticism Rockwell's work has received: "Rockwell is accused of working with outmoded and restrictive stereotypes that offer us only very limited ways of engaging our complex social reality. The darker side of this reality—issues like divorce and loneliness, poverty, and environmental degradation—Rockwell simply ignores." Further, "Rockwell's art is said to be neither subtle nor psychologically deep."[36]

Other art critics and commentators, however, are much more accepting of Rockwell's vision of America. Peter Plagens, art critic for *Newsweek* magazine, acknowledges that Rockwell painted "warm and fuzzy stereotypes" but points out that he also

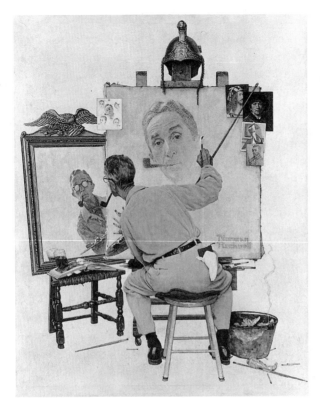

3-2 *Triple Self Portrait,* 1960. Norman Rockwell (1894-1978). Oil on canvas. 44½ x 34¾ inches. Collection of The Norman Rockwell Museum, Norman Rockwell Art Collection Trust. Printed by permission of the Norman Rockwell Family Agency. © 2002 the Norman Rockwell Family Entities.

provided "delicious detail" in representing "heartwarming moments in everyday life."[37] In the exhibition catalogue, Laurie Moffatt praises Rockwell's images because they "convey our human shortcomings as well as our national ideals of freedom, democracy, equality, tolerance, and common decency in ways that anybody could understand." She also writes, "Norman Rockwell reminds us of our humor and humility, our happiness and humanity. Those are not bad qualities to embrace."[38] In defense against arguments that Rockwell's work lacks profundity, Judy Larson and Maureen Hennessey, who also contributed essays to the exhibition catalogue, write that "to be profound, however, is also to be wise, heartfelt, acute, and intense—and Rockwell was all of these." They also argue that Rockwell never claimed to portray reality and quote him saying that he depicted "life as I would like it to be."[39]

Regarding interpretations of his pictures, Rockwell's son Peter says that his father "believed that the picture and the observer should encounter each other directly without interference from words or interpretation."[40] Of all of his father's paintings, Peter

Rockwell thought *Triple Self-Portrait,* 1960, best exemplified this characteristic. Nevertheless, critics and commentators do offer interpretations of his pictures. Larson and Hennessey think that Rockwell's work is dominated by four themes. The first theme is his fondness for celebrating the ordinary, the elusive commonplace moments by means of which he elevated mundane experiences to levels of great significance. Second, Rockwell shaped a sense for the past while America was moving forward with a twentieth-century agenda. Rockwell embraced "nostalgia—a feeling of comfort in the longing for times past, where the accuracy of memory is subordinated to the mythologizing of history." Third, he made the new seem familiar in a time of rapid social change with new industrial and technological advances, new political and economic relationships, and shifting gender and race relations. Fourth, he honored the American spirit, especially in times of crisis, with his patriotism and unquestioned allegiance to the United States, and promoted "American values such as industriousness, fair play, and decency."[41]

The most appreciative among contemporary art critics of the work of Norman Rockwell seems to be Dave Hickey, who writes in the exhibition catalogue, "Rockwell was the last, best practitioner of a tradition of social painting that began in the seventeenth century. In the history of America's democracy and popular culture, he was something brand new: the first visual artist who aspired to charm us all, and for more than half a century managed to do it. . . . To put it simply, Norman Rockwell invented Democratic History Painting—an artistic practice based on an informing vision of history as a complex, ongoing field of events that occurs at eye level—of history conceived and portrayed as the cumulative actions of millions of ordinary human beings, living in historical time, growing up and growing old."[42]

To support his admiration of Rockwell's work, Hickey offers an interpretive and positive analysis of the artist's picture *After the Prom,* 1957 (**Color Plate 9**). Hickey gives this particular painting credit as "a full-fledged, intricately constructed, deeply knowledgeable work that recruits the total resources of European narrative picture-making to tell the tiny tale of agape he has chosen to portray." Hickey describes the painting in careful detail, telling us that the setting is a 1930s-era soda fountain, bathed in golden light, and the people are dressed in 1950s-era clothing. There are four characters: the young man and his date, the soda jerk, and a customer at the counter wearing a tattered bomber jacket and air force cap. Hickey identifies the customer as a veteran of World War II and thinks the soda jerk is the older brother of the young man because they have similar noses, chins, and eyebrows. The young man looks proudly at the soda jerk as he leans over to sniff the young woman's gardenia. The customer glances over and smiles.

Hickey observes that the composition of the picture welcomes us. The picture plane places us inside the store but not up at the counter: we are part of the society but not part of the community. "The clustered burst of white in the center of Rockwell's painting, created by the young woman's dress, the young man's jacket, and the soda jerk's hat and shirt, constitutes *our gardenia;* we stand in the same relationship to

71

that white blossom of tactile paint as the soda jerk does to the young woman's corsage."[43] Hickey also tells us that the soda jerk is our surrogate: he inhales the fragrance of the flower which is the symbol of love. He visibly responds. The other figures respond to the soda jerk's response and to one another and we respond to the totality of their responses. We join the many who have seen this picture on their weekly issue of the *Saturday Evening Post*.

Hickey does not confuse the subject matter of the painting—a scene after the prom—with the painting's meaning. He argues that the painting is not about "the innocent relationship between two young people"; rather, it is about "the generosity of the characters' responses, and of our own." He explains that in the 1950s it was the parents who were rebelling against their children. The parents had endured the Great Depression and fought in World War II: they saw their children as spoiled. In the painting, the veteran's response to the children counters the attitude of their disapproving parents. According to Hickey, the veteran's smile says, "This is what I was fighting for—this is the true consequence of that great historical cataclysm—this moment with the kids and the gardenia corsage." Hickey interprets Rockwell's work to be about the promise of the young rather than the wisdom of their elders. He judges *After the Prom* to be "one of the most complex, achieved emblems of agape, tolerance, and youthful promise ever painted."[44]

Hickey also attempts to correct what he thinks are *mis*interpretations of Rockwell's work. Although Rockwell is commonly held up as a "conservative icon," Hickey argues that traditional values were never Rockwell's true subject. Hickey cites *Saying Grace,* a painting that appeared on a *Post* cover in 1951, as an example of a Rockwell picture that Hickey thinks is widely misinterpreted. The painting shows a grandmother and her grandson praying quietly with heads bowed, before a meal, in a crowded restaurant with many onlookers. The painting is often interpreted as a celebration of traditional "family values" of obedience to elders, adherence to established religion, and respect for tradition. Hickey argues, however, that the painting is not so much about the grandmother praying as it is about the onlookers who tolerate the different values of the grandmother. According to Hickey, it is the onlookers in the painting (and we as surrogate viewers), who are being celebrated, "because in a democracy where everyone is different and anything can happen, tolerance is the single, overriding social virtue."[45]

Although Hickey praises Rockwell as a heroic defender of true democracy and attempts to convince his readers and the art world that *After the Prom* is a masterpiece and ought to be added to the canon of Western art, a fellow critic, writing in the same catalogue, distributes her praise (and blame) more broadly than to Rockwell himself. Rather than focusing on the individual genius of the artist, Anne Knutson places Rockwell's paintings and their popularity within the context of the *Saturday Evening Post*. She argues that part of the popularity of Rockwell's images is due to how they were distributed and received and that Rockwell's ideas were heavily shaped by the editorial policy of George Horace Lorimer, the *Post*'s first permanent editor.

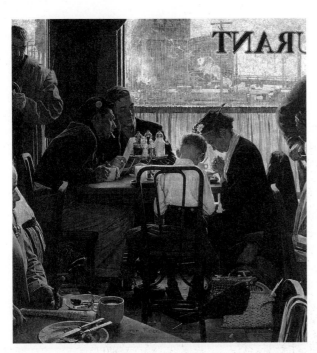

3-3 *Saying Grace,* 1951. Norman Rockwell (1894-1978). Oil on canvas, 42 x 40 inches. Photo © The Curtis Publishing Company. Printed by permission of the Norman Rockwell Family Agency. © 2002 the Norman Rockwell Family Entities.

Knutson reminds us that every week at approximately the same time, millions of households across the country received the *Saturday Evening Post* and subsequently read it in their living rooms, kitchens, bathrooms, bedrooms, and in their doctors' offices, barbershops, and dentists' waiting rooms. Americans read it while seated in their favorite chairs, surrounded by personal belongings, in the company of people with whom they were comfortable. This casual and shifting viewing context, within the home and in the neighborhood, Knutson argues, profoundly influenced understandings of Rockwell and of his paintings which graced the magazine's covers. Additionally, the *Post* was tremendously popular and enjoyed a public influence unrivaled by movies, radios, or competing magazines. According to Knutson, the unparalleled dominance of the *Post* as one of the first truly mass-market periodicals in the United States gave it an unusually powerful opportunity to shape the beliefs and attitudes of Americans: "Not even mass-media giants of our own time enjoy a comparable dominance."[46]

As editor, Lorimer developed and adhered to formulas for fiction, articles, editorials, advertisements, and illustrations. Knutson quotes another scholar studying the *Post* and its influence, Jan Cohn, who writes that "to read the *Post* was to become American, to participate in the American experience. Rockwell's covers became the visual expression of Lorimer's ideas." According to Knutson, informed by Cohn, the *Post* "was a major source of political, social, and economic information about the United States and the

world. The articles, fiction, illustrations, and advertisements functioned as how-to guides for living in twentieth-century America: they taught readers how to make sense of the vast and rapid changes in their new century; they explained how modern consumers should live and work in a society reshaped by technological advances and mass communication." The magazine also provided the latest information on fashion, advised which washing machine or television set to buy, educated housewives on the best way to care for their homes and families, and provided business advice to men, especially promoting the self-made man (see Color Plate 10, *New Television Set*). In soothing, clarifying prose, the *Post* explained complicated new technology, kept its readers informed about international and domestic politics and sports, and provided fantasies through serialized stories of romance, adventure, and history.[47]

Knutson stresses the significance of the magazine's influence on intellectual and emotional life in the United States, as well as the editor's influence on the magazine and on Rockwell's covers made for it. Knutson writes, "The *Post* celebrated traditional, old-fashioned values such as hard work, thrift, and common sense; it argued that these virtues were crucial to success in a twentieth-century consumer society." Moreover, Lorimer "approved every article, short story, editorial, and illustration before it went to press, and had a great deal of control over Rockwell's *Post* images." Lorimer's criterion was clear and decisive: "'If it doesn't strike me immediately,' Lorimer used to say to Rockwell, 'I don't want it. And neither does the public. They won't spend an hour figuring it out. It's got to *hit* them.'" Rockwell's *Post* covers were the result of a continual process of negotiation between the artist and the editor. "Like the stories in the *Post*, Rockwell's pictures wed the familiar and traditional to the unfamiliar and contemporary, creating reassuring visual narratives about change."[48]

While Hickey cites *After the Prom* as a Rockwell painting that exemplifies his interpretation and evaluation of Rockwell's work, Knutson points to *New Television Antenna*, 1949, and *Girl at Mirror*, 1954, to illustrate her interpretations. *New Television Antenna* was painted during the peak year of new television purchases, 1949, when a hundred thousand sets were sold in one week. Knutson notes that Rockwell uses humor and introduces the new technology into "something worn, weary, and familiar, blunting the newness of technology" by selecting timeworn architecture, including broken millwork, holes in the siding, missing bricks in the chimney, and the wartime Red Cross symbol in the window. She also observes that Rockwell uses the familiar pyramidal composition of traditional religious paintings, placing the television antenna, rather than a cross, at the top of the composition. Thus, Rockwell invests the television with a sense of tradition. She also notes "Rockwell's witty observation that mass communication was usurping the power of religion in twentieth-century American culture—the antenna towers over the church spire in the bright background of the picture."[49]

Knutson interprets *Girl at Mirror* as Rockwell's exploration of makeup as the most visible sign in the 1950s of a girl's passage into womanhood. The girl holds a photograph of Jane Russell, the movie star, in her lap and embraces new standards of beauty offered by Hollywood and the cosmetic industry. Rockwell, however, again smoothes

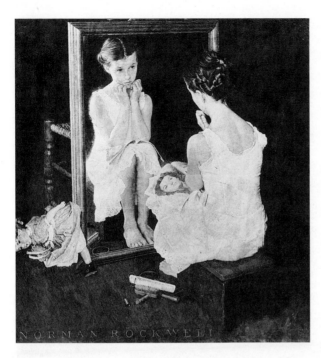

3-4 *Girl at Mirror,* 1954. Norman Rockwell (1894-1978). Oil on canvas, 31½ x 29½ inches. Collection of The Norman Rockwell Museum, Norman Rockwell Art Collection Trust. Printed by permission of the Norman Rockwell Family Agency. © 2002 the Norman Rockwell Family Entities.

the transition from the old to the new with traditional signifiers: the girl's modest, ruffled, lacy slip and her antique doll. These details, writes Knutson, will bring the girl and us safely into the new world. Rockwell broadens the appeal of the scene by erasing signs of specificity regarding place and class. The image is apt for readers of the *Post* who face decisions about whether to buy the goods advertised within the magazine's pages. Knutson concludes that "a Rockwell cover image was designed and used to sell three things to a newly defined public: the magazine itself; the goods advertised inside the magazine; and, perhaps most importantly, a vision of who we are and how we should be Americans."[50]

RACIALLY CONTROVERSIAL ART: KARA WALKER AND MICHAEL RAY CHARLES

Some African American artists are causing controversy by using explicitly racial and racist subject matter in their works of art. In the mid-1970s, artist Robert Colescott made blackface versions of famous paintings. For example, he remade Vincent van Gogh's *Potato Eaters* into *Eat Dem Taters*. About his painting, Colescott says, "It's a polemical painting. It's a frontal and brutal attack on the myth of the 'happy darkie,' with a raw, almost minstrel element in it. It has always been convenient for white people to believe that black people can sing and laugh and be happy, even in the worst situations."

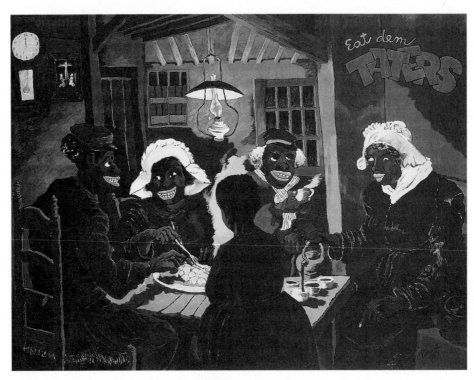

3-5 *Eat Dem Taters,* Robert Colescott (1925-). Oil on canvas. Courtesy of the Artist.

In the 1990s and 2000s, Kara Walker and Michael Ray Charles, also African American artists, are incorporating into their art racist images of "Sambos," "Aunt Jemimas," "mammies," "pickaninnies," "Nigger wenches," and other stereotypes of blacks that circulated freely and widely in America in the past in print advertisements, on packages of goods (for example, "Darkie Tooth Paste" and "Nigger Head Stove Polish"), and in household items such as salt and pepper shakers and cookie jars.

Michael Harris, an art historian, explains the offensiveness of the original racist images: "Sambo and Aunt Jemima come out of a long literature that categorized Africans in certain essentialist ways and by extension, any person of African descent in the New World. So you have the asexual mammy who is the perennial servant and is non-threatening. With the black male you have either the buffoon who is childlike and inept, or you have the threatening, blood thirsty savage. The motivation for the production of this imagery was to control black people within white society as well as to justify taking over their African territories. These images codified notions of who black people were."[51]

The following pages are concerned with the art of Walker and Charles, two of the most prominent African American artists who today are reiterating and reinterpreting

3-6 *Camptown Ladies,* Kara Walker, detail, cut paper and adhesive on wall, overall size 9 x 67 feet, 1998. Courtesy Brent Sikkema, NYC.

racist images made in the past. Following descriptions and interpretations of their works is a discussion of the conflicting judgments their works provoke, especially within the African American art community.

Kara Walker

In a *New York Times Magazine* article, Julia Szabo describes Walker at work in front of a nine-foot-square sheet of black paper adhered to a wall: "Squinting at some ghostly faint, tentative sketches in white pencil, she breaks a blade segment off a slim X-Acto knife and lets it drop to the floor. Then with swift, sure strokes, holding the metal knife like a pencil, she begins to slice. . . . Her work has from the beginning featured images like a white woman in a poke bonnet and hoop skirt with the penis of a small black child in her mouth; a nude black woman vomiting human body parts, the remains of a white man lying, tellingly, nearby; and a smiling female field hand picking cotton while engaging in intercourse with a white master in hat and boots."[52]

Szabo refers to Walker's imagery as "a tableau of subverted slavery-era icons" and finds it "simultaneously funny, grim and beautiful." Szabo acknowledges that Walker's

3-7 *Gone: An Historical Romance of Civil War As it Occurred Between the Dusky Thighs of Young Negress and her Heart,* 1994. Kara Walker (1969-). 21 paper silhouettes approximately 13 x 50 feet installed. Courtesy of the Artist and Brent Sikkema, NYC.

78

art is very graphic: "high contrast, sexually explicit, violent, scatological." Szabo interprets Walker's art to be about history, "specifically black history and how its telling and retellings have altered the African-American experience." Walker uses the "Nigger wench" and the "free Negress" in retelling history. Taking her interpretation further, Szabo writes, "Hardly the obedient, victimized female slave, the Negress is a star player in this version of history, seducing her masters as much as being molested by them or stuffing hobbyhorses down white children's throats."[53]

Szabo and Holland Carter, who also reviewed Walker's work for the *New York Times,* note the irony of Walker's use of silhouettes. Walker's mural-size black paper cutouts are based on eighteenth-century portrait silhouettes, which were a style of portraiture somewhere between illustration and photography, more craft than art. Clients were of high social standing and, as Szabo explains, "the silhouette was marked by its chaste depictions of men in tail coats and top hats, ladies in hoop skirts and poke bonnets holding flowers, sailor-capped boys riding hobbyhorses and pantalooned girls holding dolls. Many women took it up as a handicraft, like needlepoint, and the form is still used to illustrate children's books."[54] Carter writes that Walker's versions of the silhouettes are "phantasmagoric narratives, farcical in tone, of an antebellum South in which blacks, often women and children, are both victims of and participants in scenes of degradation. The result is a deeply cynical ship-of-fools vision, superbly executed, rivetingly offensive right across the board."[55]

Michael Ray Charles

"Michael Ray Charles attacks some serious issues and with a deft humor, which is very hard to do. He makes you laugh while he's killing you. That's a real artist."[56] Spike Lee, the filmmaker (*Do the Right Thing, Jungle Fever, Malcolm X, He Got Game, Summer of*

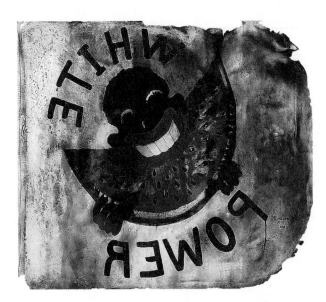

3-8 *(Forever Free) RE-WOPETIHW,* Michael Ray Charles (1967-), acrylic latex, oil wash, and copper penny on canvas, 46 x 51¾ inches, 1994. Collection: The Brand Foundation. Courtesy of the Artist.

79

Sam), wrote these words in an exhibition catalogue of Charles's work. When Lee first saw Charles's work, he wrote, "Michael Ray Charles is a natural born filmmaker who so far has never made a film. He instead is a painter. His work is cinematic. His works are one-sheets, posters for movies that Hollywood would never have the courage to make, exploring race and sex in this country."[57] After seeing Charles's work, Lee invited Charles to collaborate with him on a movie, *Bamboozled,* which was released in the fall of 2000. The satirical film is about the production of a minstrel show for prime-time TV.

For his subject matter, Charles uses stereotypical racist images of blacks found in visual culture in the United States that are associated with slavery, southern black folklore, and nineteenth-century minstrel shows. In the words of artist and art writer Calvin Reid, Charles's subjects are "big-lipped little dark pickaninnies with heads full of nappy pigtails; the happy-go-lucky coon; charcoal dark Little Black Sambo; Aunt Jemima, her head in a kerchief smiling down from the grocery shelves (and don't forget Uncle Ben); watermelon-eating darkies and the evil black thug looking to rob white men and rape white women." Reid asserts that these are the images that denigrated and degraded African Americans while they fed racist delusions about the absence of humanity in blacks: White society saturated mass culture with "a debased mythology of its most oppressed and degraded members." Reid writes that Charles's appropriated signifiers collide in a reduced version of a kind of race war, without guns but fought with images and the ossified stereotypes still rumbling around the American subconscious."[58]

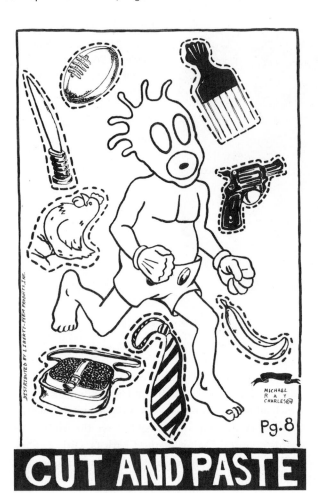

3-9 *Cut and Paste,* Michael Ray Charles, acrylic on paper, 60 x 35 inches, 1994. Collection: Estate of Gil Traub, New York. Courtesy of the Artist.

80

Charles's *Cut and Paste,* 1994, satirically asks us to attach our stereotypes of choice onto the Sambo running down the street. Onto the paper doll we may paste a football, hair pick, knife, handgun, chicken, purse, banana, or tie. When conjuring a black man, a racist first reduces him to a Sambo with shorts, white gloves, and black face, vaguely reminiscent of Mickey Mouse, himself a derivative of the minstrel show. A racist may then choose to fear the black man by attaching to him a gun or a knife and adding a purse, presumably snatched from a white woman. Or the racist may offer a false compliment to the black man by acknowledging his athletic prowess with a football, degrading him to a figure of brawn without brain, who has only recently emerged from the jungle with a banana. The black man, even with hair picked and adorned with a necktie, will never outrun the images with which he has been identified.

Marilyn Kern-Foxworth, in an essay for an exhibition catalogue of Charles's work, lists twenty-three ways that scholars have identified that blacks have been codified in images and language. Guy McElroy identified four general types found in American culture between 1710 and 1940: grotesque buffoons, servile menials, comic entertainers, and threatening subhumans. Lawrence Redneck expanded the list in 1944 and identified nineteen different and distinct stereotypes assigned to blacks: the savage African, the happy slave, the devoted servant, the corrupt politician, the irresponsible citizen, the petty thief, the social delinquent, the vicious criminal, the sexual superman, the unhappy non-white, the natural born cook, the natural born musician, the perfect entertainer, the superstitious church-goer, the chicken and watermelon eater, the razor and knife toter, the uninhibited expressionist, and the mental inferior.[59]

As a black male and as an artist dealing with racist images of blacks, Charles is well aware of the consequences of such images. Kern-Foxworth quotes a passage written by Leon Litwack in *Ethnic Notions,* a catalog that accompanied an exhibition of stereotypical artifacts, identifying the dreadful consequences of racial stereotyping of African Americans.

> The image of the black man as an unreliable and shiftless incompetent shaped his employment opportunities, confining him to a position of service and hard labor that required the least skill and knowledge and provided the least income. The image of black people as incapable of reaching higher levels of intelligence shaped and curtailed their educational opportunities. The textbook image of black people as contented and loyal slaves or as wretched and easily misled freedmen shaped early perceptions of blacks in the classroom. The image of the ignorant black man rationalized his exclusion from the polls and juries. The image of the race as degenerate and given to uncontrollable sexual and criminal urges explained the need to segregate them rigidly and to lynch them occasionally. The image of the black man as less than a man made it much easier to make him the butt of the white man's humor and the victim of white terrorism.[60]

Kern-Foxworth writes in a fictional first-person singular, interpreting Charles's images as if she were speaking for him: "You can see me and you can see that I am black, but you don't really know who I am. Is your vision so clouded that you totally miss my intelligence? Were your eyes so blinded by distorted depictions that you have missed my infinite beauty? Were your shallow minds so threatened by my raw ambition that you missed my genius? I am constantly and consistently re-envisioning your vision of who you think I am. I paint it the way I see it."[61]

Nevertheless, the way Charles sees it and paints it, and the way Walker retells it in silhouettes, is not the way many want it to be seen or shown. A summary of the controversy about the work of such artists as Robert Colescott, Kara Walker, and Michael Ray Charles follows.

The Controversy

It is frequently black viewers who are the most offended by Walker's work. According to Juliette Bowles, writing in the *International Review of African American Art,* the heated opinions about the work of Walker and Charles are divided somewhat along age and geographic lines. Younger artists and viewers tend to be for it, while older ones tend to be against it; northerners and westerners also tend to be for it, while southerners tend to be against it.[62]

Szabo has empathy for those who are offended by the work: "With its recycled derogatory stereotypes of Mammy, Prissy, Sambo, Topsy, Uncle Tom, Simon Legree and Eva, this art cannot exactly be called race-positive." Walker herself draws a parallel between the effect of her work and that of the old sharecropper in Ralph Ellison's book, *The Invisible Man,* "who raped his wife and daughter and kept telling his horrible story over and over, and the white people in town gave him things. He's an embarrassment to the educated blacks, and a fascination to the whites."[63]

Some of those antagonistic to the work of Walker and Charles point out that it is mostly whites who buy and show the work. They also argue that Walker, Charles, and others "are making their reputations and large sums of money off of their own people's suffering, are repeating monotonous themes to exhaustion, and are catering to the base interest of white curators and collectors."[64]

One fear expressed by those who object to satirical uses of racist images is that people who view the images will not see the satire. If satirical art is not understood to be satirical it is then misunderstood, with dire consequences, as straightforward expression. Troy Gooden, a community planner, raises this question: "How does Charles's work confront the negative stereotyping of blacks by merely repeating it?"[65] Elizabeth Catlett, artist and activist, asserts that in Charles's work "the symbolic impression is too weak to counter the immediacy of the image."[66] Roberta Smith, an art critic for the *New York Times,* understands the satire in the work of Charles, but she too asserts that he leaves his art too close to the original racist sources, that he has not transformed them enough.[67]

Walker and Charles also have eloquent defenders of their work in the African American community. Juliette Bowles, in the *International Review of African American Art,* writes, "Like resourceful, violated black people in the past, Kara Walker transformed her pain into art. In searching for a medium to express the sexually and psychologically violent history of race relations that she felt was not addressed by most African American artists, Walker retrieved the mode of the silhouette that was fashionable at the beginning of the era of horrors drenched in lust that she now surveys."[68]

Gwendolyn Dubois Shaw, in the art journal *Parkett,* supports artists like Walker and Charles who have the courage to deal with the weighty subject of historical domination and exploitation: "the act of reenactment is important in itself, and the role of the artist as provocateur is not to be undervalued, no matter how taboo or painful the materials they present may be." She praises these artists because they choose "to wrestle with the legacy of tainted imagery that the non-visual world chooses to ignore, subsume, or reject."[69]

Henry Louis Gates is eloquent and passionate in his defense of Walker's art and that of other black artists who "have chosen to draw upon seminal stereotypical images of African Americans that were created as a fundamental part of the white racist on-slaught against our people. These artists have done so not to glorify and perpetuate those images; rather they have done so to critique the racist impulses that manifest themselves in bizarrely heinous representations such as Sambos, Coons, Mammies and Jigaboos . . . seeking to liberate both the tradition of the representation of the black in popular and high art forms and to liberate our people from residual, debili-tating effects that the proliferation of those images undoubtedly has had upon the col-lective unconscious of the African American people . . . the black object has become the black subject in a profound act of artistic exorcism."[70]

Kenneth Goings is a historian and author of *Mammy and Uncle Mose: Black Col-lectibles and American Stereotyping*.[71] He collects racist items and defends his collect-ing this way: "Black memorabilia are historical artifacts from our nation's past. They are literal and physical representations of the kind of stereotypes African Americans have lived and died with for the past century. By possessing these artifacts I demon-strate that this negative past that so many naysayers assert never happened really did, and at the same time, as many other collectors also believe, I am robbing these arti-facts/stereotypes of the power to hurt me."

Responding to those who defend such positive uses of racist imagery, however, Michael Harris, the art historian quoted at the beginning of this section, warns that if African Americans keep circulating images of pickaninnies, "there's no need for a Klan," because African Americans are oppressing themselves. He wants to be sup-portive of young artists, but asks, "Of all the options, of all the possibilities in the uni-verse and all the creativity that's there, couldn't we find some other way to make a cri-tique than to make six foot Sambos? Isn't there something else? That's all I ask . . . artists deserve room to do what they want and need to do. But at the same time, art is not individual . . . art is more communal than people may acknowledge." He warns that ". . . things have impact upon us and African Americans' position in society is not a secure enough position for us to just bring the memorabilia into our homes with no consequences. I think that these artists who are dealing with stereotypical imagery have not fully grasped the complexity and the pain that some things can inflict upon people in the community."[72]

Interpretation is at the heart of these controversies about the use of racist stereo-types of blacks by Walker and Charles. The artworks that they make are intended to be satirical, but if they are not interpreted to be satirical by their viewers, the images will be severely misinterpreted to be a continuation of racism and, this time, racism perpetuated by blacks themselves. Judgement is crucial to the debate. Some hold that even when racist images are made to be satirical and are interpreted as satire, such satire is not an effective antidote to the poison of racism in society. They believe that parody is not progress but perpetuation. Others counter that the artworks that Charles and Walker make are clearly satirical, that they offer powerful visual critiques of past

and present racism, and remind us that no matter how painful it may be for some to face such images, neglect of racism allows it to continue.

CONCLUSION

- *Art* matters.

The arguments for and against some works of art clearly and forcefully show that art matters to people. Images can hurt and can heal. Images are important and must be interpreted. Because they are important they are judged. If images were of no consequence, we would neither bother to interpret them nor judge them; we would simply ignore them as uninteresting and inconsequential.

- *Interpretability is the basis of some judgments.*

One major conclusion already drawn from the examples of interpretive disagreements and value disputes in this chapter is that descriptions, interpretations, and judgments are intermeshed. How one judges a work of art may determine whether it is to be interpreted at all. For many decades, Rockwell's work was not interpreted by art critics and other scholars because they judged it to be so obvious that it neither needed nor merited interpretation. Nor did directors of art museums see the need to collect it and exhibit it until recently. Interpretation, in a sense, provided a criterion for judgment: an artwork that does not need or deserve to be interpreted is not to be valued as art. The opposite is also true: when something is deemed too difficult to interpret, or incomprehensible when interpreted, then it is judged unworthy, as in the case of some abstract art written about in the next chapter.

- *Judgment can supersede a perceived need for interpretation.*

When some heard the word "dung" combined with "painting of the Virgin Mary," they formed immediate negative judgments that prevented them from considering any interpretation of the work except an implied, unarticulated, and vague interpretation of the work as a defamation of the sacred. Judgment, for these viewers, superseded the need for interpretation. This book, however, holds the position that judgments require interpretations and that judgments without the benefit of interpretations are not responsive to the artwork and are irresponsible on the part of those who make them.

- *Descriptions are dependent on interpretations and judgments.*

In this chapter, we have also seen that interpretations and judgments are dependent on descriptions. How something is described affects how it is interpreted and judged, and how it is judged affects how it is described. A conclusion to be drawn is

that descriptions are not independent of interpretations and judgments. Further, descriptions offered by observers ought to be checked for accuracy, especially when judgmental consequences rest on them.

• *There are differences between preferences and values.*

There is an unstated distinction in play in the commentators' expressed views of the artworks they write about concerning preferences and values. Preferences have to do with personal likes and dislikes. To state a preference is to provide a psychological report about oneself. We usually do not argue over preferences, although we do sometimes judge our preferences to be superior to another's differing preferences. We do argue, however, and sometimes heatedly and even with weapons, over values. Mayor Giuliani was not saying that he merely *preferred* other representations of the Virgin to Ofili's *Holy Virgin Mary;* he condemned Ofili's representation as "sick stuff" and used the power of his office to try to prevent others from seeing it. The critic Arthur Danto may *like* Norman Rockwell's depictions of "amiable codgers, nurturing moms," and "adorable dogs," but he does not *value* them as good art because he *judges* them to be "too cute to be true," fostering a sense of "indulgent superiority" in their viewers. Dave Hickey also seems to *like* Rockwell's paintings; however, he explicitly *judges* Rockwell to be "the best practitioner of a tradition of social painting that began in the seventeenth century." A. M. Holmes may not *like* to "explore feelings and relationships and memories" that Eric Fischl's paintings evoke, but she *values* them because she interprets them to be honest paintings that depict "the very parts of ourselves we work so hard to keep hidden." We may dislike what we value and fail to value what we like, as well as value what we like and like what we value.

• *Aesthetic judgments can lead to physical consequences.*

Many lawyers, as well as politicians and religious leaders, went to battle over a painting made by a relatively unknown artist shown in one of the many museums in New York City. Those who condemn Ofili's *The Holy Virgin Mary* fear that it will cause harm if it is seen. As a consequence of a judgment, a lot of money for the arts was put in jeopardy. Some fear that Fischl's paintings of dysfunctional families will cause further dysfunction. Similarly, some viewers vociferously worry that images made by Walker and Charles do not parody racism, but reinforce it.

In 1989, the Ayatollah Khomeini of Iran condemned to death the British novelist Salman Rushdie for writing *Satanic Verses,* a novel that the Ayatollah believed to insult the prophet Muhammed and to blaspheme Islam. Rushdie has so far survived the *fatwa* after years in hiding and with British police protection, but another person associated with the book has not. Central News Network (CNN) reports that Hitoshi Igarashi, the Japanese translator of the book, was stabbed to death in July of 1991. That same month, the Italian translator, Ettore Capriolo was wounded in a knife at-

tack. In 1993, Aziz Nesin, the Turkish publisher who printed extracts of the book in a newspaper, was attacked by Islamic rioters in a hotel that they set on fire, killing 37 people. Nesin escaped. In October of 1993, a Norwegian translator of the novel, William Nygaard, was seriously wounded by gunfire.[73]

• *Multiple interpretations of a controversial work of art can bring rationality to a controversy.*

As Stephen Dubin (the inventor of *Homo censorious*) insightfully observes, those who would censor a work of art hold the work to a single meaning, and they believe their interpretation of it to be the right interpretation and the only one. Conversely, multiple interpretations of a controversial work of art can dissipate the heat of controversy and slow the impulse to condemn or censor by entering more than one understanding of the work into consideration. People can consider alternate meanings, arrive at different judgments, and have more ideas with which to approach the controversy and more solutions for its resolution. Censorship is not a satisfactory resolution of conflict over works of art. Those arguing that works by Walker and Charles may further erode racial dignity are not advocating censorship of the work: they are requesting that the artists take seriously the potential consequences of their art.

• *Aesthetic judgments are sometimes based on moral criteria.*

The cardinal's and the mayor's and the Ayatollah's judgments of a painting and a novel are based not on aesthetics, but on ethics. Art critics cite Rockwell's honesty or lack of it. Viewers who are negative about Fischl's paintings condemn the subject of the paintings—social and sexual dysfunction. Although some critics and aestheticians believe that art is a realm of value separate from moral value, and that it should only be judged by aesthetic criteria, most contemporary critics, aestheticians, scholars, and ordinary people do not.

• *Multiple criteria can be employed simultaneously.*

Some critics praise Fischl's paintings as honest and other critics devalue Rockwell's paintings as dishonest. It is possible, however, for one person to appreciate the arguments for and against judgments based on the criterion of honesty and still value the artworks of both Fischl and Rockwell. To do so, however, one would need to have multiple criteria for judging works of art, rather than a single criterion that is applied to all art. A critic could conceivably value Fischl's painful honesty and also value Rockwell's ability to soften the harshness of social living. Holding multiple criteria for art is referred to as aesthetic pluralism. Pluralism offers the advantage of being able to value different kinds of artworks for different reasons. This book supports a pluralistic approach to art and aesthetic values as liberating and expansive.

Interpretation and Appreciation: Abstract Painting

COMPLAINTS ABOUT ABSTRACTION are many. A most common objection is "That's not art!" Viewers who are resistant to abstraction often see no skill in it: "Anyone could do that!" or "My six-year-old paints better than that!" They also tend to suspect artists of abstraction and the art world of conspiring to make fools of them by having them believe that there is something of aesthetic and economic value in what seems to be merely smears of paint—"What kind of fools do they think we are?"

The relationship between interpretation and appreciation is close for any work of art. To appreciate a work of art is to apprehend it with enjoyment. A sympathetic understanding of a work of art will usually result in a positive appreciation of the object as a work of art and as a contribution to knowledge and experience. What is required of one to be able to enjoy an abstract work of art? What might there be to appreciate in abstract works of art? This chapter provides some answers to these questions by exploring the different abstractions of two contemporary American artists: Willem de Kooning and Sean Scully.

AESTHETIC ATTITUDE

An aesthetic attitude is a basic requirement for appreciating any work of art. An aesthetic attitude is one of openness to new sensory experiences. It is an attitude of wonder and a predisposition to generally apprehend sensory things positively. Those sensory things can be objects and events in the natural world such as frosted spiderwebs and long green grasses swaying against a blue sky; they can also be paintings and sculptures and other things made expressly for aesthetic apprehension. An aesthetic

apprehension of a natural or purposely made thing is an apprehension of the thing for its own intrinsic merit. We enjoy it for what it is in itself, not for what it might be used for or for its economic value. An aesthetic apprehension is a unique view of the world and that view is valued in itself. An aesthetic apprehension *may* prompt utilitarian action: moved by the beauty of the spiderweb, we might also become aware of its fragility and politically seek to protect the natural environment on which it depends.

An aesthetic attitude entails a certain degree of general trust. It is a trust that the art world and those in it are generally people of goodwill whose desire it is to make and show work that they sincerely believe is of interest and import. It is a trust that artists and museum curators and gallery owners are not out to dupe us and that they do not take us to be fools who can be duped. People in the art world who bring us art are generally sincere about their endeavors, no matter how esoteric they are or might seem to be. They devote their lives to their enterprise and they believe it to be worthy. We may find that we are ultimately not interested in pursuing an interest in things and events we find to be too esoterically aesthetic, but that decision does not require us to suspect artists and museums and galleries of being less than honorable in their professional endeavors.

AN OVERVIEW OF ABSTRACTION

Before looking specifically at paintings by Willem de Kooning and Sean Scully, a general historical introduction to abstraction in art is offered here, first by introducing common terms with which to discuss abstraction, and then by providing a brief overview of the historical development of abstraction through the history of art.

> • *Any image of a real thing is necessarily an abstraction of that thing: Abstraction in art is a matter of degree.*

Terms

'Abstract' when used in art discourse is a term that refers to the simplification and stylization that occurs when rendering images and objects. In these two senses, all art is abstract because nothing can be rendered in its full reality. Even Norman Rockwell's *After the Prom*, which we easily recognize as a realistic painting, is abstract in that it is a reduction and a stylization of what we might have seen had we been there, if the event had taken place in reality and not just in the artist's imagination.

Reduction: with all its realistic detail and believable rendering, *After the Prom* is abstract in that it is a simplified rendering, of a living, three-dimensional event, with conversation and background noises that Rockwell has left out, on a small, still, flat, and silent surface. It's a picture. It's a representation of an imagining or an event. It is not the people and place.

Stylization: *After the Prom* looks like a Rockwell painting, and it does not look like a painting made by Eric Fischl nor one by Chris Ofili. Women in paintings by Rockwell, Fischl, and Ofili are recognizable as women, but each is also recognizable as a woman by Rockwell, a woman by Fischl, or a woman by Ofili. Each artist is of the twentieth century, living in the Western Hemisphere, enmeshed in culture and ways of seeing and presenting. Each of these artists is male. Each artist is also an individual, with different artistic training and skills, and with different artistic intents. Because of these factors, when looking at their work, we can discern differences, including, importantly, stylistic differences.

The young woman in Rockwell's *After the Prom* is differently abstract than the young woman in Fischl's *Slumber Party,* and the woman in Chris Ofili's *Holy Virgin Mary* is more abstract than both. All three subjects are recognizable as women, but Ofili's woman is the most abstract of the three, and, as we will see, de Kooning's women are less recognizable as women than the women painted by any one of these three artists.

Abstractions can be thought of as 'representational,' 'nonobjective,' or 'nonrepresentational.' Both Rockwell's and René Magritte's paintings are 'representational,' showing what we recognize as people, places, and events. Magritte's representational paintings are more abstract than Rockwell's are: that is, Rockwell's pictures resemble the world of natural appearances more than Magritte's do. Both Rockwell's and Magritte's paintings offer pictures in which we can confidently recognize people and places and things, but Rockwell's renditions seem to us more natural than Magritte's and thus are referred to as more 'naturalistic.' Sean Scully's paintings, as we shall soon see, are said to be 'nonrepresentational' or 'nonobjective' in the sense that they do not attempt to realistically render recognizable objects that exist in the natural world. Scully insists that his paintings *refer* to real things in the world, but they are not meant to *look like* soda fountains, or Holy Virgins, or men wearing bowler hats.

An art textbook defines 'abstract art' as "Art that departs significantly from natural appearances. Forms are modified or changed to varying degrees in order to emphasize certain qualities or content."[1] The above paragraphs talk about art departing from natural appearances, but that artists modify forms to emphasize certain content is a further idea offered by this definition. Abstraction in art is a choice. Abstraction in art, like other choices in art, is purposeful. Abstraction in art causes different perceptions and realizations. When we look at a Magritte painting, the painting directs us to consider *this* rather than *that:* it does not, for example, direct us to appreciate subtle nuances of light reflecting off snow-covered mountains as might other painted landscapes, but it instead asks us to imagine a snowy mountain as if it were a giant white bird of prey. Rather than offering an architecturally accurate floor plan of a dance hall, Manet's *A Bar at the Folies-Bergère* confronts us with a mirrored space that bewilders our spatial orientation.

A window is a common and helpful metaphor for thinking about abstraction and painting. Imagine a kitchen window facing a garden in the backyard of a house. The

89

painter can use the window as a frame and a lens to show the garden. Our attention is then focused on the garden, its greens and textures, the lights and darks of the foliage, and the colored brilliance of the flowers. In this imagining, the window is transparent. We look through it to see that garden. We are hardly aware of the window because it so focuses our attention on the garden. Now imagine that the kitchen window, still facing the garden, is smudged, or heavily textured, or made of different pieces of stained glass. The window now draws our attention to itself, not to the garden. We can look at the window and enjoy it, or we can look through the window, ignore the smudge or texture or color of it, and look at the garden. Some paintings want us to notice the garden, others want us to notice the window only, and others ask us to attend to both the garden and the window.

History

Differences in rendering appearances are made by way of 'conventions,'[2] that is, by implicit societal agreements. Through the inventions and refinements of artists, we have come to accept certain kinds of renderings as realistic and others as abstract. We are normally very comfortable with some kinds of representations because we have learned to read them easily and quickly. Realism in art is easy for us to read because we are so accustomed to it. This does not mean that these pictures actually are *more real;* it's just that they are easy for us to accept and we take them for granted. We do not ordinarily ponder a road map as an abstract representation of real world space, we just read the map to get to where we want to go. We had to learn to do that. Topographical maps require a different kind of reading. Whether a road map is a more or less realistic rendering of reality than an Ansel Adams photographic landscape is usually a moot distinction: we read each differently, and easily, and both are realistic by different conventions. We may be much less comfortable with abstract paintings than with what we call realistic paintings because we are not familiar with their conventions.

Different societies throughout history developed different conventions for visually representing things and expressing ideas. All of the conventions are abstract in the sense that they are approximations of things and ideas; they are all *invented* ways to show things and ideas. These conventions developed by different communities look different: classical Egyptians, for example, drew pictures of land and buildings from a bird's-eye view—a kind of aerial perspective, many centuries before airplanes were invented. An African community expressed reverence for fertility by exaggerating human reproductive organs. A medieval Christian community invented a sequential pictorial narrative style to tell Bible stories in colored-glass windows. One cultural community might have difficulty interpreting another community's ways of representation: for example, twenty-first-century scholars still ponder the meaning and significance of cave paintings found in central Europe. It is conceivable that an ancient Greek familiar with only classical stone carvings of men and women would not be able to readily perceive the content of a photograph of a nude figure made today.

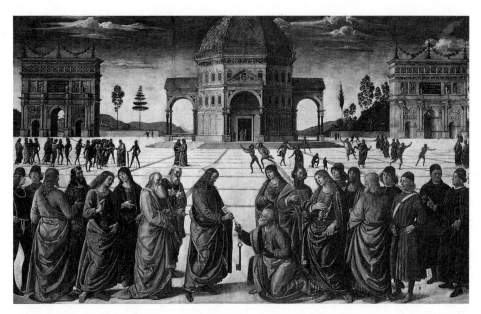

4-1 *Christ Delivering the Keys of the Kingdom to St. Peter,* Pietro Perugino, fresco, 11 x 18 feet, 1481–1483 © Scala/Art Resource, NY. Sistine Chapel, Vatican, Vatican State.

The term 'realistic' is usually juxtaposed with the term 'abstract.' We have come, since the invention of perspectival rendering during the Renaissance, to accept 'realistic' to mean 'closest to looking like' things in the world. We have learned to recognize realistic pictures as renderings that look like High Renaissance drawings and paintings. Conventions have been established by artists and accepted by viewers that things that appear small on a picture plane are meant to be understood to be farther away than similar objects appearing larger on the plane. For example, the robed people in the background of *Christ Delivering the Keys of the Kingdom to St. Peter* are painted smaller than those in the foreground. We have learned that this signifies that they are farther away from us, not that they are little people. Things that appear darker and more intense in color are usually meant to be understood as being closer to the viewer than things that appear lighter. The mountains in the background are painted a flat gray, not because they are gray in reality, but because this makes them seem to be farther away. Some of the heads of the people in the foreground overlap the feet of the people in the background. We have learned to accept this not to mean that little people are growing out of the heads of bigger people, but that what is overlapped is further away. There are many such conventions at work in the Renaissance painting, and in "realistic" pictures that were made after it.

Today, looking 'realistic' usually means looking like photographs. We tend to forget, however, that photographs are constructions invented by artists and scientists, and they are modeled after Renaissance ways of seeing and depicting. Photographs of land

could have been made to look more like Egyptian ways of depicting land, always giving us a bird's-eye view, for example, or to show like things to be the same size, rather than in Renaissance perspective. Photographs, like cave paintings, are conventional.

> • *Realism is an artistic invention: photographs, like*
> *cave paintings, are conventional.*

The second chapter of this book includes thoughts about Manet's early incursions into artistic abstraction. In light of de Kooning's and other artists' twentieth-century paintings, Manet's incursions into abstraction seem quite subtle, even hard to recognize as abstract. Nevertheless, historians tell us that Manet was less interested in optically matching his canvases to what his eye perceived in the world and more interested in what he saw as the aesthetic opportunities and challenges of his canvas. Artists of the nineteenth and twentieth centuries who were trained in classical traditions of art-making could render persons and places and objects in convincing realistic style, but artists such as Manet began to choose not to. When the fixed photographic image was invented, around 1849, there was less reason for any painter to slavishly render in a realistic style when the camera could do that so much more quickly and easily.

Arthur Danto, art critic and aesthetician, explains abstraction in Modern art as a history of "erasures," or reductions, or simplifications. Modernist artists, including abstractionists, showed us that "art did not have to be beautiful [in the traditional sense], it need make no effort to furnish the eye with an array of sensations equivalent to what the real world would furnish it with; need not have a pictorial subject; need not deploy its forms in pictorial space; need not be the magical product of the artist's touch."[3] Some historians and artists think of these erasures as a progression or a series of advances in art, from representational images to abstract images, from description to expression, from subject to pure form. Other scholars just take this history to be one of many ways to tell stories about how art has been made differently at different times and in different cultures.

If we are uncomfortable looking at very abstract paintings, we are likely most comfortable in looking through windows to see gardens. Perhaps we enjoy Impressionist paintings, where we can easily appreciate the garden as well as the window. Claude Monet, the French Impressionist influenced by Manet, shows us both the window and the scene. He uses the conventions of Renaissance realism in painting the haystack in winter, and he also shows us the windowpane of his canvas by how he applies his paint. When we look at Perugina's *Christ Delivering the Keys of the Kingdom to St. Peter,* we are not asked by the artist to attend to the surface of his fresco, but we are instead visually directed to look through it at the scene he and the Church have provided.

With Impressionism, we are given traditionally beautiful subject matter, such as flowers, bodies, and landscapes. Impressionist paintings furnish our eyes with an array of sensations perhaps even more sensational than the real world would provide.

They draw our attention in gentle ways to pictorial space, and they often dazzle us with the skill of the artist's touch. They give us a lot to enjoy, and perhaps our enjoyment of abstraction is sufficiently satisfied. Nonetheless, artists moved on or back or sideways and explored pictorial space; and, when they did so, they eliminated or erased recognizable subject matter, focusing on the window itself and what they could do on it, rather than through it. To appreciate art is, in part, to know the problems that artists are trying to solve; to see the problems they have set for themselves; to recognize their self-imposed restrictions and limitations. De Kooning, for example, made paintings of women but the paintings are very much about the surface of the canvas, the paint, and how it is applied.

WILLEM DE KOONING: TWO *WOMEN* SERIES

Both Holland and the United States proudly claim Willem de Kooning as their own. He was born in Rotterdam in 1904, studied art and mastered traditional artistic techniques in Holland at the Rotterdam Academy of Fine Arts and Techniques. In 1926 he sailed to America as a stowaway. He first lived in New Jersey, making a living painting signs and making window displays, and, then, with the help of artist Arshile Gorky, moved to New York City, where he became the "quintessential artist-bohemian." He was hard-drinking; in his marriage, both he and his wife, Elaine, took other partners. Elaine was herself a painter, an art critic for *Art News,* and a promoter of her husband's work. Willem and Elaine separated in 1954, with other relationships and alcoholism as contributing factors to their parting. De Kooning was of the same stature in the art world as Jackson Pollock, "with whom he had a long and rancorous rivalry, fomented on either side by their wives."[4] After Pollock killed himself in a car wreck in 1956, de Kooning, in a very public affair, took up with Ruth Kligman, once Pollock's mistress and a survivor of the car crash. In 1976, Elaine tried to rescue de Kooning from his drinking and provide him a new career impetus. She concealed his deteriorating condition, due presumably to alcohol and the onset of Alzheimer's disease. Elaine died in 1989, Willem in 1997. It is disputed whether the paintings de Kooning made from the mid-80s onward can be totally attributed to him.[5]

Pollock and de Kooning were the nucleus of the New York school. Whereas Pollock developed his "allover" style in completely abstract drip paintings, de Kooning retained subject matter in his work. Both became known as Abstract Expressionists and Action painters. The work of both and the critical acclaim it was given are credited with having moved the attention of the art world from Paris to New York City in the 1950s. Each artist had his supporting critic who championed his work: Clement Greenberg wrote on behalf of Pollock and Harold Rosenberg for de Kooning. These two influential critics themselves had a falling out and became antagonistic to one another.

The term 'Abstract Expressionism' was first used in 1946 in America; 'Art Informel' was the name given it in Europe. It may be thought of as a combination of two dif-

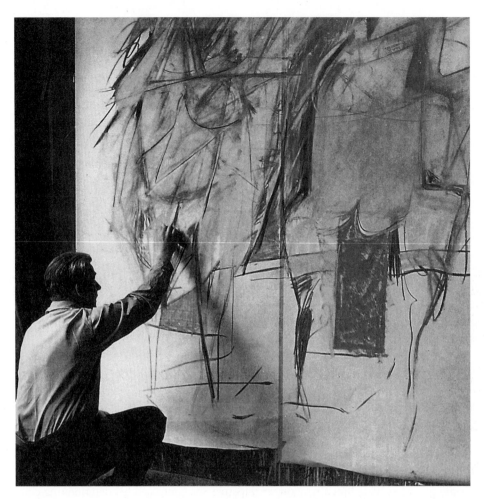

4-2 Willem de Kooning, 1950. Photo Rudolf Burckhardt (1914–1999) Courtesy Tibor de Nagy Gallery, NY.

ferent ways of thinking about painting: as expression and as abstraction. (Vincent van Gogh can be thought of as an expressionist; Wassily Kandinsky as an abstractionist. Whereas van Gogh used representational subject matter such as flowers and birds and people to vividly and passionately express emotion, Kandinsky used nonrepresentational forms in making paintings that are totally nonobjective.) Robert Atkins describes Abstract Expressionism more as an attitude than as a style.

The totally abstract drip paintings of Pollock do not look like the totally abstract, intensely colored, amorphous fields of color in the paintings by Mark Rothko, but both artists are accurately identified as Abstract Expressionists. What unites the work of these artists is "a fierce attachment to psychic self-expression."[6] The work is also united in its marked contrast to art that immediately preceded it, for example, the realistic and representational American Scene paintings by Thomas Hart Benton and

Grant Wood, and the Socialist Realism born out of leftist political concerns, such as the murals made by Mexican artist Diego Rivera.

Critics Greenberg and Rosenberg wanted Action painting to become a term used synonymously with the new American-style painting. Rosenberg defines the Action painter's canvas as an arena to act in: "At a certain moment the canvas began to appear to one American painter after another as an arena in which to act—rather than as a space in which to reproduce, re-design, analyze or 'express' an object, actual or imagined."[7] Rosenberg tells us how to appreciate such work: "Begin by recognizing in the painting the assumptions inherent in its mode of creation. Since the painter has become an actor, the spectator has to think in a vocabulary of action: its inception, duration, direction—psychic state, concentration and relaxation of the will, passivity, alert waiting. He must become a connoisseur of the gradations between the automatic, the spontaneous, the evoked."[8]

Dore Ashton, an art critic, gives her understanding of the abstract artists known as the New York school: "Certainly the configuration of artists who by convention are called action painters or Abstract Expressionists cannot be reduced to a stylistic category. Flamboyant, extravagant, hard-drinking, angry, tormented, introspective—adjectives so often used about artists of that period and that, to some degree, do qualify, hardly suffice to describe a historical movement, or even a moment. The only way to do that, more or less, is to take the long view. In the long view, the activity in the realm of the visual arts that erupted after the disaster of the Second World War can be seen as a chapter in the intellectual history of Romanticism, and who knows, even now, if that chapter is closed?" She explains attitudes of Romanticism that she sees in the work of de Kooning and the Action painters (*Woman I,* **Color Plate 11**): a respect for the imagination and an emphasis on the power of reason; a capacity to live with doubts, uncertainties, and mysteries; "that there was something that could speak to and from the senses that was superior to classic notions about the act of thinking"; and that intuition is a powerful capacity and artists who used it contributed nonverbally to knowledge.[9]

Gardner's Art through the Ages characterizes Action painting as paintings that eternally seem to be "coming into being before the eyes of the viewer." In de Kooning's paintings, "the tension between flat design and lines in space, between image and process, is heightened by the recognizable figure whose violent power demands recognition." The book notes that de Kooning has been called an "artist who makes ambiguity a hypothesis on which to build."[10]

De Kooning would seem to agree. In describing his manner of painting, he said, "If you write down a sentence and you don't like it, but that's what you wanted to say, you say it again in another way. Once you start doing it and you find how difficult it is, you get interested. You have it, then you lose it again, and then you get it again."[11]

Art critic Brian O'Doherty writes that a de Kooning painting, especially in the 1950s, "is a mess of cancellations, houses of cards continuously being blown down." O'Doherty continues, "There is an oscillation between abstraction and the figure; be-

tween all-over and focused space; between varieties of relative confusion and varieties of relative calm; between, finally, opacity and invisibility. There are also remarkably consistent themes—a persistence of certain habits and flourishes on the one hand and certain strategies on the other. We may also point to two persistent motifs: a woman, and an elbow-like brush stroke. And to certain moods: irritation and humor. And finally to a color: pink. And the ambition, however dissembled or cancelled, that tries to include all these, so that they can all be treated equally, like the spaces in which they are set."[12]

If we recall reactions to Manet's paintings, particularly his nudes, we should by now be used to viewer reactions of "shock." When de Kooning first exhibited his *Women* series in 1953, the paintings "scandalized many people, even some of de Kooning's friends." Were they shocked by de Kooning's use of nudity? No. By his treatment of women? No. By his use of abstraction? No. They were shocked that the paintings were not abstract enough![13]

Subject Matter and the Subject of *Women*

Those who have written about de Kooning's paintings frequently draw implicit and explicit distinctions between his *subject matter* and the *subject* of his paintings. When looking at the *Women* paintings it is evident that the subject matter is women, but is this their subject, is this what they are about?

O'Doherty writes, "With de Kooning the process becomes the subject, and it is continually disappearing and reappearing. When a subject (for example, a woman) appears in a de Kooning, it appears like an abstraction embedded in the real subject—the process."[14]

Sarah Rogers-Lafferty, a contemporary curator, writes that de Kooning's *Women* are not so much about women as they are about the space of the canvas and the action of the painter on the canvas. They are about the expansion and dissolution of traditional painting. De Kooning's *Women* are situated in the then new abstract vision based on the artist's action: "Willem de Kooning confounded figuration and abstraction, transforming his traditional subject of the female figure into a tense battleground of gesture, form and space—creating a new order amid the glaring chaos. The lush, energized handling of paint reveals his primary assertion that the subject of these works is less the figure than the space."[15]

Jonathan Fineberg, a scholar writing about art in America since 1940, wonders about the sources of de Kooning's subject matter, the women, and says that there is much speculation about de Kooning's inspiration for them. Fineberg writes that Thomas Hess, former director of the Metropolitan Museum of Art in New York, thought that de Kooning's mother provided the prototype for the "monstrous" females. De Kooning's mother had been a tough bartender in a place in Rotterdam frequented by sailors. Fineberg says that other people suggest that de Kooning's wife, Elaine, is de Kooning's source. Elaine thought that idea was preposterous and asked

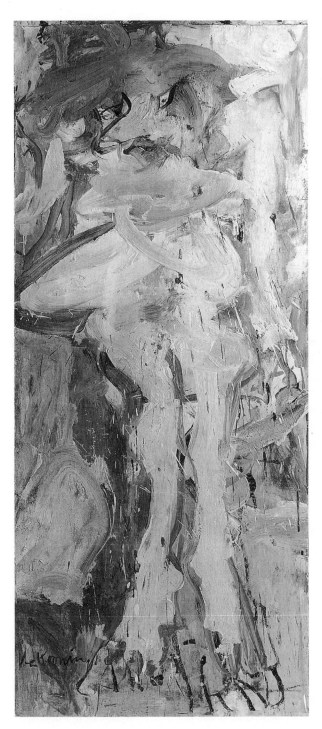

4-3 *Woman Accabonic,* Willem de Kooning, oil on paper, 79 x 35 inches, 1966. Whitney Museum of American Art, New York City. © The Willem de Kooning Foundation/Artist Rights Society (ARS), New York.

Hans Namuth, a photographer who frequently made portraits of people in the art world, to take a picture of her next to one of the *Women* paintings to prove that they had no resemblance to her. However, she was taken aback when she saw the photograph and said, "I and the painted lady seemed like . . . mother and daughter. We're even smiling the same way."[16]

Fineberg tells us that de Kooning himself mentions the Paleolithic Venus of Willendorf and that de Kooning also cited as an inspiration female Sumerian idols with huge eyes. The Sumerian idols seemed to de Kooning "like they were just astonished about the forces of nature." De Kooning kept pin-ups of women on his studio wall and said, "I *like* beautiful women. In the flesh, even the models in magazines." Fineberg further speculates, "If intimations of Elaine provided a starting point for these paintings, then feelings about the artist's mother, about the comical variety of costume mannerism among the ladies shopping on 14th Street, and the pretty pin-ups on his studio wall all entered into the complex sequence of thoughts that led gradually to the final compositions."[17]

Fineberg describes de Kooning's 1950s painted women as "sensuous, full-figured Aphrodites of vulgar warmth." He describes de Kooning's *Women* paintings of the 1960s (*Woman, Sag Harbor,* **Color Plate 12**), as having loose, sensuous handling with saturated rich color made with a great buildup of smaller brush strokes. "Even the simplest of pencil drawings from this time have a fleshy voluptuousness. The *Women* of the sixties are more relaxed and more frankly sexual; increasingly, too, the contours of the figure open out with a lateral sweep into expansive surrounding landscapes. These nudes belong to the tradition of Rubens, although the bodily functions and appetites are more explicitly revealed."[18]

Social critic and occasional art maker bell hooks pays a personal tribute to de Kooning:

> I loved the work of painters using abstract expressionism because it represented a break with rigid notions of abstract painting; it allowed one to be passionate, to use paint in an expressive way while celebrating the abstract. Studying the history of painting by African-Americans, one sees that abstract expressionism influenced the development of many artists precisely because it was a critical intervention, an expansion of a closed turf. It was a site of possibility. The artist whose work served as a catalyst for my painting was Willem de Kooning. As a young student in the segregated South, where we never talked race, it was not important to situate a painter historically, to contextualize a work. The 'work' was everything. There are times when I hunger for those days: the days when I thought of art only as the expressive creativity of a soul struggling to self-actualize. Art has no race or gender. Art, and most especially painting, was for me a realm where every imposed boundary could be transgressed. It was the free world of color where all was possible. When I studied de Kooning's use of paint, those broad brush strokes, the thick layering of color, I was in paradise. To be able to work with paint and create textures, to try and make color convey through density an intensity of feeling—that was the lesson I wanted to learn.[19]

About the subject or theme of the subject matter, de Kooning himself said, "The Women had to do with the female painted through the ages . . . I look at them now [in 1960] and they seem vociferous and ferocious. I think it had to do with the idea of the idol, the oracle, and above all the hilariousness of it." Fineberg thinks the subject of the Women paintings includes "an attack on closed systems, finality, and any fixed way of looking at things" and that it embodies Rosenberg's notion of Action painting and its "fundamental assertion of existence, of being alive, of resisting dissolution in the chaos of modern life." Fineberg further writes that de Kooning's painting "nakedly shows the artist's method of working, a process which gives the canvas its characteristic unfinished look" and that for de Kooning "the complexity of the individual's experience, especially in the urban environment, was central."[20]

SEAN SCULLY'S PAINTINGS

Art critic Donald Kuspit, reviewing a 1999 exhibition of Sean Scully's painting, provides a good overview of the artist's work. Kuspit writes, "Scully reminds us that abstract painting is the grand climax of the romantic pursuit of the ineffable, and he achieves a sense of tangible intangibility through two methods. On the one hand, ingenious overpainting creates a certain murky atmosphere, for the shadow of the lower layers seems to fall across the upper layer, so that there is no conclusive surface, no clear difference between outer and inner—but a kind of painterly quicksand. On the other hand, Scully arranges many of his rectangles—they almost resemble Lego building blocks—alongside one another in units of three, forming squares or rectangles. But sometimes one unit is missing, and some squares are larger than others, disrupting the neatness of the serial sequence. Moreover, the painterliness softens the geometry—edges are not always firm and straight—and the geometry contains the painterliness, so that it seems peculiarly concentrated, almost solid."

Kuspit then offers a particular analysis of one painting, *Wall of Light White* (**Color Plate 14**), saying the painting "is composed of twelve such 'squares,' each comprising two or three rectangular bands of color. In one square a soft blue-gray rectangle lies horizontally sandwiched between two black ones, while another square consists of a black band nestled vertically between two grays. Again and again geometric and color patterns reverse, destroying the symmetry of each row and the effect of a stable all over pattern and generating a tension that is never resolved. The grid is 'off' and oddly restless. The surface trembles, as though registering unpredictable oscillations. And through it all—through the very fiber of the paint—a strange light, dim but vital, shimmers. . . . Imbued with this odd, impacted light, at once gloomy and elated, Scully's paintings become peculiarly urgent, secretive, and intimate."[21]

An Intentionally Restricted Vocabulary

"Scully can be seen as relying entirely on two elements: the vertical and the horizontal, each of which is given a single attribute—the color is either light or dark." This characterization of Scully's painting is written by an art critic, Armin Zweite. Zweite continues, "Looking at Scully's oeuvre as a whole—his paintings, watercolors, pastels, and prints—one is struck by the exceptionally limited repertoire of motifs, comprising vertical and horizontal stripes of varying lengths and breadths, occasionally augmented by diagonal lines."[22] Critic Lynne Cooke observes that "the stripe has long held a multitude of possibilities for Scully, narrowing at times to line, expanding at others into bands, zips, zones, vectors, even blocks" and that in the 1990s the lines have metamorphosed into "tesselations on a checkerboard."

Ned Rifkin, curator of a large retrospective exhibition of Sean Scully's work, notes that the artist chooses to work within a purposely limited self-imposed vocabulary, restricting himself to only a few visual motifs. Rifkin praises the artist for his consistency, tenacity, and resourcefulness with a confined range of visual tools: "regular widths of bands or lines placed immediately adjacent to one another; no space and only the slightest emanation of light out of the darkness." According to Rifkin, Scully "struggles to define and play with nuances of values, distinctions between acrylic and oil paints and how they hold, reflect, and absorb light, and oppositions of horizontal and vertical linear elements." Rifkin admits having an "orgasmic twitch" in seeing a "little visual caress" when one band of paint crosses another.[23]

The artist himself reinforces these insights by the curator and critics when Scully says that in his work "there's an endless process of cannibalization and recycling and reinterpretation and material being reused, over and over and over again." Something as particular as the "edge" is for him a major element in his paintings: "the way things abut, the way things are cut, abbreviated, truncated."[24] Scully also asserts that his paintings are about much more than formal explorations of this limited vocabulary: he expresses a strong desire "to make more than mere art, more than mere artifacts."

For Scully, his paintings are metaphors of life: "My work is based on structures that I believe express human nature." Scully says that he wants "to make a painting that really somehow empowers the person looking at the painting." He wishes that viewer to "get to the spirit through the physical, or through the sensual."[25] For him, his making of paintings is a moral activity and an ethical stance: he wants to show that "the way you do something is very important." He says that confrontations with "good and evil" are deeply embedded in his work. Scully freely admits his passion, sincerity, and empathy and asserts that in his work "irony has no place."

Scully says, "There are two zones of reality. One is the mundane and the physical in which we are condemned to live, and the other is the zone of Art." The zone of Art, for Scully, is a zone of spirituality. His notion of spirituality is "connected to an intensity of empathy and identification with human life." It is a spirituality that does not refer to religion. He thinks "our spirituality is in ruins" and he wants to make art that

addresses this major problem. "I think abstraction is best suited to this. . . . I believe with elemental forms painted from deep within the self, it is possible to make something empathetic that addresses the architecture of our spirituality."[26]

Conjunctions of Opposites

Scully identifies specific themes in his work including power, survival, competition, the tyranny of perfection, staircases and ladders, masculinity and femininity. Scully says, "My paintings are very much about power relationships, or they're about things having to survive within the composition . . . the composition is a competition for survival. It's interesting that something tall can stand up and be in a composition, dynamically, and have to deal with something much bigger."[27]

Critics readily agree with Scully's perceptions of his own work. Cooke writes, "Scully invokes situations of power. Relationships of dominance, intimidation, competitiveness, rivalry and dependence permeate his works of the early eighties." She also writes that "Scully focuses on relations centered in power and hence on issues of domination and control. . . . That such relationships have recently become key issues in discussions of gender, race, ethnicity, and class cannot be coincidental."[28]

Critic Zweite writes that "Scully's pictures are always balanced on a knife-edge, seeking to reconcile the tension between part and whole, conflict and harmony, opaqueness and transparency, coldness and warmth, plane and space, expansion and restriction." In his paintings, "Scully is evidently playing on the opposition between the part and the whole, rule and deviation, order and disorder, but instead of exaggerating the contrasts and exploiting them to the full, he merely hints at their presence."[29]

- "To say that these are abstract paintings is neither to say that they are non-referential, nor that they are exclusively self-referential."[30]

Scully's paintings may not look like what he paints, but his works do refer to real things in the world and to experiences of the world. Scully says, "My works are not only about me. I want them to deal with something larger."[31] Zweite tells an anecdote about Scully one day walking to buy paints on Canal Street in SoHo, New York. When Scully walked by a post office he noticed the warning pattern of black and yellow stripes painted on the street. Scully found the painting of the stripes so energetic and bursting with raw immediacy that he went into the art supply store and bought the same colors to finish off the painting he was then working on, *Heart of Darkness*. Scully was responding to the vitality of urban life, but he was not painting a picture of the stripes: the painting is a reference to the stripes and to the vitality of the city. Abstractions refer to things and experiences and ideas without looking like them.

Zweite's point in relating this anecdote is to emphasize what he sees as Scully's "wish to liberate abstract painting from the ghetto of noncommittalism and hermetic

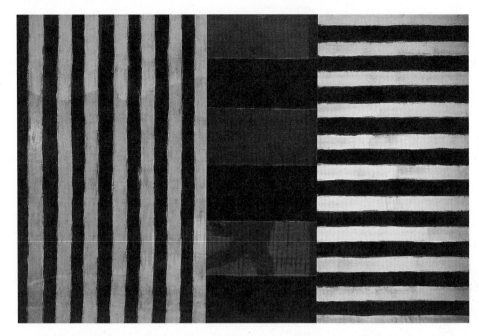

4-4 Sean Scully, *Heart of Darkness*. Art Institute of Chicago.

isolation, and to incorporate in his pictures a reaction, albeit of a highly indirect kind, to the realities of the city, of nature, of the individual and society."[32]

Many of Scully's paintings allude to interpersonal relationships. Some of the paintings directly oppose "feminine horizontality" and "masculine verticality."[33] Scully says that there is masculinity and femininity embedded in all his work. Some of Scully's paintings have paintings inserted within the larger painting, a small rectangle situated within a larger one, and Scully gives these paintings the names of women: Marianna, Helena, Eve, and Petra. He says that he made a painting for his grandmother, Helen, because he loved and admired her so much.[34] Combalia thinks that Scully's view of relationships became more complex over the years, and that in the late 1980s and 1990s the paintings that refer to relationships "have made a new appearance in the form of greater stability on the one hand, and a greater understanding of the complexity of relationships on the other. A new, more mature sense of balance, aimed at safety, but that has assimilated and accepted the multiplicity of this world which surrounds us. Is this a new metaphor for human relationships? Without a doubt."[35]

Scully says that he is content to live in the world without wanting definite truths. This requires of him the moral strength to tolerate such ambiguity. He refuses to give literal explanations of his work or his experiences and says, "When you have some-

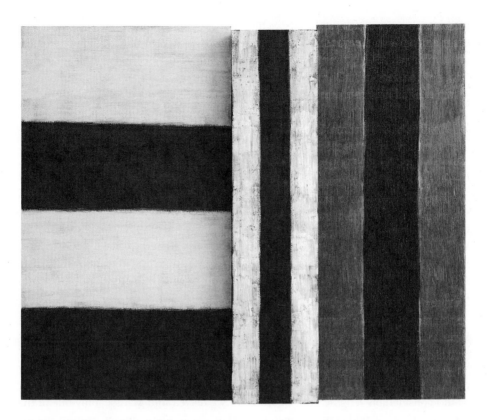

4-5 Sean Scully, *Paul.* Tate Gallery, London.

thing that, in a way, is incomplete, unfocused or unclear, the person looking at the painting is empowered to complete the painting."[36]

Scully's Biography: Natural and Aesthetic

Scully was born in Dublin, Ireland, in 1945, the son of a barber. He finished art school in 1968 and went on to complete a degree at Newcastle and graduated in 1971. Art for him was a "balm and a refuge" from a difficult, violent neighborhood in London. He has experience as a construction worker, attended graduate school at Harvard in 1972, and considers himself an American artist who is working with post-World War II American art. He is married to Catherine Lee and resides in Munich, New York, and Barcelona. In 1983, Scully lost his nineteen-year-old son, Paul, in an auto accident in London, and in 1984 painted *Paul,* a painting that Rifkin says contains sensuality and light seemingly emanating from within. Titles of major paintings from around this pe-riod such as *Backwards Forwards, Light to Dark,* and *Battered Earth* bear witness to in-

ternal crisis, according to Rifkin."[37] Scully first traveled to Mexico in 1983 where he began to make watercolors and he returned to Mexico between 1987 and 1990 for new sources of artistic stimuli. These brief facts are part of Scully's *natural biography*.

> • *"Painting is also, in the same way Hegel would say that philosophy is, above all, the history of philosophy, the history of painting."*[38]

Scully succinctly gives us his *aesthetic biography:* "If you have Matisse, Mondrian, Rothko, then you've got my work."[39] This statement presents perplexing problems for interpreting Scully's work. If we do not "have" Matisse, Mondrian, and Rothko, can we have Scully's work? Do any of us sufficiently "have" Matisse, Mondrian, and Rothko? What do interpreters of Scully's work need to know about these three artists? What does Scully require of interpreters, in order to say that they "have" these artists? What are interpreters to do when faced with this authoritative statement by the artist? Are we now obligated to delve into research about the work of Matisse, Mondrian, and Rothko?

We could try to make sense of the formula Scully has provided us for understanding his work, namely: Matisse + Mondrian + Rothko = Scully. We could look at paintings by these three artists and conjure relationships and additions that approximate Scully paintings. Additionally, we could now pursue all the works of Matisse, Mondrian, and Rothko, individually, and then relate each to Scully. Such pursuits, however, would considerably lengthen this book. Once we delved into Matisse, only one of the three artists, we would certainly encounter Matisse's aesthetic lineage or most important influences, which in turn would require more searching and looking and pondering of other artists in diverse places and throughout history and culture. Matisse's interests would direct us to inspirations Matisse found in non-Western art, in Polynesian decorative wood carvings, African fetishes, and textiles of ancient cultures of Central and South America. If we then took up a study of Mondrian and Rothko, we would be led to Holland, and then to the United States, and to two new sets of myriad influences. This would be one interesting way to proceed, but it is one that is beyond the intended scope of this book: this book is not a world history of visual culture, although a *thorough understanding* of any one image might require such knowledge.

Critics who write about Scully say that his work synthesizes Abstract Expressionism and Minimalism. Cooke, for example, says Scully's work is "a fusion of the transcendent aspirations of the one with the physicality, objecthood, and quiddity of the other."[40] That is, Scully's paintings can be seen as Abstract Expressionist works that have "transcendent aspirations" in that they seem to want to take us to the emotions of the artist and the existence of a world beyond the canvas. Minimalism is a more recent iteration of abstraction, and the Minimalist work of art tends to call our attention to its "quiddity"; that is, it asks us to see it as a *thing in itself,* and not as a narrative, nor as an expression of the artist's psychological state while he or she was

making it, and not as a metaphor. In the often-quoted words of artist Frank Stella, "What you see is what you see." But Scully's works ask you to see what you do not see, to see references in his use of minimal strategies of rectangles and colors. Scully wants his work to go beyond Clement Greenberg's critical dictum that Art should be about Art, *ars gratia artis*. Scully wants his work to be art about life. The scope of Scully's art is broader than self-referentiality: it refers to abstraction in the history of art, but the work wants to be looked at as *abstraction about life*. Scully's aim is to tap into "forms of experience which have to do with everyday life as well as the world of art."[41]

So in addition to investigating the three artists that Scully claims as essential to understand his work, we have the added requirement given to us by scholars to see that Scully synthesizes Abstract Expressionism and Minimalism. Does it take all this knowledge of recent art history to understand and appreciate the paintings of Sean Scully?

Appreciating Scully's *White Robe* Out Loud

And now we are back to an originating question for this chapter: What does it take to understand and appreciate an abstract work of art, Sean Scully's *White Robe* (**Color Plate 14**), for example? I want to see if I can make sense of *White Robe* without appealing to the recent history of art, to Abstract Expressionism and Minimalism, to Matisse, Mondrian, and Rothko.

To appreciate the painting, I can look directly at it while attempting to bracket out what I know of the history of art. I can look at what the artist gives me on the canvas and make meaning for myself about art and about life. I can enjoy it for what it simply offers. To do this requires an aesthetic attitude, a joyful willingness to look and to wonder expectantly and to forgo any need for certainty.

I see the painting's bands of black and white and gray. The whites are not really white, and the blacks are not really black. The painting is made of variations of grays, from very light to very dark, but because of the wide range of tones I read them as black, white, and gray. The white and the gray are different temperatures: the white is warmer than the gray. When the painting is reproduced in black and white, the painting's temperature changes are lost.

The black and the white and the gray are painted thickly. They are textured. I notice how the whites, especially, are brushed on. I can see undercoats, even in the reproduction. The strokes show a history of their making. The stripes are not made precisely, they do not have crisp edges, and they are obviously hand-painted. They are made by an artist, not by a machine. The handwork connotes the feeling of the artist.

I think of blackboards and chalk when I look at the painting. Then I think of white stripes on paved black asphalt. I can see the smaller rectangles as grates set into solid streets or alleyways in a city. I can look at it as a floor or as a wall. Even though the painting would be hung on a wall, I see it as referring more to a surface I would walk on than as a wall I might lean against. I think I would have associations with black-

boards and asphalt even if I had not read that Scully's paintings refer to such things in the real world.

The overall composition is horizontal, but within this whole horizontal rectangle are mostly vertical bands or stripes. Yet the painting seems to me to be equally balanced between verticality and horizontality.

The painting's proportions want to be noticed. The vertical gray stripes that form the two inset blocks are narrower than the black and the white bands. The gray inset on the right side of the painting is less tall than the gray inset on the left side. On the right the inset is a square; on the left, it is a vertical rectangle. I measure the insets on my reproduction with a ruler to make sure I am seeing accurately. The two insets are the same width, but the one on the right, though it looks to be square, is not: it is a vertical rectangle as well.

The painting is divided in half, vertically. The right vertical half is then composed of one square atop another. When I check with my ruler, I find that they are not squares, because they are wider than they are tall. Now that I know they are not squares, I see them as rectangles, but before I knew by measuring, they seemed to me to be squares. This painting reminds me to empirically check my perceptions.

The vertical line down the middle of the painting seems straighter and more precise than other vertical lines in the painting. Perhaps this painting is made of two vertical canvases bolted together from behind. I assume that the insets are separate canvases, set into the larger one or two. Or are there three large canvases with two small insets? The lower right corner of the painting could be a separate canvas. I cannot tell from my reproduction.

Although I am working from a reproduction, I have seen Scully exhibitions in person and easily recall how large the paintings are. *White Robe* is over eight feet high and ten feet wide, two feet taller than I am and much wider than I can reach. I like it small, as well as large. Some art reproduces better than other art.

Around the time that we married, my wife, Susan, sent me a greeting card that had on the front of it Scully's *White Robe*. Before we met, she and I had both independently come to greatly admire his work. Early in our relationship, Susan and I shared a black, white, and gray plaid robe made of flannel. It is reminiscent of Scully's *White Robe*. I don't know if Susan had our robe in mind when she chose this Scully card for me. Because Scully says that many of his paintings are about relationships, I am encouraged to think about Susan and me and *White Robe*.

I see Susan as the smaller rectangles, engulfed by me, the larger rectangles. I see her nestled within me. She is strong and whole and independent but able to be held and embraced. I can reverse and be the smaller within the larger. Although the smaller rectangles take up considerably less space than the larger surrounding rectangles, they hold their own and garner equal attention. They have stability and perhaps stabilize the whole painting. They are compressed and solid energy. They could be removed from the painting and hang well on their own. Were they removed from the painting, the larger painting would have two noticeable absences, holes, missing parts.

The painting is built like a relationship is built. The relationship is built of black and white, vertical and horizontal, one, two, one, two. I am glad that the black and white are not so clearly black or white, that they are modulated, the black by the white, and the white by the black. These are not dogmatic statements in black and white, but strongly asserted blackish and whitish statements that reveal influence on one another. The painting is not built randomly, nor is the relationship. One stripe answers another stripe, one event is built on a prior event, and one rectangle resonates with another rectangle.

The parts fit comfortably within each other. Neither dominates the other. Although the relationship is based on simple things, blacks and whites, stripes and stripes, verticals and horizontals, there is much to hold my interest. The painting is strong, condensed, and contains a lot of energy within its edges.

The painting is like a good relationship also, in that it has established good boundaries. The black knows where it ends and the white knows where it begins, although the black and the white have some of each in each other, and although the position of one white stripe clearly influences the position of the black stripe next to it. They are individuated and distinct. This is not a de Kooning *Woman* who has no boundaries, who cannot distinguish herself from her background or the person next to her. A de Kooning *Woman* is out of control, out of herself, invasive to her surrounding environment, without clear boundaries of where she ends and another begins. To be in relationship with a de Kooning *Woman* would be psychologically threatening, even physically threatening, because she observes too few boundaries.

In *White Robe,* I wonder if Susan is black and I am white. I'd want to be the white simply because there is more of it: there are twenty-four white bands and twenty-two black. More of the white in number might be needed to balance the weight of the black. I wonder what Susan would pick to be, if she were to be the black or the white, the small inset rectangles or the larger.

Interpretations by Teenagers

Young high school students without prior knowledge of Scully, of Minimalism and Abstract Expressionism, or of general art history are able to interpret relationships in Scully's paintings. Each year, for many years, Sean Scully has given his wife, Catherine, one of his paintings; these have become known as the *Catherine Paintings* (**Color Plate 15**). When shown a group of *Catherine Paintings,* 1982–1996, and asked what they could infer about Catherine, Sean, or their relationship, this is what some freshman and sophomore boys and girls wrote.[42]

Mike sees "two views of Catherine . . . Catherine in the world. She only stands out a bit. The other is Catherine in his world, the only thing in view, the dominating part." Shelly thinks "the colors that can be seen underneath the whole painting show a link, a bond, they [Sean and Catherine] will always share, no matter who they are or where they are. They'll always be connected despite the whole picture." Patti says that who

Catherine is "inside and outside are not in agreement, but she [Catherine] is still the same person underneath. She may feel trapped but she is also not very willing to open up. Her personality is separated or torn between two selves." Karen wrote that the paintings "represent a life very well. At times we are happy, but other times we're sad. Sometimes we're outcasts, other times we seem to fit in. We all change over time, just as Catherine changes in the paintings. Catherine is a good representation of all of us going through our lives." Mike wrote, "Catherine represents the struggle all of us share in survival. She conforms so she is not an outcast, yet she is an individual with her own feelings and ideas." Megan wrote, "Catherine is this amazing, complex woman that totally fascinates her husband, the artist. She is his earth, his sky. Catherine is a standout in a conformist society and maybe that's why he adores her. She must be so many wonderful things rolled into one, so many parallels and contrasts."

CONCLUSION

Abstraction is more complicated than we may have first assumed. Terms used to discuss abstraction in art can cause confusion and misunderstanding. For example, a current art textbook defines 'nonobjective, nonrepresentational art' as "a type of art that is entirely imaginative and not derived from anything visually perceived by the artist. The elements, the organization, and their treatment by the artist are entirely personalized and, consequently, not associated by the observer with any previously perceived natural objects." Willem de Kooning and especially Sean Scully would presumably be aghast at such a definition. Scully's work is clearly abstract, yet according to the artist and to scholars who write about his paintings, they are certainly referential and are certainly derived from what Scully has seen in the world and has experienced as a person.

In response to some often-heard skeptical objections to abstraction, we now can offer some answers. To the accusation "That's not art!" there is a simple distinction that can prove very helpful. The distinction is between the use of the word 'art' as a *descriptive* term or as an *evaluative* term. Its two uses are often conflated to mean the same thing, but they do not. To call a de Kooning a "painting" is to identify it as a certain kind of thing and to distinguish it from other kinds of things. It's a piece of art; it is not a cherry pie or a baseball bat. Knowing that it is a piece of art, we would look for it in a museum or artist's studio, not in a bakery or a baseball park. Saying "That's a work of art" in this descriptive sense is not to praise it, but to identify it, in the same way that saying "That's a cherry pie" is not to say that it's necessarily a *delicious* cherry pie. But we also use 'art' in an evaluative sense, or in an *honorific* sense. When we do this we imply or assert that the object to which we refer *deserves* to be called a work of art. It deserves the honor. Thus when some people say, "That's not a work of art," they mean that it is not a good work of art and does not deserve the honorific title of art at all.

When those with a minimum familiarity with recent art look at what de Kooning has made, they see something that looks to them like a work of art, something that

acts like a work of art, and they respond to it as work of art and not as a cherry pie. It is made of materials that are used by artists; it hangs on a wall in a museum; it has a wall label; it is under the protection of a security guard. It is a piece of art. That is not to say that it is a great work of art, nor the best painting ever made, nor the best of de Kooning's paintings. It is to acknowledge, however, that the art museum in which it hangs considers it a work of art and one that is worthy of collection and preservation.

Once we know that an object is a work of art, then we can proceed to discuss how it came to be a work of art, how and why it is considered to be worthy of collection and preservation. The distinction between art and non-art is simple and helpful for moving discussions forward: "OK, let's agree that it is in the class of objects called 'art,' and now let's consider whether we like it, or want to own it, or hear why the museum thinks it is worthy of collection and preservation." Making the distinction this way is helpful for cases where artists make objects of art that are difficult to distinguish from ordinary objects—Andy Warhol's famous *Brillo Boxes,* for example. Here the distinction is paramount: a box of Brillo pads in the grocery store is for household cleaning; *Brillo Box* in the museum is a work of art. Like it or not, to figure out how the two things are different is to engage in discourse about twentieth-century art.[43]

To the irate claim made to someone or no one in front of a Willem de Kooning *Woman*—"I could have done that!"—we can respond, with courtesy, "But you didn't. He did. Had you made them, we would be talking about your work and not his." Not only did de Kooning paint that one, he painted a whole series of them. They are large. They took a lot of materials and energy. He did them over many years, reflected on them, and then came back years later and made more *Women,* working even when physically debilitated and unto his death. It was a life commitment, not a one-time slash with a paint-covered brush. Before he made the paintings for which he is better known, he studied art. While he was making them, he was part of a loosely connected professional community composed of other artists, critics, curators, dealers, all of whom took his and their work seriously. De Kooning was making these paintings with the knowledge that he was making works of art. They were seen as such by a community of people interested in such things, and they talked about them, and wrote about them, and valued them as good works of art, for reasons offered in this chapter. People bought them and preserved them so that future generations might also enjoy them. De Kooning was an integral part of this community that we call an 'art world.'[44] There are many art worlds, around the world and in your local community and throughout history and across cultures. People within the art world inhabited by de Kooning and his paintings and sculptures are generally comfortable with de Kooning's work because they generally know how to look at it. It is the purpose of this book to enlarge that art world of appreciative viewers.

If some individual, cleaning out house-painting brushes on an old piece of plywood in the garage, happened to make marks that looked like one of de Kooning's paintings of women, we would not have a de Kooning nor something as aesthetically or economically valuable as a de Kooning, even though the garage smears look like a

109

de Kooning. We could certainly look at the smears *as if* they were a de Kooning, and we could enjoy an authentic aesthetic experience when looking at the plywood with its intriguing set of marks. Artists and critics and curators and collectors would not likely give the plywood much attention, were they to even know about it. However, had that house-painting individual, upon seeing the accidental abstraction, become enthralled by its possibilities, and gone on to make many more of these, and reflected upon them as works of art, and begun showing them to others, and spent the next decades of his or her lifetime making things like this, and varying them, and showing them to other artists and getting their insights, and seen this work in relation to the work of de Kooning and other abstractionists, the brush cleaner would now be making what we call art. It might even be good art. If this person were sufficiently committed and energetic, showed the work around, and got some breaks, he or she might even make a living making paintings.

More likely, when the house painter made accidental marks on the plywood, even if he or she recognized these marks to be like a de Kooning painting, it is most unlikely that the house painter would then be converted to a lifetime of making such things. De Kooning, on the other hand, chose to spend his whole life doing such paintings. Rather than selling stocks and bonds, or shoes, or breakfast cereal, he made pictures, albeit pictures that looked strange and unskilled to many people. But he continued making them, and by doing so he expanded our notion of what art can look like and showed us an alternate way to spend one's lifetime.

To the response that "My three-year-old could have done that!" we can reply, politely, "No, your child could not have." Simply, because of the child's age, he or she does not have the storehouse of life experiences that de Kooning brought with his brushes to his canvases. The child does not have the experiences of 'mother' that de Kooning had, nor of 'women.' Because of the child's age, he or she has different experiences of 'mother,' and probably more positive experiences of 'mother,' than de Kooning seemed to have had. Your three-year-old child simply does not have the intellectual or emotional capacity to do what de Kooning did.

A stronger, though longer and more tedious, answer to the skeptical objections of "this is not art" could be in the form of a historical answer, showing how one de Kooning painting is set within the context of hundreds of paintings by the same artist, to show how one work of art emerged from another and how one painting inspired the next, and then to take the skeptic to a further remove and explain how one de Kooning is situated within post–World War II abstraction, in Europe and in the United States, and within other styles, movements, and art ideas to which his work contributed. If you are going to reject any de Kooning with a sneer, then you will also likely have to reject a whole century of work by many artists here and abroad and the ideas of all those people who have studied it and admire it. Rejecting a century of work from different continents might be more onerous than dismissing one canvas by one artist whose work is unfamiliar to you.

Interpreting Old and Foreign Art

THE TERMS *old* and *foreign* are both relative terms. *Old:* What is new to me might be old to you. *Foreign:* Foreign to whom? What is foreign to me is common to many millions of people. *Old* and *foreign* also frequently come laden with values. An old thing might be enduring, continuing, long-lasting, constant, perpetual, solid, steady, and irreplaceable. On the contrary, an old thing might also be considered along in years, old hat, decrepit, feeble, infirm, declining, antiquated, archaic, bygone, Neanderthal, old-time, outdated, and due for replacement. Synonyms for *foreign* in a thesaurus include strange, exotic, exciting, incompatible, incongruous, inconsistent, distasteful, obnoxious, repellent, and repugnant. All too frequently, in social and cultural contexts, foreign is other, and the other is threatening. Because the other is interpreted to be a threat, she, he, or it is eliminated, frequently with violence.

The further removed from one's own lifetime and one's own culture one gets, the more difficult it is to understand and appreciate the times and cultures of others and what they have produced. The consequences of interpretation can be very serious. Today and in the past, when faced with people different from them, the groups with the power often have segregated, enslaved, and/or eliminated the weaker groups. When faced with art and artifacts different from their own, the groups with the power often interpret differences to be dangerous and destroy the material culture of others. The world, for all time and for all subsequent persons, loses what someone has interpreted to be too foreign or too old.

This chapter examines the interpretive study of art that is historically old and art that is foreign to us by looking at examples of Western paintings and at a magnificent architectural structure with sculptures from the East. These examples are selected to illuminate questions and answers, challenges and solutions, to interpreting art that is

unfamiliar because of its age or location. This chapter is not a comprehensive story of world art through time and across cultures. The examples, however, provide insight into challenges of understanding and appreciating much world art. About historical art, we generally wonder, What did it mean to them, then? What can it mean to us, now? About culturally different art, of the past and present, we generally wonder, What does or did it mean to them, there? What can it mean to us, here? When asking these questions, who *them* refers to constantly shifts, depending on the context we are in when we ask the questions. When looking at material evidence, interpretive questions become more specific and empirical rather than philosophical, anthropological, or personal.

Art historians Andrea Kirsh and Rustin S. Levenson refer to their study of works of art as "technical examinations," which they define as the study of artists' techniques with a close look at the actual work in available light. They distinguish this looking from high technology examinations with sophisticated specialized equipment. Although they sometimes use technology, their studies always begin, and often end, with *close looks with their natural sight.* They understand that much interpretation rests on *material evidence* that works of art provide. As historians interested in material evidence, these are the questions they ask and attempt to answer about works of art:

Is the painting correctly dated?

What is the painting's condition, and how closely does it resemble its original appearance?

Is the format original, or has it been reduced, enlarged, or otherwise altered? By the artist, or by later hands?

Have the color relationships changed since the work was painted?

Are there repainted areas?

Does the painting betray evidence of change through use? Has a religious image been updated for iconographic or liturgical purposes?

Was a group portrait altered to account for a birth or death, or was a fragment of a religious work 'secularized' to appeal to the art market?

Did more than one artist produce the work?

How did the artist(s) achieve the effects?

Were the painting's materials or technique chosen for theoretical or political reasons? Are they part of a larger debate about the role of culture?

Did contemporary criticism influence the technique?

Does the technique reflect the artist's education, travels, or exposure to foreign artistic traditions?

Were substantial changes made during the painting's execution?

What is the relation among known variants of a painting?[1]

MATERIAL EVIDENCE AND EXPLANATION
OF *THE FEAST OF THE GODS*

J. Carter Brown, director of the National Gallery of Art in Washington, D.C., calls *The Feast of the Gods* (**Color Plate 16**) one of the most important paintings in its collection. The painting was made by two famous Italian artists of the Renaissance, Giovanni Bellini and Titian. "Two great artists in one great painting," declares a current historian, David Bull.[2] The painting is even lauded by Giorgio Vasari in his famous *Lives of the Most Eminent Italian Architects, Painters, and Sculptors,* written in 1568. Vasari called it "one of the most beautiful works that Giovanni Bellini ever created" and said that since Titian "was better than all others," he was summoned to complete it.[3] As renowned as the painting is, however, there are many things unknown about it.

Between Bellini and Titian, who painted what and when? Bull and fellow historians and conservators now at the National Gallery have discovered that the painting was radically altered twice, within fifteen years after Bellini first painted and signed it in 1514. Bull asks three main questions about *The Feast of the Gods:* "First, how extensive were these alterations? Second, if we accept that it was Titian who made the final alteration, who made the first change to the Bellini composition? Third, why were these alterations made?"[4]

> • *Different interpreters ask different questions of works of art.*

Bull details some of what is known about *The Feast of the Gods.* Alfonso d'Este, Duke of Ferrara, a man of import and wealth in sixteenth-century Italy, commissioned Bellini to paint *The Feast of the Gods* and also commissioned Titian to make three other paintings, all for the decoration of private rooms in an elevated passageway linking the castle and the palace in Ferrara. Alfonso's hope was to bring together in one room the work of the finest living painters in Italy. He failed to do this, but Bull states that he did manage to acquire four "superb" Venetian paintings. They are Bellini's *The Feast of the Gods* and Titian's *The Worship of Venus* and *The Adrians,* both of which are now in the Prado in Madrid, and *Bacchus and Ariadne,* now in the National Gallery of London. In addition, Dosso Dossi, a court painter at Ferrara, contributed a frieze, *Bacchanal of Men,* and Dosso and his brother Battista Dossi painted ceiling decorations.[5] A letter written by Alfonso in 1514 authorized final payment to Giovanni Bellini for *The Feast of the Gods.*

Historians are able to accurately trace the succession of owners of *The Feast of the Gods.* Bull writes that in 1598, when the Este line of succession failed, the City of Ferrara reverted to the papacy. Cardinal Pietro Aldobrandini took possession of the castle in the name of Pope Clement VIII and dispatched the most important paintings to Rome. *The Feast of the Gods* remained with the Aldobrandini family until 1797, when it was purchased by Vincenzo Camuccini in Rome, where it remained until

Camuccini's death in 1844. After that it went to Alnwick Castle in England in 1856, and it was bought by Joseph Widener in 1922 and hung in Lynnewood Hall in Philadelphia, until it was given to the National Gallery of Art as the "central star" of the Widener Gift in 1942.

In 1956, John Walker, then director of the National Gallery, undertook a study of the styles and tastes of Bellini and Titian, and published a book that celebrates *The Feast of the Gods* and that includes reproductions of X-radiographs of the painting. Since the publication of Vasari's *Lives* during the Renaissance, historians had known that Titian had repainted most of Bellini's landscape behind the foreground figures, and Walker's use of the X-radiographs revealed glimpses of the original Bellini composition, along with changes and additions to Bellini's figures made by Titian. Walker also discovered a surprising and totally unsuspected alteration to Bellini's landscape that seemed not to have been made by Titian. Why Titian had repainted Bellini's painting was still unknown, and now there was a newly discovered mysterious alteration painted by someone else. Further examination of the painting was severely limited by the painting's very thick, discolored and partially opaque varnish that had been applied at different times over the centuries.

In 1985 the Trustees of the National Gallery of Art allowed restoration of the canvas, including the removal of its varnish, and scientific study of the painting. David Bull carried out the work of restoring, studying, and writing about the painting with the acknowledged help of historical scholars of the Southern Renaissance, the scientific staffs of the National Gallery in London, and the National Gallery in Washington and its conservators, photographers, and librarians. Bull's monograph on the painting was published five years later, in 1990, along with a report by Joyce Plesters of her very technical investigation of the materials of the painting and the techniques of the painters.

What follows is some of what Bull discovered, including factual claims and his evidence for them, along with his acknowledgments of what remains speculative about the painting. When the heavily varnished painting was removed from the Gallery wall, Bull described it this way: "The figures seemed without animation, subdued in color, and overhung by an ominously heavy, dark brown landscape." The painting had been framed with an enormous mid-nineteenth-century tabernacle frame that further diminished the painting itself. The conservators removed the frame and found that the fine-weave original canvas had been lined with an equally fine canvas and the lining bore wax seals of Vincenzo Camuccini. The lining was about a hundred and ninety years old. The canvas and the lining were in "a remarkably plastic and sound state for their age." Through tests they found the varnish to be readily soluble and removed it. According to Bull, removal of the varnish "revealed much of the extraordinary color and tonal range of the painting."[6]

A subplot quickly developed to the main storyline of Bellini and Titian both painting the same canvas. Bull and the conservators discovered that, around the time when the canvas was lined, the painting was also cleaned, but "harshly," resulting in damage and "gross overpainting" in spots. The prior harsh cleaning had permanently damaged the

orange robe of Silenus: the Venetians were particularly known for their color and Bull writes that "this once glorious orange so typical of this period of Venetian painting has now been lost." Bull states that evidence "convincingly incriminates Camuccini." His evidence is twofold: the overpaint medium and an engraving. The overpaint medium was analyzed and is likely nineteenth century in origin. More convincing evidence comes from an engraving made in 1823 of *The Feast of the Gods*. The engraving indicates that parts of the painting had already been changed by overpainting before the engraving was made, most likely when the painting was owned by Camuccini.[7]

Why did Titian alter Bellini's landscape? Vasari in his writing in 1568 seems to offer a simple answer: "Unable to carry through this painting completely because he [Bellini] was very old, Titian was summoned, since he was better than all others so that he may bring it to completion."[8] Although many historians believe Vasari's account, Bull does not. Bull argues that the canvas bears Bellini's signature and date of 1514, and the final payment for the painting was made in 1514, and Bellini did not die until 1516. After an exhaustive search of the painting, Bull could find no evidence that it was not completed by Bellini. Bull argues that Vasari used the word *opera* to refer both to work and the painting, and when Vasari was writing about the *opera* being unfinished, he was referring to the room in which *The Feast of the Gods* hung.

Based on his study and analysis of available evidence, Bull believes that the first alterations to Bellini's *The Feast of the Gods* were likely made by Dosso Dossi, a court painter of Alfonso's during the time Alfonso commissioned the painting. Bull thinks that sometime after Bellini's death and before Titian became involved in completing the decoration of the room, probably between 1514 and 1519, Alfonso had Dosso alter Bellini's background landscape to enliven the painting. Bull writes, "It must be assumed that Alfonso had found Bellini's concept for a Bacchanal too archaic for his taste, lacking in spirit and energy."

Bull conjectures that, when Titian had finished his three commissions for the Camerino and they were hanging together with Bellini's *The Feast of the Gods,* Dosso's alterations would have seemed crude and stylistically out of place. (Bull physically reconstructed what he thinks the Dosso-altered Bellini would have looked like.) Titian, uncomfortable with Dosso's alteration of Bellini's landscape, would have repainted it to bring it into harmony with his own three paintings, which hung alongside it. There are records indicating that Titian and four assistants stayed at the Camerino for eleven weeks after the room was completed, and according to Bull "Titian's repainting of the landscape in 1529 seems logical." Dosso had added the pheasant in the tree to Bellini's background landscape and Titian chose to keep it, but Bull does not know why—"the two men were separated by a vast distance in reputation, talent, and creative genius."[9]

When Bull and the conservators removed the dark varnish on the painting, it also became apparent that the leaves and grapes around the waist of the satyr with the blue-and-white bowl on his head had been painted over. When Bull and the conservators removed these "false additions" with solvents, "subtle and delightful brushwork" was revealed, as was the fact that the satyr has furry thighs. More significantly,

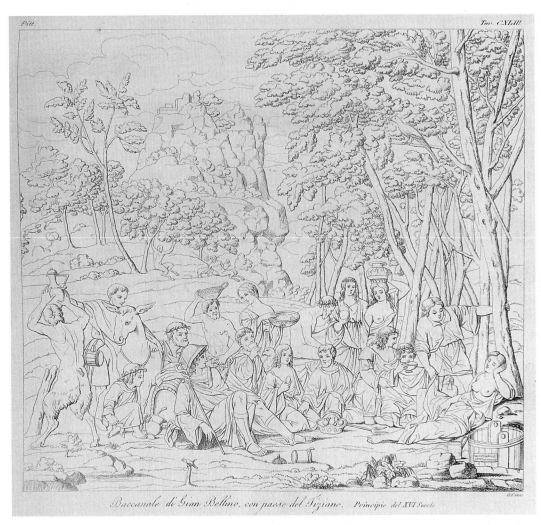

5-1 *The Feast of the Gods,* engraving from Seroux d'Agincourt, 1823.
Identities of the foreground figures, from left to right: satyr, Silenus, infant Bacchus,
Silvanus, Mercury, satyr with bowl on his head, Jupiter, Nymph with a bowl, Cybele,
Pan, Neptune, nymph with her hand outstretched, nymph with a crock on her head, Ceres,
Apollo, Priapus, and Lotis. Photo © 2002 Board of Trustees, National Gallery of Art, Washington, DC.

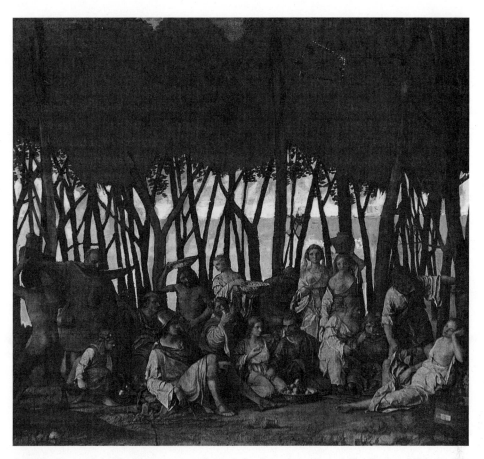

5-2 *The Feast of the Gods,* reconstruction of the first alteration of The Feast of the Gods, David Bull. Photo © 2002 Board of Trustees, National Gallery of Art, Washington, DC.

Bull also saw that the hair of the nymph holding the blue-and-white bowl had been painted over, and, when that paint was removed, her hair was revealed to be amber-colored and flowing and once again has become "a most important part of the com-position." Bull explains that the source for *The Feast of the Gods* is Ovid's story of Priapus and Lotis. Ovid's story "tells how Silenus' ass brays and wakes up the gods, who then see Priapus caught in the act of trying to ravish Lotis. The swing of the nymph's hair supplies the only display of movement within the framework of the other static figures, suggesting that her head was quickly turned at the sound of the braying ass. The angle of her hair and the pose of her body, placed in the center of the figures, neatly link the braying ass with the figures of Priapus and Lotis."[10]

Almost in passing, to illustrate the importance of having uncovered the nymph's hair, Bull relates Ovid's story of Priapus and Lotis, the theme of the painting. It is

likely that Bull assumes that readers of his monograph would already know the subject matter and narrative of *The Feast of the Gods*. In his study and report, Bull is not interested in these aspects of the painting because he has asked a different question, namely, Why are there so many alterations to it?

When they write about *The Feast of the Gods*, the authors of *Gardner's Art through the Ages* have a different interpretive purpose in mind than does Bull, and they begin by offering the subject and story of the painting as Bellini derived them from Ovid. Different historians and different interpreters have different purposes in mind when they interpret, different questions to answer. While Bull was answering specific questions about who made the painting and when, the Gardner authors offer a general interpretation of *The Feast of the Gods,* situating it within stylistic developments of the Renaissance and particularly within the question of what artists living in Venice contributed.

> Bellini's source is Ovid's *Fasti,* which describes a banquet of the gods. The figures are spread across the foreground: satyrs attend the gods, nymphs bring jugs of wine, a child draws from a keg, couples engage in love play, and the sleeping nymph with exposed breast receives amorous attention. The mellow light of a long afternoon glows softly around the gathering, touching surfaces of colorful draperies, smooth flesh and polished metal. Here, Bellini announces the delight the Venetian school will take in the beauty of texture revealed by the full resources of gently and subtly harmonized color. . . . The atmosphere is idyllic, a lush countryside making a setting for the never-ending pleasure of the immortal gods. The poetry of Greece and Rome, as well as that of the Renaissance, is filled with this pastoral mood, and the Venetians make a specialty of its representation. Its elements include the smiling landscape, eternal youth, and song and revelry, always with a touch of the sensual.[11]

Bull's account of the painting and that of the Gardner authors are different because they serve different purposes. The accounts are complementary to each other and add to our understanding of an old and foreign work of art, especially in its own time and context, that of Renaissance Venice. When analyzing the painting and writing his monograph about it, Bull was specifically interested in establishing historical facts about the painting: who made it; when, how, why it was altered; and how it came to look the way it does today. In attempting to establish a factual and historically accurate account of the physical object of the painting, he examined documentation pertaining to the painting written around the time it was created, compared the stylistic and painterly tendencies of Bellini, Titian, and Dosso paintings to the painterly techniques evident in *The Feast of the Gods,* and relied on scientific instrumentation to draw his conclusions. He carefully identified what he considered to be fact and distinguished fact from speculation.

Bull's account of *The Feast of the Gods* enlightens us about the painting based on his examination of physical properties of the work and knowledge of the time when it was made. In his monograph, he does not express interest in what relevance this old

painting might have for him, or for us, now in the twenty-first century. Following, however, is an example of a writer who considers some old paintings for what they mean to her and what they might mean for us today.

OLD ART AND CURRENT RELEVANCE: PAINTINGS BY JOHANNES VERMEER

A predominant theme of this book is to encourage readers to make art relevant to their lives through interpretations. When looking at old art, the challenge seems larger than with art made by artists of one's own time and place, about issues of one's own day. Deborah Solomon, an art critic for the *New York Times,* is an example of one who is able to make relevant the art of the past, specifically paintings by Johannes Vermeer. Vermeer is an acknowledged master of the Western tradition, but he produced only thirty-seven paintings that we know of, and little is known about his life. Vermeer (1632–1675) was a seventeenth-century Dutchman who lived in Delft, Holland. He is known by historians as having taken realism to "its greatest heights" through his scientific exploration of optics and his use of a *camera obscura,* a photographic device that projected images through a pinhole onto a darkened wall, allowing artists to render images in perspective, giving the illusion of three dimensions. He also approached color scientifically, discovering, according to *Gardner's Art through the Ages,* that "shadows are not colorless and dark, that adjoining colors affect one another, and that light is composed of colors."[12]

Amazingly, given that he is so revered artistically, Vermeer received his first retrospective exhibition ever only in 1995, in Washington, D.C. and The Hague, Holland. When the second part of that exhibition, "Vermeer and the Delft School," came to the Metropolitan Museum in New York City, Solomon posed this question for herself and her readers: "What is it about Vermeer's pictures that allows them to speak so forcefully to the current moment?" Her short answer is the absence of noise. Her longer answer is her understanding of the sovereignty Vermeer gives to women.

Solomon writes this about one of Vermeer's more renowned paintings: "*Young Woman With a Water Jug,* that daydreamy picture from the 1660's. It shows a room where a woman stands in her royal-blue dress, gazing absently toward a window. Although she's holding a silver pitcher, her distracted expression suggests a suspension of her womanly duties. One imagines that she is taking a respite from a busy household, from bawling children and mounds of laundry. The space around her is a kind of clear fog—deep, dense, enveloping—and seems like an extension of her inner life."[13]

Solomon explains that Vermeer's work has meant different things to different generations. Nineteenth-century intellectuals saw his paintings as a defense of democratic ideals. Twentieth-century intellectuals saw him as a precursor of abstraction, admiring his sense of geometric design, long before Mondrian reduced Vermeer's rooms into colored grids. For Solomon, the meaning of Vermeer's paintings is more personal.

119

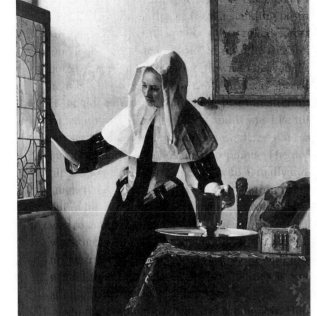

5-3 *Young Woman with a Water Jug,* about 1665, Johannes Vermeer. Oil on canvas, 18 x 16 inches. The Metropolitan Museum of Art, Marquand Collection, Gift of Henry G. Marquand, 1889 (89.15.21).

Solomon acknowledges that Vermeer idealized what he saw: "Real women are not as serene as the ones he painted, and real rooms are not nearly so calming (nor so dust free)." This does not diminish her view of him, and she has personal admiration for him: "To me, he's the painter who honored the sovereignty of women by giving them their own space—pictorial space, that is. His paintings are beautiful to the eye because they bring us life as glimpsed through his eyes, eyes that found infinite pleasure in the sight of a room where a woman stands silently by a window."[14]

When referring to another renowned Vermeer, *Young Woman with a Pearl Earring,* Solomon tells us, "Like other Vermeer female subjects, it is impossible to know who she is, where she is, and what's going on. His paintings are narratives with missing plots." This girl in Vermeer's painting has also become the central character in a best-selling novel. In *Girl with a Pearl Earring,* Tracy Chevalier, an American novelist, invents this identity for the girl: she's a tile-maker's daughter and a live-in maid for the Vermeers in Delft who falls madly in love with the artist. Chevalier's fictional account of the painting serves as another interpretation of it.[15]

Contrast Solomon's and Chevalier's interpretations of Vermeer's paintings with this more expected, and informative, description by Arthur Wheelock, an art historian:

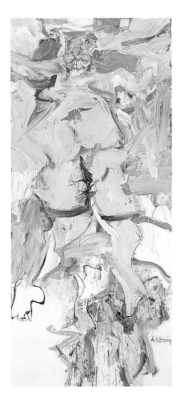

12 *Woman, Sag Harbor,* 1967, **Willem de Kooning** (1904-1997). 80 X 36 inches. Hirshhorn Museum and Sculpture Garden, Smithsonian Institution, Gift of Joseph H. Hirshhorn, 1966. Photo © Lee Stalsworth. © The Willem de Kooning Foundation / Artist Rights Society (ARS), New York.

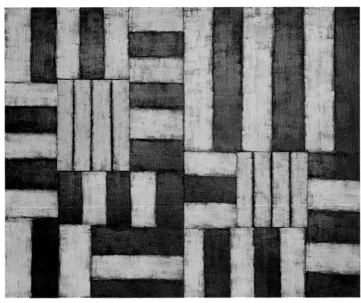

13 *White Robe,* 1990, **Sean Scully** (1945-). Oil on canvas, 244 x 305 cm. High Museum of Art, Atlanta, Georgia, USA

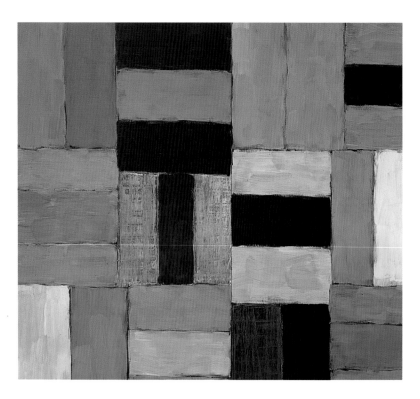

14 *Wall of Light White,* 1998, **Sean Scully** (1945-). Oil on linen, 96" x 9'. Private Collection.

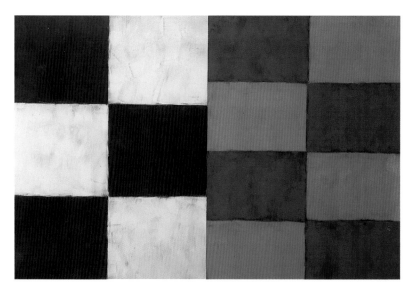

15 *Catherine,* 1994, **Sean Scully** (1945-). Oil on linen 274 x 411 cm. Fort Worth Museum of Modern Art

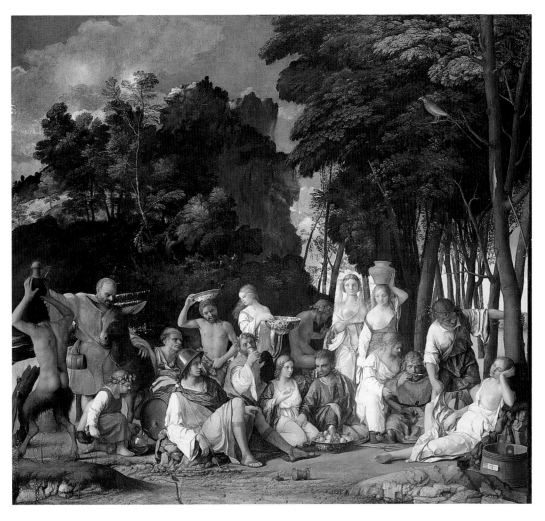

16 *The Feast of the Gods,* 1514-1529, **Giovanni Bellini** (about 1423-1516), **& Titian** (about 1487-1576). Oil on canvas, 67 x 74 inches. Widener Collection. Photo © 2002 Board of Trustees, National Gallery of Art, Washington, DC

17 *Cardinal Albrecht of Brandenburg as St. Jerome,* 1526, **Lucas Cranach the Elder**, German, (1472-1553). Oil on wood panel, 45 1/4 x 35 1/16 inches, SN308. Bequest of John Ringling, Collection of The John and Mable Ringling Museum of Art, the State Art Museum of Florida

18 *Near (modern) Disaster #8,* 1982, **Nic Nicosia** (1951-). Color photograph, 40 x 50 inches. Courtesy of the Artist, P.P.O.W. Gallery, NY, Dunn + Brown Contemporary, Dallas, Texas

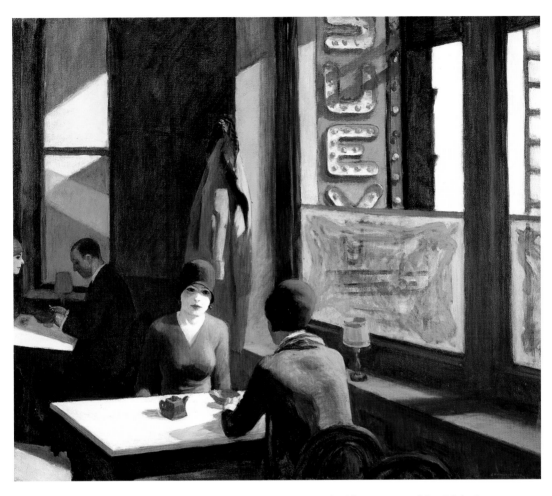

19 *Chop Suey,* 1929, **Edward Hopper,** American (1882-1967). Oil on canvas, 32 x 38 inches. Collection of Mr. and Mrs. Barney A. Ebsworth

20 *Cape Cod Evening,* 1939, **Edward Hopper,** American (1882-1967). Oil on canvas, 30 x 40 inches. John Hay Whitney Collection. Photo © 2002 Board of Trustees, National Gallery of Art, Washington, DC

21 *Nighthawks,* 1942, **Edward Hopper,** American (1882-1967). Oil on canvas, 84.1 x 152.4 cm. Friends of American Art Collection, 1942.51. © The Art Institute of Chicago

22 Bebe Miller performing in *Rain,*
November 29, 1989, Brooklyn Academy of
Music/Leperco Space Video Image © Mark
Robinson. Still from Video © Robbie Shaw

23 *Stones,* 1998, **Maya Lin**.
Tables made of spray-
molded fiberglass-
reinforced cement with
integral color.
Photo credit: Bill White. Courtesy
of Knoll

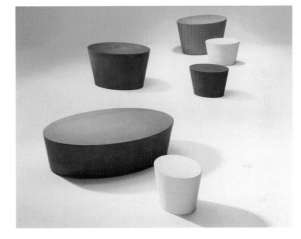

25 *The Mandrill,* 1926, **Oskar
Kokoschka** (1886-1980). Oil on
canvas, 127 x 101 cm. Collection
Museum Boijmans Van Beuningen,
Rotterdam.

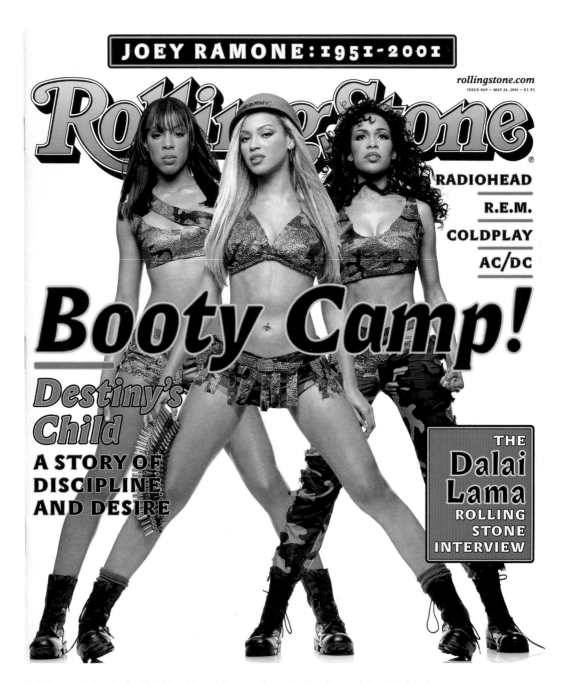

24 Photo of Destiny's Child by Albert Watson From *Rolling Stone,* May 24, 2001
© 2001 Rolling Stone LLC All Rights Reserved. Reprinted by Permission.

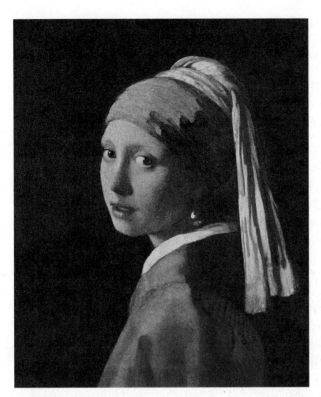

5-4 *Head of a Girl (Girl with a Pearl Earring),* Jan Vermeer (1632–1675). Oil on canvas, 18 x 16 inches. © Scala/Art Resource, NY. Mauritshuis, The Hague, The Netherlands.

121

Here, in one of Vermeer's most engaging images, a young girl dressed in an exotic turban turns and gazes at the viewer. Her liquid eyes and half-opened mouth impart the immediacy of her presence, yet her purity and her evocative costume give her a lasting quality, unconstrained by time or place.

The relatively large scale of this figure reveals how Vermeer enhanced the sense of realism through his expressive paint techniques. For example, he enlivened the young girl's half smile with two small white dots on either side of her mouth, echoing the highlights in her eyes. He also ingeniously used his paints to capture the effect of light falling across her features, turban, and ocher-colored jacket. He evoked the delicacy of her skin with a soft contour for her cheek, which he created by extending a thin glaze slightly over the edge of the thick impasto defining the flesh color. He indicated reflected light from the white color in the pearl earring, but also, and more subtly, in the shadows on her left cheek. Finally, he painted the shaded portion of the blue turban by covering a black underpaint with freely applied glazes of natural ultramarine.[16]

There are many different kinds of questions asked, and various and varied answers to be given, about any work of art.

BUILDING NEW MEANING FROM OLD ART:
HIGH SCHOOL STUDENTS, LUCAS CRANACH, CARDINAL ALBRECHT,
SAINT JEROME, AND ARNOLD SCHWARZENEGGER

In 1526, a painter by the name of Lucas Cranach the Elder painted a portrait that is now titled *Cardinal Albrecht of Brandenburg as Saint Jerome* (**Color Plate 17**). The painting is owned by the John and Mable Ringling Museum of Art in Sarasota, Florida, and is prized by the Museum staff as one of its most important holdings. The portrait of Albrecht is strangely filled with animals and things in a combination that does not make sense today: a beaver, an antelope, a pair of partridges, and pheasants with chicks next to a crouching lion inside a room where a man dressed in red sits at a table with an odd candelabra over his head. To make sense of this diverse subject matter requires engaging in what art historians call *iconography*, the identification, analysis, and interpretation of subject matter and what it meant to the people who saw it when it was first made.

The painting was made in Germany, in the Northern Renaissance style. Around 1526, Cardinal Albrecht commissioned Lucas Cranach to paint a portrait of him as Saint Jerome. Cardinal Albrecht was a powerful leader of the Catholic Church in Germany during the theologically tumultuous time of Martin Luther and the Protestant Reformation, and Cranach was a well-known and respected artist and craftsman who ran a flourishing workshop, which produced prints and books as well as paintings. Cranach was a Protestant and a friend of Luther's, but he accepted commissions from Catholics. He also made erotic paintings of nudes, usually guised as mythological figures, such as *The Judgment of Paris,* for his private collectors. Jerome was a monk and a scholar who lived in Bethlehem, in Palestine, in the fourth century, and was especially known for translating the Bible from Greek and Hebrew into Latin, the common language of his place and time; Albrecht, himself a scholar, chose to be painted as Saint Jerome because he admired the saint's scholarship. (At the time, patrons often stipulated how they were to be portrayed, and it was traditional for church leaders to have themselves portrayed as saints whom they admired.)

People viewing the painting at the time of Albrecht and Cranach would have been able to read the imagery in the portrait. According to legend, Jerome removed a thorn from the paw of a lion and the lion became his companion; hence Cranach's portrayal of the lion in the painting. Viewers would have also known the beaver as a symbol of industriousness, the pheasants for immortality, and the peacock for redemption. On the table in the foreground sit fruits: the apple represents original sin, the pear the incarnate Christ, and the grapes the embodiment of Christ in bread and wine. The Madonna and Child on the wall beside Albrecht would have been read as Albrecht's defense of Catholicism against Luther's criticism that Catholics overemphasized the importance of Mary, mother of Jesus.

Susan Hazelroth Barrett, a museum educator at the Ringling, and Barbara Kenney, an area high school teacher, engaged a group of high school students in an interpretive exercise about *Cardinal Albrecht of Brandenburg as Saint Jerome* in 1992. The

5-5 *Cardinal Albrecht of Brandenburg as Arnold Schwarzenegger,* 1993. Southeast High School students, Barbara Kinney's art class. Acrylic on canvas, 45 x 35 inches. The John and Mable Ringling Museum of Art, Sarasota, Florida.

123

teenagers first studied the painting's iconography and form, and then selected "a contemporary individual who embodies the qualities and values that Cardinal Albrecht might embrace if he were alive today—the individual he would wish to be depicted as in his portrait."[17] They chose Arnold Schwarzenegger because of his work with handicapped children, his dedication to his wife, and because he was appointed by the president of the United States to lead a national fitness program, much as cardinals were appointed by popes to head commissions. (The students' arguments against the choice of Schwarzenegger had included his sexist attitudes toward girls when he was a teenager and his penchant for gore and violence in his movies. Other candidates nominated by the students included General Schwarzkopf (this was during the U.S. war in Iraq and Kuwait called Desert Storm), Christ, Santa Claus, and the Easter Bunny.)

The students researched Schwarzenegger, invented symbols to represent his values, and made a portrait they called *Cardinal Albrecht of Brandenburg as Arnold Schwarzenegger.* Here is a comparison of the two paintings written by Brent Wilson and Juliet Moore, art educators who documented the project:

Comparisons between Cranach's painting and the students' work are fascinating. According to the students, they chose Schwarzenegger because of the strong values he possesses. A lion identifies Albrecht with the revered saint, Schwarzenegger is surrounded by the images he attributes to the American dream; both paintings are set in offices; Cranach's rendition of the office interior shows typical sixteenth-century Northern Renaissance architecture, whereas the students' is a combination office and locker room with sophisticated twentieth-century office furniture. The animals with whom the cardinal/saint shares his office in Cranach's painting would probably not co-exist peacefully, but perhaps neither would the symbols collected in Schwarzenegger's office. In the painting of the cardinal as St. Jerome, the beaver represents industriousness and constancy; the pheasant and peacock symbolize immortality and redemption. In the students' painting of Schwarzenegger, the owl represents knowledge and the importance of education, the collie and the cat represent friendship and loyalty, and the white doves represent peace and love. For the cardinal as saint, apples and pears represent original sin and Christ incarnate; the grapes stand for the Eucharist. For the cardinal as Schwarzenegger, a box of Wheaties and scattered barbells symbolize dedication to health and physical fitness. In the students' painting, movie posters and sports cars represent the drive and determination of a self-made man. A portrait of Schwarzenegger's wife, Maria Shriver, stands in for that of the Virgin. A back three quarter view of a disabled child in a wheelchair (shown larger in the painting than Schwarzenegger himself) represents Schwarzenegger's interest in the disabled and the part he plays as a role model for America's young people.[18]

The Ringling Museum of Art showed the teenagers' painting next to Cranach's for several years.

AN IDEOLOGICAL INTERPRETATION OF OLD PAINTINGS BY JOHN BERGER

In 1972, in "Ways of Seeing," a series of television programs (and, later, in a published book made from the series), John Berger, a British art critic, presented an influential and now classic critique of oil painting, and particularly oil paintings of women made by men. Berger's thesis has since become famous as the identification and explanation of "the male gaze": Women are pictured by men for male pleasure. Excerpts from *Ways of Seeing*, the book, are quoted here without commentary because what he says is both clear and persuasive.

> To be born a woman has been to be born, within an allotted and confined space, into the keeping of men. The social presence of women has developed as a result of their ingenuity in living under such tutelage within such a limited space. But this has been at the cost of a woman's self being split into two. A woman must continually watch herself. She is almost continually accompanied by her own image of herself. Whilst she

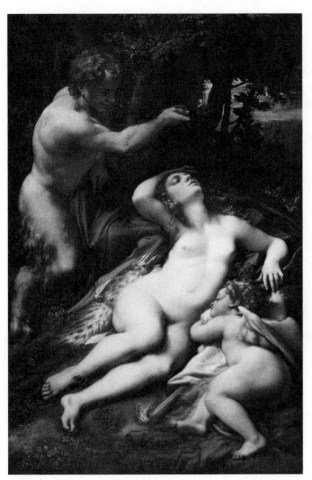

5-6 *Venus, Satyr and Cupid,* (formerly *Jupiter and Antiope*), 1524–1525. Correggio, (1489–1534). Oil on canvas, 190 x 124 cm. © Réunion des Musées Nationaux/Art Resource, NY. Musée du Louvre (Louvre), Paris, France.

125

is walking across a room or whilst she is weeping at the death of her father, she can scarcely avoid envisaging herself walking or weeping. From earliest childhood she has been taught and persuaded to survey herself continually. . . .

And so she comes to consider the surveyor and the surveyed within her as the two constituent yet always distinct elements of her identity as a woman.

She has to survey everything she is and everything she does because how she appears to others, and ultimately how she appears to men, is of crucial importance for what is normally thought of as the success of her life. Her own sense of being in herself is supplanted by a sense of being appreciated as herself by another. . . .

One might simplify this by saying: men act and women appear. Men look at women. Women watch themselves being looked at. This determines not only most relations between men and women but also the relation of women to themselves. The surveyor of

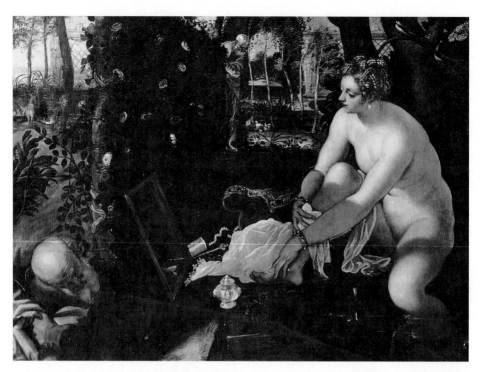

5-7 *Susannah and the Elders,* Jacopo Tintoretto (1518–1594). Kunsthistorisches Museum, Vienna, Austria. © Alinari/Art Resource, NY.

woman in herself is male: the surveyed female. Thus she turns herself into an object— and most particularly an object of vision: a sight. . . .

The subject (a woman) is aware of being seen by a spectator.

She is not naked as she is.

She is naked as the spectator sees her.

Often—as with the favourite subject of Susannah and the Elders—this is the actual theme of the picture. We join the Elders to spy on Susannah taking her bath. She looks back at us looking at her.

In another version of the subject by Tintoretto, Susannah is looking at herself in a mirror. Thus she joins the spectators herself.

The mirror was often used as a symbol of the vanity of woman. The moralizing, however, was mostly hypocritical. You painted a naked woman because you enjoyed looking at her, you put a mirror in her hand and you called the painting *Vanity,* thus morally condemning the woman whose nakedness you had depicted for your own pleasure.

The real function of the mirror was otherwise. It was to make the woman connive in treating herself as, first and foremost, a sight.

The *Judgement of Paris* was another theme with the same unwritten idea of a man or men looking at naked women.

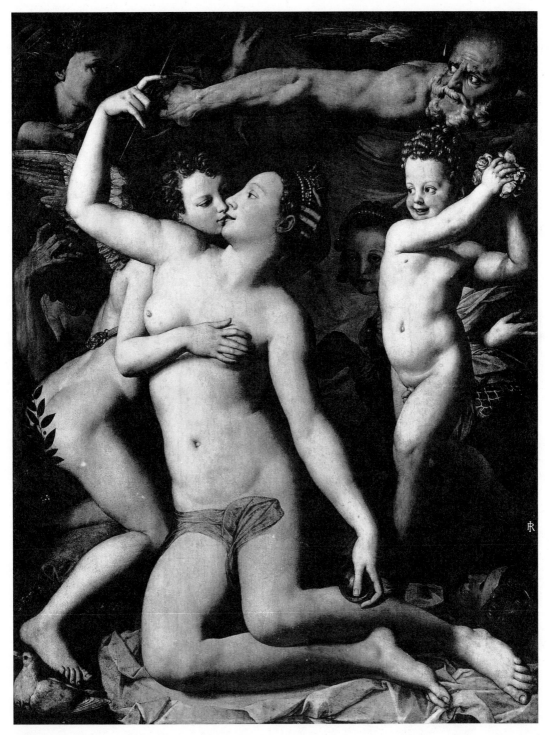

5-8 *Venus, Cupid, Folly, and Time (Exposure of Luxury),* about 1564. Agnolo Bronzino (1503–1572). Oil on wood, 61 x 56 inches. National Gallery, London, Great Britain. © Alinari/Art Resource, NY.

But a further element is now added. The element of judgement. Paris awards the apple to the woman he finds most beautiful. Thus Beauty becomes competitive. (Today *The Judgement of Paris* has become the Beauty Contest.) Those who are not judged beautiful are *not beautiful*. Those who are, are given the prize.

The prize is to be owned by a judge—that is to say to be available for him. Charles the Second commissioned a secret painting from Lely. It is a highly typical image of the tradition. Nominally it might be a Venus and Cupid. In fact it is a portrait of one of the King's mistresses, Nell Gwynne. It shows her passively looking at the spectator staring at her naked.

This nakedness is not, however, an expression of her own feelings; it is a sign of her submission to the owner's feelings or demands. (The owner, that is, of both woman and painting.) The painting, when the King showed it to others, demonstrated this submission and his guests envied him.

Consider *Venus, Cupid, Folly, and Time* by Bronzino. . . . Before it is anything else, this is a painting of sexual provocation.

The painting was sent as a present from the Grand Duke of Florence to the King of France. The boy kneeling on the cushion and kissing the woman is Cupid. She is Venus. But the way her body is arranged has nothing to do with their kissing. Her body is arranged in the way it is, to display it to the man looking at the picture. This picture is made to appeal to his sexuality. It has nothing to do with her sexuality. (Here and in the European tradition generally, the convention of not painting the hair on a woman's body helps towards the same end. Hair is associated with sexual power, with passion. The woman's sexual passion needs to be minimized so that the spectator may feel that he has the monopoly of such passion.) Women are there to feed an appetite, not to have any of their own. . . .

Dürer believed that the ideal nude ought to be constructed by taking the face of one body, the breast of another, the legs of a third, the shoulders of a fourth, the hands of a fifth—and so on.

The result would glorify Man. But the exercise presumed a remarkable indifference to who any one person really was.

In the art-form of the European nude the painters and spectator-owners were usually men and the persons treated as objects, usually women. This unequal relationship is so deeply embedded in our culture that it still structures the consciousness of many women. They do to themselves what men do to them. They survey, like men, their own femininity. . . .

Today the attitudes and values which informed that tradition are expressed through other more widely diffused media—advertising, journalism, television.

But the essential way of seeing women, the essential use to which their images are put, has not changed. Women are depicted in a quite different way from men—not because the feminine is different from the masculine—but because the 'ideal' spectator is always assumed to be male and the image of the woman is designed to flatter him.[19]

FOREIGN ART

When we, as people born and raised in the United States in the twentieth century, come across images of Dharna Vihara, of what looks like a glorious monumental stone temple in a place called Ranakpur, India, we are faced with a mystery that we cannot comprehend when limited to our own senses, our own knowledge and experiences. We can permit and encourage ourselves to be thrilled by what we see and feel when, in our imagination, we walk around and through the structure as it is pictured in a book. We can be overwhelmed by the structure's large size and scale. We can trust our experiences that are telling us that this is a very important place. We can recognize depictions of persons in garb and postures that are strange to us. Elephants with and without riders are depicted in the building. We can be delighted by the building's intense and intricate and seemingly omnipresent ornamentation. When we see a graphic of the structure's floor plan, we can notice symmetry throughout the overall design, and when we see pictures of the structure's supporting pillars, we can see that they are all differently ornamented: there is perfect symmetry in the floor plan and asymmetry in how the pillars are decorated. We can be struck with awe in looking at pictures of the place, and this feeling of awe is close to what some people mean when they say they are having an "aesthetic experience."

129

Looking at a book about Dharna Vihara, I wish I could actually walk through the place in person and physically experience its mass and detail. I am sure that my sense of awe would increase. Even within the limitations of its reproduction in a book, the structure in itself seems marvelous and evokes wonder. But limited to my own looking and thinking I cannot know what the place is, who built it, when or for what purposes, nor can I know who lived there or visited there and how they used the structure and what it meant to them. I want to know more than I can learn through my own experience of pictures of the place and I want to come away with understanding as well as with an aesthetic experience of the place. I would also like the structure to have personal meaning to me.

Looking at Dharna Vihara, however, is very different from looking at paintings by Norman Rockwell or Eric Fischl: Rockwell's and Fischl's pictures are of our time and place in the world, while Dharna Vihara is not. Conversely, if an original fifteenth-century resident of Ranakpur, familiar with the temple Dharna Vihara, were to come to our time and place, he or she might be bewildered by St. Patrick's Cathedral in New York, though it is readily accessible to many of us.

The Temple Dharna Vihara in Ranakpur

Saryu Doshi, an Indian scholar of Indian art and architecture, wrote the book I am looking at: *Dharna Vihara, Ranakpur.*[20] It is an oversized book with forty-four pages of lush color photographs, twelve pages of compact informational writing in English, and a glossary of about two hundred Indian terms. From the book, I learn that the

temple was built in the fifteenth century but suffered severe damage from Muslim desecrators; later, the temple and surrounding buildings were abandoned when a series of famines besieged the area and its people fled. Eventually, the structures in deserted Ranakpur were overgrown with vegetation and infested with snakes. After two hundred years of neglect, the temple was restored at great expense over eleven years, beginning in 1933, and today it is an active site of sacred ritual.

Early in her text, in descriptive language that invites me in, Doshi writes,

> The tiny bells tied to the flagstaffs atop the eighty-one spires of the Dharna Vihara at Ranakpur swing lightly in the breeze. But, as darkness descends, their tinkling is lost in the awesome sounds of the evening diparadhana, when the pillars and domes of the temple reverberate to the beat of the kettle-drums and the clang of bells and cymbals. Surrounded by the wafting fragrances of incense sticks and burning camphor, the worshippers chant prayers in accompaniment, while priests recite mantras and wave a tray of oil-lamps in front of the deity. As the ritual ends, and the sounds of the bells and the kettle-drums subside, the little bells on the spires can be heard once again. Their delicate chimes and the flickering lamp-light cast a mystical spell on the devotees in this sacred shrine of the Jains.[21]

130

In her text, Doshi explains the Jains and their religious beliefs, which shape their architecture. She explains how this temple is like and different from other Jain temples and tells the story of its desecration and restoration. The domes of the temple, for example, are reminiscent of the *nalini-gulm-vimana,* a celestial vehicle shaped like a lotus by which heavenly beings travel the skies.

The Jains are a small community, less than one percent of the Indian population, whose beliefs and practices can be traced back to the Sharmana philosophy of great antiquity, which advocates a strict code of conduct and mortification of the flesh as a means to salvation. Practitioners pursue perfection through solitary seclusion and in meditation away from the mundane world. Doshi observes that, to modern visitors, their temples may appear "strikingly aloof, symbolic of the sublime detachment advocated by the Jain religion."[22]

When the Aryans invaded India in 1500 B.C.E., they brought many material goods, powerful priests, elaborate sacrificial rituals, and four volumes of sacred literature known as the Vedas. The Aryans eventually established the Vedic tradition, which evolved into the Hindu religion, while the Sharmanic tradition evolved into Buddhism, Jainism, and many other religious currents. In the first millennium B.C.E., the Vedic and Sharmanic cultures represented two antithetical religious precepts and practices. The Vedic worshipped many gods and the Sharmanic did not believe in any. Believers of the Vedic tradition tended to be communal and celebratory, appeasing their gods with complex sacrificial rituals in order to obtain earthly material prosperity. People of the Sharmanic tradition, however, shunned wealth and comfort, sought spiritual improvement through meditation and self-denial, and lived in isolation.

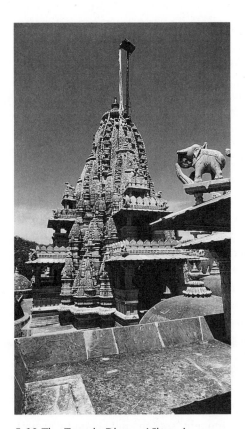

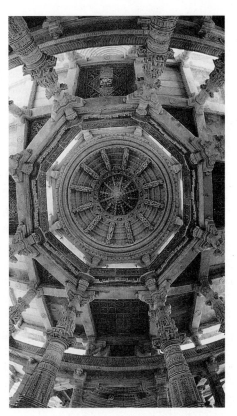

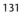

5-10 The Temple Dharna Vihara in Ranakpur, India built by Dharna Sah and his architect Deparka. Also known as the Temple of the Light of Three Worlds, 15th century. Partial view, the roof showing an open rectangular courtyard and the high *shikhara* with balconies marking each of the three stories. Photo © Homi Jal.

An interior detail of the Dharna Vihara, Ranakpur. Central view of the triple-storied dome resting on an octagon formed by eight pillars. Photo © Homi Jal.

Doshi observes that, because the Jains observe strict self-restraint, it may seem contradictory that the interiors of their temples contain depictions of "pleasures of the senses" such as dancing women in seductive poses. She tells of, but does not show, a carved ceiling panel in the temple that tells the story of Stulibhadra, a monk known as the epitome of self-restraint. According to the parable, Stulibhadra lived a life of pleasure with his mistress Kosha until, disillusioned with his worldly ways, he became a

Jain monk and vowed celibacy. Later, as penance, he moved back to the house of his mistress. Kosha was delighted and tried to seduce him but failed. The ceiling panel shows Stulibhadra seated peacefully and prayerfully, surrounded by people in erotic dalliance.

Doshi explains that the creed of Buddhism as professed by the Gautama Buddha (about 566–486 B.C.E.) spread throughout southern, central, and eastern Asia, but after a thousand years in India its presence weakened and was eventually erased "when the iconoclastic fury of the Islamic armies razed the large Buddhist monastic complexes of eastern India to the ground. The monks fled to Nepal, and with them, Buddhism quietly disappeared from the land of its birth."[23]

Unlike Buddhism, Jainism successfully countered threats to its existence from Hinduism, Islam, and Christianity. In the first century C.E., differences in beliefs between monks in the north and the south resulted in a split in Jain society: the more staunch among the Jain monks advocated complete nudity for Jain ascetics and formed the *Digambara* or "sky-clad" sect. This accounts for some depictions of frontally nude males in the temple. The other monks grouped themselves into the *Shvetambara* or "white-robed" sect. The two sects evolved along parallel lines, with each retaining its own identity.

132

The Jains believe that every creature experiences "the wretchedness of worldly existence as it is caught in *samsara*—an unending cycle of birth, death, and rebirth." There is no escape from samsara because the soul is "bound to matter by the force of *karma*, a force that allows the soul to feel the effects of good and bad deeds. The soul can be purged of the matter clinging to it by annihilating karma through spiritual processes." Karma, particles of matter, can be removed in two stages. First, one can block karma from entering the soul through thought, speech, and action by exercising supreme self-restraint and withdrawing from the world. Second, one can burn existing karma by the blaze of *tapas* (penance). The soul is then released from matter and reverts to its original state of purity and perfection. It ascends to the apex of the universe where it dwells as a *siddha,* a liberated and perfected soul "without feeling, without form, without birth, without death, enjoying an endless unbroken calm." The emancipation of the soul can only be undertaken when the soul is born as a human being. This normally happens after the soul has gone through the rounds of rebirth "eighty-four hundred thousand times." Because it is not easy for a soul to be born a human, one must make the most of it when it occurs.[24]

The Jains have three worlds: *urdhva-loka* (the upper world), *madhya-loka* (the middle world), and *adho-loka* (the lower world); together, these three form the *loka*, a vast three-dimensional space. In Jain temple frescoes and religious manuscripts, such as *Loka-purusha*, the Jain manuscript illustration from the sixteenth century reproduced here, the *loka* is often portrayed as *loka-purusha* (cosmic man), standing upright with arms akimbo and feet spread apart. His torso, shoulders and head represent the upper world of celestial spheres. The curved *siddha-shila* on the forehead is the dwelling place for liberated and purified souls. Below the waist and to the feet is the nether regions, the lower world, with seven layers of hell, each "more gloomy and horrible"

5-11 *Loka-purusha,* Jain manuscript illustration from Samgrahanisutra, Camboy, 1604. Gujarat, gouache on paper (watercolor drawing). Spencer Collection. The New York Public Library. Astor, Lennox and Tilden Foundations.

than the one above it. The flat disk in the waist represents the middle world, the place where all human activity takes place, subject to cosmic cycles.

Existence is cyclical and each cosmic cycle can be thought of as a wheel with twelve spokes, dividing it into twelve phases: *sushama-sushama / sushama / sushama-dushama / dushama-sushama / dushama / dushama-dushama / dushama-dushama / dushama / dushama-sushama / sushama-dushama / sushama / sushama-sushama /* (extreme happiness / happiness / happiness with some unhappiness / unhappiness with some happiness / unhappiness / extreme unhappiness / extreme unhappiness / unhappiness / unhappiness with some happiness / happiness with some unhappiness / happiness / extreme happiness).

Jain scriptures describe the movement of one cosmic cycle as one rotation of the wheel. During its downward movement, the cosmic cycle passes through the *avasarpini* era, comprising phases one through six, when conditions on earth deteriorate steadily. During its upward swing, a new era of *utsarpini* dawns and the wheel moves through phases seven through twelve, each phase being happier than the last.

Doshi tells us that despite "the severe, and perhaps even harsh, character of Jainism," it spiritually sustains more than seven million followers. During ancient and medieval times, it received patronage from affluent families and the faithful erected many temples embellished with sculptures. Jain monks direct conservation and restoration by urging their followers to channel their piety and wealth into the temples.

Most of the information provided by Doshi in *Dharna Vihara, Ranakpur* is more explanation than interpretation, and only a little of the information she provides is reiterated here. Throughout her text she occasionally uses phrases such as "it is said that," "it appears to have," and "possibly due to" to indicate where she is surmising rather than reporting on historical fact. Her information is the cumulated findings of scholarship. It is information thought to be historically accurate about the beliefs of a group of people from ancient to present times. In her account, Doshi does not offer her personal interpretation of what the Jains might mean to her or for us today, but she does indicate what she thinks is some of the significance of the Jains when she relates that Mahatma Gandhi, leader of the Indian Freedom Struggle, was inspired by Jainism and effectively employed its tenets of nonviolence to fight British imperialism. Since then, she explains, several countries have resorted to this form of protest to draw global attention to injustice. And though Jainism, unlike Buddhism, never spread outside the Indian subcontinent in ancient times, today its principles carry with them "a message of moral strength and ethical justification all over the world."[25]

In another source on the Jains, a book primarily about religious rather than aesthetic matters, Mary Pat Fisher, a contemporary Western author, goes further than Doshi to interpret the meaning that Jainism might bring to the world today: "Its gentle ascetic teachings offer valuable clues to our global survival."[26] Fisher writes that Western commentators used to be negative about Jainism, because it had no personal savior or creator as first cause, but that now Jainism is increasingly being recognized

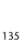

5-12 *The Linga and Yoni.* This large copper Linga-Yoni stands on a plinth alongside the sacred Ganges River, viewed as a Goddess. Varanasi, Uttar Pradesh. Photo: Stephen P. Huyler. Courtesy The Huntington Archive of Buddhist and Related Arts.

as offering a path for uplifting human sensibilities toward higher standards of personal ethics. She explains that the Jains have never condoned war, or the killing of animals, for any reason; that they believe every centimeter of the universe to be filled with living beings, even a drop of water; that humans have no right to supremacy; that all things deserve to live and grow; and that to kill anything has negative karmic effects. Jainism holds that one's possessions ought to be kept to the bare minimum because "possessions possess us."[27] Non-acquisitiveness is a way to inner peace, and the principle of *aparigraha* limits consumption in ways that reduce world poverty and hunger and degradation to the environment. Fisher tells us that Jains also maintain an attitude of open-mindedness and attempt to be nonjudgmental, believing that truth is multifaceted and that one's view of it can be only partial.

One task of an interpreter that is stressed throughout this book is to seek communal understanding of works of art and to make personal meaning from aesthetic objects. Gloria Steinem, founder of *Ms.* magazine, provides an example of one contemporary Western woman who made personal meaning from her experiences of religious structures from times and places different from her own. After college, Steinem lived in India for two years and relates some of her experiences there.

In Hindu temples and shrines I saw the lingam, an abstract male genital symbol, but I also saw the yoni, a female genital symbol, for the first time: a flowerlike shape, triangle, or double-pointed oval. I was told that thousands of years ago, this symbol had been worshiped as more powerful than its male counterpart, a belief that carried over into Tantrism, whose central tenet is man's inability to reach spiritual fulfillment except through sexual and emotional union with woman's superior spiritual energy. It was a belief so deep and wide that even some of the woman-excluding, monotheistic religions that came later retained it in their traditions, although such beliefs were (and still are) marginalized or denied as heresies by mainstream religious leaders.

For example: Gnostic Christians worshiped Sophia as the female Holy Spirit and considered Mary Magdalene the wisest of Christ's disciples; Tantric Buddhism still teaches that Buddhahood resides in the vulva; the Sufi mystics of Islam believe that fana, or rapture, can be reached only through Fravashi, the female spirit; the Shekina of Jewish mysticism is a version of Shakti, the female soul of God; and even the Catholic church included forms of Mary worship that focused more on the Mother than on the Son. In many countries of Asia, Africa, and other parts of the world where gods are still depicted in female as well as in male forms, altars feature the Jewel in the Lotus and other representations of the lingam-in-the yoni. In India, the Hindu goddesses Durga and Kali are embodiments of the yoni powers of birth and death, creation and destruction.

When Steinem returned to the United States after her stay in India, she was struck by the contrast between Indian and American attitudes about women's bodies. Her experience of these differences is one of regret. Years later, she found herself wondering about similar issues while working on another project.

In the 1970s, while researching in the Library of Congress, I found an obscure history of religious architecture that assumed a fact as if it were common knowledge: the traditional design of most patriarchal buildings of worship imitates the female body. Thus, there is an outer and inner entrance, labia majora and labia minora; a central vaginal aisle toward the altar; two curved ovarian structures on either side; and then in the sacred center, the altar or womb, where the miracle takes place—where males give birth.

Though this comparison was new to me, it struck home like a rock down a well. *Of course,* I thought. *The central ceremony of patriarchal religions is one in which men take over the yoni-power of creation by giving birth symbolically. No wonder male religious leaders so often say that humans were born in sin—because we were born to female creatures. Only by obeying the rules of the patriarchy can we be reborn through men. No wonder priests and ministers in skirts sprinkle imitation birth fluid over our heads, give us new names, and promise rebirth into everlasting life. No wonder the male priesthood tries to keep women away from the altar, just as women are kept away from control of our own powers of reproduction. Symbolic or real, it's all devoted to controlling the power that resides in the female body.*

Since then, I've never felt the same estrangement when entering a patriarchal religious structure. Instead, I walk down the vaginal aisle, plotting to take back the altar with priests — female as well as male—who would not disparage female sexuality, to universalize the male-only myths of Creation, to multiply spiritual words and symbols, and to restore the spirit of God in all living things.[28]

The point of quoting Steinem here is not to say that she is right (or wrong) about the theological beliefs she derives from her experiences of sacred architecture, but to show that one can (and should) make personal meaning that has contemporary relevance to one's life about structures and images and beliefs from times long ago and places far away.

The art and architecture of India is culturally and religiously based. Indian art, and much of the art of the world, has ancient origins, and historic specificity, but as ancient as it is, it remains alive and vital. Photographer and Indian scholar Stephen Huyler accompanies his photograph of a modern Indian woman with this commentary: "In her hands a woman clasps a brass bowl that holds sacred water representing the Goddess: the Divine Feminine. She prays to the first rays of the sun, considered a God: the Divine Masculine. By daily acknowledging the two, she honors the absolute balance of existence: male and female, wrong and right, black and white, good and evil."[29]

137

CONCLUSION

Different kinds of understanding can be available to us when interpreting art that is old, art that is foreign. For art that is old, we can seek understanding of what the art meant to the people who made it and viewed it in its own time. This kind of understanding requires knowledge that scholars of history make available to us in books, in lectures, and on wall texts in museums. Their knowledge frequently comes from close study of available physical evidence as well as from knowledge of the culture gained through sources other than the art itself. We can learn much by close looking, but our looking will be limited by what we know of the time, place, and people who originally made and viewed the object.

When contemplating and studying old art, we can also seek to build personal meaning about it for our lives today. What did it mean to them, then; what might it mean to me, now? If we are going to be responsible to the art and to the artist who made it, we will not want to skip over historical knowledge, however hard it may be to obtain. If we neglect the meaning the art had for those who first made it and used it, we are, in a sense, not looking at the art at all: instead we are doing something akin to looking at clouds in the sky and engaging in personal flights of fantasy by imagining that we are seeing locomotives or angels or whatever.

When looking at art that is foreign to us, either because of time or place or culture, we again have interpretive options. We can seek to understand what the art means to

those for whom it is native and natural, when it was made, throughout its history, and today. We can also seek to interpret it for what it might mean for our lives here and now, wherever our "here" may be. If we remain ignorant of what "foreign" objects mean to those for whom they are not foreign at all, we lose the opportunity to gain knowledge and appreciation of a culture different from our own, and we remain ignorant of beliefs that are different from our own. Instead of expanding through knowledge of others, we contract into what is familiar and comfortable.

Perhaps, when faced with art that is old and unfamiliar to us because of time or place, we can benefit from a "tour guide." What kind of guide would be ideal? Someone who knows about the place; ideally, all about the place. Someone who knows the facts of how the structure came to be, when, and why. Someone who knows more than architecture; someone who knows the worldview of its creators. A guide from within the belief system that caused the building to come about, to look the way it looks, to contain what it contains; a guide who could provide an insider's view for authenticity; a guide who was sympathetic to the endeavor of the structure.

However, it would also be beneficial if the guide could step outside that belief system and was someone who did not believe that that belief system was the only alternative—not a dogmatic guide but a sympathetic one who could consider questions of disbelief or incredulity or skepticism. A preacher or a proselytizer who only allowed their version of the world would not be desirable.

An ideal guide would allow, invite, and encourage us to try on the beliefs of the building's original inhabitants so that we could experience a worldview other than our own. We would want this perspective so that we would have the opportunity to alter our worldview, to correct it, or to confirm that we are happier with what we already believe. We might want to come away from the tour with a renewed sense of awe for the human ability to make such sacred places.

It is rare that any single individual could be this ideal a guide. Were such a person available, she or he would still be an individual bound and limited by his or her unique beliefs and experiences. Thus this book provides and promotes multiple voices of interpretation.

Interpretation and Medium: Photography

Consider any work of art, imagine it in a different medium, and consider the interpretive consequences. What if Michelangelo's *Pieta* was made of Styrofoam instead of marble? What if the cup of the Holy Grail was a White Castle paper coffee cup? What if the Arc de Triomphe in Paris, the largest arch in the world and a masterpiece of Romantic Classicism, was made of cinder block? What if a Madonna was adorned with elephant dung? Medium matters: it strongly affects meaning.

• *Medium affects meaning.*

Luis Jiménez, a contemporary sculptor, consciously celebrates his Mexican heritage in the bright and gaudy materials he chooses for his sculptures, as if to throw the clichéd cultural accusations of "tackiness" hurled by anglos back at them. His medium, his subjects, and his forms are intentionally and meaningfully colorful, shiny, and audacious.

In her art-making, contemporary sculptor Deborah Butterfield concentrates on horses, exploring various media in rendering similar subject matter. She constructs horses by welding together scraps of metal she has retrieved from junkyards. She makes horses from driftwood gathered along the edges of western riverbeds. She constructs some of her horses from sticks and mud. Hers are not gilded sculptures of charging steeds with flared nostrils, ridden by fierce cavalry wielding swords with which they decapitate foot soldiers; Butterfield's are gentle creatures, made of common materials.

This chapter explores one medium, photography, and considers many examples of a how a particular medium affects meaning. The choice of photography is somewhat

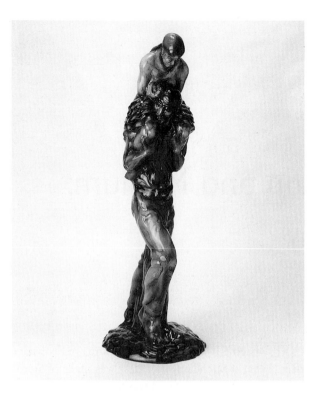

6-1 *Border Crossing,* 1994.
Luis Jiménez. Maquette
Fiberglass, 24 x 12 inches.
Museum of New Mexico,
Museum of Fine Arts.
Museum purchase, 1994.
Photos by Blair Clark.

140

arbitrary: we could just as meaningfully look at paint or marble. The belief asserted in this chapter is that different media carry different connotations and that those connotations are important to consider; an example of any medium could be used to illustrate the point. Photography, however, is a particularly apt medium to examine because the majority of the images that we receive today are not conceived and executed in egg tempera or stained glass; they are photographic images that come to us by way of the Internet, newspapers, magazines, movie screens, and especially through television.

In this chapter I am positing that photography, as a medium, has peculiarities of its own, ones that I am calling selectivity, instantaneity, and credibility. These attributes are present in any and all photographs, but each attribute has different weight in any given photograph. Determining how they function in any photographic image is a powerful interpretive strategy.

SELECTIVITY

Photography can be thought of as a subtractive medium and painting and drawing as additive media. That is, when I paint, I am typically faced with an empty canvas. When I make a photograph, however, the viewfinder of my camera is always filled

6-2 *Horse,* Deborah Butterfield (1949-), steel armature, wire mesh, and sticks, 77 x 124 x 33 inches, 1979. William S. Ehrlich and Ruth Lloyds.

with whatever is in front of the lens. I move the camera around, side to side, up and down, closer to my subject or farther away. By positioning the camera, or by removing things from the scene, I eliminate what I don't want in the frame so that I can better show what I want to be seen. Who shall be in the frame? Who shall be out? Looking at the group of people in my viewfinder, should I isolate one person for an effect of loneliness; join two people into one frame, implying intimacy; show the whole group but emphasize the setting instead of the people? As a viewer, I remind myself to interpretively consider what the photographer has included and what the photographer has excluded.

A first choice for photographers is often one of subject matter: what or who they take pictures of. Photographers are commonly identified by their choice of subject matter. Diane Arbus is known for having made photographs of persons on the outside of mainstream society: individuals in nudist camps, performers in circuses, a giant in a small room. The name of Ansel Adams usually conjures up black-and-white photographs of pristine landscapes. William Wegman makes drawings, paintings, photographs, videotapes, and films, but Wegman is known as a photographer of dogs, weimaraners in particular. His dogs are memorialized in books on twentieth- and twenty-first-century art because they are the frequent subject of Wegman's photographic art.

6-3 *Chip and Battina,*
William Wegman (1943-),
color Polaroid, ca. 1993.
Puppies, Hyperion.

142

Once a general subject matter is chosen—people or dogs, for example—then further choices follow as to what kind of people, what kinds of dogs, in what situations, under what conditions, and so forth. Of all the people Diane Arbus could have chosen, she specifically chose Russian midgets, a young man in curlers, a girl with a cigar, a retired man and his wife in a nudist camp, a loser at a diaper derby, a Mexican dwarf, two men dancing at a drag ball, a transvestite at her birthday party, and a hermaphrodite and a dog in a trailer park.[1] Wegman chooses his own weimaraners and takes them out of their natural environments, dresses them up, poses them amidst props, and photographs them, usually with very fine grain in saturated colors with a very large Polaroid camera, making unique images. We can interpretively imagine all the people and dogs and settings, and types of people and dogs and settings, that Arbus and Wegman would not choose to photograph. Then we can interpretively ask, Why this one?

Choice of subject matter is consequential. Because Wegman is an artist of considerable reputation, his work is collected by art museums. As a result of his selection of dogs as subject matter, many pictures of dogs and some very cute puppies are now in the major museum collections. Cuteness in modern art used to be anathema, but

6-4 *Fading Away,* Henry Peach Robinson (1830-1901), photograph, 1858. Royal Photographic Society, Bath, England.

Wegman's selection of subject has helped erode distinctions between high art and daily living, between fine art and popular culture.

Some photographers do not tamper with reality except by photographing it. They believe that theirs is a moral choice as well as an aesthetic one: I shall respect the world as I find it; I shall not alter what Nature has put before me. Other photographers invent situations for their cameras, freely adding and subtracting subjects and effects to fulfill their communicative and creative intents. Henry Peach Robinson, in England in the 1800s, assembled his photographs from different negatives that were all posed and composed to tell stories. *Fading Away* is a composite print, made from five different negatives to depict a young girl dying in the presence of her grieving relatives. Around the same time and also in England, P. H. Emerson directly opposed the photographic aesthetic of Robinson. Emerson, a naturalist, believed that the art of photography ought to lie in photographing natural subjects in natural settings without artificial techniques and manipulations.

As an interpretive viewer I remind myself to wonder if what I am looking at in the photograph is obviously and intentionally manipulated by the photographer, and if it is, to consider to what purpose, and then, to think about it and enjoy it as a fictional

Chapter 6 • Interpretation and Medium

account. While looking at any photograph, I can interpretively wonder how the photographer has purposely or accidentally affected what is photographed. No matter the subject nor the arrangement of it in the photograph, the fact that it is photographed and before me renders the subject an object for some kind of contemplation or appreciation. It is a photograph of a thing and not the thing itself: it is a picture, and all pictures are open to interpretation and must be interpreted if they are to be meaningful.

Selection of subjects is an important choice for photographers, but there are many other selective choices to be made when photographing: distance from the subject, angle of view, degree of magnification or reduction, conditions of light, and so forth. After photographing, more choices emerge when processing the film and even more when printing the negative. Robinson, for example, felt no hesitation in cropping and pasting to make his finished pictures. Arbus, in contrast, employed a soft edge around her prints: she achieved this by making the opening in the negative holder larger than the frame of the picture and thus is able to show that she has printed the whole frame and has not cropped her photograph. Arbus's choice of presentation is meant to signify that her aesthetic is reality-based rather than fictional, that although it is obvious that she composed her picture in her viewfinder, she did not later crop or trim off parts of her picture with a paper cutter.

Similarly, Wegman leaves the edges of his Polaroids soft and the top smeared: see *Chip and Battina.* He probably likes how this looks, but it is probably more than just an aesthetic choice. By leaving the top smear and the soft edges, Wegman lets us know that the image is made by a Polaroid process. By doing this, he is showing the full frame and that he has not cropped it. What is more, we can deduce that this image is unique: it is not a multiple of a print produced from a negative, as are most photographs; it is one of a kind.

Some early, as well as contemporary, photographers selected textured, warm-toned paper on which to print, so that their images had the look and feel of paintings or etchings, like the established art forms of their day. Edward Weston, the American modernist and advocate of "straight photography" who was very influential in raising the status of photography to "art," debased soft focus, textured images as "pseudo-paintings," arguing that they were neither good paintings nor good photographs. His modernist aesthetic looked for what the camera could uniquely accomplish that was different from other media. His aesthetic demanded sharply focused, crisply printed photographs of naturalistic subject matter such as the nude, a famous series of close-ups of green peppers with evocative sculptural structures, and details of pristine landscapes and seascapes. Soft or crisp focus, matte or shiny photographic surfaces affect a viewer's response to what is pictured.

Ansel Adams accepted Weston's aesthetic and contributed to its scientific base by authoring technical books on precise photographic technique. Adams championed "previsualization," which requires that the photographer have the aesthetic vision and the technical skills to accurately prevision what the finished photograph would look like before the exposure was made. Jerry Uelsmann, a contemporary, countered with

6-5 *Pepper,* 1930. Edward
Weston (1886-1958).
Gelatin-silver print, 9⅜ x
7⅟₁₆ inches. Los Angeles
County Museum of Art,
Anonymous gift. Photo
© 2002 Museum Associates/
LACMA. © 1981 Center for
Creative Photography,
Arizona Board of Regents.

145

a notion of "postvisualization." Uelsmann, like Robinson long before him, makes
composite photographs from many different negatives, seamlessly joining them in the
darkroom to make surrealistic imagery. For his aesthetic, a variety of means justifies
his photographic purpose.

These disagreements and challenges about photographic practice are in the realm
of the aesthetic, or art photography. The consequences of manipulating subjects and
subject matter, and of altering photographs after the negatives have been exposed, are
more consequential, ethically and politically, when photographs are a source of news
and information. With the aid of computer technology, the manipulation of photo-
graphs for aesthetic or political purposes is much easier and more convincing than
with the simpler photographic technology of the past. Governments have made polit-
ical use of faked photographs in times of war and peace, and *Time* magazine digitized
a police mug shot of O. J. Simpson at the time of his arrest for the murder of Nicole
Simpson and Ronald Goldman and then darkened his skin color for the cover of June
27, 1994. The editors apologized in the following issue, after hearing outcries of
racism from readers. The ability of politicians and editors to convincingly alter pho-

6-6 *Untitled,* 1999. Jerry Uelsmann (1934-). Photograph. © Jerry N. Uelsmann.

tographs undermines image authentication in courts of law, the enforcement of missile-verification treaties, and other documentary uses of photographs.

Black-and-white photographs were the artistic norm for many decades, even after color photography became easier to use: black and white was considered artful, while color was relegated to commercial or informational purposes. Whereas in the 1950s black and white was a standard property, a given, of art photographs, now photographers of art and information choose color or black and white more consciously, and their choices continue to affect the meanings of their photographs.

It is easy to make a photograph, especially when one compares the relative effort it takes to make a detailed and representationally accurate picture of a person using a camera and to make the same level of accurate representation using a paintbrush. I can "point and shoot" and make an extraordinarily detailed and accurate photograph of a person in an instant, whereas it would take me hours, days, or weeks to portray that person in equal detail and stylistic realism with brushes and paints. Because it can be easy and quick to make some kinds of photographs, some photographers take very many photographs and make many more images than a painter could paint, and then

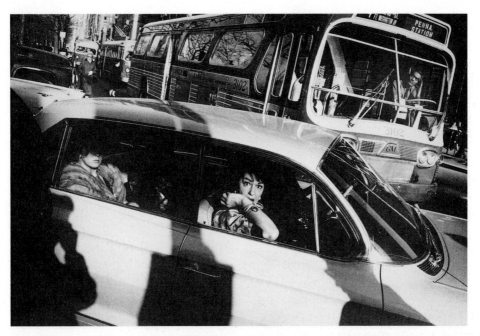

6-7 *Untitled,* 1955–56. Garry Winogrand. (1928-1984). Photograph. Collection Center for Creative Photography, The University of Arizona. © The Estate of Garry Winogrand, courtesy Fraenkel Gallery, San Francisco.

select which to exhibit or publish. Garry Winogrand, for example, had a "ten roll a day" goal: he tried to shoot ten rolls of thirty-six exposures a day, every day, all the working years of his life. The Center for Creative Photography, which inherited Winogrand's archives, is inundated with his posthumously developed film, unprinted negatives, proof prints, and finished photographs.

Press photographers routinely take many more pictures than they know they will use. They can afford to make many, discard many, for the one that they save. Sometimes they send many shots of the same subject and let the editor pick the one that will be printed.

There are consequences to this ease of picture making and to the availability of such choice among the many existing pictures: consider an editor with many pictures by many photographers of a politician—Senator Hillary Rodham Clinton, for example. With the pick of a picture, a newspaper editor may present to the world a view of the woman that is flattering or foolish.

As an interpretive viewer of any photograph I can profitably wonder how many photographs of the subject matter have been made: Is this one picture out of a thou-

6-8 *A Quasar Portrait,* NASA. J. Bahcall (IAS, Princeton), M. Disney (Univ. Wales), NASA.

sand, or one out of two, or the only one made? And why has this one been selected for me to view? Photographs, like paintings, are opinions.

INSTANTANEITY

Any photograph is made by having a camera lens open for a certain amount of time, whether that amount is one thousandth of a second or an hour. Because a photograph is made by light passing through a lens onto light-sensitive material for a measured or measurable amount of time, in a sense, any photograph is a representation of time. At one extreme, NASA photographs of objects in space may be exposed in a matter of seconds, but they record billions of light-years and present them as a single instant; at the other extreme, a photograph can stop the motion of a bird in flight with an exposure of one thirty-thousandth of a second.

Photographs are instantaneous in many different ways. They are made in a measurable length of time. What photographs show, they show as if it were an instant, even if it is a picture of the universe billions of years ago. Photographs also show only that instant during which they were made. Photographs are always made in and of a particular, discrete, measured, and measurable instant of time, usually one that is very short. What they picture has existed in time. In all of these ways, photographs are different than drawings or paintings, and our experiences of them are different.

Our sense of astonishment at the quickness of achieving a realistic picture in seconds is renewed by watching a Polaroid color print develop before our eyes. While reporting on the discovery of photography, Dominique François Arago in France in 1839 said, "the rapidity of the method has probably astonished the public more than anything else," particularly when photography's speed is coupled with its "unimaginable precision."[2] Harry Callahan, a Modern art photographer, associated the speed of making photographs with its *raison d'être:* "It seemed absolutely anti-photography to me to go in the darkroom and take an hour to make one print, just to see what it looked like . . . if you're gonna take that long, maybe you could've drawn it."[3] One of the unique characteristics of photography is that one can get a stylistically realistic picture in seconds, study it, and modify it until it is considered finished. Modifying the print is also quick compared to drawing or painting. Inserting filters in the enlarger can instantly alter complete tonal ranges or color palettes. A painter would have to redo an entire canvas to achieve such variation. With Adobe Photoshop and other digital tools, such technical and aesthetic alterations are very quick and easy, and each of them can be instantly previewed and saved or discarded, and all permutations can be saved in their complete and complex manifestations.

Photographs stop action and reveal their moving subjects as instants. Sometimes this is dramatic and the very point of the picture, as when physicist Harold Edgerton photographically stopped a rifle bullet in mid-air as it traveled at twelve hundred feet per second, tearing through and shredding three balloons. Henri Cartier-Bresson, the art photographer identified with "the decisive moment" when all elements coalesce in an aesthetically charged arrangement, is eminently aware of time: "the world is movement, and you cannot be stationary in your attitude . . . you must be on the alert with the brain, the eye, the heart; and have a suppleness of body."[4] Landscape photographers such as Ansel Adams, Eliot Porter, and Richard Misrach, who work with the apparently still subject matter of mountains and forests and deserts, are also extremely aware of time in making their pictures. Porter said, "never put off taking the picture . . . nothing is stationary. Nothing is permanent. Everything is changing."[5]

Photographers, despite careful planning and "previsualization," are often surprised by their pictures, in ways that painters are not, due to the photograph's link with time. Painters see what they paint; photographers frequently do not see what they photograph. Sometimes this is due to the speed and complexity of the photographer's subject matter, and sometimes it is because of equipment: with most cameras the view through the camera is blocked during the instant of exposure, meaning that the photographer cannot see what is actually photographed at that instant.

Painters paint and paint over, seeing and evaluating forms as they emerge and relate to other forms on the canvas. Photographers, however, must learn to see the world as if it were made up of instants. Photographers must see objects, often as they are moving or interacting with other objects; how objects will be transformed into two-dimensional forms; how colors of objects will be rendered in grays or in color film and print materials. Unlike painters, who perceive emerging forms relating to

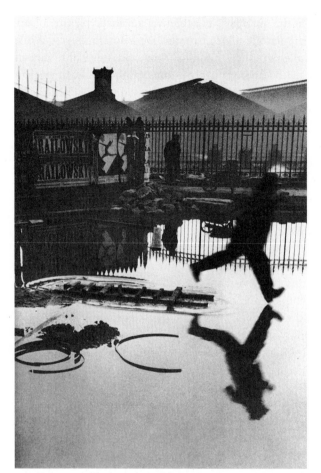

6-9 *Behind the Saint-Lazare Station, Paris,* 1932. Henri Cartier-Bresson (1908-). Photograph. © Henri Cartier-Bresson/Magnum Photos.

150

other forms as they paint, quickly or slowly, over days, months, or years, photographers must acquire the ability to perceive all that is happening through the viewfinder as a would-be instant in an instant. It is not only the interaction of visual forms that must be perceived, but the implications of those interactions also must be perceived and evaluated in terms of expression and meaning.

As interpreters of any photograph, knowing that the photograph is of an instant, we can imaginatively reconstruct what may have happened before that instant and after. Because we know that photography is inevitably linked to time, we can interpretively consider how the photograph we are looking at is related to time.

Some photographs, such as Cartier-Bresson's photograph entitled *Behind the Saint-Lazare Station, Paris,* are aesthetically dependent on time. Somehow, Cartier-Bresson was able to see what was about to happen before him, was able to visualize it as a pho-

tograph, was able to point and focus and click, capturing a man jumping over water. The photograph would likely have been interesting just because it arrested the man's movement. The photograph becomes all the more fascinating when we notice the posters of the ballerina pasted to the wall behind the man. Cartier-Bresson, in a captured instant, has delighted us with a comparison of a pedestrian and balletic movement in the same frame.

The photograph by Nic Nicosia called *Near (modern) Disaster # 8* (**Color Plate 18**) plays off of images made by Cartier-Bresson and other photographers who treat relations between time and cameras reverently. Nicosia fabricates a fictional instant for the camera and then makes a photograph as if it were an instant in reality, rather than a tableau on a photographer's set. Nicosia's is a humorous use of time and photography, while Cartier-Bresson's is straightforward. Both images are magical in their own different ways, partially due to their visualization of instants.

CREDIBILITY

People believe photographs, for better or for worse, and with or without proper justification. That is, when viewing photographs, people generally tend to grant them more credence than they would to paintings, drawings, prints, or sculptures. In experiencing photographs, viewers blur distinctions between subject matter and pictures of subject matter and tend to accept photographs as reality recorded by a machine. In ordinary conversation, I am likely to pull out of my wallet a photograph of my wife and me and say, "This is Susan and me," whereas if I were to show a painting or a sketch of us, I would be more likely to say something like "This is a picture of us painted by Charlotte." In the second case, the original declaration is rather automatically qualified by "picture of" and "painted by." In casual interactions with photographs, we rarely give these qualifications, though we routinely offer them in casual interactions with other kinds of pictures.

Consider for a moment the power implications of picturing others for a mass audience. In the length of a book, Catherine Lutz and Jane Collins examine *National Geographic* magazine, a widely read, long-circulating, and very influential magazine that relies on photographs for its impact and marketability.

> While the *National Geographic* photograph is commonly seen as a straightforward kind of evidence about the world—a simple and objective mirror of reality—it is in fact evidence of a much more complex, interesting, and consequential kind. It reflects as much on who is behind the lens, from photographers to magazine editors and graphic designers to the readers who look—with sometimes different eyes—through the *Geographic*'s institutional lens. The photograph can be seen as a cultural artifact because its makers and readers look at the world with an eye that is not universal or natural but tutored. It can also be seen as a commodity, because it is sold by a magazine concerned with revenues. The features of the photographs, and the reading given them

by others, can tell us about the cultural, social, and historical contexts that produced them. This book traces how the magazine has floated in American cultural and political-economic currents of the post-World War II period and asks what the photographs tell us about the American-fashioned world.[6]

Photography is an invented form of picture making. Its precedents are the customs, concerns, and conventions of painters. But the conventions borrowed from painters by the inventors who fashioned the first cameras, the conventions with which photographers work, and the determinations photographers make in taking their pictures are all de-emphasized in favor of seeing the photograph as a transparent and natural reflection of reality made by a machine. The photographic image is seen as nature rather than as an item of culture that requires interpretation.

Photographs share in the convincing construction of Western pictorial realism that leads us to believe that renderings in perspective are pictorially equivalent to what we see. But photographs are significantly different from paintings and drawings. A painter can paint a man who never existed, and a writer can describe a place that never was; but, when faced with a photograph of a man or a scene, we know that what we see in the photograph, however it may have been modified or manipulated, has actually existed. This is because of the causal interaction of light reflected from objects and the light-sensitive materials of photographs: there has to be something before the lens that reflects light through the lens to the light-sensitive film. French scholar Roland Barthes was so impressed with this difference that he named the essence of photography "that which has been." What a photograph pictorially contains is not an optionally real thing to which an image or sign refers, as in painting or language, but "the necessarily real thing which has been placed before the lens, without which there would be no photograph."[7]

We also know that when looking at a photograph, we are looking at something that was produced in great part by a machine and even, now, some very advanced machines that utilize sophisticated computer technology. Because photographs are generally very realistic and because they do have an optical and chemical causal relation to the things they picture, they easily come to be thought of as transparent. We tend to see through them to what is pictured and forget the artistry employed in their making and the subjectivity of their makers; we grant photographs more credibility than they perhaps deserve. The photograph enjoys a halo of credibility that is a psychological condition that influences our experience of photographs.

The cultural credibility of the photograph is neither categorically good nor categorically bad: it is, rather, a very interesting given that ought to be a cause of wonder, interpretation, and evaluation. Of any photograph, we can gainfully ask, What is factual and what is fictional in this picture?

Photographers work with the assumed credibility of photographs. The fact that there really was a man behind the station who was jumping over water and that Cartier-Bresson was able to capture the movement on film adds to the wonder of *Behind the Saint-Lazare Station, Paris.* Nicosia depends on the credibility of the photo-

graphic image to add humorous punch to *Near (modern) Disaster # 8*. If either the Cartier-Bresson or the Nicosia image were a painting rather than a photograph, I doubt that they would have the effect they have now, one serious and the other humorous.

The major point is that photography is a significantly different medium than other pictorial media, and this leads to some immediate conclusions and implications for interpretation. One is that if we conflate photographs and paintings as pictures, rather than marking their distinctions, we lose some of the richness of each and risk misunderstanding both. By being unaware of the photographic-ness of the photograph, we also lose the unique understanding and aesthetic enjoyment a photograph can yield. Just *because* photographs are highly selected images and discrete instants snapped from the flux of time, photographs are always out of context, and it behooves us to interpretively put them back into the context from which they emerged. Because photographs are often seen to be transparent natural objects, rather than culturally inflected visual expressions made by individuals, we ought to be especially interpretively attentive to them.

SALLY MANN: *IMMEDIATE FAMILY*

In 1992, Aperture published a book of photographs by Sally Mann called *Immediate Family*.[8] The book contains fifty-nine full-page photographs, an introductory essay by the photographer, and an essay in the back of the book by Reynolds Price, a novelist and writer of short stories and poems. The year it was published, *Immediate Family* was a cover story of the *New York Times Magazine,* with the title "The Disturbing Photography of Sally Mann." The book continues to be controversial, and groups occasionally picket bookstores that sell *Immediate Family* and photography books by Jock Sturges: both Mann and Sturges make photographs that sometimes include children, clothed, partially clothed, or nude.

Some of the fears of those who publicly object to or privately worry about the photographs in *Immediate Family* and in Sturges's books[9] are for the children in the photographs, as well as for all children, because of the reality of sexual predators in the world. The belief seems to be that pictures of children partially clothed or nude will excite or encourage pedophilia, and that, as a preventive measure, children should not be photographed nude; artists like Mann and Sturges, in other words, should self-censor, as should curators and booksellers and professors. Other objectors seem simply to be against showing nudity of any form, particularly nude children, in any pictures. When I had photographs from *Immediate Family* displayed behind plexiglass in the university corridor for study by my Photography Criticism students, who were to write about them, someone in the university community anonymously called campus police to investigate "child pornography" on display in the art building. The police did and found none.

This section of the chapter interpretively addresses some photographs from *Immediate Family* through the conceptual lenses of selectivity, instantaneity, and credibility, which, taken together, I propose as a methodology for understanding any pho-

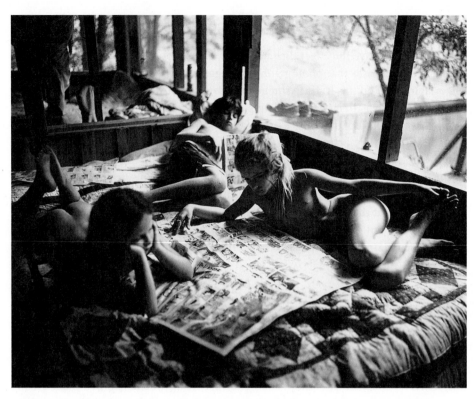

6-10 *Sunday Funnies,* 1991. Sally Mann, (1951-). Photograph. © Sally Mann. Courtesy: Edwynn Houk Gallery.

tographic image. These three lenses, then, are used here to examine a specific and important collection of recent images. The concepts of selectivity, instantaneity, and credibility play differently with different photographs: with Mann's *Immediate Family,* instantaneity is at play, as is credibility, but it is selectivity that emits most light.

Credibility and *Immediate Family*

Although time is significant in *Immediate Family,* it is probably selectivity and credibility that are the most significant forces at play in our interpretive reaction to the work. Whether in factual or fictional situations, these are undeniably real children who were before their mother's lens. We know this because of knowledge of how the camera works: it was light, reflecting from Jessie and Emmett and Virginia to light-sensitive material through a lens, that caused the photographs.

Were these drawings or paintings of the children, rather than photographs, we could regard them as imaginings of their mother, or any artist, and grant them artistic license, and perhaps not be bothered by them at all. Balthus, the painter recently

deceased, is well known for his licentious paintings of young girls. Many of his paintings are much more explicit with their sexual connotations than are Mann's images. Balthus, however, is not the cause of picketers outside of bookstores that sell books of reproductions of his paintings. Those offended by pictures of nudity or sexuality are much liklier to object to photographs than to drawings or paintings of sexuality.

Books and magazines using photographs of nudes are quickly and frequently labeled "pornographic," with accompanying attempts to censor, although drawn or painted pictures of similar subject matter in print publications may be allowed to exist as "erotic" or "sensual" without strong objection, protest, or picketing.

Instantaneity

Time certainly influences Mann and the photographs of her children. She selects which instants to photograph and which to photographically bypass. She has selected specific years in the lives of her children and decided to stop making photographs of them when they reached puberty. The children also had choices about when and when not to be photographed: a picture of Emmett standing in a river is titled *The Last Time Emmett Modeled Nude.*

Because of Mann's work, and because of photography's interaction with the temporal, we and the Manns will always have stilled instances in the flux of the development of three children. These instances will remind us of times we have forgotten or never had in our own childhood. This is a part of the wonder of the photographicness of *Immediate Family.*

Selectivity: Subject Matter and *Immediate Family*

Immediate Family includes photographs of three children—Emmett, Jessie, and Virginia—and, occasionally, adults, made by the children's mother in the seven years between 1984 and 1991. In 1992 Emmett was 12, Jessie 10, and Virginia 7. The mother, father, and children live in Lexington, Virginia, in a comfortable house with a garden, trees, and a yard that runs down to a creek. The Manns also have a cabin on a four-hundred-acre farm deep in the woods, miles from electricity, with access to the Maury River where the children swim in the nude. Most of the photographs in the book were made on the farm during hot months in southwestern Virginia.

Mann's photographs of her children have always been an intentional mix of fact and fiction, metaphor and document. The subjects are almost always aware of the photographer and her camera. In many of the pictures, they look at the photographer's lens. In pictures in which they do not look at the lens, or at us, the viewers, they are very aware of the camera and pose for it, with directions from their mother. Richard Woodward, who wrote the *New York Times Magazine* cover story on Mann, witnessed the taking of one picture. Jessie, having come from swimming in the river, is wearing a skirt and bolero she has just fashioned from green leaves. Her mother gets her camera and tripod.

Jessie stands on a bed and adjusts her costume, as Mann calls out instructions—"Raise your head. Look out the window. Point your toe. Bend your knee. Put your chin up. Make yourself look veerrry uncomfortable." (Laughter all around.) "There we go."

Mann has been photographing her children regularly since they were born. She has thousands of negatives, thousands of prints. After she chooses which to exhibit or publish, she first allows her children veto power over any image of themselves. Mother, father, and children gathered professional insight from a psychologist on implications of the photographs and their release. They also obtained legal opinion. Mann and her husband have become used to their surprises at what the children do not like: The children are comfortable with their nudity in the photographs, they just do not want to appear like "dorks" or "geeks" or "dweebs."[10]

Price, in his essay at the end of *Immediate Family,* poses several intriguing questions surrounding the topic of selectivity: "Think of your own shoe boxes of pictures, the dog-eared, fading and technically spotty record of your own childhood (if such a record exists or survives; if it doesn't, you probably know the sad economic or emotional reasons why not). Who took the pictures—both of your parents? Mainly Mother or Father, and why one or the other? Or retired Grandfather with time on his hands, or a hired professional? If one parent or a single other relative was the family's head cameraman, what can you deduce now about his or her sense of you and your world, of your place in the adult world around you? Do the earliest pictures of you coincide with what you believe to be your earliest memories (and to what extent have the pictures "created" those memories for you or merely served as reminders of them)? What important known events or persons from your childhood are omitted from the photographic record? Which of those events and persons do you wish you had pictorial evidence for? Do you have, as I do, seeming recollections of moments so happy that you want hard evidence the moments aren't simply dreams or longings?"

Price asks two other crucial questions that we should ask of any image: "What's lacking here? What, in their later adult years, will they wish their mother had caught or omitted? To be sure, there are no kindergarten graduations, no school hockey matches, no scenarios rigged for the aunts and uncles or their nearest grandmother . . . and what are the children bent on showing or even concealing from their mother's steady watch?"[11]

The artist herself talks of her selections in *Immediate Family* this way: "The place is important; the time is summer. It's any summer, but the place is home and the people here are my family." Mann continues, "These are photographs of my children living their lives here too. Many of these pictures are intimate, some are fictions and some are fantastic, but most are of ordinary things every mother has seen—a wet bed, a bloody nose, candy cigarettes. They dress up, they pout and posture, they paint their bodies, they dive like otters in the dark river."[12]

Importantly, how one identifies the subjects of a photograph is highly interpretive: telling how one sees tells us about the observer; telling how one sees encourages certain understandings and discourages others. Woodward refers to these photographs as

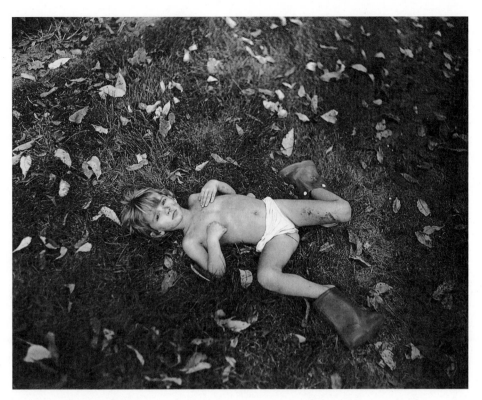

6-11 *Dirty Jessie,* 1985. Sally Mann (1951-). Photograph. © Sally Mann. Courtesy: Edwynn Houk Gallery.

"intimate black and white portraits." Katherine Dieckmann, reviewing the book in the *Village Voice,* described some of the subject matter this way: "dirtied children splayed on the ground, their limbs bent so they almost look broken . . . afloat in water like a dead frog, or lying in a vulval channel of water . . . suspended from a hay hook, iridescent white, like a perfect alabaster slab of meat . . . nude or semi-nude children marked by stains and gashes and pox and blades of grass stuck to flesh like incisions."[13]

A summary of the subject matter: children, posed, individually and with each other, sometimes with friends, sometimes with adults, sometimes dressed, sometimes with no clothes, in the hot months, indoors and out of doors and in a screened porch, playing dress-up, playing board games, reading Sunday funnies, blowing bubbles, roller-skating, napping, wading in the creek, laying in the grass, with a bloody nose, with chicken pox, with a cut above the eye, smoking a candy cigarette, fishing for crabs, with a dead hunted deer and squirrel, with a grandmother, often in the midst of lush summer nature, and with household and childhood props.

Dieckmann, Price, Woodward, and Mann speak from adult perspectives. Those who find the photographs controversial are adults. Following are how some nine- and

ten-year-old children describe and interpret photographs in *Immediate Family*. The children quoted are about the same age as the Mann children were when the photographs were made.[14]

Jean: "These pictures also show how the family lives. They show that they live in a big house with a river and next to the woods. It also shows that the family hunts because in some of the pictures they show them crabbing and one has a dead deer in it."

Mary: "Some of the pictures showed the children in the nude. I think that was because they were just around their mom, on a farm, and they felt carefree. They didn't care about clothes and they really didn't need them. . . . The poses expressed mostly what the photographer was feeling, not the children. Some of the poses showed what the children were feeling, not their mother."

Abby: "I think some of her pictures are candid, some are posed and some are reenacted. The pictures show her feelings and emotions. All of the pictures are in the summer. They are of her family and friends."

Susan: "Sally Mann's photographs tell the world that children are very playful at heart, yet very serious. A few photographs tell how some children grow up way too fast. In a majority of the photographs, the children had clothes on but in some they didn't. This shows that children don't think it matters if you have clothes on or not. It's what's inside that counts. Some of the photographs also tell the world that even through play children can work very hard. But some photographs were disgusting like the ones showing dead animals."

Amy: "I think the children would be nice to have as friends. They look like honest people, like they don't try to be someone other than who they really are. I say this because they dress how they want, do their hair how they want, etc. Sally must be pretty loyal, too. Her children trust her and let her take pictures of them in situations people don't see in everyday life."

Lindsey: "Sally Mann takes pictures of her immediate family. Mostly her children. The pictures tell a story, like how they live. Her children, Jessie, Emmett, and Virginia, might be partly naked. I think that it tries to show us how open-minded she and her family is. They are not ashamed of their bodies, way of life, or where they live. Their home is in Virginia. They go crabbing, squirrel hunting, weasel hunting, and deer hunting. Some pictures are made up. Some are real life pictures."

When Jessie Mann, a frequent subject of the photographs in *Immediate Family*, turned eighteen, she granted an interview about her experiences of being photographed. She said, "we enjoyed being photographed. It gave us a sense of beauty. When you're around an artist all the time, you're always reminded of what's beautiful and what's special, and you can't forget it." Jessie also added these insights into the photographs her mother made of her and how the photographs are negotiated by some viewers in society: "There are so many levels to childhood that we as a society ignore, or don't accept. Rather than just saying it, she was able to capture it with photographs. It's easy to discount these things unless you can really see them in the kids' eyes, or see it in their actions. I also think she brought out a certain sexuality in chil-

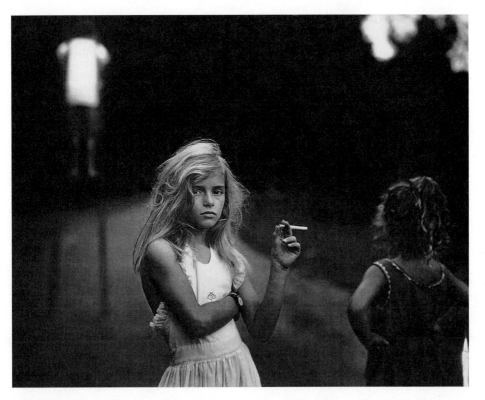

6-12 *Candy Cigarette,* 1989. Sally Mann (1951-). Photograph. © Sally Mann. Courtesy: Edwynn Houk Gallery.

dren that nobody wants to think about. Some people still have real problems with the pictures. . . . I'll make a friend, and eventually I'll say, 'I wonder if I'm ever going to meet your parents?' And the person will answer, 'Well, my Mom really opposes your mother's work, so you may not want to come over.' I used to get all riled up about it. But now I understand—it's hard for people. I think if you have a certain background or beliefs those photographs could be upsetting or offensive."[15]

Selectivity: Form and *Immediate Family*

In the *New York Times Magazine* article on *Immediate Family,* Woodward makes many observations about the formal selections Mann has made in her photographs. Here is one: "The photographs have kept up a continuing dialogue between Mann's literary and visual selves. Before the birth of her children, she trained her large-format view camera to bring out the mythic resonances in landscapes. Her prints, which often contrast the paleness of flesh or stone with darker surroundings, hint at shadowy forces

that can be sensed but not always seen. She wants to push this quality of ambiguity in her pictures to locate something 'richer, softer, lusher' in the woods and fields around her." Woodward also observes that "the warm tones of her favorite printing paper (Agfa Insignia) deepen the chronological ambiguities of her pictures."

The implications of Mann's choice of camera are significant. She uses a large-format view camera with eight-by-ten-inch negatives. The camera is big and heavy and requires a tripod. The photographer must put a black cloth over her head, blocking out extraneous light so that she can see the image on the ground glass before her. Once she has the camera and subject situated, she selects aperture and shutter speed and inserts a film holder into the camera; at that point she can no longer see through the camera nor see what the camera sees. Because the camera is so large, the subjects have to be aware of the photographer's presence. There's nothing quick nor facile nor candid about using a large-format camera. Ten exposures is a common number of negatives made during a shooting session using a large-format camera. Cartier-Bresson can snap off many pictures, very quickly and surreptitiously, with his small handheld camera; Mann cannot. Mann and Cartier-Bresson make different kinds of pictures, in part, because of the different cameras they use.

The large negatives give Mann's enlargements lush tonality and precise detail unavailable to Cartier-Bresson's enlargements made from small negatives. Mann's are warm-toned, richly detailed, with a full range of blacks to grays to whites. They are selectively focused, one to the next: some have crisp detail from foreground to background, and others are shallowly focused, with sharpness just where Mann has chosen. They are lovely to look at in the original. The darkness around their edges is purposeful and effective: Woodward characterizes Mann's images as "lush and brooding scenarios." Ted Orland, a former assistant to Ansel Adams, the consummate master craftsman, is quoted by Woodward, saying that Mann is "among the half-dozen best printers in the country."[16]

CONCLUSION

The meaning of any artwork is highly dependent on the medium in which it is executed. Artists are well aware of this. Artists who are facile with many media choose a specific medium they think apt for a particular idea. Artists who choose to work primarily in one medium, rather than many, work with ideas that can be expressed well in their chosen medium.

Every medium has its own idiosyncratic characteristics and artists know these well and play with them and off of them. This chapter is based on photography. We have seen in this chapter that artists like Nicosia play off of the "reality-based" medium of photography by concocting some preposterous fictions for their lenses, but his fictions take on the jolt of a reality effect because they are photographs.

Media other than photography could have been selected for the chapter. Glass is an old medium of art that has received new attention from artists, and they use it vari-

ously, playing with and off its peculiarities. Glass can be made to be flat, and its flatness has been utilized in artworks such as Joseph Cornell's mysterious assemblages in boxes covered with glass. Glass can be flat and colored and transparent or opaque, and it is used for both secular and religious leaded glass windows in homes designed by Frank Lloyd Wright and the rose windows of Gothic cathedrals in Europe. Glass can also be blown into rounded and elongated forms: Dale Chihuly's is an example. We tend to think of glass as fragile, and sometimes Chihuly has defied our expectations of the fragility of glass by blowing large balls of glass that he has then literally tossed from a boat into the canals of Venice, Italy, to float unharmed like sea creatures. Glass can break, and some artworks utilize this fact expressively, purposely breaking or cracking glass for the meaning such a gesture and result implies: Duchamp's glass and metal sculpture, *The Bride Stripped Bare by Her Bachelors, Even* (1915–1923), is an example.

The large point of this chapter is that medium affects meaning, and medium can always be explored by an interpreter, seeking answers to such questions as What is this made of? How has the artist used the material? Is the artist working with or against the medium: Is the clay, for example, fashioned as if it were hardened gold or has the artist left it looking soft and malleable like the mud in the river bed from which it was dug? How does the use of the medium affect my reaction to and understanding of what I am looking at?

161

A Sampler of Interpretations

THIS CHAPTER BROADENS THE scope of interpreters included in this book and widens the range of examples of things that can be interpreted. It first presents different voices articulating thoughts through different literary forms about the paintings of Edward Hopper, a prominent twentieth-century American painter. Hopper's work has inspired many visual and literary artists, three of whom are anthologized below.

Following the Hopper writings is an interpretive consideration of a modern dance, included here to show how the interpretive thoughts and strategies that are employed by persons thinking about visual art can be applied to art forms other than the visual.

Finally, following these "fine art" examples, we consider some artifacts selected from popular culture, or what some scholars refer to as "visual culture": a Gary Larson cartoon, a TV commercial, and a magazine ad. It is likely that we are all more influenced by popular culture than we are by art in museums and on stages, and it is particularly important that we purposely examine artifacts in our daily lives and how and what they might mean to us and to others.

These diverse examples of interpretations of a variety of objects and events are offered here for several reasons. One of the main reasons is for the enjoyment of reading interpretations by a variety of literate people about works of art. Mark Strand, Ann Beattie, and Joyce Carol Oates, whose writings follow, are good writers who have written about interesting paintings by a renowned painter, Edward Hopper. They are enjoyable to read. More than this, they offer us interpretive insights into paintings they find to be meaningful to them and write about them in ways that can make the paintings more meaningful to us. They also offer us more strategies for writing about

art: a poet has written short essays about Hopper paintings; a novelist wrote a short story inspired by one of Hopper's paintings, *Cape Cod Evening;* and a poet wrote a poem about Hopper's best-known painting, *Nighthawks.*

INTERPRETATIONS OF EDWARD HOPPER'S PAINTINGS

Edward Hopper (1882–1967) is one of America's foremost painters and a major exponent of American Realism. He depicted city life in New York and the New England countryside and its people. Deborah Lyons, a curator of Hopper's work at the Whitney Museum, introduces Hopper this way: "In Hopper's paintings we find the seemingly ordinary experiences of our individual lives elevated to something epic and timeless, and yet his work appears deceptively simple and straightforward." She adds that he has "a commitment to speak a plain language."[1] Gail Levin, an art historian and biographer of Hopper, details Hopper's influence in American culture, high and low. His work is internationally important and has especially influenced American painters including Richard Diebenkorn, Willem de Kooning, Alex Katz, Pop artists Jim Dine and Claes Oldenburg, George Segal, Andy Warhol and Tom Wesselman, Ed Ruscha, David Hockney, Roger Brown, Photo-Realists such as Richard Estes and Ralph Goings, and Eric Fischl. The influence of Hopper's work is not limited to the fine arts. "Besides the innumerable cartoons that continue to appear, his images are frequently recycled for advertisements, posters, T-shirts, record jackets, and greeting cards. Novelists and poets refer to his art, and choreographers, composers, filmmakers, and playwrights have added their tributes."[2]

163

Who, What, When, Where, Why?

Hopper's work is narrative but mysteriously so. It is very open-ended. He provides characters in settings with props and atmosphere, but we don't know where the characters have come from, where they are going, what propels them, nor when they will rest. As an introduction to interpreting Edward Hopper's paintings, I ask students to pose questions about the paintings that they have when they first see them. Their questions are to take the form of Who, What, When, Where, Why?[3] The questions themselves, without answers, already reveal much about the paintings and interpretive minds. The questions are purposely about the subject matter, not about the intent of Hopper in making them. I do not want to encourage mind reading by asking "Why did Hopper . . . ?" I do want to encourage a curiosity about what the artist has shown in his work. The questions engage viewers in imaginatively wondering about the people, places, and things that Hopper has given us. Here is a list of such questions, posed by college students in Ohio in 2001,[4] about the subject matter of one of Hopper's paintings, *Chop Suey*, 1929 (**Color Plate 19**). The questions are offered here as a heuristic introduction to Hopper—that is, as an invitation for you to provide your own answers to the fictional situations Hopper presents—and also as moti-

vation to read some answers to such questions written by the professional authors who follow.

Who are these women? Are they friends? Who is behind them? Do the two sets of people know each other? Who actually eats chop suey? Who are the women talking about? Who will pay for lunch? Whose coat is hanging on the wall?

What are they talking about? What are they not talking about? What do they do for a living? What is the relationship between the two women? Are they a couple? What are they like? What are the women feeling? What experiences have they had? What does the woman with her back to us look like? What is the relationship between the man and the woman? What are the ages of the people? Are they happy? What is outside? What time of day is it? What time of year is it? What floor is the restaurant on? What city is this? What is the yellow on the windows? What causes the blue in the far window? What is chop suey? What is so important? What did the women do before they came here? What will they do when they leave? What is the social class of these women? What is their culture? What did they order? What will they tip? What will they pay with? What year is this? What is going on outside the restaurant? What is the fabric of their clothes? What does the sign outside the window say? What does their clothing tell you about them?

When did they arrive? When will they leave? When will the food come? When do the women have time to get together? When will the windows be cleaned?

Where will the women go from here? Where will the couple go? Where did they meet? Where are they each from? Where is the waiter? Do they come here often? Where are their husbands? Where are their children?

Why are the women meeting? Why did they decide to meet here? Why are they together? Why does she look so serious? Why is the bowl on the table empty? Why is there no food? Why is the lady in the background leaning into the man? Why does it seem so quiet? Why did the women choose this specific place? Why are they wearing hats? Why do the windows look dirty? Why are there only two chairs at the women's table? Why is the lamp so small?

In the pages immediately following, three authors provide their answers to some of the kinds of interpretive questions that the students articulated about Hopper's painting *Chop Suey*. The first writing is a critical essay, the second a short story, and the third, a poem. Each constitutes interpretive thinking of different kinds.

Mark Strand on the Paintings of Edward Hopper

Mark Strand is a poet laureate of the United States who in 1994 wrote a short book of critical prose on the paintings of Edward Hopper.[5] Four excerpts from his book *Hopper* are reprinted here: the first is about *Cape Cod Evening*, 1939 (**Color Plate 20**); the next two are Strand's general statements about Hopper's paintings; and the fourth specifically considers *Room in New York*, painted in 1932. Strand is particularly in-

terested in showing how the structure of Hopper's paintings ought to affect their meaning.

From *Hopper,* Mark Strand

VIII

In *Cape Cod Evening,* painted the same year as *Ground Swell,* the use of the triangle is more subtle in its narrative implications. Instead of being an instance of geometric insularity and safety set against the virtual emptiness of a deep space, it is a fragile and momentary arrangement of three figures set against the powerful claims of the familiar trapezoid. A woman watches while her husband tries to get the attention of their dog, whose gaze is fixed on something off canvas on the lower left. The fact that the man's coaxing is not answered suggests that it is only a matter of time before the dissolution of the family, momentarily bound by focused attention, will occur. The trapezoid, which comes in from the right and is defined by the house's painted footing and the cornices above the door and the bay window, stops abruptly with the edge of the house halfway across the picture plane. But the movement it initiates is carried on, in a ragged way, by the woods, which dissolve into a foreboding darkness. The "evening," so matter-of-factly—even blandly—descriptive in the painting's title takes on a disturbing and powerful resonance. What at first seemed like a picture of unremarkable calm—a couple taking time out to play with their dog—is undermined by the impending dissolution of the structures in which they live. The house gives way to the woods, and domestic unity turns on the vagaries of a dog's attention.

IX

Hopper's paintings are short, isolated moments of figuration that suggest the tone of what will follow just as they carry forward the tone of what preceded them. The tone but not the content. The implication but not the evidence. They are saturated with suggestion. The more theatrical or staged they are, the more they urge us to wonder what will happen next; the more lifelike, the more they urge us to construct a narrative of what came before. They engage us when the idea of passage cannot be far from our minds—we are, after all, either approaching the canvas or moving away from it. Our time with the painting must include—if we are self-aware—what the painting reveals about the nature of continuousness. Hopper's paintings are not vacancies in a rich ongoingness. They are all that can be gleaned from a vacancy that is shaded not so much by the events of a life lived as by the time before life and the time after. The shadow of dark hangs over them, making whatever narratives we construct around them seem sentimental and beside the point.

X

Within the question of how much the scenes in Hopper are influenced by an imprisoning, or at least a limiting, dark is the issue of our temporal arrangements—what do we do with time and what does time do to us? In Hopper's paintings there is a lot of waiting going on. Hopper's people seem to have nothing to do. They are like characters

whose parts have deserted them and now, trapped in the space of their waiting, must keep themselves company, with no clear place to go, no future.

<div align="center">XX</div>

Room in New York is another of those scenes one might encounter on a walk in the city or see from one's apartment. A couple sit in their living room. He leans forward and reads the paper. She sits across the small room, looking down as she touches the piano keys with one finger. It is a scene of domestic calm in which a man and a woman are absorbed in their own thoughts and appear at ease within the confinement of their small apartment. But are they at ease? The man is intently reading, but the woman is not intently playing the piano. She is idling away time, presumably until her husband is through with the paper. It is one of those in-between moments that are more common and more characteristic of our lives than we care to acknowledge. This of all Hopper's paintings is the most reminiscent of Vermeer, especially of his *A Lady Writing a Letter with Her Maid.* The lady writes, and the maid, like the wife in *Room in New York,* waits. The disposition of objects, the kind of light, the placement of people, differ considerably, and so does the fact that one is seen through a window and the other from an undetermined but omniscient point of view. But they are alike in their suggestion that one's separateness can flourish in the company of another. The man and the woman in *Room in New York* are both joined and apart, just as the boat and buoy are in *Ground Swell.* But here something is said about the habit of estrangement, that it not only exists among couples, it flourishes calmly, even beautifully, among them. The man and the woman are caught, fixed in a sad equilibrium. Our gaze is directed not at either one, but right up the middle between them, right to the door, which is shut not on either one but on both together.

"Cape Cod Evening," a Short Story by Ann Beattie

The following is a short story written by Ann Beattie.[6] Her story title bears the same title as a Hopper painting made in 1939 (see Color Plate 20). Beattie is a novelist; she wrote this story for an anthology of writings, *Edward Hopper and the American Imagination,* that accompanied a large retrospective exhibition of Hopper's work at the Whitney Museum of American Art in 1995. Note that above, Mark Strand also chose to write about *Cape Cod Evening:* he saw the two people in the painting as a married couple, and Beattie imagines them as brother and sister. There is one further note of interest about this painting provided by Andrea Kirsh and Rustin Levenson, the art conservators quoted in chapter five. They inform us that the bluish color of the trees in this painting is unintended: "One might assume that the blue trees are a metaphorical interpretation of *l'heure bleu* (French for 'twilight'). That would be a mistake. Hopper painted them a conventional green, but the yellow he used in the mixture has faded."[7]

"Cape Cod Evening" *Ann Beattie*

Our neighbor on Cape Cod the summer of 1939 was a painter. Ace
avoided him whenever he could. Most things—Mr. Hopper included—
drove Ace crazy: the daily grass mowing across the street (the other
neighbor's son was retarded. That's what he did, beginning when the sun
was strongest); Shirlene's letters, asking for money (paper punctured by
the fountain pen, puddles of blue-black ink a landslide that followed be-
hind as she toppled down the page in her excited desperation). There
were real problems: Mother, suffering from heart disease; Little Roy run-
ning up such gambling debts he lost the gas station; my former husband,
Lew Dial, persuading our son to work in a factory with him in Buffalo,
New York, instead of going to study medicine the way he'd promised his
grandfather he would. Now people think of Cape Cod and they hear that
awful song in their heads, or they think of President Kennedy's family
compound in Hyannis. Everywhere you look in the summer, the roads
are jammed and people are buying candles shaped like Santas and
Christmas trees. Then, let me tell you, Cape Cod was emptiness and
working people. The house you see in Mr. Hopper's painting burned the
summer after Ace finally finished painting it. He'd been helped (not
enough, according to him) by two brothers who drifted through and
stayed for a month to make money doing chores. At night they slept in
our shed. This was a fairly common thing. The way they cavorted on the
lawn wasn't, but I liked their high spirits: they did cartwheels and hand-
stands, showing off for each other in the evening, after they'd finished
the day's work. They were as puppyish as their collie, and as unpre-
dictable as their kitten that ran away and never was found, though who
could blame it, after being slung in a sack on a stick? It was just part of
their baggage when they first knocked on the front door. Next day it was
gone, and we were all involved in the search, the neighbor's boy swear-
ing he'd seen it climb a tree and then ascend to heaven. When he
dropped in that detail, we went back to looking for it on the ground.
The dog sniffed everywhere, acting more like a full-grown bloodhound
than a collie, but to tell the truth, it was more interested in finding
something to eat, or the exact right place to pee.

 The men were named Jones (that was Mr. Miles's first name) and
Chesapeake. According to them, they could do absolutely anything,
though except for frying a good egg (Chesapeake) and painting very
neatly, but much too slowly (Jones; Chesapeake was mediocre, at best, at

painting), the only thing they really excelled at was their odd acrobatics: taking off to flip in the air from a standing position; curling into a ball and rolling, gathering speed as they rolled across our perfectly flat field. One night Jones almost crashed into the tree from which the cat had reportedly sprouted wings and flown to heaven. You would have believed he was a hoop, rolling downhill. Ace was speechless, he was so alarmed. He couldn't even get words out, just ran after him and blocked his way, ended up in a pile with Jones, and it was like the cartoons: you could all but see electrical charges in the air, dizzy stars drawn above their heads, question marks and exclamation points. The dog got into the fracas and nipped Ace's heel. Chesapeake, who actually did hold his sides when he laughed—probably because he was so thin his ribs might have popped out of his body otherwise—clapped his hands as he gasped for air, he was so amused. We had lemonade afterwards and agreed that in some ways, men were likely to remain boys. It was a funny night, though not necessarily the funniest we ever passed with Jones and Chesapeake, when I think about Chesapeake's abilities as a mimic and Jones' recreation of Charlie Chaplin routines.

On the evening I've been describing, Mr. Hopper's wife, Jo, happened to be outside, working in the garden at their house. I beckoned for her to come over, but she let me know by waving and pointing to the ground that she was busy with the flowers. Nevertheless, she must have let him know about what had gone on, because he asked Ace about "the circus" the next day. He said he was sorry he'd missed the circus, and at first Ace didn't know what he was talking about; could a carnival have come to town we hadn't known about? "Well," Ace said he told Mr. Hopper, "you look out the window most nights, those two will be spinning and doing headstands. I'm surprised you haven't seen it already."

Mr. Hopper had missed out on observing the fun because he had been landscape painting. Ace, who was never inordinately fond of Mr. Hopper, said that whenever Mr. Hopper mentioned the landscape, he rolled his eyes upward, as if what he really meant to say was the sky.

It was getting on to summer's end, as they talked. The air had changed. The light. The dog, who liked Mr. Hopper much more than Ace, had fallen on his back to writhe on the ground and try, with its paws, to push Mr. Hopper from where he was standing. I'd come out from the kitchen to let Ace know dinner was almost ready. The collie snorted when it saw me and bounded to my side. "Must be nice to have so many things to entertain you," Mr. Hopper said, bending to scratch the dog behind its ears. "When the landscape talks, I have to stay absolutely silent, to listen. Sort of like having a circus going on, but not be-

ing able to clap or laugh, for fear you'll miss something."

Ace usually didn't question people when they spoke. It wasn't his way. He said what he had to say, and he didn't seem to listen to anybody's reaction. When they spoke, he usually just took it in silently—though you can bet that a lot of the time, I heard exactly what Ace thought about somebody's comments afterwards. The thing that Mr. Hopper had said, though, provoked Ace. It provoked him because, as he later admitted to me, it was the straw that broke the camel's back. Because that summer, out of a job, stuck in a house with me, his older sister, whom he'd always regarded as a surrogate mother because of Mother's near constant indisposition while he was growing up—that summer, Ace felt sure he was losing ground. That's why whatever ridiculous thing the neighbor's retarded son said upset him inordinately. That's why he never quite got in the spirit of Jones and Chesapeake's antics—because they saw the world as absurd, but Ace was only afraid of it. Mr. Hopper, though, was making a living, and in a quite unconventional way. So: Mr. Hopper, who was one up on Ace, was at the very least to be listened to . . . but what had he just said? I saw the surprise, the absolute lack of comprehension, cross Ace's face. "You're saying the trees talk to you?" he said.

"In a manner of speaking," Mr. Hopper said.

"Then did you ever see a cat in a tree fly straight up to heaven?" Ace asked.

"Maybe if I keep looking," Mr. Hopper said. He was bemused. He wasn't bemused with Ace, he was bemused by himself, but I knew Ace didn't see that.

"We had to give up," Ace said. "Only Roy, over there, saw it," he said, nodding toward the neighbor's house. "Rest of us think the cat ran away."

Mr. Hopper hesitated a moment, then clapped me on the shoulder. When he first extended his hand, I thought he'd taken bad aim for a handshake, but then his hand squeezed the top of my shoulder. He was giving me courage. He had seen that my brother had no desire to imagine, which was enough to make him take his leave instantly, waving his hand the way I've heard the Queen of England waves from her carriage, greeting or taking leave of everyone, but of no one in particular.

That night, at dinner, I said: "You've heard music and it's made you imagine a waterfall. Or fairies dancing."

"Crazy people," Ace said. "You think about it. I'm surrounded by 'em."

"He only meant that the landscape put him in a particular mood. That he could communicate with it."

He glared at me, then at his soupbowl.

"How are you so smart?" he said. "You married a gambler who ran off with a waitress. You promised Daddy that Henry'd go to medical school, and where is he but a factory in Buffalo, New York, where it's probably already snowing, and he'll be at that factory all of his life."

"I didn't say I was smart," I said. "One thing I do understand, though, Ace, is that when and if something like the landscape speaks to you, it's magic, and you'd better listen."

"Crazy," he said again, and cut a thick slice of bread.

We were contentious, because somebody had to find a way to get more money to Shirlene. It was her house we were in, having said we'd pay her rent while she was off looking for a job in New York City. We'd assumed Ace could get the tugboat work he'd been promised, but it had never materialized. And because that morning a letter had come with more bad news, and by now we were both sure that by winter, Mother would be dead. What he said was true: I'd made mistakes I didn't seem to be able to recover from—at least financially. And Henry was lost to me, always influenced by his father, not enough self-confidence to fill a thimble.

Things weren't very cheerful, so I was happy for the collie, and its playfulness that gave us something to think about other than ourselves. The fact that Jones and Chesapeake left it behind when they disappeared one morning seemed to me a real kindness, not a burden. It was an entertaining dog, a rascal, sleek-coated in spite of mediocre feedings, quiet when we insisted on that. It learned everything we taught it, and it was a mouser, too, as good as any cat.

In August, I went over to the Hoppers' house. She'd asked me to make a dress, which I'd done two fittings for and still it wasn't exactly right, which we both could see. She shrugged around inside, tried to help me adjust the shoulders. This happens sometimes, for a reason I can't explain, except to say that the dress actually resists. It's as if it just doesn't want to be worn by that particular person. As if it could speak and say, *this is wrong.* I pinned it again, apologizing. She was nice about it, and I worried that maybe that was because she didn't have the money, though that was probably irrational. I really needed the money that day. I was hoping to redo the dress before evening, so I could send Shirlene the money in the next day's mail.

"I haven't seen your acrobats lately," Mrs. Hopper said.

"They disappeared without even a note," I said. "Ace says they were mad that it was such a big job to paint the house. You'd think we'd gone out and found them and misled them, or something, when what they did

was show up hungry on our doorstep, with no great skills and nothing to eat and nowhere to sleep."

"He wanted to paint them. He'll be upset they're gone," Mrs. Hopper said.

"Mr. Hopper wanted to paint those two men?"

She nodded.

"Well," I said. "They left without even so much as a nod goodbye."

"Restless," she said. "Everybody's that way now. On the move."

I had finished lengthening the hem. "If they come back, I'll let you know," I said, talking through the pins in my teeth.

"In fact," she said, " I think he wanted to paint all of you. Not just the men."

"Paint us? My brother and me?"

"Yes," she said.

"Oh, we don't know how to model," I said, suddenly embarrassed.

"To tell you the truth, he may have been thinking of the house."

Why was I suddenly so disappointed? It had just been painted; I should be proud of the house. Also, what I'd told her was true: I'd be self-conscious posing for Mr. Hopper. Ace, of course, probably wouldn't even consider sitting still.

"Yes, I do think that's what he was thinking of," she said, letting me help her out of the dress.

As I lifted it over her head, I was lost in thought, creating the dress I'd wear in the painting. I could make it from the lovely blue fabric I had in the house. The lady who bought the material decided last week that it didn't flatter her and told me to hold off making it. I could trade her my services for the material she didn't want, let her pick out some other fabric. He might come intending to paint the house, but once he saw me in the dress, he would decide, instead, to paint my portrait. Imagine what that would be like: appearing in a painting, when I never even had a photograph of myself on my wedding day! Not exactly a chance to do things over, but a substitute for what I'd missed. I'd be in my favorite color, blue, instead of the white dress I wore to my wedding. I'd look confident, not young and nervous and falsely hopeful.

What a sweet notion: to imagine I might re-create the past, while Mr. Hopper painted the present. Then, like the dog, I could sense danger in the air, take notice of which way the wind was blowing, be skeptical because stars shone in my eyes, not overhead. Naturally, I would not marry the wrong man. My life would be different. And so would the world.

Such was my vanity, in late summer, 1939. Within a week—which makes me wonder: would it have been too early, just too early, for Mr. Hopper to see the future clearly?—the world would be at war.

A Poem about Hopper's *Nighthawks* by Joyce Carol Oates

Joyce Carol Oates writes fiction, poetry, and literary criticism. Below is reprinted a poem she wrote in 1989[8] about one of Hopper's best-known works, *Nighthawks* (Color Plate 21), painted in 1942.

Edward Hopper, "Nighthawks," 1942 *Joyce Carol Oates*

The three men are fully clothed, long sleeves,
even hats, though it's indoors, and brightly lit,
and there's a woman. The woman is wearing
a short-sleeved red dress cut to expose her arms,
a curve of her creamy chest, she's contemplating
a cigarette in her right hand thinking
her companion has finally left his wife but
can she trust him? Her heavy-lidded eyes,
pouty lipsticked mouth, she has the redhead's
true pallor like skim milk, damned good-looking
and she guesses she knows it but what exactly
has it gotten her so far, and where?—he'll start
to feel guilty in a few days, she knows
the signs, an actual smell, sweaty, rancid, like
dirty socks, he'll slip away to make telephone calls
and she swears she isn't going to go through that
again, isn't going to break down crying or begging
nor is she going to scream at him, she's finished
with all that and he's silent beside her
not the kind to talk much but he's thinking
thank God he made the right move at last
he's a little dazed like a man in a dream—
is this a dream?—so much that's wide, still,
mute, horizontal—and the counterman in white
stooped as he is, and unmoving, and the man
on the other stool unmoving except to sip
his coffee but he's feeling pretty good,
it's primarily relief, this time he's sure
as hell going to make it work he owes it to her
and to himself Christ's sake and she's thinking
the light in this place is too bright, probably
not very flattering, she hates it when her lipstick
wears off and her makeup gets caked, she'd like
to use a ladies' room but there isn't one here

and Jesus how long before a gas station opens?—
it's the middle of the night and she has a feeling
time is never going to budge. This time
though she isn't going to demean herself—
he starts in about his wife, his kids, how
he let them down, they trusted him and he let
them down, she'll slam out of the goddamned room
and if he calls her SUGAR or BABY in that voice
she'll slap his face hard YOU KNOW I HATE THAT: STOP.
And he'll stop. He'd better. The angrier
she gets, the stiller she is, hasn't said a word
for the past ten minutes, not a strand
of her hair stirs, and it smells a little like ashes
or like the henna she uses to brighten it
but the smell is faint or anyway, crazy for her
like he is he doesn't notice, or mind—
burying his hot face in her neck, between her cool
breasts, or her legs—wherever she'll have him,
and whenever. She's still contemplating
the cigarette burning in her hand,
the counterman is still stooped gaping
at her and he doesn't mind that, why not,
as long as she doesn't look back in fact
he's thinking he's the luckiest man in the world
so why isn't he happier?

INTERPRETATIONS OF *RAIN,* A DANCE CHOREOGRAPHED AND PERFORMED BY BEBE MILLER

Rain (Color Plate 22) is a solo dance choreographed by Bebe Miller, a contemporary American choreographer and dancer.[9] *Rain* is included here to expand notions of what is interpretable. Candace Feck, a university dance instructor who teaches a writing course to graduate dance students, wrote an interpretive essay about *Rain* and asked her students to do the same. This is how she posed the assignment for herself and her students:

> Your paper is a response to Bebe Miller's 1989 performance of her work, *Rain,* which is available for viewing on video in the dance lab. In developing your paper, consider what the reader might need to know in order to understand your response to *Rain,* and write persuasively, providing lively and descriptive evidence and reasons for your response. Illuminate the aboutness of *Rain,* articulating how you find meaning in the work. Be sure to give your writing a title. The paper should not exceed 1200 words.

Feck's paper in its entirety follows, and then sections are quoted from others' papers that amplify or expand Feck's observation. This section on *Rain* is meant to show what is likely obvious: Dances, like paintings and other works of art, are open to interpretation, and the interpretive principles and strategies used for art criticism are readily applicable to dance criticism. This is not to say that a dance and a painting, for example, are equivalent: Dances are temporal and moving art forms that change to a greater or lesser extent every time they are performed. Dances are usually accompanied by sound. Every person who sees a dance sees it from a different vantage point. The writers about *Rain* who are cited here worked from a videotape of the dance as it was performed by its choreographer, Bebe Miller.

Primal Scream	*Candace Feck*[10]

Bebe Miller's 1989 work *Rain* frames a duet between a soloist and a thick patch of live grass. A mixture of referential and abstract movement, the dance digs down beneath the possibility of superficial interpretation and addresses the viewer on a gut level. In a word, the dance is primal.

As the piece opens, a pool of light casts a circle around Miller, her glistening crimson figure foregrounded by a rough slab of green sod. When I first saw the dance, I was mesmerized by this unkempt rectangle of earth. Like a thirsty stranger in a dry land of orderly seats and production equipment, it beckoned to be touched, connecting performer, grass and viewer in a triangle of longing that endured throughout the work. Miller's silhouette hovers several feet in front of this vegetation, moving almost imperceptibly, enveloped in silence. Her torso twists so that her head wraps around to face the grass, feet padding the floor in place, skirt swishing softly back and forth. Slowly, she uncoils, bringing into focus the partners in this terrestrial duet.

Miller's motion turns to viscous fluidity, thick and slow-moving like molasses, sustaining a wake of ruby ripples around her. Led by the slow, rocking motion of her hips, she inches backwards toward the grass. Suddenly, head snapping over one shoulder, she pauses intently, studying the sod before resuming her path. Probing the space behind with outstretched leg, she grazes the turf's edge, initiating the first contact: she plants her foot down into the soil, then pivots abruptly to face it. This moment of connection is curtailed, however, as Miller quickly retreats. Curving forward, her arms spread out from the elbows like wings, then turn themselves inside out in skyward invocation. Does she beg the heavens for rainfall, or acknowledge her grounded dependence on whatever may come? This enigmatic dance keeps me wondering, prolonging my curiosity about the relationship between grass and dancer; sky and earth; thirst and satisfaction.

Meanwhile, the movement vocabulary develops with edge-like clarity, emphasizing the articulation of each joint and gesture, granting every movement its distinct moment. This attention to detail reveals unexpected movement initiations: a crook of the elbow here, a jutting hip there, a flexed foot, a swoop of the knee. The gestures tend to unfold sequentially, each action yielding to an adjacent one, so that when Miller's leg darts out like a dagger or her figure collapses suddenly to the floor, the simultaneity of motion emerges in startling relief. Similarly distinctive are the transitions between movements, a finely-etched but curious fusion of silken and spiked. Throughout, discrete hand motions embellish the flow of *Rain*. Calculated and cryptic, they shake brusquely, as if to rid themselves of excess water; they cup and flick and wave with odd singularity. Fingers tighten into fists; palms open to paw the floor like the farewell caresses of a desperate lover.

Rain is nothing if not grounded. Miller rarely breaks her bent stance, body inclined to earth. Much of the action occurs on the floor, dancer splayed out on back or belly, legs open and angular as in the throes of labor, or the observance of a fertility ritual. Even the single section of airborne movement calls attention to the weightedness of the body, rather than its ability to soar. This passage builds to a series of running circular paths, led awkwardly by the heel. Miller crosses over the sod on each loop, her steps growing faster, the circles smaller. Finally, she comes to a place of respite as the music shifts to a rich but dolorous aria. Advancing slowly toward the audience, she begins to jump, relentlessly, in place—feet flat, knees scarcely bent. A human oxymoron of tension and release, her shoulders hike stiffly toward her ears, arms dangling, dreadlocks splashing around her head like sprung rivulets gushing life-giving water onto the ground.

Both selections of music, by Hearn Gadbois and Villa-Lobos respectively, are integral to this dance. After the velvet hush of the opening moments, Miller's uplifted arms lower, pulling the weight of her head into a pair of forward bounces. Precisely, on the downward beat of the second drop, a shrill soprano scream perforates the silence, followed by the bass undertones of throat-singing. These sounds, juxtaposed with an insistent drumming pattern and the urgency of Miller's performance, connote a sense of ritual, perhaps the retelling of an ancient myth—part rain dance, part environmental manifesto. A network of recurring pauses punctuates the flow of movement, providing visual and kinesthetic counterpoint to the aural score. Miller allows each of these stillnesses to fully register, undergirding the work with a feeling of suspense.

175

Rain eludes the construction of narrative, garnering its meaning through an accumulation of associative components. Miller claims that the dance is simply a study of opposites, and those are indeed apparent. There is power and submission; resignation and heightened alert; stillness paired with panther-like attack; stalking versus pleading; hard angles against the softness of grass. Still, the evocative title and the partnering of crimson-clad dancer with shaggy slice of turf create a puzzle for the viewer that courts a deeper search for meaning. There is a dancer, fully alive, and a hunk of sod, suggestive of life, but inert. There is the power of the music, both ominous and soulful—primal scream atop deep, rooted tones. Most compelling of all, there is the visual and tactile tension between dancer and sod that remains at play, yet resists resolution. Most of the movement is located away from the parcel of earth, with moments of contact cast in an off-centered, almost peripheral manner. Towards the conclusion of the dance, an earlier gesture is reprised in which the dancer's arms swept beneath her arched back; now, she slips a hand underneath the sod, sandwiching flesh between floor and soil. An ecstatic interlude occurs when Miller sinks into the grass, lowering her pelvis between collapsed knees, basking, with upturned face to the sky— but this moment of surrender evaporates, too brief to quench a gathering thirst. The piece ends with prone dancer angled alongside one corner of the sod, neither on nor off its seductive surface.

I could see *Rain* again and again, and not tire of it. Although its message deflects a linear reading, I feel immersed in something urgent and mysterious. Like rainfall itself, the piece soaks through me in ways that are beyond my control; I become aware that I had entered the space in a parched condition, and leave it inexplicably refreshed.

Quite naturally, and informatively, the other writers in Feck's class emphasized some aspects that Feck did not address in her essay on *Rain,* or they addressed the same aspects but with different interpretations and emphases. Each of the essays on *Rain* that Feck obtained addresses the grass, sod, or turf and its metaphorical implications, treating it, in part, as a sculpture with meaning in itself. Its meanings for the interpreters, however, are very dependent on how the dancer interacts with it. How the dancer relates to the grass, for example, is variously described and interpreted. Feck gives it great prominence in her interpretation, seeing it as the second partner of a duet. She thinks of the grass as a "thirsty stranger in a dry land." Jessica Wilt interprets the dance to be a "rain ritual" and thus the grass is central to it. Jessica Lindberg writes this about the grass in her essay that she titled "Traveling Partner":

> *Rain* resonates with the theme of the hunt. The hunt, almost taking on the mythic status of a quest, has been a part of the earthly dancer for so long that a void is felt in place of the life-long searching once the aim is reached. Was this the premise on which

the piece opened? Was she nearing the end of her internal quest, displaying an animal-istic drive to cross that last distance? Her triumphant springs conclude in a bewildered stillness as she contemplates what to do now that her quest is at an end.

Contact with the living rectangle is limited. The dancer addresses it early on, with a toe, she runs across it, and she yields to it. Resting her head upon the edge of the lawn, nature quiets the frightfully rushing mind. Following the lead of her feet, the body slowly works itself into the lush green. She sits, her legs first thrown wide, then tucked securely under her weight in the center of the down light. The animal within surveys its new territory. She explores it. One hand works into and then under the vibrant green patch. In the end, she is nestled in a shadowed corner of her partner, the earth, and falls asleep in its security.

Jeannine Potter, in her essay entitled "Growing," sees the grass as a particularly American symbol of class. Although Feck does not acknowledge the race of the dancer and choreographer, Potter addresses race in the very first paragraph of her essay and throughout it, explicitly interpreting race to be central to the dance's meaning:

Green is the color of grass; thousands of leafy fingers pointing upwards to the sun. My dad mows it down weekly in the summer, daring it to climb past his blade setting. I was a white girl growing up in middle-class suburban Dayton, Ohio. Only the second 'non-Caucasian' family moved into my parents' neighborhood after I went away to college.

. . . The red dress flipped and turned, showing me forbidden sections of thigh as she threw herself from moment to moment stopping only to start again. She froze flat on her back, shackled to the floor spread-eagle, and I waited for her captors to shove hands beneath skirt, her head pulling from the stone ground and collapsing. Coming from the floor, she gave birth again and again flinging limbs wide and pulling herself together combating ripping flesh. In quick falls and immediate recoveries, I saw her slapped to the kitchen floor once, twice, each time rising again in challenge.

. . . I saw abuse, pain and turmoil, but Miller's character was not a victim. There was a joy in this battle that left me feeling there was no possibility for defeat. Each time she sat legs to-gether back straight, I knew I had found my heroine. Her hair hardly mussed, her dress barely wrinkled, she sat toe-painted-proud with roots reaching down through the earth.

. . . I know what the grass means for me. It represents a lifestyle labeled The Ameri-can Dream to my parents' generation. It was not accessible to everyone. Here was the land, the earth, the green, mocking her in her barren black-floored world. It shone there in the light, present but unreachable. She is a woman, a black woman, on the outside with the patch of paradise so close she could dip an occasional foot in the damp earth, but far enough away that unfamiliarity prevents her from feeling at home there. House, home, husband and children all encircled by a white picket fence is out of reach.

Elisha Clark also considers race in her essay "Prophetess Remains," and adds African ancestry to her interpretation of *Rain*, and in that context interprets the grass to be "grassland":

This is the dance of an old tribal woman leading her people through life. She is tired, yet strong and determined; torn between the world she inhabits and the one that resides within her consciousness. She cherishes her visions, yet they exact a heavy toll upon her spirit. Pitted against her desire to lead and protect her people is the need to be with those for whom her connection is stronger. She craves the presence of the ancestors that influence and impart the vitality that sustains her. After an intense struggle she resolves to remain—for now—where she is: between two worlds, with responsibilities to both.

In his essay "Intricate Travels in Reverse," Karl Rogers interprets the grass as "a cloud, or her burial plot, or maybe just a patch of serenity" but does not dwell on it, nor does he mention race. He does, however, stress the differences between a dance and life, rejecting a copy theory of art in favor of an Expressionistic one. That is, *Rain,* or any work of art, is not a copy of the world but a new world unto itself:

> As a viewer I become immersed in Miller's work and slowly strip away my everyday concerns to watch it. Within seconds I conform to her laws and forget about any previous sense of governance. Miller transforms me from a compulsive conquistador of my daily regime to a docile citizen of her world. In essence, a description of the movement isn't enough, the dance has a marrow of life. It would be easy to describe this dance as one odd lady doing lots of odd rolls in front of and on top of a strip of sod. Yet that description falls short because it hails from a sensibility formed in a world sharply divided from the one which Miller inhabits.
>
> *Rain* is alluring because it is distinct from our daily lives. The moment the light dawns on Miller in a bird-like pose, I am spellbound by the "complete, autonomous" world that Miller describes with her body. The enigmatic character who populates that world—an enchanting woman who embarks on a profound journey of reverse—simply entrances me.
>
> . . . Bebe Miller's *Rain* reminds me of the profound possibilities of art. It manages to create a distinct world, a world distanced from my everyday life, a world in which the peculiar seems natural and significant, a world where a woman intricately travels in reverse.

None of these interpretive essays contradicts the others, and each one adds to an understanding and appreciation of *Rain.* They variously and to greater and lesser extents attend to elements of *Rain* including sound, costume, lighting, the set, particularly the grass, the choreography, and most especially to the movements of the dancer: "panther-like attack," "stalking," "pleading," "viscous fluidity, thick and slow-moving like molasses," "odd rolls," "she arches skyward," "she slumps to the floor," "she gracefully writhes," "with animalistic abandon her body is splayed out," "convulsive heaves of the limbs and torso," "fiercely flexed feet," and "sat toe-painted-proud." The meanings the essayists ascribe to the movements in parts of the dance and to the whole of it also vary: she is interpreted to hunt, plead, beg, survey, explore, lead; she is in the throes of labor, lowers her pelvis in a moment of ecstasy; she gives birth again and again; she is captured, abused, shackled to the floor spread-eagle, slapped, dies, falls asleep. . . .

The writers of these essays mostly describe and interpret, and when they describe, they then infer interpretive meaning from the descriptions. Feck explicitly states a judgment: "I could see *Rain* again and again, and not tire of it." The other essayists clearly imply that they value the piece by how attentively they observe it and empathetically and enthusiastically write about it. Although they do not explicitly state that it is a good dance, we know that they believe it to be by the way they write about it.

Most important, these essays show that a dance, like a work of visual art, is open to and rewarded by interpretive efforts. Further, they show that a dance, like any work of art, is open to multiple interpretations and that each interpretation or interpretive nuance gives us insights that we would not otherwise have.

INTERPRETATIONS AND POPULAR CULTURE

Interpretation need not and ought not be limited to examples drawn from the galleries of fine art. So far in this book, fine art examples have been used, and, as wide a range as it is—East Indian architecture, illustrations by Norman Rockwell, Renaissance painting, photography fine and commercial—the range of objects open to interpretation and contemplation is even wider and is sometimes holistically referred to as visual culture. Following is a sampler of interpretations and interpretive strategies applied to a broader range of artifacts than have been examined so far in this book. These examples of interpretations of items and events in popular culture are offered in the hope that they will be entertaining, informative, and motivational in prompting you to interpret similar items in your own way.

David Carrier: The Aesthetics of a Gary Larson Cartoon

David Carrier is a serious scholar of art history who has fostered a childhood interest in comics in general, and he is particularly fond of the "Far Side" cartoons made by Gary Larson. Following is a brief excerpt from Carrier's book *The Aesthetics of Comics*.[11] It is an interpretive and admiring meditation on Gary Larson and his work. Carrier's writing is offered as an example of interpretive thinking about a common object in popular culture, cartoons found in daily newspapers.

From *The Aesthetics of Comics*	*David Carrier*

Totally apolitical—apart from his passionate support for animal rights—Larson hates change, which he thinks always brings disaster. Taking almost all his subjects from lower- or middle-class white American life, but not a chauvinist, his only significant foreign settings are African jungles, the Arctic, and rivers inhabited by headhunters. Borderlines between city and country, humans and animals, are blurred: deer are hunted in their

own living rooms; dogs steal family cars; animals take photos on vacation and appear on quiz shows. Larson loves endless mindless repetition—people in hell doing five million leg lifts or discovering that cold fronts never arrive, and disasters that befall those stupid enough to eat potato chips or buy tropical fish in the desert. (Heaven is of less interest to him than hell.) He shows petty theft, minor crime, and, occasionally, homicide; menacing ocean scenes hold a special attraction for him. He adores sharks.

Larson's archaeologists are doomed never to learn about the past, his anthropologists to understand nothing of the "natives" they study. His animals mimic humans doing stupid things. Larson's world is oddly asexual in a preadolescent-male way. He loves toilet humor and human-animal couples, not as illustrations of bestiality but as just another variety of dumbness. His women would just as soon be married to animals—and why not, when all people are so stupid? Apart from such normal fascinations as dog-cat battles, his odd obsessions include cross-dressing cowboys, men with peg legs, and—what does this mean?—the erotic significance of chickens. His stupid, sadistic, and dysfunctional characters enjoy their lives. Gravely serious academic commentators have written much about "postmodernism" and the end of history. Larson's immense popularity—is there anyone who really dislikes his work?—shows that, at some level, very many people suspect that progress is finished. It is hard to imagine him showing the triumph of virtue.

The man at the blackboard who has discovered "the purpose of the universe"—an elaborate equation he works on sums up to zero—summarizes Larson's worldview. Living in a run-down universe can be fun. Scientists who play games instead of doing research, pilots who cannot read instrument-panel dials, a musician who tries to perform with only one cymbal: Larson's characters are happily, hopelessly incompetent. He really has only this one major theme, disaster. This is why encountering his pictures one by one in the newspaper was more fun than looking at the collections of his art. Humor of this sort is only occasionally a central concern in old-master art. Unfunny paintings, calling for knowledge of esoteric texts, give their interpreters the sense that they are smart. Larson's cartoons make you feel as stupid as the characters he loves to depict; temporarily imagining being stupid, he shows, can be fun. Or as he puts it, quoting Mel Brooks: "Tragedy is when I cut my finger. Comedy is when you walk into an open sewer and die."

Spalding Gray Interprets "Bad Words"

How would you explain the concept of "bad words" to a young child? Spalding Gray is an author and performing artist who writes and delivers monologues, some of

which have been made into feature films, such as *Swimming to Cambodia*. In the following excerpt from a short book about his family and parenting, he offers an explanation of how language works to Forrest, his kindergartner son, while they are on a bike ride to their local video store. Gray's explanation serves for bad words and also for understanding works of art and other signs and how they function in society.

From *Morning, Noon, and Night* **Spalding Gray**

Just outside our gate, he rides for a bit and then brakes and turns to me to say, "Dad, could I tell you something? Aliens don't have armpits."

"How do you know?"

"I just do, Dad."

"Dad, could I tell you something? I know what's inside ghosts."

"Oh, really, Forrest? Well then, what is inside ghosts?"

"Nothing, Dad."

"And what is nothing, Forrest?"

"Nothing is just a word, Dad. But, Dad, 'oh my' is not a bad word, is it?"

"No, Forrest, I've told you over and over there are no bad words. A word only starts to take on a good or bad meaning when it's used in context, and we'll discuss that one later. Also, 'oh' and 'my' are two words, not one."

"But my teacher said we could not say 'Oh my God.' "

"Forrest, you can say any word you want. You can say 'God.' You can say 'my.' You can say 'oh.' You can say 'God my oh.' Now let's go over the lesson again. What might your teacher think is a real bad word? Let's take a good bad word. Now there's a concept, a 'good' bad word. Let's take 'shit.' Well now, we don't have the word 'shit' yet, do we, so we're going to have to construct it. Create it. Now I'm going to write the word 'shit' in the air. It starts with the letter 's.' Now is 's' a bad letter? Does it smell? No. My first name begins with 's.' It's kind of a nice snaky letter. Now we make the 'h.' Anything bad about that? No. Now we have 'i' and now 't.' There it is, Forrest, there's the word, 's-h-i-t,' written in the air. Now please don't mistake the word with the substance in the toilet. The substance in the toilet is the-thing-in-itself. It smells and it has some offensive properties. Don't confuse the word with the substance. The word is only a signifier.

"Girls, Girls, Girls": A McDonald's TV Commercial

In 1987, Jason Simon, an independent filmmaker and videographer, produced and distributed a thirty-minute videotape entitled *Production Notes: Fast Food for Thought*. In it he showed six commercials made for TV: one each for Schlitz Malt Liquor, Pert Shampoo, Pepsi, and Mars Bars, and two for McDonald's. On Simon's thirty-minute videotape, you see each of the six commercials, but, rather than hearing their sound tracks, you hear a male voice reading the production notes for each of the commer-

7-1 Video still from proposed McDonald's commercial, "Production Notes: Fast Food for Thought," Jason Simon. Distributed by Video Data Bank, Chicago. Jason Simon is an artist in New York City.

182

cials; then you see the commercial again, this time the actual commercial with its own sound track. These are all commercials that were made for distribution over commercial networks on television. The production notes are a verbal description of the look and feel of the commercial that the ad agency sent for approval to the sponsors before the commercials were made. Following is a transcription of voice-over production notes by Leo Burnett, recorded on January 26, 1986, for a sixty-second McDonald's commercial the ad agency called "Girls, Girls, Girls."[13]

The production notes are reproduced here, verbatim, as an inside look at the intentions of the makers of one commercial. They also provide us with a sense of the makers' attitude toward their target group, girls from age ten to sixteen. This set of production notes is typical of the production notes of the other five commercials. It is offered as a prompt to you to interpret other commercials you see while watching television. When seeing any commercial on TV, you can interpretively consider these questions: Who are the makers? Who is their intended audience? How is the commercial meant to appeal to the audience? What social values does it promote? On the basis of this commercial, what would the makers have their audience believe? What might be the consequences of such beliefs?

"Girls, Girls, Girls," a McDonald's TV Commercial

Objective: The objective of this spot is to convince girls in the age group of ten to, say, sixteen, that McDonald's understands, empathizes, and admires them.

This spot is a tribute to the female gender.

"Look," "design" is the key word for this spot.

Everything should be taken into account to give the viewer an overall look of style, graphic design and realism to what girls are really about.

Since the subject is girls, design of scenes take on the utmost importance. For instance the bedroom scene with the girl getting her hair done like the cover girl: Let's say the walls in that room are purple, the bow in the girl's hair is pink and her sweater is, say, purple and pink. The magazine cover has a slate gray background, and the girl behind her is dressed in a rose-colored jacket with, say, a light gray silk skirt.

The whole scene now has colors that complement each other and an intense design element.

Each scene should be looked at this way color-wise. Every object, prop, and piece of clothing should complement each other.

Also, the photographic approach should be fresh, alive, active, and inspiring. "Contemporary" is a good word here, like the Dexter Coke ads, like the *Chicago Tribune* ads, like the 501 Jean ads, like the Levi cords night ad, like the Honda scooter ads.

The eighties-film-look. Not seventies European new wave, but eighties. Contemporary, heightened reality. Even yet, that all exists in the examples I've just described.

For this commercial, the look, the style, and the music is everything. Without that, we'll end up with another boring vignette spot about girls.

Girls and guys should be between the ages of 13 and 16.

Again, the cast should be aspirational. Kids want to appear older.

We don't want rowdy street-looking kids, but we don't want midwestern milk-fed-looking kids either.

The kids should look mature, wise, and have character. We don't want redheads with freckles, all blonde blue-eyed darlings.

We want a cross-section of the American girl; some pretty, some not so pretty, but with character.

We want to portray the world the way it is so we have to cover the ethnic requirements—some Blacks, some Latins.

This is not your typical McDonald's commercial. We are talking a daring step for McDonald's.

The kids we are speaking to are grammatically sophisticated.

The McDonald's objective is to portray happy smiling kids in their own world. The camera is like a disembodied spirit that catches these kids in the act of being themselves.

McDonald's still represents God, America, and apple pie.

They tell you they want to move out of the neighborhood but then we find out that they only wanted to go next door.

I'm saying this to say that there is a fine line between where we are and how far we can go.

These spots should not look too urban, too ethnic, too new wave or too anything that doesn't jive with McDonald's image.

Lighting should be dramatic but not shadowy.

Location should be beautiful but not weird.

Clothing should be contemporary but not punk.

Casting should be characterizations but not to the point of hoodlums.

Film style should be graphic but not gritty European.

In other words, we can go out of the ordinary but we can't live there.

I know this may sound confusing but I find it better to know the way McDonald's works now than argue on the set about it later.

Good luck, everyone.

Henry Giroux, *The Little Mermaid, The Lion King,* and *Aladdin*

Henry Giroux, a social critic and educator, examines some possible negative social effects of children's exposure to commercial culture, especially the ever-popular anima-

tion produced by Disney. At issue is how persons, groups, cultures, and histories are understood by Disney and then interpreted through delightful animated images that shape the desires of children. Giroux's interpretive and critical analysis of Disney's productions is easily applicable to other movies and television shows made for children and to many aspects of commercial culture as it is represented visually in print and electronically.

What Children Learn from Disney Henry Giroux[14]

The construction of gender identity for girls and women represents one of the most controversial issues in Disney's animated films. In both *The Little Mermaid* and *The Lion King,* the female characters are constructed within narrowly defined gender roles. All of the female characters in these films are ultimately subordinate to males and define their power and desire almost exclusively in terms of dominant male narratives. For instance, modeled after a slightly anorexic Barbie doll, Ariel, the mermaid in *The Little Mermaid,* at first glance appears to be engaged in a struggle against parental control, motivated by the desire to explore the human world and willing to take a risk in defining the subject and object of her desires.

. . . Although girls might be delighted by Ariel's teenage rebelliousness, they are strongly positioned to believe, in the end, that desire, choice, and empowerment are closely linked to catching and loving a handsome man. . . . Ariel becomes a metaphor for the traditional housewife in the making. When Ursula tells Ariel that taking away her voice is not so bad because men don't like women who talk, the message is dramatized when the prince attempts to bestow the kiss of true love on Ariel even though she has never spoken to him. Within this rigid narrative, womanhood offers Ariel the reward of marrying the right man for renouncing her former life under the sea. It is a cultural model for the universe of female choices in Disney's worldview.

The rigid gender roles in *The Little Mermaid* are not isolated instances in Disney's filmic universe; on the contrary, Disney's negative stereotypes about women and girls gain force through the way in which similar messages are consistently circulated and reproduced, to varying degrees, in many of Disney's animated films. For example, in *Aladdin* the issue of agency and power is centered primarily on the role of the young street tramp, Aladdin. Jasmine, the princess he falls in love with, is simply an object of his immediate desire as well as a social stepping-stone. Jasmine's life is almost completely defined by men, and, in the end, her happiness is ensured by Aladdin, who is finally given permission to marry her.

185

. . . Rather than a young adolescent, Pocahontas is made over historically to resemble a shapely, contemporary, high-fashion supermodel. Bright, courageous, literate, and politically progressive, she is a far cry from the traditional negative stereotypes of Native Americans portrayed in Hollywood films. But Pocahontas's character, like that of many of Disney's female protagonists, is drawn primarily in relation to the men who surround her. Initially, her identity is defined in resistance to her father's attempts to marry her off to one of the bravest warriors in the tribe. But her coming-of-age identity crisis is largely defined by her love affair with John Smith, a blond colonist who looks like he belongs in a Southern California pinup magazine of male surfers. Pocahontas's character is drawn primarily through her struggle to save John Smith from being executed by her father. Pocahontas exudes a kind of soppy romanticism that not only saves John Smith's life but also convinces the crew of the British ship to rebel against its greedy captain and return to England.

Of course, this is a Hollywood rewrite of history that bleaches colonialism of its genocidal legacy. No mention is made of the fact that John Smith's countrymen would ultimately ruin Pocahontas's land, bring disease, death, and poverty to her people, and eventually destroy their religion, economic livelihood, and way of life. In the Disney version of history, colonialism never happened, and the meeting between the old and new worlds is simply fodder for another "love conquers all" narrative.

. . . The issue of female subordination returns with a vengeance in *The Lion King.* All of the rulers of the kingdom are men, reinforcing the assumption that independence and leadership are tied to patriarchal entitlement and high social standing. The dependency that the beloved lion king, Mufasa, engenders in the women of Pride Rock is unaltered after his death, when the evil Scar assumes control of the kingdom. Lacking any sense of outrage, independence, or resistance, the women felines hang around to do Scar's bidding.

. . . Racial stereotyping is another major issue in Disney films. There is a long history of racism associated with Disney, tracing back to *Song of the South,* released in 1946, and *The Jungle Book,* which appeared in 1967. Moreover, racist representations of Native Americans as violent "redskins" were featured in Frontierland in the 1950s. In addition, the main restaurant in Frontierland featured an actor representing the former slave Aunt Jemima, who would sign autographs for the tourists outside of her "Pancake House."

. . . One of the most controversial examples of racist stereotyping facing the Disney publicity machine occurred with the release of *Aladdin* in 1992, although such stereotyping reappeared in full force in 1994 with the release of *The Lion King. Aladdin* is a particularly important example

because it was a high-profile release, the winner of two Academy Awards, and one of the most successful Disney films ever produced. The film's opening song, "Arabian Nights," begins its depiction of Arab culture with a decidedly racist tone. The lyrics of the offending stanza state: "Oh I come from a land/From a faraway place/Where the caravan camels roam./Where they cut off your ear/If they don't like your face./It's barbaric, but hey, it's home." A politics of identity and place associated with Arab culture magnified popular stereotypes already primed by the media through its portrayal of the Gulf War. Such a racist representation is furthered by a host of grotesque, violent, and cruel supporting characters.

Yousef Salem, a former spokesperson for the South Bay Islamic Association, characterized the film in the following way: "All of the bad guys have beards and large, bulbous noses, sinister eyes and heavy accents, and they're wielding swords constantly. Aladdin doesn't have a big nose; he has a small nose. He doesn't have a beard or a turban. He doesn't have an accent. What makes him nice is they've given him this American character. . . . I have a daughter who says she's ashamed to call herself an Arab, and it's because of things like this."

. . . Racism in Disney's animated films is also evident in racially coded language and accents. For example, *Aladdin* portrays the "bad" Arabs with thick, foreign accents, while the anglicized Jasmine and Aladdin speak in standard American English. A hint of the racism that informs this depiction is provided by Peter Schneider, president of feature animation at Disney at the time, who points out that Aladdin was modeled after Tom Cruise.

Racially coded representations and language are also evident in *The Lion King*. Scar, the icon of evil, is darker than the good lions. Moreover, racially coded language is evident, as the members of the royal family speak with posh British accents while Shenzi and Banzai, the despicable hyena storm troopers, speak with the voices of Whoopi Goldberg and Cheech Marin in the jive accents of a decidedly urban black or Hispanic youth. Disney falls back upon the same racial formula in *Mulan*. Not far removed from the Amos'n'Andy crows in *Dumbo* is the racialized low-comedy figure of Mushu, a tiny red dragon with a black voice (Eddie Murphy). Mushu is a servile and boastful clown who seems unsuited to a mythic fable about China. He is the stereotype of the craven, backward, Southern, chitlin-circuit character that appears to feed the popular racist imagination. Racially coded language can also be found in an early version of *The Three Little Pigs*, in *Song of the South*, and in *The Jungle Book*. These films produce representations and codes through which children are taught that characters who do not bear the imprint of white, middle-class ethnicity are culturally deviant, inferior, unintelligent, and a threat.

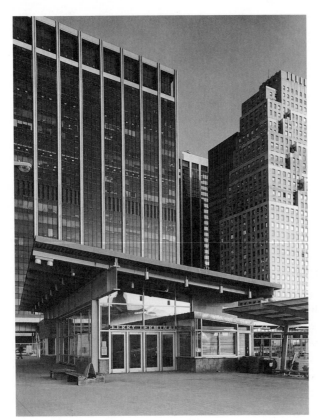

7-2 *Pier 11 in the East River,* 2001. Henry Smith-Miller and Laurie Hawkinson. Photo seen in May 28, 2001 issue of *The New Yorker.* Photo © Robert Polidiori.

Interpreting a Building

The following entry is a one-paragraph essay written by Paul Goldberg, a critic of architecture, about a new building in New York City designed by two young architects, Henry Smith-Miller and Laurie Hawkinson. Goldberg's essay was originally published in the *New Yorker* magazine in May 2001, with a full-page photograph of the building, reproduced here. It is succinct: less than 300 words. In the essay, Goldberg praises the building as one of "the most refreshing public buildings to have gone up on the waterfront in years." More important for this book, he *interprets the building,* writing that it alludes to a barge, an aircraft carrier, and high-tech industrial structures and "it celebrates the routine passages of everyday life. . . ." Goldberg shows that buildings, even ones as humble as this, have expressive meanings that can be interpreted.

Gateway to Gotham *Paul Goldberg*[15]

Architects often have more ideas than it is possible to fit into one build-
ing, but sometimes they get away with including them all. This is the
case at the new ferry terminal at Pier 11 in the East River, where Henry
Smith-Miller and Laurie Hawkinson designed a tiny pavilion that man-
ages to allude to a barge on the Grand Canal in Venice, an aircraft car-
rier, high-tech industrial structures, New York's old waterfront architec-
ture, and a garage. The building doesn't literally resemble any of these
things, although its metal-and-glass façade, which tilts upward to open
the entire space to the outdoors, does make the place seem a bit like a
dream haven for a pair of silver Porsches. Smith-Miller and Hawkinson,
who last week were awarded the Brunner Prize by the American Acad-
emy of Arts and Letters, have modernist inclinations, and to turn a
derelict pier at the foot of Wall Street into a hospitable entrance to the
city they produced a nimble, tensile structure that holds up beside the
skyscrapers of lower Manhattan. If Frank Gehry's new downtown
Guggenheim Museum is built, the terminal will have to stand up to that,
too, since the ferry building would be nestled almost beneath the mu-
seum behemoth. But Smith-Miller and Hawkinson's pavilion is tough,
and it will do just fine whatever happens in lower Manhattan.[16] It is one
of the most refreshing public buildings to have gone up on the water-
front in years. The new ferry terminal celebrates the routine passages of
everyday life while hinting at the excitement of travel across water, and
it reminds us that eager young architects with ideas don't often enough
get the chance to express themselves in the public realm in this city.

189

On The Table: Interpretations of Tables and Tableware

In 1999, the Wexner Center for the Arts produced an exhibition of tables and ceramic
ware that it called *On the Table*. Sherri Geldin, director of the contemporary arts center,
wrote this about the exhibition: "In its many guises—dining surface, vanity, conference
prop, desk—the table is a nearly ubiquitous presence in personal, professional, and
public life: the site of activities both commonplace and ceremonial. Its very familiarity
makes it a provocative choice for curatorial investigation, precisely because it's so rarely
examined." The table, and things on tables, are provocative for interpretive investiga-
tion because they offer a wealth of insights into the evolution of human development,
design, and style. Mark Robbins, the curator of the exhibition, gathered tables and
tableware of many kinds from collections of museums and individuals and businesses.
The collected tables include a lady's small worktable for sewing made of wood and

brass (1880), a wooden Shaker table (1850), a tubular steel vanity table (1934), a ma-hogany table with inlay and brass fittings for chess and checkers (1820), a granite cooktop that uses propane gas for heat (1985), and minimalist tables called *Stones* (1988) made by Maya Lin (**Color Plate 23**), architect and designer of the Vietnam Vet-erans Memorial in Washington, D.C.

Paola Antonelli, a curator of design and architecture at the Museum of Modern Art in New York City, wrote an essay for the *On the Table* exhibition catalogue that he be-gan with these interpretive comments: "Tables are omnipresent in the history of West-ern design, so much that they can be used as keys to an extended narration of its events. They can be pinpointed as symbols of historical moments in the evolution of society and evaluated in their capacity to fully represent their times. The tables and tabletop objects in this particular exhibition can be considered main witnesses in the development of American material culture, as they comment on design and technol-ogy, on the vagaries of taste, on the evolution of materials, and on the timely paragons of comfort and availability. They bespeak the search for an American style and for American society's identity."[17]

Mark Robbins included three sets of dinnerware in the exhibition: Tea Leaf Iron-stone China made by the British in the late 1800s for export to the United States and Canada, a set of President Ronald Reagan's presidential china made by Lenox for the White House in 1981, and a set of Lifetime ware made of plastic in 1947 in America.

The British Tea Leaf Ironstone pattern was affordably priced by its British manu-facturer for use by lower- and middle-class households in the United States and Canada. It was made of sturdy ironstone but made to look like fine porcelain and dec-orated with motifs made of copper luster rather than gold or silver. Tea Leaf Ironstone provided a huge selection of service items including a variety of cups (such as a pos-set cup, for a drink of hot milk curdled with wine or ale), platters, bowls, relish trays, several tureens, compotes, waste bowls, and a bone receptacle. With this pattern, the less-well-to-do could imitate the dining rituals and customs of the upper classes.

During Ronald Reagan's term as president of the United States, Nancy Reagan com-missioned Lenox to produce a new set of presidential china. The china inherited by the Reagan administration from President Lyndon Johnson had no finger bowls. In consul-tation with Mrs. Reagan, Lenox in 1981 produced a set of china to serve two hundred and twenty, with nineteen-piece place settings and a total of 4,372 pieces. The official state service is decorated in twenty-four-carat gold with a lattice diamond pattern on the rim of each service plate and the presidential seal on each piece of the place settings.

In extreme contrast to the Tea Leaf ironstone and Reagan porcelain, *On the Table* also features a set of simple and nearly indestructible Lifetime bowls, made in 1947. Made of melamine, a durable thermosetting plastic, dishes such as these were com-mon in many American homes in the post–World-War-II era, sitting comfortably alongside colorful spun aluminum tumblers, Tupperware, and TV trays. By juxtapos-ing these three sets of dinnerware, Robins implicitly asks us to consider the functional and symbolic implications of the choices we make about the things we use.

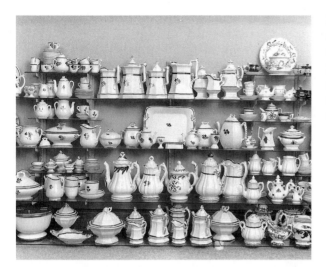

7-3 *Tea Leaf Ironstone China, and Variants,* 1856–1900. Collection of Dale Abrams. Photo © Richard K. Loesch, courtesy of the Wexner Center for the Arts, The Ohio State University.

191

The following six paragraphs, from the *On the Table* exhibition catalogue, are meditative essays on tables in the life of the author, Holly Brubach, who writes professionally about design, architecture, dance, and fashion. It is reprinted here for the joy of reading and to encourage interpretive thoughts in the readers of this book about tables in their lives.

Tables 1998 *Holly Brubach*[18]

TABLE 1

When I was a little girl, a table was for sitting under. The dining table was modern, in blond wood with a pronounced grain. The ceiling in those days was too far above me. I needed reassurance that the sky wouldn't fall on my head.

TABLE 2

I did my homework seated on the floor at the coffee table in the living room. My parents kept urging me to get up and sit in a chair. But it was the sixties, and my generation sat on the floor, as a way of expressing solidarity with those who had no chairs. The coffee table was long and narrow, with four removable glass panels, each about a foot square. The panels, turned upside down, could function as trays. I don't remember my parents ever using them that way, not even for parties. Still, I thought it was a nifty concept.

TABLE 3

When I was a teenager, we moved into a new house and replaced the blond wood dining table with a Louis XVI replica—the top walnut, the base carved and painted white. This signified our upward progress in the community.

TABLE 4

As a recent college graduate in New York, I became the beneficiary of spare furniture from my grandmother's house, including a mahogany dining table with Queen Anne legs. During my childhood, it had resided in the upstairs parlor, where we used it for wrapping Christmas presents. My cousin Glenn, Jr., otherwise known as "Bud," had carved his nickname into the top with a pocketknife. Years later, sitting at the table, I embarked on my career as a freelance writer.

TABLE 5

A friend, visiting in Paris for a weekend, was shocked to find me picnicking on the floor of my empty dining room and resolved to buy me a table at the flea market. We settled on a Louis XVI table that seats six, with a carved green-painted base and a marble top. When it was delivered, I thought, this is the real thing of which my mother's was the copy.

TABLE 6

Two years ago, after hip replacement surgery, I came home to my new loft. Construction had been completed while I was in the hospital; my only furniture was a bed and three patio chairs. I would be housebound, on crutches, for six weeks. My friend David, an interior designer, called. "Can I do anything for you?" he asked. Come to think of it, Yes, I replied and asked him to loan me a table. Later that day, he sent over something his firm had put into storage in the basement: a schizophrenic orphan with a gilded metal base in the style of 1940s French furniture and a faux-granite plastic-laminate top that takes after 1970s American kitchen counters. Sitting at the table, I wrote a children's book in which everyday objects have not only personalities but souls, and a boy befriends them.

Denotations, Connotations, and a *Rolling Stone* Magazine Cover[19]

Roland Barthes, the late French scholar, was a semiotician who investigated how culture signifies, or expresses meaning, and he paid particular attention to how photographs signify. He identified two signifying practices: denotations and connotations.[20] A photographed still-life arrangement may denote (show) flowers in a vase on a wooden table; it may connote (suggest, imply) peace, tranquility, and the delightfulness of the simple. These connotations may be conveyed by the lighting, colors, and the absence of superfluous objects. A fashion photograph may denote a model wearing a coat and a hat but may connote flair, sophistication, and daring by the look and pose of the model and the setting. To look at the photographs and to see only flowers

in a vase on a table, or a hat and a coat on a woman, and not to recognize what they express is to miss the point of the pictures.

The distinction between denotations and connotations is made clearer by an interpretation of a magazine advertisement that Barthes provides. The advertisement is a photographic ad for Panzani spaghetti products that appears in a French magazine. The ad shows cellophane packages of uncooked spaghetti, a can of tomato sauce, a cellophane package of Parmesan cheese, and tomatoes, onions, peppers, and mushrooms emerging from an open string shopping bag. The color scheme is formed by yellows and greens against a red background. The Panzani label is on the can and cellophane packages. Barthes identifies three parts of the ad: the linguistic message, the denoted image, and the connoted image. The linguistic message is the word *Panzani*, which is both denotational and connotational. Barthes explains that the word denotes a brand name of the packaged products but that it connotes, just by the way it sounds, "Italianicity." The word *Panzani* would not have that connotation in Italy, for Italian readers, because they would not perceive that the word sounded Italian.

The photographic image itself denotes what it shows: a can, spaghetti packages, mushrooms, peppers, and so forth. But Barthes explains that the image connotes several other messages. The ad represents a return from the market, and it implies two values: freshness of the products and the goodness of home cooking. The variety of the objects connotes the idea of total culinary service, as if Panzani provided everything needed for a carefully prepared dish. The vegetables imply that the concentrate in the can is equivalent to the vegetables surrounding it. The predominance of red, yellow, and green reinforces Italianicity. The composition, focus, lighting, and color transmit a further value: the aesthetic goodness of a still life.

Barthes's schema can be applied to all images, paintings as well as photographs, and it is a powerful means of interpreting images. Following is an example of the uses of *denotation* and *connotation* by college students[21] to interpret the cover of a popular magazine featuring the rock group Destiny's Child (**Color Plate 24**).[22]

Denotations: three women, seemingly African American, with very light brown skin and slim, fit bodies. The two women at the left gaze down at us and the woman on the right looks over our heads above our right shoulders. Two of the women part their lips and the third keeps hers closed. The woman in the middle smiles slightly, with a raised eyebrow and head tilted to her right.

The women all have long, well-coiffed hair: the woman on the left has dark hair streaked with red, the middle woman is blonde, and the woman to the right has long curly black hair. The three women's faces are lightly made up with cosmetics. Each has manicured fingernails. The three are attractive by conventional standards.

The woman in the middle wears a green helmet that says U.S. Army on its front, and all three are scantily dressed in camouflage combat attire, including fabric adorned with sequins. All three wear brief halter tops and two wear short shorts; the other one wears long, tight-fitting pants with tears in them. All three wear similar clean and shiny black leather boots with laces. The woman in the middle holds a belt of large caliber bullets. She has a pierced navel showing and a very apparent cleavage.

The woman on the right has one hand visible and it is a clenched fist.

The three stand with legs spread wide; the two outer women are standing firmly on the floor, but the middle woman tilts her left foot from the floor, destabilizing her stance. The background is white and blank, except for reflections of the women's boots on the floor, which is shiny white.

Denoted text: Across the mid-section of the women, in outlined and italicized letters, is the phrase "Booty Camp!"; beneath it, in small type, is "Destiny's Child"; beneath that, in smaller and different type, in caps, is "A STORY OF DISCIPLINE AND DESIRE." My students know that the denotation "Destiny's Child" identifies a rock group composed of the three women pictured on the cover. Some of the students also know that the group has survived internal squabbles and break-ups. At the top of the magazine is a black banner: "Joey Ramone: 1951–2001" and we quickly decode this as a tribute to a musician who has recently passed away. The *Rolling Stone* masthead is behind the women's heads. Under and to the right of the masthead are four lines of type: "Radiohead," "R.E.M.," "Coldplay," and "AC/DC," which denote, to some of us, musical groups, and connote stories about these groups within the magazine. In a rectangle in the lower right of the magazine cover is a red box with "The Dalai Lama Rolling Stone Interview," which denotes editorial content within the magazine. Dalai Lama is the exiled spiritual and political leader of Tibet, which has been taken over by China.

The denotations and some simple and immediate connotations listed above are gathered from observations by college students preparing to be art teachers. They found it a challenge to describe the expressions on the women's faces. Defining the word *booty* was also a challenge, most likely because we were a mix of females and males and younger students with an older professor. They said that *booty* referred to *loot,* as in a pirate's captured treasure, but that it also referred to female anatomy, specifically buttocks, and generally to sex. They believe the term was first popular among African Americans and that it has now "crossed over" into white culture. We deciphered *camp* straightforwardly as an outdoor place with tents. We knew that *boot camp* refers to arduous physical training such as what one would have in the military.

Connotations: The women reveal a lot of bare skin. Crotches are prominent, emphasized by the triangles of the women's spread legs. "Booty Camp!" is placed above the crotches of the women, below their breasts, and across their bare stomachs, drawing attention to their sexual anatomies. They invite visual exploration. Whatever musical talents the women have is subordinated to their physicality. Whereas boot camp prepares one to fight, booty camp prepares these three for sex.

By her position in the middle and in front of the other two, the woman in the center appears the leader of the three. She holds the ammunition. Her legs are also spread the widest, and her facial expression is the flirtiest. The women in my class read her posture and expression as flirty, playful, and revealing weakness. She is likely the lead singer of their musical group. My students know that she is, and they know that the group is called "Destiny's Child"; those who are familiar with pop music also know that "a story of discipline and desire" refers to these three having the discipline and desire to stay together as a group, surviving internal disputes within their group,

which was once larger in number. Some in the class know that their attire also makes connections to their hit song "Survivor," which is the theme song for the reality-based TV show of the same name and enjoyed great popularity at the time.

The projected sexuality of the women is ambiguous. Their gaze is toward the viewer and not toward one another. The text of "discipline and desire" could imply that the women are sexually dominant and afford pleasure of a sadomasochistic sort, but they hold none of the items, such as whips, that are usually the coded signs of sadomasochism. They are conventionally attractive and reveal their bodies in sexually provocative ways, yet they are dressed for battle. Their aggressive attire is symbolic rather than practical: these are not the clothes one would want to wear in a physically violent fight, in either a natural or urban theater of war. Their attire is better suited for a battle between the sexes. They attract with their bodies and repel with their aggressive attire and stance. If they are to engage in sex, it will be on their terms or there will be a fight.

The women seem to assert that they have taken over and are in charge of their sexuality. Some students observed that this group is part of a trend toward "girl power" and associate Destiny's Child with Power Puff, Spice Girls, Britney Spears, and Christina Aguilera, groups and singers popular at the time who also present themselves as physically fit, kick-boxing women who are strong, sexy, and powerful.

The women of Destiny's Child wear military attire and have bullets, but because they have no gun or other weapons, they are very susceptible to being overcome by any stronger or better-armed predators. They are merely posturing. Do they want to be taken? Their dress, the vulnerable leg position of the middle woman, and their facial expressions suggest so. Sex that they encourage is connoted to be aggressively physical and emotionally shallow. The students noticed the irony of the contrast between the physicality of Destiny's Child and "Booty Camp!" and the spirituality of the Dalai Lama, the leader of the Tibetan people exiled from his country and religion by the current atheistic and anti-religious government of China. The entire cover of *Rolling Stone* is a field of conflicting values competing for attention and dominated by an ambiguous image of sexuality and desire.

195

CONCLUSION

This chapter is a compilation of samples of interpretations by many interpreters of diverse artifacts and works of art. The interpretations of paintings by Edward Hopper include a traditional critical essay, a poem, and a short story. After Hopper's paintings, and indeed paintings by many other visual artists, came interpretations of a modern dance to broaden our scope of interpretive objects from the solely visual to the kinetic and aural. Following the interpretations of paintings and a dance are interpretations of objects selected from daily popular culture, including interpretations of cartoons, "bad words," a TV commercial, animated characters in feature films, functional tables and dinnerware, and a magazine cover. The types of interpretation in this chapter vary widely: some interpretations are clearly art-historical in intent: that is, written by scholars of art for those interested in scholarly understandings of art (for example,

Strand on Hopper, the writings on *Rain* by academics). Some of the interpretations are clearly fictional—a poem and a short story—but they provide interpretive responses to works of art, in this case, paintings by Edward Hopper. This chapter was written to broaden the scope of both interpreters and objects to be interpreted and to encourage us to move thoughtfully through art museums and spaces of daily living in a meaningful manner: that is, interpretively.

Principles for Interpreting Art

THIS CHAPTER OFFERS further explanation and a summation of what interpretation is, with some guiding principles for how one might go about interpreting a work of art, an item within visual culture, or anything that can be treated as a "text." The emphasis of the book, of course, is on visual things rather than literary or musical things, but the principles of interpretation are sufficiently broad that they should cover any humanly made item or text. The principles offered here are eclectically compiled from scholars of art and literature and philosophy of knowing. The principles constitute a set, but a loose set that can be expanded or contracted. The set is meant to be noncontradictory. All the principles are asserted as reasonable, but not all reasonable people concerned with matters of interpretation will agree with all of them as a set or even with any one of them. When a principle is particularly contentious, the chapter provides fair opposition to it and reasons for acceptance of it. All of the principles are open to revision and none of them are meant to be read dogmatically.

These principles are offered to help guide any interpreter of any artistic object or event. They may well provide direction for any and all interpretive endeavors, not just making meaning of artworks; but interpretation in realms other than the artistic are beyond the chosen scope of this book. The principles are meant to provide some security and stability as a foundation for the insecurity, the riskiness and exhilaration, of trying to make meaning of artistic objects and events that seem to shift as we gaze at them and change as we reflect upon them. If I follow these principles, I will be able to be confident that my interpretive efforts are in a right direction and a right spirit.

One may also use the principles as methodological ways to begin and continue constructing an interpretation of, for example, a painting, a dance, or a poem. Any

single one of the principles will set one on one's way toward a meaningful encounter with a work of art. To apply all principles to every interpretive situation would likely be beneficial but prohibitively exhausting, except in cases of very serious pursuit. In some interpretive discussions and for some works of art, it's likely that the reader will find some principles more pertinent than others in the set.

To provide an overview of the chapter, here is, first, the complete set of principles. Explanations of each follow.

- Artworks are always about something.
- Subject matter + Medium + Form + Context = Meaning
- To interpret a work of art is to understand it in language.
- Feelings are guides to interpretation.
- The critical activities of describing, analyzing, interpreting, judging, and theorizing about works of art are interrelated and interdependent.
- Artworks attract multiple interpretations and it is not the goal of interpretation to arrive at single, grand, unified, composite interpretations.
- There is a range of interpretations any artwork will allow.
- Meanings of artworks are not limited to what their artists intended them to mean.
- Interpretations are not so much right, but are more or less reasonable, convincing, informative, and enlightening.
- Interpretations imply a worldview.
- Good interpretations tell more about the artwork than they tell about the interpreter.
- The objects of interpretation are artworks, not artists.
- All art is in part about the world in which it emerged.
- All art is in part about other art.
- Good interpretations have coherence, correspondence, and inclusiveness.
- Interpreting art is an endeavor that is both individual and communal.
- Some interpretations are better than others.
- The admissibility of an interpretation is ultimately determined by a community of interpreters and the community is self-correcting.
- Good interpretations invite us to see for ourselves and continue on our own.

198

ARTWORKS ARE ALWAYS ABOUT SOMETHING

A work of art is an expressive object made by a person and, unlike a tree or a rock, for example, it is always about something. Thus, unlike trees and rocks, artworks call

for interpretations. This is not to say that rocks and trees cannot be interpreted. Geologists and botanists have much to tell us interpretively about rocks and trees. Poets and philosophers and theologians have much to say about rocks and trees. But rocks and trees are things, and artworks of rocks and trees are objects about these things, things about things. Artworks are different kinds of things. Arthur Danto, a contemporary philosopher and art critic, names, as an *essential* characteristic of art-works, "aboutness." That artworks are necessarily about something is the cornerstone of Danto's philosophy of art.[1] Since they are about something, they must be interpreted. This book is significantly influenced by Danto's theory of art, as well that of Nelson Goodman (see below). Noël Carroll, a contemporary aesthetician, summarizes Danto's theory as containing five major propositions, namely, that a work of art (1) is about something, (2) projects a point of view, (3) projects this point of view by rhetorical means, and (4) requires interpretation and that (5) the work and interpretation require an art-historical context.[2]

Nelson Goodman is a philosopher who has expended much thought on artistic versions of the world.[3] In his view, there are many good versions of the world, linguistic and visual, scientific and artistic. Art has important cognitive value. Goodman values works of artists as well as the contributions of scientists because both science and art present us with views of the world that provide us with powerful insights, valuable information, and new knowledge. However, *art provides insights, information, and knowledge only if we interpret works of art.*

Carroll contends that it is a *standard* characteristic of artworks "that they often come with features that are unusual, puzzling, initially mysterious or disconcerting, or with features whose portents are far from obvious."[4] This is not a problem to be dreaded when facing artworks, but a challenge to be enjoyed. If we want the obvious, we probably ought look to things other than artworks. *Artworks require a tolerance for ambiguity.* Since artworks are rarely obvious, they need to be interpreted to be understood. Even when artworks seem obvious at first glance, they can be revealed to be much more complex than we first thought, especially if we ask some of the interpretive questions offered in this book. For example, an Elvis-on-velvet painting sold on a street corner might require no interpretation to make sense of it, but that Elvis painting will become much more interesting if we ask some questions of it, such as What is it a part of? Within what tradition does it belong? What needs does it relieve? What pleasures or satisfactions did it afford the persons responsible for it? Does it change my view of the world?

Subject matter + Medium + Form + Context = Meaning

This principle is a formula for constructing meaning about works of art: subject matter + medium + form + context = meaning. It can serve as a definition of interpretation and it can also be used as a guiding methodology for interpreting works of art.

Subject matter is the recognizable stuff in a work of art: persons, places, things, and so forth. Not all artworks have subject matter: much abstract art, for example,

purposefully omits subject matter. *Subject matter* is not the same as *subject:* the subject matter of a painting may be boats in a harbor but the subject may be tranquility. *Subject* is synonymous with *topic, theme,* or *aboutness.* Subject is a subset of meaning.

Medium is the material out of which an artwork is made: oil paint or marble, for example. Media are often mixed in a single work of art: elephant dung, glitter, map pins, and oil paint, for example.

Form refers to compositional decisions the artist has made in making and presenting a work of art: namely, how it is composed; how it uses formal elements such as line and texture and color; how it organizes space so that something is dominant and other things are subordinate. Although not all art has subject matter, *all art has form.*

Context refers to the artwork's causal environment, that is, what was historically present to the artist at the time the artwork was made. All art has a social context in which it emerged.

Meaning refers to interpretations that we construct about a work of art to make it understandable to us and to others. *All artworks can be interpreted and can be shown to have meaning.*

The term *content,* in this book, is synonymous with *meaning.* All works of art have content, including, for example, minimalist abstract paintings like those made by Sean Scully as shown in chapter four. Although some authors[5] differentiate between *form* and *content,* this book does not: it is in agreement with Nelson Goodman that *the distinction between form and content is dubious.* All art has content, and all content must be interpreted to arrive at meaning. In abstract and Formalist works of art, the form of the artwork is the content to be interpreted and the form conveys its meaning. In works with recognizable subject matter, how that subject matter is selected and formed and contextualized constitutes the content of the work and conveys its meaning. The term *content* is used in too narrow a way when authors use content to refer only to *social* and *political* content. *All works of art have content and that content must be interpreted to arrive at meaning.*

TO INTERPRET A WORK OF ART IS TO UNDERSTAND IT IN LANGUAGE

To interpret is to respond in thoughts and feelings and actions to what we see and experience, and *to make sense of our responses by putting them into words.* When we look at a work of art we might think thoughts and notice feelings, move closer to the work and back from it, squint and frown, laugh or sigh or cry, blurt out something to someone or to no one. Our initial responses to a work of art are usually inchoate, incipient, beginning rumblings of undistinguished emotions and vague thoughts. If we make the effort and are able to successfully transform these initial thoughts and feelings into articulated thoughts and identified feelings with language, we have an initial interpretation.

To interpret a work of art is to make sense of it. To interpret is to see something as "*representing* something, or *expressing* something, or *being about* something, or *being a response to* something, or *belonging in a certain tradition,* or *exhibiting certain formal features,* etc."[6] It is to ask and answer questions such as What is this object or event that I see or hear or otherwise sense? What is it about? What does it represent or express? What does or did it mean to its maker? "What is it a part of?"[7] Does it represent something? What are its references? What is it responding to? Why did it come to be? How was it made? Within what tradition does it belong? "What ends did a given work possibly serve its maker(s) or patron(s)? What pleasures or satisfactions did it afford the person(s) responsible for it? What problems did it solve or allay? What needs did it relieve?"[8] What does it mean to me? Does it affect my life? Does it change my view of the world?

Jonathan Culler, a literature scholar, articulates other interpretive questions about "what the text does and how: how it relates to other texts and to other practices; what it conceals or represses; what it advances or is complicitous with. Many of the most interesting forms of modern criticism ask not what the work has in mind but what it forgets, not what it says but what it takes for granted."[9] Karen-Edis Barzman, an art historian, asks similar questions: "What is left *unsaid* in particular figurations?, or, in psychoanalytic terms, what is repressed?" Regarding figurations of women, Barzman asks, Is she presented as virgin, witch, muse, prostitute? How do the various figurations contradict one another?[10]

Recall, from chapter five, a specific set of interpretive questions that *scientifically-minded* art conservators and restorers might ask of a work of art. "Is the painting correctly dated? What is the painting's condition, and how closely does it resemble its original appearance? Is the format original, or has it been reduced, enlarged, or otherwise altered? By the artist, or by later hands? Have the color relationships changed since the work was painted? Are there repainted areas? Does the painting betray evidence of change through use? Has a religious image been updated for iconographic or liturgical purposes? Was a group portrait altered to account for a birth or death, or was a fragment of a religious work 'secularized' to appeal to the art market? Did more than one artist produce the work? How did the artist(s) achieve the effects? Were the painting's materials or technique chosen for theoretical or political reasons? Are they part of a larger debate about the role of culture? Did contemporary criticism influence the technique? Does the technique reflect the artist's education, travels, or exposure to foreign artistic traditions? Were substantial changes made during the painting's execution? What is the relation among known variants of a painting?"[11]

Paul Thom, an aesthetician, classifies general acts of interpretation this way: "The object of interpretation may be a text, an action, or a person; it may be an artifact or part of nature; it may be present or past. Objects of interpretation include dreams; unexplained facts; damaged texts; historical documents; unfamiliar social practices; sentences in unknown languages; works of literature and visual art; unperformed music, drama, or dance; and the conversation of our companions. Another type of interpre-

tive object occurs during the process of artistic creation, when the artist takes a set of elements from the emerging artwork and subjects them to illuminating transformations. The development of musical themes falls into this class. We distinguish different types of interpretation according to whether they have these different types of objects; for example, we are accustomed to distinguishing textual interpretation from the interpretation of art or nature, and so on."[12]

When interpreting a work of art, we could select any one of the questions in the preceding paragraphs and use that question to further our initial interpretation, if we so desire. By carefully telling or writing what we see and feel and think and do when looking at a work of art, we build an understanding of it by articulating in language what might otherwise remain only muddled, fragmented, and disconnected to our lives. When writing or telling about what we see and what we experience in the presence of an artwork, we build meaning; we do not merely report it. As Marcia Siegel, a dance critic, says, "Words are an instrument for thinking."[13] Thom characterizes interpretations as both *discoveries* and *inventions*. Interpretations are discovered: "by finding out something about the object of interpretation we come to understand it." Interpretations are invented: "we make of the object something it previously was not."[14]

To interpret is to make meaningful connections between what we see and experience in a work of art and what else we have seen and experienced. Richard Rorty, a contemporary philosopher, says that "reading texts is a matter of reading them in the light of other texts, people, obsessions, bits of information, or what have you, and then seeing what happens."[15] By *texts*, Rorty refers to paintings as well as poems. By "*seeing what happens*," Rorty means examining what connections we can make between a painting, a dance, or a poem and relevant experiences of books we have read, pictures we have seen, music we have heard, emotions we have felt in situations we have lived or heard about from others. Some of these connections are meaningful and worth pursuing toward greater knowledge and insight about the artwork, the world, and ourselves. Other connections are less worthy and we simply let them fade away.

What Rorty says about processes of interpretation—"*reading texts is a matter of reading them in the light of other texts, people, obsessions, bits of information, or what have you, and then seeing what happens*"—seems to me to be precisely what Suzi Gablik did when she interpreted the paintings of René Magritte, as reported in chapter one. Gablik read the *texts* (Magritte's paintings) *in light of other texts* (stories by Edgar Allan Poe, Surrealist manifestos by André Breton, the older Newtonian physics, and the newer physics of Einstein), *people* (Freud, Einstein, acquaintances of the artist), *obsessions* (Tom Stoppard praises Gablik for being "mad about Magritte"[16]), *bits of information* (conversations with and observations of the artist), *or what have you* (thoughts and ideas that Gablik had but may or may not have put in her book), *and then seeing what happens* (her book, her interpretations of Magritte, the sense she made of his paintings for herself and for us).

To interpret is to make something meaningful for ourselves and then, usually, to tell another what we think. Gablik spent ten years on her book, *Magritte*. During that

time I imagine that she wrote her interpretations of Magritte's work by making sense of them for herself and then wondering if her interpretation would make sense to her readers and most especially, probably, to other viewers of Magritte, other interpreters, professional and lay. I imagine that she vacillated between two versions of her book, one that made sense to her and another that must make sense to her readers.

As I write this book, I am doing at least three related things: making sense of concepts of interpretation in ways that seem sensible to me; making sense of interpretation in ways that will be sensible to my intended readers, generally college students; and making sense of interpretation in ways that are acceptable to those who know more about interpretation than me. These three senses (mine, the one I provide for my intended readers, and the one other scholars will judge and hopefully approve), when I have them in alignment, fit comfortably and seamlessly together. Until I have each of the senses of concepts of interpretation compatible, I allow one version to affect the other versions.

If I can't make sense of interpretation for my readers, then perhaps I need to adjust my own understanding of it. If what I write will be found to be seriously flawed by a knowledgeable scholar of interpretation, then I must adjust both my understanding and the one I have fashioned for my readers. This is not to say that I expect universal acceptance of the ideas I have written: many sensible people might disagree with positions I am taking. What I am hoping, however, is that sensible people interested in matters of interpretation will find my writing about interpretation sensible and defensible. Thus it ought to be with all interpretive endeavors: good interpreters make sense of artworks for themselves, and for others, including those in the community of interpreters who are very knowledgeable about what is being interpreted. If I fashion an interpretation of something for a child, for example, I want my interpretation to be understandable to the child, but I also want it to be true or accurate in the sense that other knowledgeable people would agree that I am not misinforming the child or giving the child an interpretation that is false.

When telling our interpretation, we hear it in our own words, and we have the opportunity to obtain responses from others about what we see, think, and feel. Others' responses to our interpretations may be confirming or confounding. When their responses are confirming, we are reassured in our understanding; when their responses are confounding, we are given opportunity to further explore our interpretation or to elicit differing interpretive thoughts from the ones we have confounded. Telling is valuable for others as well as for ourselves. In successfully telling our interpretation to another, we enlarge that person's understanding of the artwork, the world as we know it, and ourselves.

Gablik did not publish her book *Magritte* to capture in words only for herself what his work means to her. She published her understandings of Magritte for others to read and to respond to. Interpreters I have read who have offered written interpretations since Gablik's confirm her interpretations and, then, perhaps, take them further or differently. Were her interpretations to confound other interpreters, they would still be of benefit to those interpreters: Gablik's interpretations would make the new inter-

preters aware of where or how their understandings of Magritte differed from Gablik's. She would have provided an interpretive service to the new interpreters. Were they to tell Gablik how her interpretations were confounding to them, Gablik would have valuable occasion to rethink her positions, maintain them with more vigor or more doubt, or change them.

FEELINGS ARE GUIDES TO INTERPRETATION

Emotions play a central role in interpreting works of art and in understanding the world. About emotions in life, Goodman writes, "In daily life, classification of things by feeling is often more vital than classification by other properties: we are likely to be better off if we are skilled in fearing, wanting, braving, or distrusting the right things, animate or inanimate, than if we perceive only their shapes, sizes, weights, etc." About emotions in interpreting art, Goodman writes, "The work of art is apprehended through the feelings as well as through the senses. Emotional numbness disables here as definitely if not as completely as blindness and deafness. . . . Emotion in aesthetic experience is a means of discerning what properties a work has and expresses."[17]

204

Israel Scheffler, a philosopher who writes about education and art and is a proponent of Goodman's theory of art, offers elaboration on how the emotions are intimately tied to our perception of the world. Emotions help us to construct a vision of the world and to define the critical features of that world: Emotions help us to see the environment in a certain light. Emotions tell us whether it is "beneficial or harmful, promising or threatening, fulfilling or thwarting." The role of the emotions in reading the world applies to interpreting works of art: "Reading our feelings and reading the work are, in general, virtually inseparable processes." In his writing, Scheffler works to destroy false dichotomies between thinking and feeling: emotions are in the service of critical inquiry; emotions undergird the life of reason: "Emotion without cognition is blind, cognition without emotion is vacuous."[18]

Throughout this book, examples of interpretation that have been cited have often relied strongly on the feelings of the interpreter in responding to works of art. Recall, from chapter three, the feelings of the critic Jack Flam as he pondered paintings by Eric Fischl: for Flam, they have "a distinctly unpleasant edge." Recall, too, what Stephen Wright, a novelist, wrote when he first saw paintings by Eric Fischl: his response was "immediate and visceral. Here was an artist tunneling through the complexities of a genuine, urgent vision, operating as much from his gut as his head, and actually saying something, it seemed to me, that needed to be said." Critic Erika Billeter felt "an erotic and psychic tension which electrifies the person looking at the pictures" and wrote that Fischl's paintings "unveil the thoughts which produce a sort of guilty feeling in the observer." When art critic A. M. Holmes approached Fischl's work, she immediately acknowledged "the emotional side where you go in and explore feelings and relationships and memories. Often times you find things you're not ready for and you can't bear that this is in front of you."

Very importantly, however, when interpreting Fischl's paintings, these critics did not stop with their feelings: they *started* with them, articulated what they felt, and found in the paintings reasons for their feelings. *Feelings are necessary for interpretations of works of art but they are not sufficiently interpretive:* feelings, to be interpretations, must be articulated in language. Further, to be *accurate* interpretations of the artworks, *they need to show the relationship between what is in the works and what interpreters are feeling.* If the feelings cannot be shown to emanate from the artwork, they may be in the interpreter, but not in the work of art. In such a case, we will learn more about the interpreter and what he or she feels, but we will not be learning about the art.

THE CRITICAL ACTIVITIES OF DESCRIBING, ANALYZING, INTERPRETING, JUDGING, AND THEORIZING ABOUT WORKS OF ART ARE INTERRELATED AND INTERDEPENDENT

When learning to engage in criticism of a work of art, it is sometimes useful to distinguish among the acts of *describing* (telling what one sees), *interpreting* (telling what one thinks it means), *judging* the work of art (telling how good one thinks it is), and *theorizing* about the work (telling what counts as art, for example). Some authors further distinguish between *describing* and *analyzing,* by which they seem to mean that to describe is to identify subject matter and to analyze is to identify formal characteristics. Some authors prescribe methods for criticizing a work of art, such as this method: first describe, then and only then analyze, then and only then interpret, then and only then judge, and do not theorize about the nature of art because the role of theory is not addressed in this method.[19] This and other methods might be helpful in some teaching and learning situations, but there are dangers in reducing the complex activities of responding to art to simple step-by-step methods or in believing that description can be meaningfully distinguished from interpretation, description from judgment, theory from interpretation, and so forth.

What one sees and how one describes are highly dependent on how one understands: descriptive facts are dependent on interpretive theory. If one judges a work of art negatively, then one is likely to describe it in negative terms, and how one understands a work of art is highly dependent on how one values it. Recall, in chapter three, how often viewers could not separate acts of interpreting from acts of judging when looking at art made by Kara Walker and Michael Ray Charles. When viewers who were quoted in the chapter interpreted the work of these two artists as reinforcing racism, they judged it as art that is detrimental to society and therefore not good. When viewers react to a work of art very negatively, they are not likely to interpret it at all. Or, when viewers are unable to interpret a work of art they may walk away from it feeling negative about it. Describing, analyzing, interpreting, judging, and theorizing about works of art are interrelated and interdependent and should not be separated too simplistically.

205

ARTWORKS ATTRACT MULTIPLE INTERPRETATIONS AND IT IS NOT THE GOAL OF INTERPRETATION TO ARRIVE AT SINGLE, GRAND, UNIFIED, COMPOSITE INTERPRETATIONS

The view here is that the aim of interpretation is not to obtain the single, right interpretation. There are some theorists who would disagree: E. D. Hirsch, for example, believes that there are singular meanings of works of art, namely what the artists intended them to mean.[20] This book, however, along with other theorists such as Marcia Eaton, Michael Krausz, Joseph Margolis, and Stephen Davies,[21] holds that there can be more than one admissible interpretation and that *it is desirable to have different interpretations.* Differing interpretations of the same work of art stand alongside each other and can attract our attention to different features of the same work. One interpretation shows us this aspect of the work of art, while another shows us that aspect. *If we only had one interpretation, we would miss the insights that other interpretations provide.*

A most compelling example of the power of this principle is Shakespeare's *Hamlet.* Consider all the books written by literary scholars that *Hamlet* has inspired. Morris Weitz, an aesthetician writing about fifty years ago, chose *Hamlet* criticism as the paradigm of literary criticism with which he could enlighten us about all of art criticism. Weitz read and analyzed the many books of *Hamlet* criticism written up to that time, seeing, in part, how each interpretation was different and similar. He found, among other things, that different interpreters asked and answered different interpretive questions about *Hamlet,* including its textual, dramatic, theatrical, and intellectual sources; *Hamlet's* relation to other plays; the audience; and the Elizabethan view of man, God, philosophy, politics, tragedy, passion, and ghosts. More succinctly, interpreters of *Hamlet* seek to identify "the causal environment" of the play, or its context.[22]

Appealing to Shakespeare's intent would yield answers to none of these questions. As Robert Pinsky, a poet, writes, Shakespeare, outside of his plays and poems, "says nothing about his own work or life. He leaves no comments about the city of London, where he chose to live for about 20 years, away from his wife and children, before returning to them (again without comment) and his native town of Stratford. That silence has become part of Shakespeare's legend."[23]

In addition to the different scholarly questions and resulting interpretations of *Hamlet* or aspects of it, consider all the different renditions of the play by directors across the world and over hundreds of years since the play was first written and produced. Then consider the many versions of *Hamlet* produced for film and television. Consider the impossible-to-count interpretations of the character of Hamlet by actors through time, across cultures, and in different media. All these constitute different interpretations, interpretations in action, so to speak. This principle holds that these numerous, varied interpretations are to be valued and that it would be a great loss to art and to humanity if they were all somehow replaced by one interpretation or if all the different interpretations of *Hamlet* or of any work of art were somehow coalesced into a single composite interpretation.

This principle encourages a diversity of interpretations of any work of art from a number of viewers and from a number of points of view. The principle is in agreement with Stephen Davies's statements that "an interpretation is true if it deals with a meaning the work will sustain; where there are many such meanings, there can be many true interpretations."[24] The principle values an artwork as a rich repository of expression that allows for a rich variety of responses. One critic presents an interpretation that contributes to another critic's previous interpretation. Both of their interpretations enrich our understanding of the work of art. They also enrich our appreciation of the responding interpretive mind: we do not all think alike about art or about life.

Because critics are currently offering new interpretations of the illustrations of Norman Rockwell, as recounted in chapter three, we have opportunity to think anew about the work of an artist that had previously been dismissed as unworthy of interpretation, as being too obvious to warrant interpretation. Because there are new interpretations, as well as multiple interpretations, we have opportunity to expand the canon of what ought to be considered worthy of interpretation and appreciation.

It may not be logically possible for one to accept all interpretations of an artwork such as *Hamlet* if those interpretations are mutually exclusive or contradictory. We could, however, listen to mutually exclusive and contradictory interpretations so that we come to sympathetically understand the beliefs of the interpreters and how they position themselves in the world. This principle of embracing the idea of multiple interpretations is an especially effective principle for dealing with art that is controversial.

Recall from chapter three that Mayor Giuliani's inflammatory remarks about Ofili's painting *The Holy Virgin Mary* divided the New York City community, setting group against group and individual against individual, perhaps from political motives in hopes of garnering votes in an upcoming election. Whatever his motives, in the mayor's remarks about *The Holy Virgin Mary,* he implied that there is only one correct interpretation of that work of art, namely the mayor's interpretation, and that no other interpretation ought be considered. The mayor's position seems to fit that of Steven Dubin's fictitious creation, *Homo censorious,* also in chapter three: "*Homo censorious* insists on a single interpretation of a work of art."

However, other interpreters did present their interpretations of the work, and these other interpretations, added to the mayor's, broadened the community's understanding of a work of art. Those individual interpretations can also broaden our knowledge of one another and of what individuals believe about art, religion, and life. When individuals honestly speak their minds about a controversial image, and when they listen carefully to one another and the range of responses the image generates, they can come to a richer understanding of one another and of the artwork. Interpretive discussion of controversial works of art can result in a new respect for one another, new knowledge of our diverse beliefs, and hopefully an increased tolerance of our differences. By speaking their minds about controversial art, people reduce the fear that comes from feeling powerless. By listening to the views of others, interpreters can reduce the fear that might be born of ignorance: I might be afraid of that which I don't know or understand, and if I allow

myself to hear and understand points of view different than mine, I might reduce my fear of what was previously unknown and scary to me.

Multiple interpretations can inform individual interpretations, causing individual interpreters to reflect more, consider further. A multiplicity of interpretations can unify rather than divide a group of individuals, helping them form a community of understanding, a community that values diverse beliefs about art and life. We all come to works of art with some common cultural constants that we have inherited from whatever social groups in which we were born and have lived our lives. We also come to works of art, and all of life, with unique sets of individual experiences. When we interpret works of art, these communal and individual life experiences necessarily affect our interpretations. This is a good thing. We are varied, and our responses to works of art will be varied. When we share our individual responses to works of art with others, we offer what can be uniquely nuanced responses that can enlarge understandings of the work of art for all who hear us.

THERE IS A RANGE OF INTERPRETATIONS ANY ARTWORK WILL ALLOW

Artworks ought not to be treated as if they were Rorschach inkblots, with interpreters seeing in them anything they want to see. A particular work of art is what it is because it is embedded in a particular culture, time, and social practice, and it is made with some human intent that can usually be recognized by examining the work itself. Thus, interpretations of a work of art ought to be consistent with the artistic conventions and intentions of the time at which the work was made. Davies, the aesthetician, states, "Interpretations are never indifferent to truth."[25]

There is a fear about interpretation that is sometimes expressed as a fear of "over-interpretation," a fear of reading too much into a work of art or of beating the work to death through too much analysis and interpretation. Art students, in particular, can be heard to express this fear, especially when it is the art that they made that is being interpreted or in their view overinterpreted. Scholars also recognize a fear of over-interpreting. Jonathan Culler, a literary scholar, in particular, addresses the concern and tries to alleviate it. Culler imagines that overinterpretation might be like overeating: "there is proper eating or interpreting, but some people don't stop when they should. They go on eating or interpreting in excess, with bad results." Although Culler acknowledges the fear, he is more fearful of "underinterpretation."

Culler does not, however, accept that a work can mean *anything* that we might want it to mean: we should not "just use texts as we use word-processors, in an attempt to say something interesting." Meanings of artworks are context-bound, "a function of relations within or between texts." But there will always be new contextual possibilities and "what may count as a fruitful context cannot be specified in advance." Culler is not afraid of overinterpreting and instead worries about squelching opportunities to bring to light connections or implications not previously noticed. Culler asks interpreters to

"ask about what the text does and how: how it relates to other texts and to other practices; what it conceals or represses; what it advances or is complicitous with. Many of the most interesting forms of modern criticism ask not what the work has in mind but what it forgets, not what it says but what it takes for granted."[26]

History and culture limit the range of interpretations that are allowable. To interpret a work from a time and place other than our own, we must first recognize and acknowledge that it is of another time and from another place. When interpreting art of the historical past, we seek to recover what it may have meant to the people who saw it in its time. Saryu Doshi, in chapter five, sought to determine what the temple signified to the Jains who built it and who used it. If she is interpreting what it meant for its original builders and users, it cannot mean *anything* that she would like it to mean. She seeks to find what it meant to them. She and we permit historical facts and cultural knowledge to guide our interpretive search and to constrain our interpretive conjectures. With art and artifacts of another culture, we learn how those objects functioned in that culture. History and culture put limits on what any work of art might be about.

Umberto Eco argues that all works of art, and not just historically old or culturally distant works of art, set limits as to how they can be interpreted. For Eco, and this book, *texts have rights*. The rights of the text are established in part by the "internal textual coherence" of a work of art that sets itself firmly against any "uncontrollable drives" of the interpreter: if one wants a plausible interpretation of a work of art, one cannot just fix on one or two elements of the work and forget about the rest of the elements in the work.[27]

This book also agrees with Michael Krausz, who argues that there is a range of admissible interpretations established by pertinent practitioners. Interpreters through practice orient other interpreters as to what features of artworks are significant or salient. The community of interpreters provides rules, guidelines, values, and procedures that indicate appropriate methods and maneuvers to be pursued when interpreting works of art. The range of admissible interpretations for any work of art is thus socially constituted by consensual agreement of pertinent practitioners. Krausz writes, "What, in the last resort, makes an interpretation admissible is, as José Ferrater-Mora says 'the consensus, or agreement, that it is, indeed, acceptable or not. This consensus functions within the rules laid down, implicitly or explicitly, by the community of researchers by virtue of habits engendered by a multitude of common experiences.'"[28] Or, as Eco asserts, certain readings prove themselves over time to be satisfactory to the relevant community of interpreters.

MEANINGS OF ARTWORKS ARE NOT LIMITED TO WHAT THEIR ARTISTS INTENDED THEM TO MEAN

Knowing what an artist meant to mean when making a work of art can be a tremendous aid to understanding that work of art. Artists' intents can play a significant role

for interpreters who want to formulate meanings about artists' works. Some artists are very articulate and insightful about what they do, how they do it, why, what it means to them, and what they would like it to mean to us. Leonardo da Vinci's and Paul Klee's journals, Edward Weston's diarist writings in his *Daybooks* about his life in photography,[29] Agnes Martin's personal notes and essays about her contemporary and very subtle paintings,[30] artists' public manifestos, and their private letters are all rich resources for understanding the work of these artists and artistic sensibilities in general.

Many living artists make themselves available for interviews about their work and offer valuable insights into what they believe their work to mean. Some artists invite critics and historians into their studios for inside looks into their working processes. Robert Irwin, for example, is a contemporary American artist who makes work that is often difficult to describe and to reproduce because of its subtlety. Irwin granted author Lawrence Weschler many studio visits and extensive interviews that resulted in a book that greatly enhances an understanding and appreciation of Irwin's art: *Seeing Is Forgetting the Name of the Thing One Sees*.[31] Irwin's art exhibits minimal perceptual properties; it is easily bypassed, not noticed, not seen, not understood as art. By granting interviews to an author and providing personal insights into his working processes and thoughts, Irwin furthers our understanding of his work in valuable ways.

From artists we can learn things about their work we can't learn from other sources. We can sometimes learn the artist's motivations, state of mind when making the piece, intended meanings, methods of working, sources of inspiration, beliefs about art and the world, attitudes about life and other artists and movements. Recall, from chapter four, that the abstract painter Sean Scully clearly stated that, in his mind, his paintings were abstract, but that they were also about social content, such as power in relationships. Scully's stated intent about his paintings provides us with a direction with which to interpret his work: his intent is helpful. Recall the interpretive mysteries of Manet's *A Bar at the Folies-Bergère,* given in chapter two. To help solve those mysteries, current historians are grateful that a contemporary of Manet, Georges Jeanniot, visited Manet's studio while Manet was painting *A Bar* and told us that Manet "did not copy nature at all closely," that Manet was not interested in exact replication and instead made "masterly simplifications." Jeanniot's visit to Manet's studio offered Jeanniot a valuable insight into what Manet was not intending to do, that is, replicate reality.

Many artists lecture about their work and their intents in making their art. It would be intellectually foolish to ignore artists' words about their works when trying to interpret those works. If today we had access to Manet's thoughts about *A Bar at the Folies-Bergère* and what he meant to convey by making that painting, many of our interpretive questions might be answered. Were we able to ask Manet, and were he able and willing to answer us, we would know whether he meant to paint the face of Suzanne, the barmaid, as "bored," "sulky," "tired," "fatigued," "glum," "disturbingly impassive," "distant," "melancholy," "absent," "detached, " "aloof," "lonely," or "not

impassive," "not bored," "not tired," "not disdainful," "not quite focused on any-thing." Different writers, quoted in chapter two, have described her in all these vari-ous ways. And yet, even if Manet wanted Suzanne's expression to be such and such, that of course does not guarantee that it is such and such or that he was able to paint it the way he wanted it to be perceived by viewers.

Were Manet here today, we might ask him and he might tell us if he was aware that the reflections in the mirror do not match optical reality and if he meant them to be the way that they are. Perhaps he was not merely inept at painting reflections, as some of his contemporary critics claimed. If the distorted reflections are the way he meant them to be, he might tell us why he meant them to be that way. His answer would add support to some extant interpretations of what the painting is about and would chal-lenge other interpretations. If he said that he happened to paint the reflections inac-curately because he really didn't give a damn about the accuracy of painted reflections, then what? Would interpreters move on to other concerns, or would they say that the reflections are the way they are, no matter Manet's intent, and continue to offer rea-sonable and meaningful consequences based on how they actually are painted? If Manet did not mean Suzanne to be sensual, does that mean that she is not? If Manet did not intend the man in the hat with the cane to be a surrogate for us, the viewers, does that mean that he is not? That we cannot see him that way? That our inter-pretation of him as a surrogate for us is a wrong interpretation? If we were to tell Manet that we saw the man with the hat and the cane as a surrogate for him, the art-ist, and that we saw the painting as a kind of psychological self-portrait of him, the artist, and Manet were to turn red and scoff at such an idea, would we be bound to withdraw that interpretation?

I once taught a high school student, Marick, who completed an assignment to make a three-dimensional self-portrait in clay. During the discussion of the class's self-portraits, the class and I formulated possible interpretations of Marick's sculpture. In the midst of our interpretive discussion, Marick interrupted, objecting that we were all wrong, that his self-portrait did not mean any of the things that we said it meant and that, furthermore, in fact his sculpture meant nothing because he did not want it to mean anything. What do you think? Marick's classmates and I argued that the por-trait did have meaning, regardless of Marick's lack of intent for it to mean, because the object that he made was by a person, in a certain shape, glazed a certain color, and it looked like a certain thing that communicated meanings to us.[32]

Marick seemed unwilling to let go of control of the object he had made. He would not agree with this statement by Scheffler: "Once the text is produced, it is objectified, released, given birth, assuming its own career beyond the maker's control. To under-stand it is to see its structure, its organization, its references, its various interpretations and not, in particular, its historical and developmental stages."[33]

This book asserts that artists' intents, *when* they are available, *can* be very useful to interpreters of those artists' works of art. This book does not assert, however, that the work necessarily means what the artist wants it to mean. Nor does it assert that mean-

211

ings of works of art are limited to what their artists intended them to mean. To believe that a work of art means what its maker intended it to mean is to adhere to what is known in criticism and aesthetics as an Intentionalist position of interpretation. (Intentionalism is also sometimes applied to judgment of an artwork's value: a work of art is successful to the extent that it meets its maker's intent in making the piece.)

There are many objections to Intentionalism and an early one is known to critics and aestheticians as the "Intentionalist Fallacy"—it is very difficult, if not impossible, to know the artist's intent.[34] This is especially the case when one is attempting to interpret art made long ago or in a faraway place by an unknown artist, but it also holds with respect to the work of living, known artists. Many critics who were originally opposed to Intentionalism worried that the goal of finding the artist's intent was not properly a goal of art criticism but, rather, the goal of a biographer or a psychologist. Seeking the artist's intent, they worried, would likely lead the interpreter to the artist's biography or personal psychology and lead the interpreter away from the artwork itself. *It is artworks we attempt to interpret, not artists.*

Another obvious objection to Intentionalism is that artists may not have actually produced what they intended to make: "an author may intend something not in fact said and say something not in fact meant."[35] The fact that artists intend to make certain objects does not assure that they have indeed made them: intention indicates *ambition* but not necessarily *achievement*.[36] Robert Stecker, an aesthetician, distinguishes two types of Intentionalism: Actual Intentionalism and Hypothetical Intentionalism. Actual Intentionalism is the view that the meaning of a work of art is what its actual maker meant it to mean. Hypothetical Intentionalism is the view that the meaning of a work of art is what an ideal viewer surmises the artist's intent to have been. In Stecker's definitions, success is a factor: in Actual Intentionalism, the artist must have *successfully* realized his or her intent in the work for it to be interpreted accurately; in Hypothetical Intentionalism, Stecker stipulates that the viewer be an ideal viewer to *successfully* interpret the work. This particular objection is sometimes thought to be taken care of by inserting "successfully" into the Intentionalist definition: a work means what its maker successfully intended it to mean; or, more fully, "the success of an interpretation is dependent on grasping the intended meaning [successfully] conveyed by the artist through the work."[37]

Gerys Gault, an aesthetician, argues against Intentionalism, writing that artworks may convey meanings that the artist did not intend or of which the artist was not consciously aware. (Marick would most likely disagree with Gault.) Using an example he invents in language, Gault differentiates between a speaker's meaning and a sentence's meaning. Someone may say, "the bat is on the mat," but intend to mean, "the cat is on the mat." Both sentences make sense, and both have different meanings, one intended and the other not. Gault also argues that "to assume that all features of a work are intended would be to ascribe an implausible mastery to writers: it is to assume that they are (unconsciously) aware of all features of their (linguistic) actions, and that is not something that we believe about actions in general."[38] Further, he asserts that art his-

torians frequently apply interpretations to artworks based on ideas that were not available to the artists who made the work: concepts of formal analysis came well after Renaissance and Baroque works, but are meaningfully applied to them, as are Freudian analyses, Marxist analyses, and so forth.

Positions about the role of artists' intention in interpreting their works of art can be extreme and polar: a work of art means what the artist intended it to mean versus an artist's intent in making a work has no role to play in interpreting that work. This book rejects both extremes and promotes a middle view: *the meaning of a work of art is not limited to the meaning the artist had in mind when making the work; it can mean more or less or something different than what the artist intended the work to mean.* It is sometimes very difficult to ascertain an artist's intent. Some artists choose not to reveal their intentions by talking or writing about their work, except in the most general terms. Some artists are not particularly articulate in verbal language: that may be one of the reasons why they paint, draw, or photograph rather than write! Cindy Sherman, the contemporary artist famous for her self-portraits, would rather not have to make images *and* provide her intent for having made them: "I've only been interested in making the work and leaving the analysis to the critics." Some artists notoriously give misleading or consciously unenlightening statements about what they make: Andy Warhol comes to mind.

213

Many artists work intuitively and from the subconscious. Sandy Skoglund, a contemporary artist who makes installations and photographs them, says one of the most captivating aspects of making her art is "the subterranean content and consciousness that kind of leaks out, that I don't intend when I'm making art."

Jerry Uelsmann, a contemporary photographer who layers several negatives to make one image, sometimes only realizes what an image means to him after he has finished it, sometimes the morning after: "I don't have an agenda when I begin. I'm trying to create something that's visually stimulating, exciting, that has never been done before but has some visual cohesiveness for me, has its own sort of life." He tells of how he made an image of a young woman, standing nude, presenting a glowing apple, and the picture now seems to him to be obviously an "Eve image." But at the time he made the multiply-exposed photograph, he was unaware of this connotation: "Because I concentrate so intensely on detail while I'm working, it wasn't really until the next morning that I recognized the obvious iconographic implications of the image that are so blatantly there. It seems impossible, in retrospect, that I didn't plan to do an Eve photograph. But at the time I was working the idea didn't enter my conscious thought."[39]

April Gornik, a contemporary painter of landscapes, says this about her thought process when she is making work: "I've had paintings—I swear to God—that painted themselves. I would start off just as nervous as usual and I always do an under painting and then work up and up and up and up from that, get it going and all of a sudden the thing would just take off with me behind the brush."[40]

Lucio Pozzi, a contemporary painter, expresses ideas similar to Gornik's about intent, but in different language: "In a dynamic and critical scenario of creativity, it

becomes impossible to statically and hierarchically conceive of intentions as a mono-lithic, binding component of artistic decision-making. Intentions become mere ever-changing, ever-updated, flexible instruments for the conduction (not the definition) of the art being made. They are a springboard for a flight or fall one never knows the end of. It is impossible to compare works of art to the original intentions of the artist. One may do so only for conversation's sake, but one can not believe such comparisons lead to an explanation of the art. The deeper (departure) intentions and the formal (arrival) meaning of the art are often unknown to the artist him/herself and a matter of continuous, unfinished, unending cultural discourse for its audience."[41]

Scheffler, the philosopher, explains what artists Skoglund, Gornik, and Pozzi are saying, with different words and emphases: "human creation is always contingent, al-ways experimental, always capable of yielding surprises—not only for others, but for the human creator himself. The product humanly made is never a pure function of creative purpose and foreseeable consequences of the maker's actions. The human maker does not fully own his own product. Understanding it is therefore not reducible to grasping the steps that went into its making." (Barzman, the art historian, reminds us that artists' understandings of their work, like all understandings, are "situated, limited, and marked by specificity that cannot be universalized."[42]) Scheffler goes on to say, "The artist is not a composite of dreamer and robot, the dreamer intuiting the idea and the robot executing it automatically in the chosen medium. The painter or composer does not first thrill to a new conception and then thoughtlessly stamp it on his raw material; rather, he tries it out on the material, which reshapes him as he re-shapes it. His thinking is not limited to the first phase of his making; it permeates every stage, the results of every move requiring fresh evaluation and a reconsidering of basic directions. . . . We may discern features, functions, and potentials of the prod-uct far outside the range of the purpose that led to its making."[43]

A significant limitation of Intentionalism is that it commits one to the view that there is a singular meaning of a work of art, and a single correct interpretation of it, namely, the artist's meaning. Conventionalism opposes Intentionalism. Stecker defines Conventionalism as the view "that the meaning of a work is the set of meanings that can be put upon the work based solely on the linguistic, cultural, and artistic con-ventions operative at the time the work was produced."[44] That is, the artist's intent is very likely part of the linguistic, cultural, and artistic conventions of the times during which the artist was working, and thus intent would play a part in interpretation, but the artist's intent does not determine an artwork's sole meaning.

Eco refers to "the intention of the text,"[45] meaning that the text (painting, poem, symphony) provides guidelines or indicators within itself as to how it ought to be in-terpreted. "Intention of the text" is different from "intention of the artist" in that it is a much broader concept, and may include the artist's intent, and certainly includes linguistic, cultural, and artistic conventions operative at the time the work was pro-duced. Eco argues that trying to find the original intention of the artist is very diffi-cult and frequently irrelevant. He also recognizes the intent of the interpreter, who, he

fears, may beat the text into a shape that suits the interpreter's own purpose. Eco asserts "the rights of the text" by maintaining "the intention of the text" which ought not to be overridden by the interpreter. This book is in agreement with Eco on this point: *artworks have rights.* The rights of an artwork ought to both guide and limit how it is interpreted.

Finally, to rely on the artist's intent for an interpretation of an artwork is to put oneself in a passive role as a viewer. Reliance on the artist's intent unwisely removes the responsibility of interpretation from the viewer; it also robs the viewer of the joy of interpretive thinking and the rewards of the new insights it yields into the art and the world.

INTERPRETATIONS ARE NOT SO MUCH RIGHT, BUT ARE MORE OR LESS REASONABLE, CONVINCING, INFORMATIVE, AND ENLIGHTENING

If one were to agree with the belief that there is a single, right interpretation of a work of art, then one would likely also believe that interpreters ought to strive for that single, right interpretation. This book, however, does not hold a belief in either the possibility or the desirability of single, right interpretations. Instead it advocates multiple interpretations. It agrees with aestheticians such as Margolis and Krausz, who argue that such a "singularist approach" is a mistaken view of cultural objects and interpretive practices.[46] That is, artworks are not the kind of things that yield simple and single interpretations; and interpreters of artworks are not the kind of responding individuals who are looking for simple, single meanings.

Barzman, the art historian, also cautions against the notion of a single, right interpretation: "Given that we come to objects and their texts as a plurality of subjects (with respect to race, ethnicity, gender, sexual orientation, age), can any of us really serve as arbiters of truth for reading audiences, which are heterogeneous communities of individuals?"[47]

If we accept multiple interpretations, then, are some right and some wrong? This principle answers that interpretations are not so much right, certainly not absolutely and definitively right, but that interpretations are more or less reasonable, convincing, informative, enlightening, persuasive, fresh, profound, well or not so well argued. Conversely, interpretations can be "unpersuasive or redundant or irrelevant or boring,"[48] fragmented, obvious, trivial, inane, "strained," and "far-fetched."[49]

INTERPRETATIONS IMPLY A WORLDVIEW

Interpretations imply a worldview: There is no innocent eye. In Nelson Goodman's words, with an acknowledgment to the scholarship of Ernst Gombrich "as Ernst Gombrich insists, there is no innocent eye. The eye comes always ancient to its work obsessed by its past and by old and new insinuations of the ear, nose, tongue, fingers,

215

heart, and brain. It functions not as an instrument self-powered and alone, but as a dutiful member of a complex and capricious organism. Not only how but what it sees is regulated by need and prejudice. It selects, rejects, organizes, discriminates, associates, classifies, analyzes, constructs. It does not so much mirror as take and make; and what it takes and makes it sees not bare, as items without attributes, but as things, as food, as people, as enemies, as starts, as weapons."[50]

We all move through the world with a more or less articulated set of assumptions about existence, and it is through these that we interpret everything, including works of art. Some viewers interpret art on the basis of less articulated theories. Others have more finely articulated and consistent worldviews, based on study of philosophy, psychology, anthropology, and other disciplines. Through these worldviews they interpret works of art. Interpreters may operate on the basis of semiotic theory, for example, or offer neo-Freudian readings of all works of art they encounter.

Sometimes the interpreters make their basic assumptions about art and life explicit; more often, however, they leave them implicit. Once the interpreter's worldview is identified, choices follow: one can accept the worldview and the interpretation that it influences or reject both the worldview and the interpretation, accept the worldview but disagree with how it is applied to the artwork, or reject the worldview but accept the specific interpretation it yields.

As worldviews affect how we understand life and interpret art, interpretations of art also affect our worldviews. Thom, the aesthetician, explains that the act of accepting an interpretation involves another act of interpretation, namely, *self-interpretation*. In order for me to adopt an interpretation, "I must have certain beliefs and attitudes; so I assume those beliefs and attitudes and by so doing partly determine who *I* am. Choosing an interpretation is in this case part of choosing who to be."[51]

GOOD INTERPRETATIONS TELL MORE ABOUT THE ARTWORK THAN THEY TELL ABOUT THE INTERPRETER

Good interpretations must clearly pertain to the work of art. All interpretations reveal the interpreter, but the interpreter's primary challenge is to direct the viewer to better perceive and understand the artwork that is being interpreted. If one cannot relate the interpretation to the work of art being interpreted, the interpretation may be too subjective. That is, it may inform us about the interpreter, but it may fail to enlighten the work of art and, hence, is not a good interpretation.

Preference statements, for example, usually tell us about the speaker rather than about the topic in question. We hear many preferences about works of art: "I like it." "I don't like it." These preference statements, however, do not provide information about the artworks and ought to be considered, not statements of art criticism, but personal psychological reports by the speaker.

Oftentimes critics tell about themselves, particularly, for example, when they tell about their emotional reactions to a work of art. It is the critic's task, however, to re-

late the personal information being offered to the artwork that is being interpreted so that we are enlightened about the artwork, not only about the interpreter.

THE OBJECTS OF INTERPRETATION ARE ARTWORKS, NOT ARTISTS

In some conversations and writings about art, it is artists who are interpreted rather than the artworks that they have made: "Kara Walker is an angry woman." "Chris Ofili's just trying to shock us." In critical discourse, however, it should be the art objects that are interpreted, not the persons who made them. We want to be reading works of art and not be engaged in mind-reading.

This principle mitigates against name-calling and blaming when faced with artworks that we might find offensive. The principle redirects our attention to the art in question, not the supposed motives of the art maker, which are difficult, at best, to determine. The principle may also divert attention from the artist and back to the work and, perhaps, to what it is in us that makes us react the way we do to a particular work of art. If we focus on the artist rather than the work or ourselves, we are missing opportunities to better understand the work of art and our reactions to it.

This principle does not exclude the gathering of biographical information about an artist. Oftentimes interpreters provide biographical information that usefully informs their interpretations. Such biographical information can be used to provide insight into the work that is being interpreted. Biographical information reminds us that art does not emerge apart from a social environment. There is a caution, however, that concerns what might be termed "biographical determinism." It is an error of logic to move from a fact of an artist's biography to certainty about what the artist's work of art might mean. Artists should not be locked into their biographic pasts, nor should one argue that if someone is of this race or that gender or this historical background, then their art *must* be about such factors.

ALL ART IS IN PART ABOUT THE WORLD IN WHICH IT EMERGED

Donald Kuspit, contemporary art critic and aesthetician, reinforces this principle when discussing his decision to include psychoanalysis in his interpretation of works of art: "I began to feel that the artist is not exempt from life. There is no way out from seeing art as a reflection or meditation or a comment on life. I became interested in the process, including the artist's life. I became interested in how art reflected life issues, or existential issues with which we are all involved."[52]

The paintings that Magritte made (chapter one) emerged from a world of World Wars, Freudian psychoanalysis, and Einstein's theory of relativity. The paintings and illustrations made by Norman Rockwell (chapter three) are inseparable from the social and political world of the United States in the years that Rockwell worked. Eric Fischl (chapter three) draws upon his childhood experiences in a dysfunctional alco-

217

holic family for the paintings he makes as an adult. The Temple Dharna Vihara in Ranakpur (chapter five) is the physical form of metaphysical beliefs of the Jains. Photographs (chapter six), because they are made by capturing light reflected from real-world objects, are intrinsically dependent on the physical world.

In addition to these examples, all art can be shown and seen to emerge from the context of the time and the space in which it was made. Conversely, we cannot understand a work of art without imaginatively repositioning it in the context from which it emerged. In the words of Michel Foucault, "a text is made up of multiple writings, drawn from many cultures and entering into mutual relations of dialogue, parody, contestation."[53]

ALL ART IS IN PART ABOUT OTHER ART

Interpreters state over and over again who influenced a particular artist and on whose art the artist's work may be commenting. Art does not emerge within an aesthetic vacuum. Artists are generally aware of the work of other artists and often they are especially aware of the work of certain artists. Even untrained artists are aware of and influenced by the visual representations in their societies. This principle asserts that all art can be interpreted with respect to how it is influenced by other art. Art can be about life, about art, or both. An important guide to interpreting any art is to see how it relates to or indirectly comments upon other art, both "popular" and "fine."

Artists are usually aware of both the artists who preceded them and those they are contemporary with. Artists, like all of us, are also immersed in an inescapable visual culture that influences them consciously and unconsciously. In the words of art historian David Carrier, "The man we call Caravaggio developed his artistic style by means of a complex dialogue within the very rich inheritance of Italian painting."[54] Sean Scully, for example (chapter four), acknowledges that if you put the work of Henri Matisse, Piet Mondrian, and Mark Rothko together, you get a good idea of what Scully's work is about. Willem de Kooning is quoted (chapter four) as stating that his *Women* paintings "had to do with the female painted through the ages." The fine art paintings that Michael Ray Charles makes (chapter three) are dependent on images circulating in mass visual culture: without knowing about racist images of blacks in visual culture, Charles's paintings will be misinterpreted and misunderstood.

Noël Carroll, reiterating views of George Dickie and others who support the theory that art is situated within an art world, writes this: "For art is a public practice and in order for it to succeed publicly—i.e., in order for the viewer to understand a given artwork—the artist and the audience must share a basic framework of communication: a knowledge of shared conventions, strategies, and of ways of legitimately expanding upon existing modes of making and responding . . . an artist needs to know the constraints on diverging from one tradition in such a way that her activity changes it rather than ends it, and the audience, or at least certain members of it, needs to share the knowledge of the modes of expanding the tradition in order not only to un-

derstand the artist's work, but, even more fundamentally, to recognize it as a development within a tradition."[55]

GOOD INTERPRETATIONS HAVE COHERENCE, CORRESPONDENCE, AND INCLUSIVENESS

The merit of any interpretation can be judged by the use of three criteria: coherence, correspondence, and inclusiveness. Coherence is an internal and autonomous criterion, correspondence is an external and dependent criterion, and inclusiveness looks both at the work itself and its causal environment.

The criterion of coherence asks that an interpretation make sense in itself. Apart from the artwork, the interpretation is a good story or a compelling account of a matter or an intriguing idea or notion. Coherence is an autonomous criterion in that it simply asks that the interpretation make sense in itself and apart from the work of art. One could judge if an interpretation were coherent without even seeing the work of art it was meant to interpret: the interpretation makes sense or it doesn't. The criterion asks that the interpretation be logical, that its premises lead to a conclusion, that it has a certain elegance and efficiency of explanation. These things can be decided by looking at the interpretation and ignoring the artwork of which it is an interpretation. Of course, a good story or a good account of a work of art that does not match the actual work of art that is being interpreted is not a good interpretation of that work. It may be a good story but it is not a good interpretation of the painting. Other criteria are necessary: the criterion of correspondence is one of them.

The criterion of correspondence asks that the interpretation match what can be seen in the work that is being interpreted. Correspondence is an external and dependent criterion that asks that the interpretation *fit the work of art.* A good argument or a good story is not enough for a good interpretation of a work of art. The interpreter must show that the story, account, or argument pertains to the work that it seeks to interpret, as well as to the artwork's causal environment. This principle protects against interpretations that tend toward unleashed speculation by asking the interpreter to adhere to what is actually in the work or in the work's causal environment. It is a criterion of relevance.

The criterion of inclusiveness asks that the interpretation account for what is in the work and what is in the work's causal environment. The request for inclusiveness asks the interpreter to account for all that is in an artwork and for what is relevant to the artwork during the time that it was made. If an interpretation omits mention of an aspect of an artwork, that interpretation is suspect. If the interpretation leads one to believe that it has the capacity to account for the omission, but that capacity has for some reason not been used, the interpretation is not as flawed as when an interpretation is simply unable to account for what is ignored.

In general, good interpretations lead viewers to increased appreciation of works of art. Robert Stecker includes the goal of appreciation in his definition of the role of in-

terpretation: "Offer an interpretation that renders the work coherent in a way that promotes appreciation."[56]

Recall, from chapter three, art critic Dave Hickey's interpretation of Norman Rockwell's painting *After the Prom,* 1957. It is coherent, it corresponds to what we can see in the painting and accounts for the time in which the painting was made and shown, and it is inclusive of what is important in the painting and around the painting in its causal environment. Hickey writes that this painting is "a full-fledged, intricately constructed, deeply knowledgeable work that recruits the total resources of European narrative picture-making to tell the tiny tale of *agape* he has chosen to portray." Hickey's statement has coherence—it makes sense in itself. In his justification for his interpretive conclusion, Hickey provides ample internal evidence that shows that his interpretation corresponds to what we can see in the painting. He carefully describes the painting's subject matter: the 1930s-era soda fountain, the four characters who are dressed in 1950s-era clothing, their body postures, their facial expressions. Hickey also provides a *formal analysis* of the painting, showing that its composition is in agreement with his interpretation of its meaning. Hickey also accounts for the painting's causal environment and makes connections between it and the 1950s, the *Saturday Evening Post,* and the relevance of the Great Depression and World War II. Hickey's is a good interpretation of *After the Prom.* It is not the only interpretation, nor the only possible interpretation, but may be the best one we have available to us at this point in time. It is a good one because it adheres to criteria for interpretation. In the long run, it may turn out to be the best interpretation we get, or perhaps equally good but different ones will join it, or an even better one will replace it. For now, however, it serves viewers well.

INTERPRETING ART IS AN ENDEAVOR THAT IS BOTH INDIVIDUAL AND COMMUNAL

We can think of acts of interpreting as having two poles, one personal and individual, and the other communal and shared. An individual and personal interpretation is one that has meaning to me and for my life. I may have formulated it for myself, or received it from another and accepted it or modified it. A communal and shared interpretation is an understanding or explanation of a work of art that is held by a group of individuals with shared interests. Communal understandings are passed on to us as common knowledge in history of art textbooks and in standard introductory art and art history lectures.

Some aestheticians position themselves closer to personal interpretations than to communal understandings. In the phenomenological tradition, specifically in European phenomenological hermeneutics, Hans-Georg Gadamer and Paul Ricoeur, for example, believe that all interpretation necessitates an act of appropriation: "All interpretation involves of necessity an act of appropriation in which the object of interpretation is made one's own through the reader's endeavor to make sense of the text

in the light of her personal experience."[57] For Gadamer and Ricoeur the purpose of interpretation is to make the artwork "one's own."[58]

For Ricoeur, the narrative in particular offers rich possibilities of understanding and self-discovery. Narratives illustrate the possibilities of our existence that can be discovered by interpreting what others have made. Narratives open up new avenues for self-definition, new ways of being in the world. For Ricoeur, *the positing of the self is not a given, it is a task.* The arts, and literature in particular, are created for the imaginative exploration of possible ways of being human. The arts and literature allow viewers and readers to freely step into alien viewpoints and to examine their own nature and illusions. "The task of the writer is to render as perfectly as possible the vision of the world that inspires him; the corresponding task of the reader is to explicate and appropriate the type of being-in-the-world that the author has unfolded."[59]

Interpreting for personal meaning is also part of the American Pragmatist tradition of philosophy. William James and John Dewey, in the past, and Richard Rorty, today, for example, think that we should use our interpretive concepts as tools for certain purposes, to solve certain problems, rather than to figure out how "the world really is." The belief that there is one way that the world is is rooted in Essentialist theory, a theory that Pragmatists reject. In the Pragmatic view, we ought to give up the project of trying to mirror the world as if there were only one way the world really is. In the Pragmatist view there are as many ways to represent the world as there are questions to ask and problems to solve.[60] In Rorty's words, the pragmatist "will come to think of himself or herself as, like everything else, capable of as many descriptions as there are purposes to be served. There are as many descriptions as there are uses to which the pragmatist might be put, by his or her self or by others. This is the state in which all descriptions (including one's self-description as a pragmatist) are evaluated according to their efficacy as instruments for purposes, rather than by their fidelity to the object described."[61] This view also applies to interpreting art.

Regarding the interpretation of art, Rorty argues that *there should be no difference between interpreting a work and using it to better one's life.* For Rorty, *a meaningful interpretation is one that causes one to rearrange one's priorities and to change one's life.* "Interpreting something, knowing it, penetrating to its essence, and so on are all just various ways of describing some process of putting it to work. . . . We pragmatists relish this way of blurring the distinction between finding an object and making it." Rorty continues, "For us pragmatists, the notion that there is something a given text is *really* about, something which rigorous application of method will reveal, is as bad as the Aristotelian idea that there is something which a substance really, intrinsically, is as opposed to what it only apparently or accidentally or relationally is. The thought that a commentator has discovered what a text is really doing—for example, that it is *really* demystifying an ideological construct, or *really* deconstructing the hierarchical oppositions of western metaphysics, rather than merely being capable of being *used* for these purposes—is, for us pragmatists, just more occultism. It is one more claim to have cracked the code, and thereby detected What is *Really* Going On."[62]

The requests from Phenomenologists and Pragmatists that we appropriate a work of art to make it our own, and that we allow a work of art to change our life, might be daunting to some readers. Actual examples drawn from teaching experiences might make these requests more tangible and less intimidating. Children can make personal what they see and experience. My wife, Susan, told me a compelling story of a young boy in her Montessori class who was able to personally enmesh himself in experience prior to making interpretive artifacts about his experience. She says, "I took my 3rd grade class to the beach for lessons in botany and zoology. One boy was especially fond of the sea. He drew many pictures of the sea. I had art books in the classroom—my college art history texts as well as contemporary books of art. He loved to look at art of the sea. He was an excellent swimmer. I watched him for more than a half-hour do this: he laid down at shore break. His body was limp. He relaxed and let his body do as the sea did. Like a jellyfish caught at shoreline, he moved as ebb and tide. It was one of the most graceful and peaceful movements I have ever seen. I asked him later to tell me about it: he said he watched the water and wanted to feel it, to be it, to draw it, and to write a story about it."[63]

Alisha, a second grader, wrote this personal interpretive response to an Expressionistic painting of a large monkey sitting in a rain forest, *The Mandrill* (Color Plate 25) by Oskar Kokoschka. Alisha's paragraph seems to me to be an example of interpretive appropriation:

> "I liked *The Mandrill.* Because . . . it felt like I was in the jungle and I could hear the birds chirping. And I could hear it moving. I liked the purple on his fingers. And I could smell the fruit he was eating. I could hear the waterfall coming down. I thought it was neat. It looked like the artist painted it fast and a little bit slow. The mandrill looked neat because it looked like I was like right there with him. I just felt like I could see what he was eating. And I could eat with him. I just like it so very, very, very, very much!"[64]

Alisha's personal interpretation of *The Mandrill* is valuable to anyone who is interested in knowing more about Kokoschka's painting. It is informative: Alisha points out the jungle environment, the waterfall on the right side of the painting, the mandrill's "purple fingers" reaching to the right of the canvas, and surmises that they are purple from the color of the fruit it was eating; she makes note of formal qualities of the painting's fast and slow brush work. Alisha also lets us know that she is very fond of the work. This information is more about her than about the painting, but through her interpretive enthusiasm, we might see the painting through her young mind and enjoy it more because of that.

A museum tour guide and widow writing about Magritte's paintings, quoted in chapter one, provided us with an example of an interpretation that caused her to change her priorities in life, when she wrote that seeing the isolation of people in the

paintings made her want to participate in life, not just observe it: "Life should not be a picture you view. You must put yourself in the picture."

It is not just children and docents who are willing and able to make artworks personally meaningful. Richard Schiff, an art historian, notes that many recent art historians are shifting from archival or biographical methods to more emphatically subjectivized, autobiographical methods. They are reflecting on what the experience of an artist's work means to them, the authors.[65] For example, when interpreting Manet's painting *A Bar at the Folies-Bergère,* Griselda Pollock, as cited in chapter two, seeks to find what the painting means to her, as a woman and a feminist, a hundred years after it was painted.

Also, some artists want their works of art to be made personal by their viewers. When Eric Fischl, whose paintings are discussed in chapter three, was asked by an interviewing critic if he thought that people should try to tell the story of his paintings in their own psychological narratives, he responded, "I like that, because it means they are possessing the work. You want possession. You want somebody to internalize it and interpret it in terms that they understand themselves. It's about them. I seek that. What I try to do is narrow the possibility of interpretation to a certain area so that they're never that far wrong. You don't want to control it so much that they have no room. You want them to participate."[66] Fischl implies that he thinks there can be interpretations of his paintings that are "too far wrong" but he gives enough clues in his paintings to narrow the possibilities for the interpreter. He believes that for him to control interpretations would not be desirable; he wants his paintings to allow viewers to "possess" his work, to "internalize it." As a painter, he wants his viewers to make the artwork, the object of interpretation, their own.[67]

Within formal art education, communal interpretations are usually privileged over personal interpretations. Professors strive to have their students understand art as the professors' community of scholars understands it. So too, usually, do tour guides in art museums give standard, accepted interpretations of historical works of art, ones that they have usually received from the curators in their institutions and then supplemented with standard scholarly art-historical texts. Communal knowledge about art is the kind of art knowledge that is commonly measured in tests about art history.

The Encyclopaedia Britannica Online (2000) offers a clear example of a communal interpretation of the work of Magritte: "Magritte, René (-François-Ghislain). Belgian artist, one of the most prominent Surrealist painters whose bizarre flights of fancy blended horror, peril, comedy, and mystery. His works were characterized by particular symbols—the female torso, the bourgeois 'little man,' the bowler hat, the castle, the rock, the window, and others." This entry on Magritte is a succinctly articulated, comprehensive, two-sentence interpretation likely synthesized from volumes of scholarly Magritte interpretations.

Interpreters of young age can also offer communal interpretations. Here is a communal interpretation of Magritte's work by Luke, a nine-year-old. He wrote it after

223

participating in a group discussion about paintings by Magritte that I facilitated with him and his classmates. "Magritte's mind is about things in common. He likes views out of a building or house. He likes perspectives. He likes to have round objects in his paintings. Optical illusions are another thing he puts in his art. He likes to make you think about his paintings. One piece of evidence of that are his titles. He does not give titles that really give any clues. Some of his art is a little fantasy, like in terms of how it looks. But most of his art looks realistic."

Luke's statement provides evidence of a communal interpretation. He synthesized the interpretation from insights and observations he gained from hearing his classmates talk about Magritte's paintings, as well as from his own insights and observations. As a teacher, I can see that Luke's communal interpretation is in line with scholarly communal interpretation. Luke and his nine-year-old peers have noted things in Magritte's work consistent with those features the Britannica scholar has noted. As a teacher, I am reassured that I am not leading the community of nine-year-old interpreters away from a broader and deeper communal understanding the art community holds about Magritte.

An interpretation that is wholly individual and personal runs the risk of being overly idiosyncratic or too personal. An interpretation that is too personal is one that does not shed any light on the object that is being interpreted. If one heard the interpretation and saw the object being interpreted, one would not be able to see relevant connections between the interpretation and the artwork. Such an overly personal interpretation may reveal a lot about how and what the interpreter thinks but it fails to reveal anything about the art object being interpreted. Thus, although Ricoeur upholds Gadamer's sense of appropriation—that to interpret an artwork is to make it one's own—Ricoeur adds the requirement that *an artwork has an existence of its own, and it must be understood as well as appropriated.*[68] There are givens that come with a work of art that must not be ignored: it was made by someone in a time and place of a material in a structure and influenced by certain conventions, and so forth.

An interpretation that is wholly communal runs the risk of irrelevance to the individual interpreter. If the individual viewer receives an interpretation that has no bearing on his or her life, knowledge, and experience, it is not a meaningful interpretation for that viewer. No matter how accurate it may be, it ought not to count as an interpretation for that viewer at all.

Shared communal interpretations and individual personal interpretations are not mutually exclusive ideas. An interpretation that is both individual and communal is an understanding of a work of art that is personally meaningful to the interpreter and relevant to his or her life. It is also an interpretation that is meaningful to the community of interpreters who are interested in that work of art because it sheds light on the artwork.

Personal, individual interpretations can and should be informed by knowledge of the artwork from other persons and sources. In the literature, there are interpretive insights about the works of Kokoschka and Magritte. The artists themselves have writ-

ten and talked about their work, and art historians, curators, critics, and philosophers have provided us with interpretive insights into those works. Luke, for example, in his interpretation of Magritte's paintings, touches upon the ambiguity of the paintings. Michel Foucault's short book, *This Is Not a Pipe,* on Magritte's painting of the same title, is largely about Magritte's use of ambiguity. If I were a skilled enough teacher, I could help Luke and his fellow nine-year-olds broaden their thinking about Magritte by telling them about some of Foucault's ideas about the same paintings they are looking at. Then the nine-year-olds would benefit from the larger community. Through this community, they have opportunities to expand and deepen their individual interpretations and understandings of art and life. If scholars could hear the nine-year-olds, perhaps they might think about things they had previously not considered.

SOME INTERPRETATIONS ARE BETTER THAN OTHERS

Many of the preceding principles clearly imply that *some interpretations are better than others;* this principle states so explicitly. If one were able to sit in on a studio critique in which students were discussing the artworks other students had made, or to overhear discussions in introductory aesthetics classes, one would likely hear beliefs something like the following from one or many of the students: whatever one says about a work of art is as good as what anyone else says; all responses to art are subjective; all subjects responding to art are equal in their abilities to respond to art; everyone has equal rights to their opinions; it is just talk about art, and all matters pertaining to art are subjective anyway. Stated another way, there is a belief in American society that whatever anyone says about art is as good as what anyone else says, because all matters of art are matters of opinion and we are all entitled to our opinions.

The principle I state here offsets what seems to be too common an acceptance of relativism, especially in American society, regarding what one can say about works of art. This principle and this book agree that many matters of art are matters of opinion but go on to assert that statements about works of art can be more than *mere* opinions, they can be *informed* opinions.

Some interpretations are better than other interpretations because they are more responsive to the emotional content in a work of art. Some interpretations are better than others because they are not limited to the intent of the artist in making the work; and some interpretations are better than others precisely because they take into account the artist's intent. Some interpretations are better than others because they are more reasonable, more convincing, more informative, and more enlightening than others. Some interpretations are better grounded in art history; some are better informed by knowledge of the world at the time the work of art was made. Some interpretations are weaker than others because they are incoherent. Some interpretations do not correspond to what we can see and feel in the presence of the artwork that they seek to interpret. Some interpretations fail to see and account for important elements in the work they interpret.

Good interpretations are persuasive arguments that get us to see and understand a work of art in the way that the interpreter sees and understands it. Interpretations that are not persuasive are not effective. Interpretations that do not build understanding based on facts combined with compelling reasons are not good interpretive arguments. Some interpretations may contain the facts that pertain to the artwork but may not order them in a reasonable way, and thus they are not good interpretations, though they are factually accurate.

Some new interpretations make improvements over older interpretations. Gerys Gault provides a criterion by which we can judge the merits of new interpretations: "One criterion for a new interpretation being an improvement over others is that, on the proffered interpretation, one can see a work that before seemed boring, inane and lacking in coherence as lively, profound and vital. The revelation of value counts toward the correctness of interpretation, for what was before fragmented and random now appears as a valuable whole whose coherence explains the structure of parts, the role of which previously seemed adventitious."[69]

Eco talks of "unsuccessful" interpretations: "certain interpretations can be recognized as unsuccessful because they are like a mule, that is, they are unable to produce new interpretations or cannot be confronted with the traditions of the previous interpretations." Eco also makes a point of not automatically accepting all interpretations as if they were right: "When everybody is right, everybody is wrong and I have the right to disregard everybody's point of view."[70]

If one accepts the principle that interpretations are not so much right as they are *more or less* enlightening and so forth, then one would accept that *some interpretations are better than others* and perhaps that *some interpretations are simply wrong*. In addition to holding that some interpretations are better than others, this book makes the further claim that *interpretations can simply be wrong*. It is easy to imagine wrong interpretations, especially if an interpretation is based on false descriptions, for example. If a picture of the Mother of Jesus is described as and believed to be "dung splattered" or "dung smeared," then certain interpretations will likely follow. If, however, the picture is in fact not dung splattered or dung smeared, those interpretations that think it is are likely to be false. Or, for example, if a painting is mistakenly thought to be from one period of time but turns out to be from another, the original interpretation is likely to be wrong. To hold that no interpretation can be absolutely right and definitive and conclusive does not imply the belief that all interpretations are therefore equally meritorious or that there are no wrong interpretations.

THE ADMISSIBILITY OF AN INTERPRETATION IS ULTIMATELY DETERMINED BY A COMMUNITY OF INTERPRETERS AND THE COMMUNITY IS SELF-CORRECTING

This is an optimistic view of the art world and scholarship that holds that artists, critics, historians, and other serious interpreters will eventually correct less-than-

adequate interpretations and will eventually put forth better interpretations. This happens in the short run and in the long run. In the short run, interpretations might be very nearsighted. This principle asserts that eventually these narrow interpretations will be broadened. Essays in exhibition catalogues, for example, are often compilations by scholarly interpreters of the best thinking about an artist's work to that point in time. Such compilations put forth the most informative interpretations available at the time and omit less informative ones.

Recent interpretations of the paintings and illustrations of Norman Rockwell, reiterated in chapter three, provide a good example of this principle in action. Critics writing at the time that Rockwell was producing his work ignored it as not even worthy of interpretation. Recent critics, however, are reinterpreting the work and reassessing it as very worthwhile. Because of re-examination and restoration of *The Feast of the Gods,* discussed in chapter five, we have a better understanding of the painting now than we did before the restoration work began. Because of John Berger's reinterpretation and critique of old paintings depicting women (chapter five), we go into the twenty-first century with a view of paintings that is very different from how they were understood in prior centuries when they were painted.

Berger's reinterpretation of old paintings of women is his individual interpretation, and it is a new interpretation, but it is informed and influenced by the thinking of others within the interpretive community. His reinterpretation, in turn, informs and influences others within the interpretive community, and those individuals, in turn will further or confront Berger's ideas. In both the long and the short run, a community of interpreters, composed of individuals, sorts out what it holds to be true at any given point in time. There will likely always be dissenting interpretations, and this is good, because these dissenting views may influence the majority view and may be cause to better it. Interpretation and the validation of interpretations is an ongoing process within the interpretive community of all those individuals who actively care about art: artists, critics, historians, collectors, curators, conservators, art publishers and readers, art students and professors, and museum-goers.

227

GOOD INTERPRETATIONS INVITE US TO SEE FOR OURSELVES AND CONTINUE ON OUR OWN

In general, good interpretations lead us to better experiences of works of art than we would have had without those interpretations. In the words of aesthetician Marcia Eaton, good interpretations usually "bring us to see things we would have missed if left on our own." She goes on to say that interpreters invite us to look at things and "provoke us to continue on our own to view the work."[71] This book, throughout, accepts the premise that multiple interpretations of works of art are more desirable than single interpretations. This book, throughout, encourages its readers to continue to build their own interpretations of works of art, interpretations that both make sense in themselves and have meaning for those building the interpretations.

Some interpretations, however, discourage further interpretations. Barzman identifies some interpretations that seek to close interpretive discussions rather than further them. She refers to some of these interpretations as "master readings" that in their manner of interpreting assert their own correctness or truthfulness with a sense of absoluteness. Such interpretations have "a dependence on so much erudition that the reader is disarmed and even daunted at the moment of reception, a moment in which asymmetrical power relations between writer and reader are at least implicitly affirmed." Such interpretations position the viewer asymmetrically, as a passive recipient of fixed meaning, namely, the interpreter's. Such interpretations harmfully deny the plurality of interpreters and suffocate thought. "They presume to read authoritatively for their audiences, universalizing their own situated perceptions, fixing meaning with the stamp of finality, and thus rhetorically denying their readers the possibility of intervening interpretations themselves." In agreement with Barzman, this book wants to "refuse finality in the fixing of meaning." Barzman and this book ask readers not to accept with finality the interpretations already given here and elsewhere but, rather, to engage critically and to produce interpretations of their own. In Barzman's words, "We *produce* meaning—*we* produce meaning—and the meaning we produce is partial, contingent, and cannot be universalized."[72]

Chapter Notes

Introduction

1. Amir Shah, "Afghan Leaders Order Destruction of Statues," Columbus Dispatch, February 27, 2001, A9.

2. Arabic News.com, Egypt Contacts Taliban for Halting Destruction of Statues, <http://www.arabicnews.com/ansub/Daily/Day/010310/2001031029.html>, February 13, 2002.

3. Abraham Verghese, "Cell Block," New York Times Magazine, August 19, 2001, 13.

Chapter 1 • About Interpretation: René Magritte

1. See Daliweb: The Official Site of the Salvador Dalí Museum, <http://www.daliweb.com/index.htm>, September 24, 1999; and The Salvador Dalí Gallery of the Fine Art Site, <http://www.fineartsite.com/gallery/Dali_1.html>, September 24, 1999.

2. The Official Magritte Site, <http://www.magritte.com/>, September 24, 1999.

3. Michel Foucault, *This Is Not a Pipe* (Berkeley: University of California Press, 1983), 15–18.

4. Michel Foucault, *Les mots et les choses: Une archéologie des sciences humaines* (Gallimard, 1966; published in English as *The Order of Things,* New York: Pantheon, 1971).

5. David Macey, *The Lives of Michel Foucault* (New York: Pantheon, 1993), 173–174.

6. Terry Barrett, *Criticizing Art: Understanding the Contemporary,* 2nd ed. (Mountain View, CA: Mayfield, 2000), 10–11, for a profile and overview of Gablik's critical writing.

7. Suzi Gablik, *Magritte* (New York: Thames & Hudson, 1970).

8. Ibid., 9–10.

9. Ibid., 11–13. Emphasis is Magritte's.

10. Ibid., 17.

11. Ibid., 9, 12. Emphasis in the original.

12. Ibid., 15.

13. Magritte, "La Ligne de vie," appended in Gablik, *Magritte,* 183–187.

14. Magritte quoted by Gablik, *Magritte,* 101.

15. Ibid., 123.

16. Ibid., 166–168.

17. Ibid., 168.

18. Ibid., 172.

19. Todd Alden, *The Essential René Magritte* (New York: Abrams, 1999).

20. Jacques Meuris, *René Magritte* (Cologne: Benedikt Taschen, 1994).

21. A. M. Hammacher, *René Magritte* (New York: Abrams, 1985).

22. Meuris, *René Magritte,* 121.

23. Hammacher, *René Magritte,* 152.

24. Meuris, *René Magritte,* 16; Hammacher, *René Magritte,* 21–22.

25. Alden, *The Essential René Magritte,* 41.

26. Hammacher, *René Magritte,* 23.

27. Meuris, *René Magritte,* 38.

28. Ibid., 157.

29. Alden, *The Essential René Magritte,* 72–74.

30. Gablik, *Magritte,* 145.

31. Magritte quoted by Gablik, *Magritte,* 146.

32. Alden, *The Essential René Magritte,* 70.

33. Ibid., 10.

34. Gablik, *Magritte,* 110–111; Hammacher, *René Magritte,* 148.

35. Alden, *The Essential René Magritte,* 64.

36. Hammacher, *René Magritte,* 44.

37. Meuris, *René Magritte,* 196.

38. Joseph Kosuth, *Art after Philosophy* (New York: Art Press, 1969).

39. Duxberry Park Elementary School, Columbus, Ohio, 1990.

40. Gablik, *Magritte,* 11–13. Emphasis is Magritte's.

41. Colonel White High School, Dayton, Ohio, September 2, 1991.

42. Hathaway Brown School, Cleveland, Ohio, November 27, 1990.

43. Art Education 367.02, Writing Art Criticism, Ohio State University, April 7, 1994.

44. Vancouver School for Arts and Academics, Vancouver, Washington, October 8, 1999.

45. Indianapolis Museum of Art, Indianapolis, Indiana, October 18, 1999.

46. SongTalk Interview, Paul Simon—Spirit Voices Vol. I, by Paul Zollo, <http://www.medialab.chalmers.se/guitar/simon.interview8.html>, December 13, 1999.

Chapter 2 • Multiple Interpretations of One Work of Art: Edward Manet's *A Bar at the Folies-Bergére*

1. Peter Schjeldahl, "The Urban Innocent," *New Yorker,* November 20, 2000, 104.

2. Stephen Eisenman, *Nineteenth Century Art: A Critical History* (London: Thames & Hudson, 1994), 239.

3. Richard G. Tansey and Fred S. Kleiner, *Gardner's Art through the Ages,* 10th ed. (Harcourt Brace, 1996), 980.

4. H. W. Janson, *History of Art* (Englewood Cliffs, NJ: Prentice-Hall and New York: Abrams, 1969), 490.

5. In Tansey and Kleiner, *Gardener's Art through the Ages,* 981.

6. Ibid., 982.

7. Eisenman, *Nineteenth Century Art,* 241.

8. Robert Bersson, *Worlds of Art* (Mountain View, CA: Mayfield, 1991), 356–357.

9. Ibid., 358.

10. Edmund B. Feldman, *Varieties of Visual Experience,* 2nd ed. (Englewood Cliffs, NJ: Prentice-Hall), n.d., 308.

11. Bersson, *Worlds of Art,* 358.

12. Eisenman, *Nineteenth Century Art,* 243.

13. Ibid., 244.

14. Bradford Collins, ed., *12 Views of Manet's Bar* (Princeton, NJ: Princeton University Press, 1996).

15. Eisenman, *Nineteenth Century Art,* 238–239.

16. T. J. Clark, *The Painting of Modern Life: Paris in the Art of Manet and His Follow-*

ers (Princeton, NJ: Princeton University Press, 1990), 205–258.

17. John House, "In Front of Manet's *Bar:* Subverting the 'Natural,'" in Collins, ed., *12 Views of Manet's Bar,* 234–237.

18. Tag Gronberg, "Dumbshows: A Carefully Staged Indifference," in Collins, ed., *12 Views of Manet's Bar,* 191–192.

19. Jack Flam, "Looking into the Abyss: The Poetics of Manet's *A Bar at the Folies-Bergère*," in Collins, ed., *12 Views of Manet's Bar,* 184.

20. Paul de Saint-Victor, quoted by George Holden, Introduction to Émile Zola, *Nana,* translation and introduction by George Holden (New York: Viking Penguin, 1972, first published in 1880), 7.

21. In Holden, Introduction to *Nana,* 9.

22. Ibid., 11.

23. Ibid., 12–13.

24. House, "In Front of Manet's *Bar,*" 237.

25. Paul Alexis, Le Senne, and Maurice Du Seigneur in Clark, *The Painting of Modern Life,* 239, 242, 243.

26. Raymond Mortimer in Flam, "Looking into the Abyss," 175.

27. Griselda Pollock, "The 'View from Elsewhere': Abstracts from a Semi-Public Correspondence about the Visibility of Desire," in Collins, ed., *12 Views of Manet's Bar,* 301.

28. Flam, "Looking into the Abyss," 164.

29. Albert Boime, "Manet's *A Bar at the Folies-Bergère* as an Allegory of Nostalgia," in Collins, ed., *12 Views of Manet's Bar,* 55.

30. Clark, *The Painting of Modern Life,* 253.

31. Pollock, "The 'View From Elsewhere,'" 302.

32. Mortimer in Flam, "Looking into the Abyss," 175.

33. Pollock, "The 'View from Elsewhere,'" 303.

34. Flam, "Looking into the Abyss," 167.

35. Jeremy Gilbert-Rolfe in Flam, "Looking into the Abyss," 185.

36. Pollock, "The 'View from Elsewhere,'" 301.

37. House, "In Front of Manet's *Bar,*" 241–242.

38. Henri Houssaye in House, "In Front of Manet's *Bar,*" 242.

39. Clark, *The Painting of Modern Life,* 253.

40. Collins, ed., *12 Views of Manet's Bar.*

41. Clark, *The Painting of Modern Life,* 241.

42. James Herbert, "Privilege and the Illusion of the Real," in Collins, ed., *12 Views of Manet's Bar,* 215.

43. Richard Shiff, Introduction: "Ascribing to Manet, Declaring the Author," and Bradford Collins, "The Dialectic of Desire, the Narcissism of Authorship: A Male Interpretation of the Psychological Origins of Manet's *Bar,*" in Collins, ed., *12 Views of Manet's Bar,* 11–12, and 115–141.

44. Houssaye in House, "In Front of Manet's *Bar,*" 243.

45. Collins, "The Dialectic of Desire," 117.

46. Flam, "Looking into the Abyss," 165, House, "In Front of Manet's *Bar,*" 236, and Collins, "The Dialectic of Desire," 119.

47. Gronberg, "Dumbshows," 189–213.

48. Collins, "The Dialectic of Desire," 118.

49. For example, Pollock, "The 'View from Elsewhere,'" 305, and Flam, "Looking into the Abyss," 176.

50. Georges Jeanniot and Theophile Thoré in House, "In Front of Manet's *Bar,*" 239, 240.

51. House, "In Front of Manet's *Bar,*" 238.

52. Shiff, Introduction to Collins, ed., *12 Views of Manet's Bar,* 7.

53. Carol Armstrong, "Counter, Mirror, Maid: Some Ingra-thin Notes on *A Bar at the Folies-Bergère*," in Collins, ed., *12 Views of Manet's Bar,* 36–37.

54. Jules Comte, Charles Flor, Houssaye, Le Senne, and Emile Bergerat in Clark, *The Painting of Modern Life,* 239–243.

55. Tansey and Kleiner, *Gardener's Art through the Ages,* 983.

56. Kermit S. Champa, "Le Chef d'Oeuvre (bien connu)," in Collins, ed., *12 Views of Manet's Bar,* 110.

57. Clark, *The Painting of Modern Life,* 254–255.

58. Armstrong, "Counter, Mirror, Maid," 25–46.

59. Robert L. Herbert in James Herbert, "Privilege and the Illusion of the Real," 222.

60. Flam, "Looking into the Abyss," 170.

61. Pollock, "The 'View from Elsewhere,'" 282–283, 307.

62. Georges Bataille, 1955, quoted by Gronberg, "Dumbshows," 204.

63. Flam, "Looking into the Abyss," 184.

64. Flam, "Looking into the Abyss," 182.

65. Pollock, "The 'View from Elsewhere,'" 294.

66. Collins, "The Dialectic of Desire," 123.

67. Champa, "Le Chef d'Oeuvre (bien connu)," 111–112.

Chapter 3 • Interpretation and Judgment: Controversial Art

1. Associated Press, "Museum's Funding Restored," *Columbus Dispatch,* November 2, 1999.

2. Robert MacDonald, "Tolerance, Trust, and the Meaning of 'Sensation,'" *Museum News,* May/June 2000, 46–53.

3. *Columbus Dispatch,* September 27, 1999, p. 2.

4. Elizabeth Kolbert, "Around City Hall: Damien Hirst and the Mayor Call Each Other Names," *New Yorker,* October 4, 1999, 40.

5. Cathleen McGuigan, "A Shock Grows in Brooklyn," *Newsweek,* October 11, 1999, 69.

6. Carol Vogel, "Amid 'Sensation,' Painter Tries to Keep His Cool," *Columbus Dispatch,* The Arts, October 3, 1999, pp. 1–2.

7. Quoted by Steven Dubin, "How 'Sensation' Became a Scandal," *Art in America,* January 2000, 55.

8. Michael Kimmelman, "Critic's Notebook: Cutting through Cynicism in Art Furor," *New York Times on the Web,* <http://www.nytimes.com/library/arts/092499 brooklyn-art-notebook.html>, September 28, 1999.

9. Lynn MacRitchie, "Ofili's Glittering Icons," *Art in America,* January 2000, 99.

10. F. Rich, "Pull the Plug on Brooklyn," Op-Ed Columns Archive, *New York Times,* October 9, 1999.

11. Dubin, "How 'Sensation' Became a Scandal," 53–55.

12. Roger Kimball, "'Art' Isn't Exempt From Moral Criticism," *Wall Street Journal,* Editorial, September 24, 1999.

13. Michael Kimmelman, "'Sensation': After All That Yelling, Time to Think," *New York Times on the Web,* <http://www. nytimes.com/library/arts/100199sensa tion-art-review.html>, October 1, 1999.

14. MacRitchie, "Ofili's Glittering Icons," p. 97.

15. Susan Loughran, Letters to Editor, *Newsweek,* November 1, 1999, 28.

16. Philippe de Montebello, "Making a Cause Out of Bad Art," October 5, 1999, *New York Times on the Web,* <NYT%20de%20 Montebello>, July 14, 2000.

17. Lee Rosenbaum, "Brooklyn Hangs Tough," *Art in America,* January 2000, 61.

18. Glenn Lowry, "The Art That Dares," *New York Times,* October 10, 1999, A31.

19. Mary Abbey, "Hooked on Art," *Minneapolis Star Tribune,* May 27, 1997, p. 1E.

20. Jack Flam, "Art: Staring at Fischl," *Wall Street Journal,* January 6, 1986, p. 1.

21. Stephen Wright, "Eric Fischl, *Inside Out,* 1982," *Artforum,* October 1999, 188.

22. Robert Hughes, *The Shock of the New* (New York: Alfred A. Knopf, 1996), 422.

23. Erika Billeter, "Eric Fischl and His Art-Historical Environment" in *Eric Fischl* (Aarhus Kunstmuseum, Louisiana Museum for Moderne Kunst, Fortatterne, Denmark, 1991), 14.

24. Oystein Hjort, "Feast or Famine—Eric Fischl and the USA in the Eighties," in *Eric Fischl,* 27.

25. Richard S. Field, "The Dreams and Lies of Eric Fischl's Monotypes," in *Scenes and Sequences: Recent Monotypes by Eric Fischl* (Hood Museum of Art, Dartmouth College, New York: Abrams, 1990), 34.

26. Elizabeth Armstrong, "Eric Fischl's Monotypes: In the Continuum," in *Scenes and Sequences: Recent Monotypes by Eric Fischl,* 55.

27. A. M. Holmes, "Eric Fischl," in Betsy Sussler, ed., *Speak Art!* (New York: G + B Arts International, 1997), 58–59.

28. Ibid., 63–64.

29. Sidney Tillim, "Eric Fischl," *Art in America,* February 1995, 94.

30. Laurie Norton Moffatt, "The People's Painter," in Maureen Hart Hennessey and Anne Knutson, *Norman Rockwell: Pictures for the American People* (New York: Abrams, 1991), 26.

31. Arthur Danto, "Freckles for the Ages," *New York Times Book Review,* September 28, 1986, 12.

32. Ned Rifkin, "Why Norman Rockwell, Why Now?" in Hennessey and Knutson, *Norman Rockwell: Pictures for the American People,* 19.

33. Neil Harris, "The View from the City," in Hennessey and Knutson, *Norman Rockwell: Pictures for the American People,* 141.

34. Wolff quoted by Daniel Belgrad, "The Rockwell Syndrome," *Art in America,* April 2000, 61.

35. Danto, "Freckles for the Ages," 13.

36. Belgrad, "The Rockwell Syndrome," 61.

37. Peter Plagens, "Norman Rockwell Revisited," *Newsweek,* November 15, 1999, 84–86.

38. Moffatt, "The People's Painter," 26–27.

39. Judy L. Larson and Maureen Hart Hennessey, "Norman Rockwell: A New Viewpoint," in Hennessey and Knutson, *Norman Rockwell: Pictures for the American People,* 63.

40. Peter Rockwell, "Some Comments from the Boy in a Dining Car," in Hennessey and Knutson, *Norman Rockwell: Pictures for the American People,* 74.

41. Larson and Hennessey, "Norman Rockwell: A New Viewpoint," 46–50.

42. Dave Hickey, "The Kids Are All Right: *After the Prom,*" in Hennessey and Knutson, *Norman Rockwell: Pictures for the American People,* 123–125.

43. Ibid., 116.

44. Ibid., 120, 121.

45. Ibid., 125.

46. Anne Knutson, "The Saturday Evening Post," in Hennessey and Knutson, *Norman Rockwell: Pictures for the American People,* 143, 144.

47. Ibid., 144–145.

48. Ibid., 145.

49. Ibid., 149.

50. Ibid., 152.

51. Michael Harris quoted by Karen C. C. Dalton, "The Past Is Prologue but Is Parody and Pastiche Progress?" *International Review of African American Art* 14 (no. 3, 1997): 15.

52. Julia Szabo, "Kara Walker's Shock Art," *New York Times Magazine,* March 23,

1997, <http://www.nytimes.qpass.com/qpass-archives>, December 27, 2000.

53. Ibid.

54. Ibid.

55. Holland Carter, "Kara Walker," *New York Times,* November 20, 1998, <http://www.nytimes.qpass.com/qpass-archives>, December 27, 2000.

56. Spike Lee in *Michael Ray Charles* (Tony Shafrazi Gallery, New York, 1997), 3.

57. Spike Lee, Introduction, *Michael Ray Charles: An American Artist's Work, 1989–1997* (The Art Museum of the University of Houston, 1997), 5.

58. Calvin Reid, "Air Sambo," in *Michael Ray Charles* (Tony Shafrazi Gallery), 4.

59. Marilyn Kern-Foxworth, "Painting Positive Pictures of Images that Injure: Michael Ray Charles' Dueling Dualities," in *Michael Ray Charles* (Tony Shafrazi Gallery), 8.

60. Litwack in Kern-Foxworth, "Painting Positive Pictures," 8.

61. Ibid., 16.

62. Juliette Bowles, "Extreme Times Call for Extreme Heroes," *International Review of African American Art* 14 (no. 3, 1997): 3.

63. Szabo, "Kara Walker's Shock Art."

64. Bowles, "Extreme Times Call for Extreme Heroes," 3.

65. Troy Gooden, "An Evening with Michael Ray Charles," *International Review of African American Art* 14 (no. 3, 1997): 3.

66. Catlett quoted by Gooden, "An Evening with Michael Ray Charles," 62.

67. Roberta Smith, "Art in Review: Michael Ray Charles," *New York Times,* <http://www.nytimes.qpass.com/qpass-archives>, December 27, 2000.

68. Bowles, "Extreme Times Call for Extreme Heroes," 7.

69. Gwendolyn Dubois Shaw, "Final Cut," *Parkett* 59 (2000): 131.

70. Gates quoted by Bowles, "Extreme Times Call for Extreme Heroes," 5.

71. Kenneth Goings, *Mammy and Uncle Mose: Black Collectibles and American Stereotyping* (Bloomington: Indiana University Press, 1994).

72. Harris in Dalton, "The Past Is Prologue," 28.

73. CNN, <http://www.cnn.com/WORLD/meast/9809/24/iran.rushdie/>, September 9, 2000.

Chapter 4 • Interpretation and Appreciation: Abstract Painting

1. Duane and Sarah Preble, *Artforms,* 4th ed. (New York: Harper & Row, 1989), 483.

2. See Ernst Gombrich, *Art and Illusion* (Princeton, NJ: Princeton University Press, 1960), and Nelson Goodman, *Languages of Art,* 2nd ed., (Indianapolis, IN: Hackett, 1976).

3. Arthur Danto, *Beyond the Brillo Box: The Visual Arts in Post Historical Perspective* (New York: Farrar, Straus & Giroux, 1992), 4.

4. Edward Lucie-Smith, *Lives of the Great 20th Century Artists* (London: Thames & Hudson, 1999), 251.

5. Ibid., 247–251.

6. Robert Atkins, *Art Speak* (New York: Abbeville Press, 1990), 36.

7. In Dore Ashton, "The Long and Short of It," in John Howell, ed., *Breakthroughs: Avant-Garde Artists in Europe and America, 1950–1990* (New York: Rizzoli, 1991), 14.

8. Harold Rosenberg, "American Action Painters," in Charles Harrison and Paul Wood, eds., *Art in Theory 1900–1990* (Oxford, England: Blackwell, 1992), 582.

9. Ashton, "The Long and Short of It," 13.

10. Richard G. Tansey and Fred S. Kleiner, *Gardner's Art through the Ages,* 10th ed. (Harcourt Brace, 1996), 1099.

11. Richard Marshall and Robert Mapplethorpe, *50 New York Artists: A Critical Selection of Painters and Sculptors Work-*

ing in New York (San Francisco: Chronicle Books, 1986), 34.

12. Brian O'Doherty, *American Masters: The Voice and the Myth* (New York: Universe Books, 1988), 115, 147.

13. Jonathan Fineberg, *Art Since 1940: Strategies of Being* (Englewood Cliffs, NJ: Prentice-Hall, 1995), 84.

14. O'Doherty, *American Masters,* 115, 122.

15. Sarah Rogers-Lafferty, "Art in America and Europe: The 1950s and the 1960s," in *Breakthroughs,* 4.

16. Fineberg, *Art Since 1940,* 81–82.

17. Ibid., 81.

18. Ibid., 84.

19. bell hooks, *Art on My Mind: Visual Politics* (New York: New Press, 1995), xi.

20. Fineberg, *Art Since 1940,* 77–79.

21. Donald Kuspit, "Sean Scully, Galerie Lelong/Danese," *Artforum,* September 1999, 168.

22. Armin Zweite, "To Humanize Abstract Painting: Reflections on Sean Scully's Stone Light," translated by John Ormrod, in Ned Rifkin, ed., *Sean Scully: Twenty Years, 1976–1995* (High Museum of Art, Thames & Hudson, 1995), 22.

23. Rifkin, ed., *Sean Scully: Twenty Years, 1976–1995,* High Museum of Art, Thomas P. Hudson, 1995, p. 12.

24. Ned Rifkin, "Interview with Sean Scully," May 20, 1994, in Rifkin, ed., *Sean Scully,* 57.

25. Scully in Rifkin, "Interview with Sean Scully," 60–78.

26. Scully in Rifkin, "Interview with Sean Scully," 58, 77.

27. Scully in Rifkin, "Interview with Sean Scully," 60–78.

28. Scully in Lynne Cooke, "Sean Scully: Taking up a Stance," in Rifkin, ed., *Sean Scully,* 52–53.

29. Zweite, "To Humanize Abstract Painting," 25–26.

30. Cooke, "Sean Scully: Taking up a Stance," 51.

31. Combalia, "Sean Scully: Against Formalism," 41.

32. Zweite, "To Humanize Abstract Painting," 21–22.

33. Combalia, "Sean Scully: Against Formalism," 43.

34. Rifkin, "Interview with Sean Scully," 78.

35. Combalia, "Sean Scully: Against Formalism," 44.

36. Ibid., 36.

37. Rifkin, ed., *Sean Scully,* 16.

38. Combalia, "Sean Scully: Against Formalism," 33.

39. In Rifkin, "Interview with Sean Scully," 69.

40. Cooke, "Sean Scully: Taking up a Stance," 48.

41. Zweite, "To Humanize Abstract Painting," 22.

42. These excerpts from writings are by ninth- and tenth-grade students in Euclid City Schools, Euclid, Ohio, under the direction of Jann Gallagher, Euclid City Schools; Sydney Walker, Ohio State University; and the author, May 1997.

43. Arthur Danto, *Beyond the Brillo Box.*

44. For more about the concept of an *art world,* see George Dickie, *Introduction to Aesthetics: An Analytic Approach* (Oxford University Press, 1997), and Arthur Danto, *Transfiguration of the Commonplace* (Cambridge, MA: Harvard University Press, 1981).

Chapter 5 • Interpreting Old and Foreign Art

1. Andrea Kirsh and Rustin S. Levenson, *Seeing through Paintings: Physical Examination in Art Historical Studies* (New Haven, CT: Yale University Press, 2000), 2.

2. David Bull in David Bull and Joyce Plesters, *The Feast of the Gods: Conserva-*

235

tion, Examination, and Interpretation (Washington, DC: The National Gallery of Art, 1990), 11.

3. Vasari in Bull and Plesters, *The Feast of the Gods,* 11.

4. Ibid., 29.

5. Ibid., 11.

6. Ibid., 22.

7. Ibid., 26.

8. Ibid., 11.

9. Ibid., 43.

10. Ibid., 29.

11. Richard G. Tansey and Fred S. Kleiner, *Gardner's Art through the Ages,* 10th ed. (Harcourt Brace, 1996), 776.

12. Ibid., 862.

13. Deborah Solomon, "He Captured the Soul," *New York Times,* March 4, 2001, 23.

14. Ibid.

15. Tracy Chevalier, *Girl with a Pearl Earring* (New York: Plume, 2001).

16. Arthur K. Wheelock, Jr., *Vermeer: The Complete Works.* New York: Abrams, 46.

17. Brent Wilson, *The Quiet Evolution: Changing the Face of Arts Education* (Los Angeles: J. Paul Getty Trust, 1997), 176.

18. Ibid., 178–179.

19. John Berger, *Ways of Seeing* (London: Penguin Books, 1972), 45–64 (chapter 3).

20. Saryu Doshi, *Dharna Vihara, Ranakpur* (Stuttgart: Alex Menges, 1995).

21. Ibid., 6.

22. Ibid., 15.

23. Ibid., 6.

24. Ibid., 7.

25. Ibid., 8.

26. Mary Pat Fisher, *Living Religions,* 4th ed. (Upper Saddle River, NJ: Prentice Hall, 1999), 125.

27. Ibid., 129.

28. Gloria Steinem, Foreword to *The Vagina Monologues* by Eve Ensler, V-Day ed.

(New York: Villard, 2001), xi-xiii, xvii-xviii.

29. Huntington Archives, The Ohio State University, 2001.

Chapter 6 • Interpretation and Medium: Photography

1. Diane Arbus, *Diane Arbus* (Millerton, NY: Aperture, 1972).

2. Dominique François Arago, "Report" (1839), in A. Trachtenberg, ed., *Classic Essays on Photography* (New Haven, CT: Leete's Island Books, 1980), 12.

3. Sally Stein and Terry Pitts, *Harry Callahan: Photographs in Color/the Years 1946–1978* (Tucson: Center for Creative Photography, University of Arizona, 1980), 6.

4. Henri Cartier-Bresson, *Teaching Guide to Images of Man 2: Scholastic's Concerned Photographer Program* (New York: Scholastic Magazines, 1973).

5. Eliot Porter, *Teaching Guide to Images of Man 2: Scholastic's Concerned Photographer Program* (New York: Scholastic Magazines, 1973).

6. Catherine Lutz and Jane Collins, *Reading National Geographic* (Chicago: University of Chicago Press, 1993), xiii.

7. Roland Barthes, *Camera Lucida: Reflections on Photography* (New York: Hill & Wang, 1981), 76.

8. Sally Mann, *Immediate Family* (New York: Aperture, 1992).

9. See, for example, Jock Sturges, *Radiant Identities* (New York: Aperture, 1994); *Last Day of Summer* (New York: Aperture, 1991); *Jock Sturges* (NY: Scalo and DAP, 1996).

10. Richard B. Woodward, "The Disturbing Photography of Sally Mann," *New York Times Magazine,* September 27, 1992, 33, 52.

11. Reynolds Price, "For the Family," in Sally Mann, *Immediate Family.*

12. Sally Mann, Introduction, *Immediate Family.*

13. Katherine Dieckmann, "Photographs . . . with Children," *Voice Literary Supplement,* November 1992, 15.

14. Fourth- and fifth-grade students, Forest Park Elementary School, Euclid, Ohio, host teacher, Dr. Jann Gallagher, 1993.

15. Jessie Mann quoted by Melissa Harris, "Daughter, Model, Muse: Jessie Mann on Being Photographed," *Aperture* 162 (Winter 2001).

16. In Woodward, "The Disturbing Photography of Sally Mann," 36.

Chapter 7 • A Sampler of Interpretations

1. Deborah Lyons, Introduction to Deborah Lyons, Adam Weinberg, and Julie Grau, eds., *Edward Hopper and the American Imagination* (New York: Norton, 1995), xi.

2. Gail Levin, "Edward Hopper: His Legacy for Artists," in Lyons, Weinberg, and Grau, eds., *Edward Hopper and the American Imagination,* 125–126.

3. I thank my colleague Judith Koroscik for suggesting this activity many years ago. It works particularly well with narrative art.

4. Rayna Alexander, Virginia Baughman, Paige Bayer, Alison Colman, Katie Edward, Sarah Gee, Nicole Gray, Mary Hanaghan, KariAnn Husted, Angela Kalb, Teri Lloyd, Sara Luring, Burton Maslyk, Paul Mollard, Maria Mongenas, Kris Segedi, Kevin Skidmore, Melissa Stolt, Pamela Talbert, Dainta Teeple, and Erin Wilkinson.

5. Mark Strand, *Hopper* (Hopewell, NJ: Ecco, 1994), 23, 25, 47–48.

6. Ann Beattie, "Cape Cod Evening," in Lyons, Weinberg, and Grau, eds., *Edward Hopper and the American Imagination,* 9–14.

7. Andrea Kirsh and Rustin Levenson, *Seeing through Paintings: Physical Examination in Art Historical Studies* (New Haven, CT: Yale University Press, 2000), 165.

8. Joyce Carol Oates, "Edward Hopper, *Nighthawks,* 1942," in Gail Levin, ed., *The Poetry of Solitude: A Tribute to Edward Hopper* (New York: Universe, 1995).

9. *Rain* and other works by Bebe Miller are available for educational use on a CD-ROM entitled *danceCODES.* It can be ordered from Ohio State University at <http://www.dance.ohio-state.edu>, under the Dance Technology Media Products link.

10. Candace Feck, essay, Department of Dance, Ohio State University, 2000.

11. David Carrier, *The Aesthetics of Comics* (University Park: Pennsylvania State University Press, 2000), 19–20.

12. Spalding Gray, *Morning, Noon and Night* (New York: Farrar, Straus & Giroux, 1999), 84–85.

13. Leo Burnett, McDonald's "Girls, Girls, Girls," 60-second spot, 1/26/86, on Jason Simon, *Production Notes: Fast Food for Thought,* 30-minute videotape, 1987.

14. Henry Giroux, *The Mouse That Roared. Disney and the End of Innocence* (New York: Rowman & Littlefield, 1999).

15. Paul Goldberg, "Gateway to Gotham," *New Yorker,* May 28, 2001, 114.

16. Goldberg wrote this essay before the attack on the World Trade Center in lower Manhattan on September 11, 2001.

17. Paola Antonelli, "On the American Table," in Mark Robbins, *On the Table,* Wexner Center for the Arts, Ohio State University, Columbus, 1999, 23.

18. Holly Brubach, "Tables, 1998," in Mark Robbins, *On the Table,* 102–103.

19. The first three paragraphs of this section are taken from Terry Barrett, *Criticizing Photographs: An Introduction to Understanding Images,* 3rd ed. (Mountain View, CA: Mayfield, 2000), 38–39.

20. Roland Barthes, "Rhetoric of the Image," in *Image, Music, Text* (New York: Hill & Wang, 1977), 32–51.

21. See note 4.

22. *Rolling Stone,* Issue 869, May 24, 2001.

Chapter 8 • Principles for Interpreting Art

1. Arthur Danto, *The Transfiguration of the Commonplace: A Philosophy of Art* (Cambridge, MA: Harvard, 1981).

2. Noël Carroll summarized by George Dickie, "Art: Function or Procedure—Nature or Culture?" *Journal of Aesthetics and Art Criticism* 55, no. 1 (Winter 1997): 20.

3. Nelson Goodman, *Languages of Art: An Approach to a Theory of Symbols* (Indianapolis, IN: Hackett, 1976); *Ways of Worldmaking* (Indianapolis, IN: Hackett, 1978).

4. Noël Carroll, "The Intentional Fallacy: Defending Myself," *Journal of Aesthetics and Art Criticism* 55, no. 3 (Summer 1997): 307.

5. See, for example, David Lauer and Stephen Pentak, *Design Basics,* 5th ed. (New York: Harcourt Brace, 2000), 5.

6. Paul Thom, *Making Sense: A Theory of Interpretation* (New York: Rowman & Littlefield, 2000), 64.

7. Ibid., 38.

8. Bradford Collins, "The Dialectics of Desire," in Bradford Collins, ed., *12 Views of Manet's Bar* (Princeton, NJ: Princeton University Press, 1996), 115–141.

9. Jonathan Culler, "In Defense of Overinterpretation," in Umberto Eco, ed., *Interpretation and Overinterpretation* (New York: Cambridge University Press, 1992), 115.

10. Karen-Edis Barzman, "Beyond the Canon: Feminists, Postmodernism, and the History of Art," *Journal of Aesthetics and Art Criticism* 52, no. 3 (Summer 1994): 330.

11. Andrea Kirsh and Rustin S. Levenson, *Seeing through Paintings: Physical Examination in Art Historical Studies* (New Haven, CT: Yale University Press, 2000), 2.

12. Thom, *Making Sense,* 54.

13. Marcia Siegel quoted in Irene Meltzer, *The Critical Eye: An Analysis of Dance Criticism,* unpublished Master's thesis, Ohio State University, 1979, 55.

14. Thom, *Making Sense,* 29.

15. Richard Rorty, "The Pragmatist's Progress," in Eco, ed., *Interpretation and Overinterpretation* (New York: Cambridge University Press, 1992), 105.

16. Tom Stoppard, *Sunday Times* (London) quoted on back cover of Suzi Gablik, *Magritte* (London: Thames & Hudson, 1970).

17. Goodman quoted by Israel Scheffler, *In Praise of the Cognitive Emotions and Other Essays in the Philosophy of Education* (New York: Routledge, 1991), 7.

18. Scheffler, *In Praise of the Cognitive Emotions,* 4–9.

19. Edmund Feldman, *Becoming Human through Art* (Englewood Cliffs, NJ: Prentice-Hall, 1970), 196–204.

20. E. D. Hirsch, *Validity in Interpretation,* New Haven: Yale University Press, 1967.

21. Marcia Eaton, *Basic Issues in Aesthetics* (Belmont, CA: Wadsworth, 1988); Michael Krausz, "Interpretation," *Encyclopedia of Aesthetics* (New York: Oxford University Press, 1988); Joseph Margolis, "Plain Talk about Interpretation on a Relativistic Model," *Journal of Aesthetics and Art Criticism* 53, no. 1 (Winter 1995): 1–7; Stephen Davies, "Relativism in Interpretation," *Journal of Aesthetics and Art Criticism,* 53, no. 1 (Winter 1995): 8–13.

22. Morris Weitz, *Hamlet and the Philosophy of Literary Criticism* (Chicago: University of Chicago Press, 1964).

23. Robert Pinsky, a review of *Dante,* by R. W. B. Lewis, *New York Times Book Review,* July 29, 2001, p. 9.

24. Stephen Davies, "Relativism in Interpretation," 9.

25. Ibid.

26. Jonathan Culler, "In Defense of Overinterpretation," 111, 115–116.

27. Rorty "The Pragmatist's Progress," 95.

28. Krausz, "Interpretation," 522.

29. Terry Barrett, *Talking about Student Art* (Worcester, MA: Davis, 1997), 72–76.

30. Scheffler, *In Praise of the Cognitive Emotions,* 36.

31. W. K. Wimsatt and Monroe Beardsley, "The Intentional Fallacy," in W. K. Wimsatt, ed., *The Verbal Icon* (Lexington: University of Kentucky Press, 1954).

32. Scheffler, *In Praise of the Cognitive Emotions,* 36.

33. Gerys Gault, "Interpreting the Arts: The Patchwork Theory," *Journal of Aesthetics and Art Criticism,* 51, no. 4 (Fall 1993): 598.

34. Paul Taylor, "Intention," in *Encyclopedia of Aesthetics* (New York: Oxford University Press, 1988.

35. Gault, "Interpreting the Arts," 600.

36. Cindy Sherman, Sandy Skoglund, and Jerry Uelsmann quoted in Terry Barrett, *Criticizing Photographs: An Introduction to Understanding Images,* 3rd ed. (Mountain View, CA: Mayfield, 2000), 50.

37. Gornik in Chuck Close, *The Portraits Speak* (New York: A.R.T. Press, 1997), 454.

38. Lucio Pozzi, "12 Questions of Art," in Susan Bee & Mira Schor, eds., *Meaning: An Anthology of Artists' Writings, Theory, and Criticism* (Durham, NC: Duke University Press, 2000), 139.

39. Barzman, "Beyond the Canon," 329.

40. Scheffler, *In Praise of the Cognitive Emotions,* 35.

41. Robert Stecker, "Incompatible Interpretations," *Journal of Aesthetics and Art Criticism,* 50, no. 4 (Fall 1992): 291–298.

42. Eco, *Interpretation and Overinterpretation,* 25.

43. Edward Weston, *The Daybooks of Edward Weston,* I & II (Millerton, NY: Aperture, 1973).

44. Agnes Martin, *Writings* (Kunstmuseum, Winterthur, Germany: Cantz, 1991, distributed by D.A.P. in New York City).

45. Lawrence Weschler, *Seeing Is Forgetting the Name of the Thing One Sees: A Life of Contemporary Artist Robert Irwin* (Berkeley: University of California Press, 1982).

46. Krausz, "Interpretation," 521.

47. Barzman, "Beyond the Canon," 329.

48. Culler, "In Defense of Overinterpretation," 110.

49. Stuart Hampshire, "Types of Interpretation," in W. E. Kennick, ed., *Art and Philosophy: Readings in Aesthetics,* 2nd ed. (New York: St. Martin's, 1979).

50. Goodman, in Schheffler, *In Praise of the Cognitive Emotions,* 7.

51. Thom, *Making Sense,* 49.

52. M. Van Proyen, "A Conversation with Donald Kuspit," *Artweek* 5, no. 19: 19.

53. In David Carrier, *The Aesthetics of Comics* (University Park: Pennsylvania State University Press, 2000), 81.

54. Ibid.

55. Noël Carroll, "Art Practice and Narrative," *Monist* 17, no. 2 (April 1988), 144.

56. Robert Stecker, "Relativism about Interpretation," *Journal of Aesthetics and Art Criticism* 53, no. 1 (Winter 1995): 14.

57. Ron Bontekoe, "Paul Ricoeur," *Encyclopedia of Aesthetics* (New York: Oxford University Press, 1988).

58. Hans-Georg Gadamer quoted in Bontekoe, "Paul Ricoeur," 162.

59. Ibid., 165.

60. See Stefan Collini, Introduction, in Eco, ed., *Interpretation and Overinterpretation,* 11.

61. Rorty, "The Pragmatist's Progress," 92.

62. Ibid., 97, 102.

63. Susan Barrett, Center for Education, Bradenton, FL, 1984.

64. Devonshire Elementary School, Columbus Public Schools, Columbus, Ohio, Melissa Webber, host teacher, 1994.

65. Richard Shiff, "Ascribing to Manet, Declaring the Author," in Bradford Collins, ed., *12 Views of Manet's Bar* (Princeton, NJ: Princeton University Press, 1996), 19.

66. A. M. Holmes, "Eric Fischl," in Betsy Sussler, ed., *Speak Art!* (New York: G + B Arts International, 1997), 69.

67. In Bontekoe, "Paul Ricoeur," 305–308.

68. Ibid., 166.

69. Gault, "Interpreting the Arts," 599.

70. Eco, *Interpretation and Overinterpretation*, 150, 151.

71. Marcia Eaton, *Basic Issues in Aesthetics* (Belmont, CA: Wadsworth, 1988), 120–122.

72. Barzman, "Beyond the Canon," 331–335.

Bibliography

Abbey, Mary. "Hooked on Art." *Minneapolis Star Tribune,* May 27, 1997.

Alden, Todd. *The Essential Réne Magritte.* New York: Abrams, 1999.

Antonelli, Paola. "On the American Table." In *On the Table,* edited by Mark Robbins, 23. Columbus, OH: Wexner Center for the Arts, 1999.

Arabic News.com. "Egypt Contacts Taliban for Halting Destruction of Statues," <http://www.arabicnews.com/ansub/Daily/Day/010310/2001031029.html>, February 13, 2002.

Arago, Dominique François. "Report" (1839). In *Classic Essays on Photography,* edited by Alan Trachtenberg. New Haven, CT: Leete's Island Books, 1980.

Arbus, Diane. *Diane Arbus.* Millerton, NY: Aperture, 1972.

Armstrong, Carol. "Counter, Mirror, Maid: Some Ingra-thin Notes on *A Bar at the Folies-Bergère.*" In *12 Views of Manet's Bar,* edited by Bradford Collins, 25–46. Princeton, NJ: Princeton University Press, 1996.

Armstrong, Elizabeth. "Eric Fischl's Monotypes: In the Continuum." In *Scenes and Sequences: Recent Monotypes by Eric Fischl.* Hood Museum of Art, Dartmouth College. New York: Abrams, 1990.

Ashton, Dore. "The Long and Short of It." In *Breakthroughs: Avant-Garde Artists in Europe and America, 1950–1990.* New York: Rizzoli, 1991.

Associated Press. "Museum's Funding Restored." *Columbus Dispatch,* November 2, 1999.

Atkins, Robert. *Art Speak.* New York: Abbeville Press, 1990.

Barrett, Terry. *Criticizing Art: Understanding the Contemporary.* 2nd ed. Mountain View, CA: Mayfield, 2000.

———. *Criticizing Photographs: An Introduc- Photographs: An Introduction to Understanding Images.* 3rd ed. Mountain View, CA: Mayfield, 2000.

Barthes, Roland. *Camera Lucida: Reflections on Photography.* New York: Hill & Wang, 1981.

———. "Rhetoric of the Image." *In Image, Music, Text.* New York: Hill & Wang, 1977.

Barzman, Karen-Edis. "Beyond the Canon: Feminists, Postmodernism, and the History of Art." *Journal of Aesthetics and Art Criticism* 52, no. 3 (Summer 1994): 327–339.

Beattie, Ann. "Cape Cod Evening." In *Edward Hopper and the American Imagination,* edited by Deborah Lyons, Adam Weinberg, and Julie Grau, 9–14. New York: Norton, 1995.

Belgrad, Daniel. "The Rockwell Syndrome." *Art in America* (April 2000): 61–67.

Berger, John. *Ways of Seeing.* London: Penguin Books, 1972.

Bersson, Robert. *Worlds of Art.* Mountain View, CA: Mayfield, 1991.

Billeter, Erika. "Eric Fischl and His Art-historical Environment." In *Eric Fischl.* Aarhus Kunstmuseum, Louisiana Museum for Moderne Kunst, Humlebæk, Denmark, 1991.

Boime, Albert. "Manet's *A Bar at the Folies-Bergère* as an Allegory of Nostalgia." In *12 Views of Manet's Bar,* edited by Bradford Collins. Princeton, NJ: Princeton University Press, 1996.

Bontekoe, Ron. "Paul Ricoeur." *Encyclopedia of Aesthetics,* Vol. 4, 162–166. New York: Oxford University Press, 1988.

Bowles, Juliet. "Extreme Times Call for Extreme Heroes." *International Review of African American Art* 14, no. 3 (1997).

Bradley, Fiona. *Surrealism.* Cambridge, England: Cambridge University Press, 1997.

Brubach, Holly. "Tables, 1998." In *On the Table,* edited by Mark Robbins, 102–103. Columbus, OH: Wexner Center for the Arts, 1999.

Bull, David and Joyce Plesters. *The Feast of the Gods: Conservation, Examination, and Interpretation.* Washington, DC: The National Gallery of Art, 1990.

Carrier, David. *The Aesthetics of Comics.* University Park: Pennsylvania State University Press, 2000.

Carroll, Noël. "Art: Function or Procedure—Nature or Culture?" *Journal of Aesthetics and Art Criticism* 55, no. 1 (Winter 1997).

———. "Art Practice and Narrative." *Monist* 17, no. 2 (April 1988).

———. "The Intentional Fallacy: Defending Myself." *Journal of Aesthetics and Art Criticism* 55, no. 3 (1997).

Carter, Holland. "Kara Walker." *New York Times on the Web,* November 20, 1998 <http://www.nytimes.qpass.com/qpass-archives>, December 22, 2000.

Cartier-Bresson, Henri. *Teaching Guide to Images of Man 2: Scholastic's Concerned Photographer Program.* New York: Scholastic Magazines, 1973.

Champa, Kermit. "Le Chef d'Oeuvre (bien connu)." In *12 Views of Manet's Bar,* edited by Bradford Collins. Princeton, NJ: Princeton University Press, 1996.

Chevalier, Tracy. *Girl with a Pearl Earring.* New York: Plume, 2001.

Clark, T. J. *The Painting of Modern Life: Paris in the Art of Manet and His Followers.* Princeton, NJ: Princeton University Press, 1990.

Close, Chuck. *The Portraits Speak.* New York: A.R.T. Press, 1997.

Collini, Stefan. Introduction to *Interpretation and Overinterpretation,* by Umberto Eco. New York: Cambridge University Press, 1992.

Collins, Bradford, ed. *12 Views of Manet's Bar.* Princeton, NJ: Princeton University Press, 1996.

Collins, Bradford. "The Dialectic of Desire, the Narcissism of Authorship: A Male Interpretation of the Psychological Origins of Manet's *Bar.*" In *12 Views of Manet's Bar,* edited by Bradford Collins. Princeton, NJ: Princeton University Press, l996.

Combalia, Victoria. "Sean Scully: Against Formalism." In *Sean Scully: Twenty Years, 1976–1995,* edited by Ned Rifkin.

High Museum of Art, Thames & Hudson, 1995.

Cooke, Lynne. "Sean Scully: Taking up a Stance." In *Sean Scully: Twenty Years, 1976–1995,* edited by Ned Rifkin. High Museum of Art, Thames & Hudson, 1995.

Culler, Jonathan. "In Defense of Overinterpretation." In Umberto Eco, *Interpretation and Overinterpretation.* New York: Cambridge University Press, 1992.

Daliweb: The Official Site of the Salvador Dalí Museum, <http://www.daliweb.com/index.htm>, September 24, 1999; and The Salvador Dalí Gallery of the Fine Art Site, <http://www.fineartsite.com/gallery/Dali_1.html>, September 24, 1999.

Dalton, Karen C. C. "The Past Is Prologue but Is Parody and Pastiche Progress?" *International Review of African American Art* 14, no. 3 (1997).

Danto, Arthur. B*eyond the Brillo Box: The Visual Arts in Post Historical Perspective.* Cambridge, MA: Harvard University Press, 1981.

———. "Freckles for the Ages." *New York Times Book Review,* September 28, 1986.

———. *Transfiguration of the Commonplace.* New York: Farrar, Straus & Giroux, 1981.

Davies, Stephen. "Relativism in Interpretation." *Journal of Aesthetics and Art Criticism* 53, no. 1 (Winter 1995): 8–13.

Dickie, George. *Introduction to Aesthetics: An Analytic Approach.* Oxford University Press, 1997.

Dieckmann, Katherine. "Photographs . . . with Children." *Voice Literary Supplement,* November 1992.

Doshi, Saryu. *Dharna Vihara, Ranakpur.* Stuttgart: Alex Menges, 1995.

Dubin, Steven. "How 'Sensation' Became a Scandal," *Art in America* (January 2000).

Eaton, Marcia. *Basic Issues in Aesthetics.* Belmont, CA: Wadsworth, 1988.

Eco, Umberto. *Interpretation and Overinterpretation.* New York: Cambridge University Press, 1992.

Eisenman, Stephen. *Nineteenth Century Art: A Critical History.* London: Thames & Hudson, 1994.

Feldman, Edmund. *Becoming Human through Art.* Englewood Cliffs, NJ: Prentice-Hall, 1970.

Field, Richard S. "The Dreams and Lies of Eric Fischl's Monotypes." In *Scenes and Sequences: Recent Monotypes by Eric Fischl.* Hood Museum of Art, Dartmouth College. New York: Abrams, 1990.

Fineberg, Jonathan. *Art Since 1940: Strategies of Being.* Englewood Cliffs, NJ: Prentice-Hall, 1995.

Fisher, Mary Pat. *Living Religions.* 4th ed. Upper Saddle River, NJ: Prentice Hall, 1999.

Flam, Jack. "Looking into the Abyss: The Poetics of Manet's *A Bar at the Folies-Bergère.*" In *12 Views of Manet's Bar,* edited by Bradford Collins. Princeton, NJ: Princeton University Press, l996.

Foucault, Michel. *Les Mots et les choses: Une archéologie des sciences humaines.* Gallimard, 1966. Published in English as *The Order of Things.* New York: Pantheon, 1971.

———. *This Is Not a Pipe.* Berkeley: University of California Press, 1983.

Gablik, Suzi. *Magritte.* 1970. Reprint. New York: Thames & Hudson, 1985.

Gault, Gerys. "Interpreting the Arts: The Patchwork Theory." *Journal of Aesthetics and Art Criticism* 51, no. 4 (Fall 1993): 597–609.

Giroux, Henry. *The Mouse That Roared. Disney and the End of Innocence.* New York: Rowman & Littlefield, 1999.

Goings, Kenneth. *Mammy and Uncle Mose: Black Collectibles and American Stereotyping.* Bloomington: Indiana University Press, 1994.

243

Goldberg, Paul. "Gateway to Gotham." *New Yorker,* May 28, 2001, 114.

Gombrich, Ernst. *Art and Illusion.* Princeton, NJ: Princeton University Press, 1960.

Gooden, Troy. "An Evening with Michael Ray Charles." *International Review of African American Art* 14, no. 3 (1997).

Goodman, Nelson. *Languages of Art.* 2nd ed. Indianapolis, IN: Hackett, 1976.

Gray, Spalding. *Morning, Noon and Night.* New York: Farrar, Straus & Giroux, 1999.

Gronberg, Tag. "Dumbshows: A Carefully Staged Indifference." In *12 Views of Manet's Bar,* edited by Bradford Collins. Princeton, NJ: Princeton University Press, 1996.

Hammacher, A. M. *Réne Magritte.* 1955. Reprint. New York: Abrams, 1985.

Hampshire, Stuart. "Types of Interpretation." In *Art and Philosophy: Readings in Aesthetics,* edited by W. E. Kennick. 2nd ed. New York: St. Martin's, 1979.

Harris, Melissa. "Daughter, Model, Muse: Jessie Mann on Being Photographed." *Aperture* 162 (Winter 2001).

Harris, Neil. "The View from the City." In *Norman Rockwell: Pictures for the American People,* edited by Maureen Hart Hennessey and Anne Knutson. New York: Abrams, 1999.

Hart, Frederick. *Art: A History of Painting, Sculpture, Architecture.* 3rd ed. Englewood Cliffs, NJ: Prentice-Hall and New York: Abrams, 1989.

Hennessey, Maureen Hart and Anne Knutson, eds. *Norman Rockwell: Pictures for the American People.* New York: Abrams, 1999.

Herbert, James. "Privilege and the Illusion of the Real." In *12 Views of Manet's Bar,* edited by Bradford Collins. Princeton, NJ: Princeton University Press, 1996.

Hickey, Dave. "The Kids Are All Right: *After the Prom.*" In *Norman Rockwell: Pictures for the American People,* edited by Mau-

reen Hart Hennessey and Anne Knutson. New York: Abrams, 1999.

Hirsch, E. D. *Validity in Interpretation.* New Haven, CT: Yale University Press, 1967.

Hjort, Oystein. "Feast or Famine—Eric Fischl and the USA in the Eighties." In *Eric Fischl.* Aarhus Kunstmuseum, Louisiana Museum for Moderne Kunst, Humlebæk, Denmark, 1991.

Holden, George, trans. Introduction to *Nana,* by Émile Zola. 1880. New York: Viking Penguin, 1972.

Holmes, A. M. "Eric Fischl." *In Speak Art!,* edited by Betsy Sussler. New York: G + B Arts International, 1997.

hooks, bell. *Art on My Mind: Visual Politics.* New York: New Press, 1995.

House, John. "In Front of Manet's Bar: Subverting the 'Natural.'" In *12 Views of Manet's Bar,* edited by Bradford Collins. Princeton, NJ: Princeton University Press, 1996.

Hughes, Robert. *The Shock of the New.* New York: Alfred A. Knopf, l996.

Janson, H. W. *History of Art.* Englewood Cliffs, NJ: Prentice-Hall and New York: Abrams, 1969.

Kern-Foxworth, Marilyn. "Painting Positive Pictures of Images That Injure: Michael Ray Charles' Dueling Dualities." In *Michael Ray Charles.* Tony Shafrazi Gallery, New York, 1997.

Kimball, Roger. "Art Isn't Exempt from Moral Criticism." *Wall Street Journal,* Editorial, September 24, 1999.

Kimmelman, Michael. "Critic's Notebook: Cutting through Cynicism in Art Furor." *New York Times on the Web,* <http:llnytimes.com/libraryarts/092499 brooklyn-artnotebook.html>, September 28, 1999.

———. "'Sensation': After All That Yelling, Time to Think." *New York Times on the Web,* <http://www.nYtimes.com/ library/arto,/10 (~1g9sensation-artre view.htmb>, October 1, 1999.

244

Kirsh, Andrea and Rustin S. Levenson. *Seeing through Paintings: Physical Examination in Art Historical Studies.* New Haven, CT: Yale University Press.

Knutson, Anne. "The Saturday Evening Post." In *Norman Rockwell: Pictures for the American People,* edited by Maureen Hart Hennessey and Anne Knutson. New York: Abrams, 1999.

Kolbert, Elizabeth. "Around City Hall: Damien Hirst and the Mayor Call Each Other Names." *New Yorker,* October 4, 1999, 38–40.

Krausz, Michael. "Interpretation." *Encyclopedia of Aesthetics,* Vol. 2, 520–526. New York: Oxford University Press, 1988.

Larson, Judy L. and Maureen Hart Hennessey. "Norman Rockwell: A New Viewpoint." In *Norman Rockwell: Pictures for the American People,* edited by Maureen Hart Hennessey and Anne Knutson. New York: Abrams, 1999.

Lauer, David and Stephen Pentak. *Design Basics.* 5th ed. New York: Harcourt Brace, 2000.

Lee, Spike. Introduction to *Michael Ray Charles: An American Artist's Work, 1989–1997.* The Art Museum of the University of Houston, 1997.

Levin, Gail. "Edward Hopper: His Legacy for Artists." In *Edward Hopper and the American Imagination,* edited by Deborah Lyons, Adam Weinberg, and Julie Grau. New York: Norton, 1995.

Loughran, Susan. Letters to Editor. *Newsweek,* November 1, 1999.

Lowry, Glenn. "The Art That Dares." *New York Times,* October 10, A31.

Lucie-Smith, Edward. *Lives of the Great 20th Century Artists.* London: Thames & Hudson, 1999.

Lutz, Catherine and Jane Collins. *Reading National Geographic.* Chicago: University of Chicago Press, 1993.

Lyons, Deborah. Introduction to *Edward Hopper and the American Imagination,* edited by Deborah Lyons, Adam Weinberg, and Julie Grau. New York: Norton, 1995.

Lyons, Nathan. *Photographers on Photography.* Englewood Cliffs, NJ: Prentice-Hall, 1996.

MacDonald, Robert. "Tolerance, Trust, and the Meaning of 'Sensation.'" *Museum News,* May/June 2000, 46–53.

Macey, David. *The Lives of Michel Foucault.* New York: Pantheon, 1993.

McGuigan, Cathleen, "A Shock Grows in Brooklyn." *Newsweek,* October 11, 1999, 68–70.

MacRitchie, Lynn. "Ofili's Glittering Icons." *Art in America* (January 2000): 97–100.

Mann, Sally. *Immediate Family.* New York: Aperture, 1992.

Margolis, Joseph. "Plain Talk about Interpretation on a Relativistic Model." *Journal of Aesthetics and Art Criticism* 53, no. 1 (Winter 1995): 1–7.

Marshall, Richard and Robert Mapplethorpe. *50 New York Artists: A Critical Selection of Painters and Sculptors Working in New York.* San Francisco: Chronicle Books, 1996.

Meltzer, Irene. *The Critical Eye: An Analysis of Dance Criticism.* Master's thesis, Ohio State University, 1979.

Meuris, Jacques. *Réne Magritte.* Cologne: Benedikt Taschen, 1994.

Michael Ray Charles. Tony Shafrazi Gallery, New York, 1997.

Miller, Bebe. *Rain,* a dance, on a CD-ROM entitled *danceCODES.* It can be ordered from Ohio State University at <http://www.dance.ohio-state.edu/> under the Dance Technology Media Products link.

Moffatt, Laurie Norton. "The People's Painter." In *Norman Rockwell: Pictures for the American People,* edited by Maureen Hart Hennessey and Anne Knutson. New York: Abrams, 1999.

Montebello, Philippe de. "Making a Cause Out of Bad Art," *New York Times,* October 5, 1999.

245

Oates, Joyce Carol. "Edward Hopper, *Nighthawks*, 1942." In *The Poetry of Solitude: A Tribute to Edward Hopper*, edited by Gail Levin. New York: Universe, 1995.

Ocvirk, Otto, Robert Stinson, Philip Wigg, Robert Bone, and David Cayton. *Art Fundamentals: Theory and Practice*. 8th ed. New York: McGraw-Hill, 1998.

O'Doherty, Brian. *American Masters: The Voice and the Myth*. New York: Universe Books, 1988.

Olsen, Stein Haugom. "Appreciation." *Encyclopedia of Aesthetics*, Vol. 1, 66. New York: Oxford University Press, 1988.

Pinsky, Robert. Review of *Dante*, by R. W. B. Lewis. *New York Times Book Review*, July 29, 2001, p. 9.

Plagens, Peter. "Norman Rockwell Revisited." *Newsweek*, November 15, l999, 84–86.

Pollock, Griselda. "The 'View from Elsewhere': Extracts from a Semi-public Correspondence about the Visibility of Desire." In *12 Views of Manet's Bar*, edited by Bradford Collins. Princeton, NJ: Princeton University Press, 1996.

Porter, Eliott. *Teaching Guide to Images of Man 2: Scholastic's Concerned Photographer Program*. New York: Scholastic Magazines, 1973.

Pozzi, Lucio. "12 Questions of Art." In *Meaning: An Anthology of Artists' Writings, Theory, and Criticism*, edited by Susan Bee and Mira Schor. Durham, NC: Duke University Press, 2000.

Preble, Duane and Sarah. *Artforms*. 4th ed. New York: Harper & Row, 1989.

Price, Reynolds. "For the Family." In *Immediate Family*, by Sally Mann. New York: Aperture, 1992.

Reid, Calvin. "Air Sambo." In *Michael Ray Charles*. Tony Shafrazi Gallery, New York, 1997.

Rich, F. "Pull the Plug on Brooklyn." Op-Ed Columns Archive, *New York Times*, October 9, 1999.

Rifkin, Ned. "Interview with Sean Scully," May 20, 1994. In *Sean Scully: Twenty Years, 1976–1995*, 57–80. High Museum of Art, Thames & Hudson, 1995.

———. *Sean Scully: Twenty Years, 1976–1995*. High Museum of Art, Thames & Hudson, 1995.

———. "Why Norman Rockwell, Why Now?" In *Norman Rockwell: Pictures for the American People*, edited by Maureen Hart Hennessey and Anne Knutson. New York: Abrams, 1999.

Robbins, Mark, ed. *On the Table*. Wexner Center for the Arts, Ohio State University, Columbus, 1999.

Rockwell, Peter. "Some Comments from the Boy in a Dining Car." In *Norman Rockwell: Pictures for the American People*, edited by Maureen Hart Hennessey and Anne Knutson. New York: Abrams, 1999.

Rogers-Lafferty, Sarah. "Art in America and Europe: The 1950s and the 1960s." In *Breakthroughs: Avant-Garde Artists in Europe and America, 1950–1990*. New York: Rizzoli, 1991.

Rorty, Richard. "The Pragmatist's Progress." In *Interpretation and Overinterpretation*, edited by Umberto Eco. New York: Cambridge University Press, 1992.

Rosenbaum, Lee. "Brooklyn Hangs Tough." *Art in America* (January 2000): 59–63.

Rosenberg, Harold. "The American Action Painters." In *Art in Theory 1900–1990*, edited by Charles Harrison and Paul Wood. Oxford, England: Blackwell, 1992.

Scenes and Sequences: Recent Monotypes by Eric Fischl. Hood Museum of Art, Dartmouth College. New York: Abrams, 1990.

Scheffler, Israel. *In Praise of the Cognitive Emotions and Other Essays in the Philosophy of Education*. New York: Routledge, 1991.

Shah, Amir. "Afghan Leaders Order Destruction of Statues." *Columbus Dispatch,* February 27, 2001, A9.

Shaw, Gwendolyn Dubois. "Final Cut." *Parkett* 59 (2000).

Shiff, Richard. Introduction: "Ascribing to Manet, Declaring the Author." In *12 Views of Manet's Bar,* edited by Bradford Collins. Princeton, NJ: Princeton University Press, l996.

Simon, Jason. *Production Notes: Fast Food for Thought,* 30-minute videotape, 1987.

Smith, Roberta. "Art in Review: Michael Ray Charles." *New York Times,* December 27, 2000.

Solomon, Deborah. "He Captured the Soul." *New York Times,* March 4, 2001.

SongTalk Interview, Paul Simon—Spirit Voices Vol. I, by Paul Zollo, <http://www.medialab.chalmers.se/guitar/simon.interview8.html>, December 13, 1999.

Stecker, Robert. "Incompatible Interpretations." *Journal of Aesthetics and Art Criticism* 50, no. 4 (Fall 1992): 291–298.

———. "Relativism about Interpretation." *Journal of Aesthetics and Art Criticism* 53, no. 1 (Winter 1995): 14.

Stein, Sally and Terry Pitts. *Harry Callahan: Photographs in Color/the Years 1946–1978.* Tucson: Center for Creative Photography, University of Arizona, 1980.

Steinem, Gloria. Foreword to *The Vagina Monologues* by Eve Ensler. V-Day ed. New York: Villard, 2001.

Strand, Mark. *Hopper.* Hopewell, NJ: Ecco, 1994.

Sturges, Jock. *Jock Sturges.* New York: Scalo and DAP, 1996.

———. *Last Day of Summer.* New York: Aperture, 1991.

———. *Radiant Identities.* New York: Aperture, 1994.

Szabo, Julian. "Kara Walker's Shock Art." *New York Times Magazine,* March 23, 1997.

Szarkowski, John. *Looking at Photographs: 100 Pictures from the Museum of Modern Art.* New York: The Museum of Modern Art, 1973.

Tansey, Richard G. and Fred S. Kleiner. *Gardner's Art through the Ages.* 10th ed. Harcourt Brace, 1996.

Taylor, Paul. "Intention." *Encyclopedia of Aesthetics,* Vol. 2, 512. New York: Oxford University Press, 1988.

Thom, Paul. *Making Sense: A Theory of Interpretation.* New York: Rowman & Littlefield, 2000.

Tillim, Sidney. "Eric Fischl." *Art in America* (February 1995): 94.

Van Proyen, Mark. "A Conversation with Donald Kuspit." *Artweek* 5, no. 19.

Verghese, Abraham. "Cell Block." *New York Times Magazine,* August 19, 2001, 13.

Vogel, Carol. "Amid 'Sensation,' Painter Tries to Keep His Cool." *Columbus Dispatch,* The Arts, October 3, 1999, 1–2.

Weitz, Morris. *Hamlet and the Philosophy of Literary Criticism.* Chicago: University of Chicago Press, 1964.

Weschler, Lawrence. *Seeing Is Forgetting the Name of the Thing One Sees: A Life of Contemporary Artist Robert Irwin.* Berkeley: University of California Press, 1982.

Wheelock, Arthur K., Jr. *Vermeer, The Complete Works.* New York: Abrams.

Wilson, Brent. *The Quiet Evolution: Changing the Face of Arts Education.* Los Angeles: J. Paul Getty Trust, 1997.

Wimsatt, W. K. and Monroe Beardsley. "The Intentional Fallacy." In *The Verbal Icon,* edited by W. K. Wimsatt. Lexington: University of Kentucky Press, 1954.

Woodward, Richard B. "The Disturbing Photography of Sally Mann." *New York Times Magazine,* September 27, 1992, 33, 52.

Wright, Stephen. "Eric Fischl, *Inside Out,* 1982." *Artforum* (October 1999): 188–189.

Zola, Émile. *Nana*. 1880. Reprint. New York: Viking Penguin, 1972. Translation and Introduction by George Holden.

Zweite, Armin. "To Humanize Abstract Painting: Reflections on Sean Scully's *Stone Light*," translated by John Ormrod, Munich. In *Sean Scully: Twenty Years, 1976–1995*, edited by Ned Rifkin. High Museum of Art, Thames & Hudson, 1995.

Index

Page numbers in *italics* indicate illustrations. Numbers preceded by CP indicate color plates.

257

259